THE SCULPTURE OF

PALENQUE

VOLUME IV

The Cross Group, the North Group,
the Olvidado, and Other Pieces

THE SCULPTURE OF
PALENQUE

BY MERLE GREENE ROBERTSON

VOLUME IV

The Cross Group, the North Group,
the Olvidado, and Other Pieces

Princeton University Press, Princeton, New Jersey

LIBRARY OF CONGRESS CATALOGING-IN-PUBLICATION DATA
(Revised for volume 4)

Robertson, Merle Greene.
The sculpture of Palenque.
"Published in association with the J. Paul Getty Trust."
Folded map in pocket.
Includes bibliographies and indexes.
Contents: v. 1. The Temple of the Inscriptions—[etc.]—
v. 3. The late buildings of the palace—
v. 4. The Cross Group, the North Group, the Olvidado, and other pieces.
1. Palenque Site (Mexico) 2. Mayas—Sculpture.
3. Indians of Mexico—Sculpture. 4. Sculpture—Mexico—
Palenque Site. I. Title.
F1435.1.P2R66 1983 709'.72'75 82-341
ISBN 0-691-03560-1 (v. 1: alk. paper)
ISBN 0-691-03568-7 (v. 2: alk. paper)
ISBN 0-691-03571-7 (v. 3: alk. paper)
ISBN 0-691-03572-5 (v. 4: alk. paper)

To my Tulane colleagues
E. Wyllys Andrews V
Joann Andrews
Betty Wauchope
Doris Stone
Martha Robertson

In memory of
E. Wyllys Andrews IV
Robert Wauchope
Roger Stone
Donald Robertson

ACKNOWLEDGMENTS

Recording the art and sculpture of Palenque by photography, drawing, painting, and research has been an ongoing project for sixteen years. I am indebted to many individuals for their many and varied contributions and for the tremendous help they have been over this long time. All of the individuals whose help I acknowledged in Volume I of this series also had a great part in seeing to completion the work in this volume—the work was not necessarily done in the order of volume numbers.

The work would not have been possible without the cooperation of the Instituto Nacional de Antropología y Historia, México, and to its staff I am most grateful. I am especially grateful for the help and cooperation Ing. Juaquin Garcia-Barcena gave during the last years of this project.

If I were to list all of the people in Palenque who have contributed in so many ways, I would have to name a great proportion of the population, but I do say to all of you Palencanos: Les quiero mucho y les doy las gracias a cada uno de ustedes por todo lo que han hecho y todo lo que significan para mí.

Many others have helped on this volume, and to them I owe many thanks. Linda Schele, you have been a great help, especially in the hieroglyphs, and we have carried on so many hours of telephone conversations on them that I am reminded of our long evenings of discussion about the fate of Palenque while we were working there in the early days. Thank you, Linda. Peter Mathews, I thank you for your never-failing help and especially for taking the time to record all of the Olvidado with me at a point when we expected it to fall down at any moment. Floyd Lounsbury, I thank you for your assistance with the short-figure–tall-figure problem of the Cross Group temples. Karen Bassie, I thank you too for your thoughts on this, and Tom Jones, you also. Linda, Floyd, Karen, and Tom, we have discussed this at great length, and though everyone will not agree with our solution, I think we have done our best.

Augusto and Marta Molina, I hope you know how much I appreciate your backing, suggestions, and friendship throughout the years of this documentation.

For discussion of topics to be taken up in this volume, I thank you, Carolyn Tate, George and Gene Stuart, Gillett Griffin, Justin and Barbara Kerr, Peter and Jill Furst, and Alfred Bush; and Patricia Amlin for reading my chapter in the *Popol Vuh*.

Charlotte Alteri, Lee Jones, and Chencho, I thank you for your help and for, it seemed at times, risking your lives when we recorded the Olvidado. I am sure you will not forget what sticklers Peter and I were about getting every single measurement.

Kathryn Josserand and Nick Hopkins, I thank you for taking such good care of our Research Center at Na Chan-Bahlum, Palenque, so everything would be in great shape when I came to work.

Chencho, none of this would ever have happened and this book would never have been written if it had not been for your and Deleri's unfailing help in every aspect of this undertaking.

Moisés Morales, I thank you for your many suggestions pertaining to the iconography, which every time proved correct. Key Sánchez, Ofelia Morales Sánchez, Mario León, Dr. Manuel León, Dr. Arnulfo Hardy, David Morales and Sonja, Carlos Morales, and Manuel León Pérez, I thank you too.

Norman Hammond, I am grateful to you for reading this volume and thank you for your helpful suggestions. I know that your advice has made this a much better volume.

I thank you, Paul Saffo, for letting me phone you at any time at the Institute for the Future at Stanford about my computer problems, and for straightening out the difficulties.

I especially thank you, David Greene, my son, for your time, your office, and your computer. Very special thanks is due you, Alane Bandy, for your hours and hours on the computer finishing this text after everything was lost in my computer. I am sure you are a confirmed Mayanist now. Barbara Metzler, my daughter, I thank you also for the many ways you have helped to get this volume finished.

And all of you at Princeton University Press, Joanna Hitchcock; Deborah Tegarden; Jane Low; Jane Van Tassel, my editor for this volume; Jan Lilly, my designer; all of my editors, I do appreciate the special care you have given to all the volumes of the *Sculpture of Palenque* series. Thank you all.

CONTENTS

LIST OF ILLUSTRATIONS

*(Page numbers indicate text pages where figures are discussed. All drawings and photos are by
Merle Greene Robertson unless otherwise noted.)*

THE CROSS GROUP,
THE NORTH GROUP,
THE OLVIDADO, AND
OTHER PIECES

INTRODUCTION

Palenque is the history of kings of long ago, and the Cross Group temples (fig. 1) divulge this ancient history on stone tablets in a way that had not been done in any Maya city before and was never done again. The hieroglyphic tablets unfold this history, both actual and mythical, in codex-like style from temple to temple. Not many years ago we did not know whether great cities such as Palenque, engulfed as they are in the dense rain-forest jungles of Mesoamerica, were independent communities ruled over by individual chieftains, warlords, or priests or if they were part of a larger group of connected centers. We now know that they were independent cities governed by their own rulers, who traded with, and also waged war against, neighboring communities. Strange stone monuments with stranger hieroglyphic texts were at one time thought to be solely time counters. Now, after many years of endeavor, scholars can decipher a great deal of the Mayan text. The information taken down by Diego de Landa, the first bishop of Yucatan, who burned all of the Maya books in Yucatan in hopes of wiping out the heathen texts, is the basis for this decipherment. For his overzealous burning of books, he was recalled to Spain in 1568, where he remained until he was allowed to return to the New World. While in exile he wrote about the ways of the Maya in *Relación de las cosas de Yucatan*, and after his return spent the rest of his life finishing that work and taking down the Maya alphabet. It is one of the copies of this manuscript (many copies were made and parts of them lost) that is used today by all scholars in understanding the ancient Maya, and Landa's alphabet is the basis for decipherment of the Mayan texts.

Early scholars who contributed to the decipherment of the hieroglyphs include Ernst W. Förstemann (1892), Cyrus Thomas (1882, 1904), Paul Schellhas (1897, 1904), Sylvanus G. Morley (1915, 1937-1938), William Gates (1931), Hermann Beyer (1937), and Günter Zimmermann (1956). In the 1960s we have J. Eric S. Thompson (1960, 1962), Tatiana Proskouriakoff (1960, 1963), Heinrich Berlin (1970), David H. Kelley (1960, 1962, 1965, 1976), E. V. Evreinov (1961), Yuri V. Knorozov (1963, 1967), Thomas S. Barthell (1961), and Dieter Dütting (1965, 1986).

Proskouriakoff's proof that the glyphic inscriptions were not date recordings but actual histories of Maya kings changed the whole outlook on Maya writing. She identified the T684 glyph, the "toothache" glyph referring to inauguration, a pictographic lolograph of a bundle tied together with a band and knot (text illus. a). She also identified the "up-ended frog" glyph as an "initial event" glyph now accepted as "birth" (text illus. b). Berlin showed us that the T644 glyph meant "accession" (text illus. c). Lounsbury recognized another glyph for "birth," a hand-over-earth sign (text illus. d).

The most recent work on decipherment has been done by Victoria Bricker, Michael Closs, John Fought, James Fox, Nikolai Grube, Nicholas Hopkins, Stephen Houston,

Text illus. a. Glyph T684, the "tooth-ache" glyph.

Text illus. b. The "upended frog" glyph.

Text illus. c. Glyph T644.

Text illus. d. A hand-over-earth sign.

Text illus. e. A glyph meaning "to paint" or "to write."

Text illus. f. The glyph for "ball-player."

Kathryn Josserand, John Justeson, David Kelley, Floyd Lounsbury, Barbara MacLeod, Peter Mathews, Linda Schele, David Stuart, and numerous others, all with extensive publication. Most recently David Stuart has recognized the glyph "to paint" or "to write" (text illus. e) and the glyph for "ballplayer" (*pa pitz pa pitzal*) (text illus. f).

At Palenque, the small group of temples known as the Cross Group—the Temple of the Cross, the Temple of the Sun, and the Temple of the Foliated Cross—has been considered by many as the most aesthetically appealing as well as the most mysteriously alluring group of structures in all the Maya realm. This allure (or his being ill with malaria) must have completely overcome Frederick Catherwood when he made his drawing of the Palace, the Temple of the Inscriptions, and the Cross Group (Catherwood 1844/1965, 1978) (fig. 2). All of the other Catherwood drawings are so accurate that if a part is missing today we can assume with some assurance that it was originally the way Catherwood drew it, but this one is distinctly mystical. The Temple of the Inscriptions looms high above the dwarfed Palace, and the Cross Group temples are somehow behind the Temple of the Inscriptions instead of in the background between the Inscriptions and the Palace. Mirador, the mountain behind the Temple of the Foliated Cross, in his engraving looms above the Palace. The terrain looks very much like a well-trimmed English garden rather than a tropical rain forest.

The Cross Group hugs the space between the Otolum River to the west and the steep mountain ridges to the east and south. The entire city of Palenque is divided into little pockets by the river systems (map 1; see also map 3 in Vol. I of this series). There are the river groups to the east, Blom's Groups B and C, and the Zutz' Group. The Lik'in, Xaman, and Ch'ul groups are still further east, set apart by the Otolum Cascades and by the Murcielagos, Balunte, and Arroyo Ach'. Then there are the groups set apart by the river

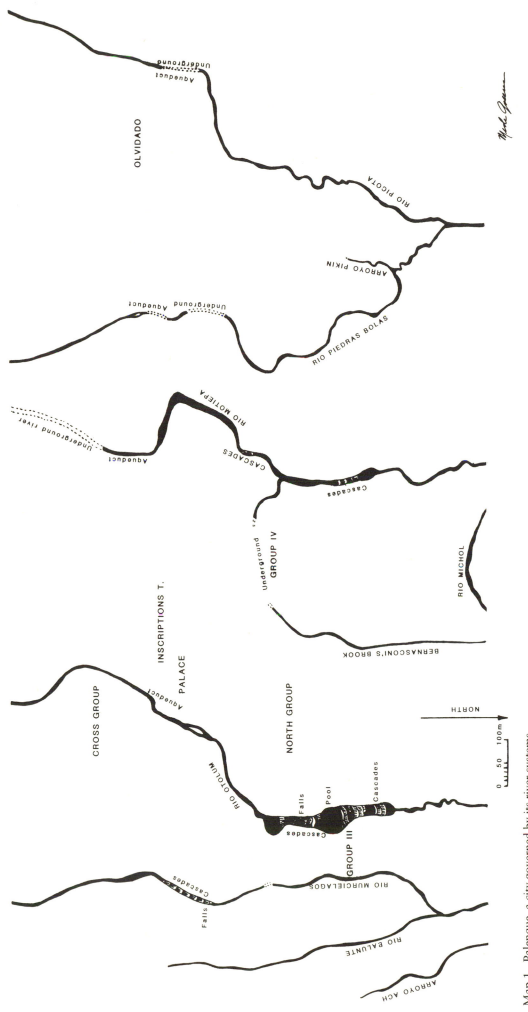

Map 1. Palenque, a city governed by its river systems.

systems to the west, the Motiepa Group, Blom's Group G, the Alvarado Group, Blom's Group E, the Great House Group, the Ti'K'in Group, the Nochol Bi' Group, and finally the Picota Group, which are separated by Bernasconi's Brook, the Motiepa River, the Piedras Bolas, and the Picota River. Behind the Temple of the Inscriptions and hugging the mountain all the way to the ridge top on the south are the Encantado Acropolis, Blom's Group H (Blom and La Farge 1926:187), and the Temple XXIV and Temple XXV Group as well as the West Ridge Group and the Blue Wood Group. All are between the Otolum on the east and the Motiepa on the west. The whole cluster hugs the mountainside as the separate groups ascend higher and higher up the mountain to the ridge behind the Temple of the Inscriptions. If I could make one significant observation about Palenque's orientation, it would be that it is a city governed by its river systems.

So sensitively placed are the three small Cross Group temples in a tiny pocket of the Sierra de Palenque hillside (map 2) that the reason for selection of this particular location for these structures has been likened to Chinese geomancy. Feuchtwang (1974:2) described "the power of the natural environment, the wind and the airs of the mountains and hills; the streams and the rain; and much more than that: the composite influence of the natural processes" and "the knowledge of the metaphysics of feng-shui that will tell the fortune of the site owner." This knowledge and the art of good siting are what is called Chinese geomancy (see also Needham 1959). I first realized how the geomancy tradition fits the Cross Group temples one evening about five o'clock when I was standing between the two center piers of the Temple of the Inscriptions, having just come up from working in the tomb all day. It had been raining, but the rain had stopped and the sun was shining. A mist was hanging over the Temple of the Cross that made the Cross Group pocket hauntingly beautiful to see (fig. 3). At first I thought this was a coincidence, but many times later, late in the day after a rain, this mist was over the Temple of the Cross and nowhere else. Did Chan-Bahlum too see this when he was standing in front of his father's memorial temple? It is the pocket in the mountains, and not the buildings, that causes the mist to rise in this particular spot.

Peter Furst was the first to note that the Cross Group is oriented along the lines of Chinese geomancy (Palenque Round Table, 1974). Every time there has been a gathering at Palenque since then, we have discussed this. John Carlson continues the discussion in "A Geometric Model for the Interpretation of Mesoamerican Sites" (1981).

By virtue of the length of the hieroglyphic texts, Palenque has left us a written record of its kings that tells us more about these rulers and their lives than the records of any other Maya city. Pacal the Great, who ruled for sixty-eight years (becoming king at the age of twelve), left us an incredible amount of information on the three tablets in the Temple of the Inscriptions. It seems strange, though, that in all of the important buildings he was responsible for, namely Houses B and C and the Temple of the Inscriptions, it was not until the very last years of his life that he left any significant textual information. Houses B and C have only isolated texts and panels of only a few glyphs. The Temple of the Inscriptions was the first temple at Palenque to have a lengthy text, 617 hieroglyphs

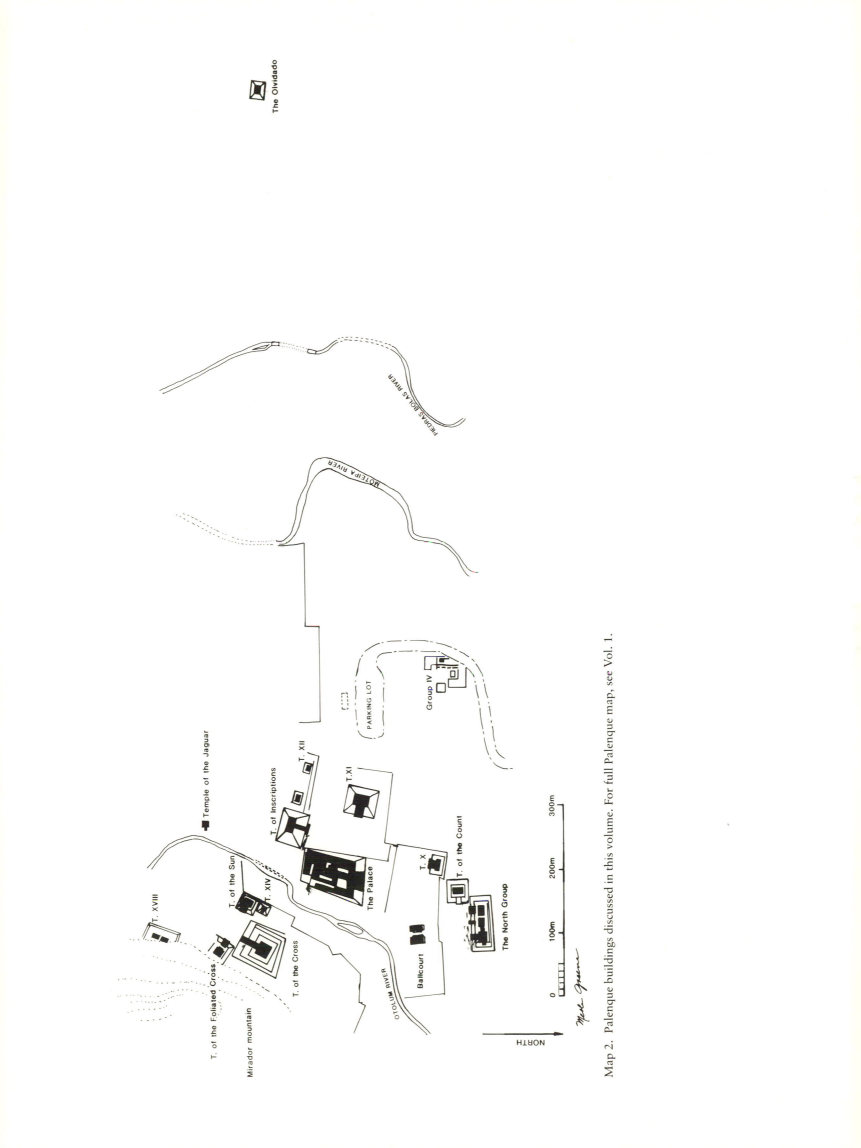

The Olvidado

PIEDRAS BOLAS RIVER

MOTEIPA RIVER

PARKING LOT

Group IV

T. XII

T. XI

Temple of the Jaguar

T. of Inscriptions

T. XVIII

T. of the Sun

T. XIV

The Palace

T. X

T. of the Count

T. of the Foliated Cross

Mirador mountain

T. of the Cross

Ballcourt

The North Group

OTOLUM RIVER

NORTH

0 100m 200m 300m

Merle Greene

Map 2. Palenque buildings discussed in this volume. For full Palenque map, see Vol. 1.

in all. These tablets parallel the katun prophecies of the Book of Chilam Balam in which
the theme is "the belief that whatever had happened in the past would likely recur in
another katun of the same name" (R. L. Roys 1933:183-84). The inscriptions record the
names of the rulers and their accession dates and important period-ending ceremonies.
This katun history takes up the major portion of the east and central tablets and continues
on the first four columns of the west panel. The last two columns have records pertaining
to Chan-Bahlum. The piers of the Temple of the Inscriptions have texts on only the two
end piers. The West Pier records information concerning Chan-Bahlum but not Pacal.

It was Chan-Bahlum II (fig. 4), the son of Pacal and the ruler who followed him, who
did the precise recording of historical and mythical data about Palenque. We think of
Pacal as being an extraordinary king who accomplished so much during his sixty-eight
years of rule. Up until now, we have recognized Chan-Bahlum as the builder of the Cross
Group temples but have not given him due recognition for being the famous king that he
actually was. In fact, it could well be that Chan-Bahlum was the one who saw the need
to record in the Temple of the Inscriptions the text for his father before he died; he left
the last two columns for his own statement.

Chan-Bahlum finished the Temple of the Inscriptions art program by depicting himself
as a child in the arms of all the standing figures on the piers (see Vol. I). The child has the
head of God K and one leg a serpent leg; that is, he shows himself as the serpent-footed
God K (fig. 5) of early times. For the first time in Maya history, a living king is recorded
as actually being God K. One other ancestor king that we know of was recorded on the
Inscriptions piers, Chan-Bahlum I, great-great-great-grandfather of Chan-Bahlum II,
the king referred to in this text as Chan-Bahlum. Like the other standing figures, Chan-
Bahlum I holds the child in his arms. Chan-Bahlum was making certain that his lineage
rights were displayed for all to see.

Before he built the Cross Group temples, Chan-Bahlum finished House A, thus tying
himself to the Palace as all kings before him had done and as all kings after him were also
to do.

1

The Cross Group

At forty-nine years of age, when he built the Cross Group temples (fig. 6), Chan-Bahlum was a brilliant man. That can be attested to by the complicated system of iconography employed in explaining the purpose of each temple as well as the role of the three Palenque Triad Gods—GI, GII, and GIII—in the dynastic history of the kings of Palenque. Chan-Bahlum would already have played a dominant role in the architectural expansion of the city, and probably in the last years of his aging father's lifetime most of the decisions were his alone. In fact, the blood relationship of kings, the divinity of rulers, and the knowledge that kings, upon dying, became gods were the sustaining reasons why more of the sculptural portraits during the later years of Pacal's life were portraits not of the divine prince but of a king long past his prime—but nevertheless a divine king whose divinity had to be reckoned with and honored.

The small niche in the hillside east of the Temple of the Inscriptions and the Palace complex is where the Cross Group temples were to be raised. This special spot is east of the Otolum River, which passes beside the Palace through an aqueduct. The spot is considerably above the great plaza upon which the Palace Complex rests. Dense forest encompasses this area on two sides. On the east, forest covers the abruptly rising mountain that we know as Mirador but that since David Stuart and Stephen Houston found the glyph we now know was called K'uk-te'-Witz in ancient times. On the south, a gradually steepening forested terrain hugs the Otolum. To the north, the area extends along an elevated platform for a short distance and then dips southward toward the small Ballcourt and the North Group buildings, again being closed off by the Otolum where it goes underground and then emerges and follows the hillside on the east. A perfect niche.

The Temple of the Cross, the largest of the three temples and on a pyramid substructure much larger than that of either of the other two temples, is positioned on the north. The Temple of the Foliated Cross is to the southeast, built almost as a part of the hillside, so close does it come to the mountain. The Temple of the Sun, the smallest, is on the southwest and forms a barrier between the Cross Group as a whole and the rest of the city (fig. 7). The temples face the center of the small plaza common to the three temples.

Each of the three temples is built with a small inner sanctuary, a small structure independent of the outer core of the building. The prominent feature of each sanctuary is a bas-relief sculptured stone tablet taking up the entire rear wall of this tiny inner structure.

Although the temples themselves were built for the populace as a whole to view, the inner sanctuaries were private art meant to be viewed by only the privileged few, the Palenque elite. Unique and unlike any other group of buildings in the entire Maya realm, these three temples play the role of a Maya codex in three parts. History, both real and mythical, is told, and it unfolds like the pages of a book from temple to temple. There was never anything like it before, and nothing like it was ever designed again.

All three of the Cross Group temples form a monument to Chan-Bahlum, king of Palenque. They were planned and built by him, just as the Temple of the Inscriptions was planned and built by the great Pacal. The buildings carry the message in glyphic text and in an iconic visual portrayal of artistic perfection. The building of these monumental feats of architecture took some sophisticated planning and manipulating of forces. Chan-Bahlum would not have started his own memorial before the death of his father in A.D. 683, and he would have finished House A of the Palace with the sculptured piers depicting himself, plus the running inscription under the eaves all along the structure referring to his reign, before he started on the Cross Group. The necessary planning, designing, and laying out of inscriptional text to fit in with the sculptural accompaniment so that the story would be carried from one temple to the other would have been no minor feat and would have taken much more than the ordinary time. And to have completed three temples of this complexity, once the plans were all made, would have taken a larger than normal labor force if the work was to be finished in time for a 9.13.0.0.0. (A.D. 692) dedication date. That is only nine years after the death of Pacal. It is not known whether the three Cross Group temples were built at the same time or seriatim, but in any case it might have taken a larger labor force than a city the size of Palenque could supply to do this in so few years. I suspect that neighboring territories were called in to help supply the labor, either by conscription, tribute, or outright warfare.

Schele (1986:120) shows why construction of the Temple of the Inscriptions took, by known sequence, at least fifteen years to complete. In addition to the engineered construction, an even greater labor force involving educated and capable designers, historians, mathematicians, scribes, astrologers, astronomers, and those well versed in historical facts and mythical knowledge as it pertained to the gods—not to mention the many carvers needed for each specialized task—would have been needed. Carolyn Tate (1988) has been able to detect the individual styles of at least twenty workers involved in the carving of a single lintel at Yaxchilan. She postulates (personal communication, 1988) that at least fifty workers were involved in the carving of lintels at Yaxchilan at one time.

A good proportion of elite Maya were more than adequately educated in mathematics, reading, hieroglyphic writing, art, religion, and the history of the people. The history must have been repeated over and over in oral rhetoric so none would forget. With books (codices) so few in number, as in all early civilizations, the Maya relied upon the spoken word, repeated often, to educate their people. Some, probably young elite lords, had their history drilled into them beginning at a very early age. It was imperative that they remember every detail concerning not only themselves and their ancestors but also events in-

volving the gods. Today, in the highlands of Guatemala and Chiapas, Mexico, the Indians are chanting history in couplets, repeating what was just said or sung. If the storyteller gets something wrong, the audience corrects him on the spot.

Chan-Bahlum is an example of a person (in this case a ruler) living in the seventh century A.D. who must have had to know everything about the past of his ancestors and about the gods who ruled over them and influenced and dictated to them. All of this knowledge could not have been in the keeping of just one person. People died. Rulers died. The knowledge had to be kept alive. Others had to interpret it into the written word—that is, the hieroglyphic text. Someone had to convey to the scribes who were to carve monuments and tablets just what message was to be delivered in each text and how it should be written. The iconography (the visual forms of the tablets) had to convey another message, one that would supplement the written text. Today we would hire historians to dig through archives and then sort out the information that was to be delivered. Editors would then go through it, changing, adding to portions, correcting spelling and mathematical notations, and deleting unnecessary portions. Actuaries would be employed to correct the facts concerning dates and timing. Computers would pull it all together. Astronomers and geophysicists would be employed to ascertain the correct dates of important happenings in the cosmos for centuries into the past. Design editors and artists would be called in to make layouts for this important work of art. Iconographers would be needed to interpret the written hieroglyphic word and the icon representing or adding to it. Some portions would need to be written in hieroglyphs; other portions would need to be shown in pictorial images.

The actual carving could be learned, and it was necessary for many to learn the techniques. Even today at Palenque, young children start carving in limestone—albeit with metal tools, a luxury the Maya did not have. Novices first get a feel for the stone and the care that must be taken in handling it; then they learn to polish a finished product to protect its surface and give it a sheen. In actual carving, the first thing they do is learn to scrape away the background carefully without nicking the portion that is to be raised. After they have perfected this technique, they are allowed to do carving on simple portions of a figure, but they still work only on unimportant pieces. Little by little, they are entrusted with more difficult tasks. The last things a student is permitted to carve are faces and glyphs. Not all master the techniques, but if they do they find themselves in great demand. I am saying that the actual carvers were not necessarily born artists. More likely, learning to carve was a privilege afforded the elite class, and learning was part of their education. As has been noted in many civilizations throughout history, the privileged classes were allowed the benefit of an education.

Stones for carving are obtained today in much the same way as in ancient times at Palenque. When the stones are taken from the ground, they are very large and usually at about a 45° to 50° angle from the surface of the ground (fig. 11a, b, c). The upper edge, and sometimes the whole top portion of the slab of stone, protrudes above the level of the terrain. One side, usually the upper, is smooth; the underside at the fracture is rough-

ened, but not drastically. When a good piece is found, many flat pieces can be pried from it, with one side always being relatively smooth.

The knowledge I have outlined had to be the purview of all those responsible for executing tablets at Palenque. Chan-Bahlum was just one of the extraordinarily capable architects, epigraphers, historians, and mathematicians of the city, and he was knowledgeable enough in astronomy and art to know how to direct those he would hire for the job. What the tablets conveyed had to be acceptable to the gods as well as to the mortal managers.

I have stressed the importance of knowledgeable persons holding the key to recording the history of the dynasties. At Palenque, as well as at other Maya sites, it can be seen that those recording the ancient history held power at the time. Pacal the Great, the most prestigious ruler of Palenque, shows this clearly in his nearly seven decades of rule. Ancient Mesoamerica is not the only place where those with the ability to record history in writing held power. In ancient China, Chang noted (1983:88), "the power of the written word came from the associates with knowledge, knowledge from the ancestors, with whom the living communicated through writing," and "access or nonaccess to the written record was the key to predictive power in the ancient art of government." The history of the gods appears almost everywhere in inscriptions at Palenque; the Cross Group temple tablets are just one example. It is here that the birth of the gods was recorded. What was asked and expected of ancient kings seems superhuman.

The importance of the Cross Group tablets is not only the hieroglyphic content of the text and the information gained from it but, equally great, their status as works of art. Unique in all of Mesoamerica, their artistic composition and the icons used in conveying visual messages work together to complement the written text. Yet all of this was done with a great artistic sense, which will be brought out more fully when we deal with the individual tablets.

ORDER OF READING OF CROSS GROUP TEMPLES

The Cross Group temples have been read in several sequential orders. I am going to read them in order of the birth of the gods; that is, first, the Temple of the Cross where the birth of GI, the firstborn of the Mother Goddess, is recorded; second, the Temple of the Sun where GIII's birth is recorded; and last, the Temple of the Foliated Cross where the birth of GII is recorded. Several other orders of reading for these temples have been offered:

Temple of the Cross, Temple of the Foliated Cross, Temple of the Sun
 Tatiana Proskouriakoff (1950). By composition.
 Heinrich Berlin (1963). Judging by the prominence of the buildings.
 David Kelley (1965). He discussed the Temple of the Sun first but listed them in
 this order, though not necessarily because he thought they belonged this way;

he did not discuss order. His important point was that the temples were the birthplaces of the Triad Gods.

Linda Schele (1976). She explains the Cross Group temples as a connected and related series of events in the life of the ruler Chan-Bahlum and the transfer of power from one ruler, Pacal (now dead), to the new ruler, Chan-Bahlum II, on 9.12.11.12.10 8 *Oc* 3 *Kayab* (A.D. 683). The text of the Temple of the Cross Tablet records Chan-Bahlum's ruling ancestors, their birth and accession. The Temple of the Foliated Cross Tablet is concerned with blood-letting for rites involving ancestry, and the Temple of the Sun Tablet concerns warfare.

Temple of the Cross, Temple of the Sun, Temple of the Foliated Cross

Tatiana Proskouriakoff (1950). Judging by the motifs in the tablets.

Merle Greene Robertson. By the dates for the births of the gods.

Linda Schele (1976 and personal communication). By reason of the dates of the gods' births and the hieroglyphic texts.

Karen Bassie (1990). By the Initial Series dates and last date in the main text of each tablet and the events in the life of Chan-Bahlum recording (1) the birth of the ancestors, (2) Chan-Bahlum's first lineage event, and (3) the accession of Chan-Bahlum.

Flora Clancy (1986). By reasoning that events in the life of Chan-Bahlum dictate the order: (1) his ancestry, (2) his heir apparency, and (3) his accession, and her feeling that the "Temple of the Cross and the Temple of the Foliated Cross are reversed images of one another."

Temple of the Foliated Cross, Temple of the Sun, Temple of the Cross

George Kubler (1972:318, 319). Going by the physiological signs of age in the tall figure where he is shown youngest in the Temple of the Foliated Cross. In the Temple of the Sun he is shown as a heavy-set person with a "large paunch and deep facial furrows from nostril to mouth."

Temple of the Sun, Temple of the Cross, Temple of the Foliated Cross

Marvin Cohodas (1973:74; 1974; 1976). He bases his reasoning on celestial events and directional placement of the temples, the Temple of the Sun (west) pertaining to the descent of the sun at the vernal equinox and "sacrificial ceremonies employed to cause the destruction of the sun through sympathetic magic"; the Temple of the Cross (north) at the summer solstice depicting the "sojourn of the sun and maize in the Underworld" with "ceremonies to bring rain"; and last the Temple of the Foliated Cross (east) pertaining to the autumnal equinox when the sun and maize rise from the Underworld and are reborn.

THE PALENQUE TRIAD GODS

The Triad Gods (fig. 12) appear almost everywhere in the inscriptions at Palenque; the Cross Group tablets are the most complete accounting of their history. Heinrich Berlin

(1963:92, 93) was the first to recognize the existence of these three deities and to identify their glyphs and associated dates, which fall about 2,700 years before the earliest historical monuments. David Kelley (1965:95, 97, 106) proved that the Initial Series dates of these temples were the birth dates of the Triad Gods, GI, GII, and GIII. Kelley has shown that the Temple of the Cross records the birth of GI, whom he refers to as Nine Wind, the Venus God, and Quetzalcoatl (prototype of the Yucatecan Kukulcan), and that GI is the patron deity of the Temple of the Cross. GII (God K), he has shown, is the patron deity of the Temple of the Foliated Cross where the god's birth is recorded, and GIII (Thirteen Death) is the patron deity of the Temple of the Sun where his birth is recorded.

The story of the Triad Gods, or more accurately two of them, GI and GIII, the Hero Twins, is the most exciting of all the myths of the ancient Maya. It is told in the *Popol Vuh*, the sacred book of the Quiche Maya, translated by many. The most popular are the translations by Adrian Recinos (1950) and Munro Edmonson (1971) and a new version by Dennis Tedlock (1985). A few words should be said about this manuscript, which Edmonson (1971:vii) believes was "almost certainly a hieroglyphic codex." The myth revolves around two brothers, the Hero Twins, and how they overpowered the Lords of the Underworld (Xibalba). In the beginning, the Lords of the Underworld wanted the playing gear of the Middle World ball game—the leather pads, rings, gloves, crown, masks, and rubber balls. They enticed two brothers from the Middle World (the living world), Hun-Hunahpu and Vucab-Hunahpu (who we shall see later were the father and uncle of the Hero Twins, who turn out to be GI and GIII), to Xibalba to engage in a ball game with the lords there.

Hun-Hunahpu and Vucab-Hunahpu never did get to play ball with the Underworld Lords, because they failed the first test in the House of Gloom and were sacrificed. But before the Underworld Lords buried them, they cut off the head of Hun-Hunahpu and hung it on a calabash tree by the side of the road in Xibalba. The tree instantly bore copious fruit, so that the head of Hun-Hunahpu was not recognizable. It looked just like the rest of the fruit on the tree.

A maiden came to the tree and desired to eat the fruit. The head of Hun-Hunahpu, looking like all the rest of the fruit, spoke to her and told her to stretch out her hand. The instant she extended her hand, the skull of Hun-Hunahpu let a few drops of spittle fall on the maiden's palm. He then spoke: "In my saliva and spittle I have given you my descendants" (Recinos 1950:199). He then told her to go to the surface of the earth. The maiden did as she was told, and upon arriving on the earth gave birth to twin sons, Hunahpu and Xbalanque, who turn out to be GI and GIII respectively. It is these twins whom the story is all about. As the two boys grew older, they played ball every day and planned on avenging the deaths of their father and uncle. So when the boys were bade to come to Xibalba to play ball with the Lords of the Underworld, they gladly went.

The twins were clever and they had their strategy well planned. In the course of playing ball in Xibalba with the Lords of the Underworld, they showed off their prowess and supernatural abilities. One of the feats they accomplished was to sacrifice themselves and

then bring themselves back to life. So amazed were the lords that they asked to be sacrificed too. The twins sacrificed them, for sure, but did not bring them back to life. Hunahpu and Xbalanque then told the people of the Underworld that they could no longer seize men and sacrifice them. Their rank was lowered, and thus their destruction began. Meanwhile the corn seeds that the twins had planted in their grandmother's house before they left on their journey to Xibalba grew. They had told their grandmother that "when a crop dries out it will be a sign of their death, but that the sprouting of a new crop will be a sign that they live again" (Tedlock 1985:42). The corn grew instantly. When all of this happened, the Hero Twins were lifted to the sky and became the Sun and the Moon.

Actually there are two GI deities. This may seem confusing, but all through Palenque's history rulers had taken the names of illustrious ancestors, and the gods did this too. Actions taken by Palenque's rulers recalled legendary and mythical events of supernaturals or cosmological and astronomical happenings, showing that humans' actions were sanctioned by the gods.

The first GI, the First Father, was the father of the Palenque Triad, GI, GII, and GIII. This First Father was Hun-Hunahpu of the *Popol Vuh*, the father of the Hero Twins whose escapades in Xibalba you have been reading about. His birth date is recorded in the first part of the inscriptions of the Temple of the Cross Tablet as 12.19.11.13.0 1 *Ahau* 8 *Muan* (3122 B.C.) in mythicocosmological time. The First Father, the Senior GI, has the same name glyph as GI of the Palenque Triad, and he is named as being the father of GI, GII, and GIII. In the inscriptions he is also named as mother, seemingly meaning that, as stated in the *Popol Vuh*, man was "created to nourish, sustain, invoke, and remember the gods" (Schele 1980a:83). Lounsbury (1980) sees this First Father as the Moon, as do Dütting (1982) and Schlak (1985). The Temple of the Cross records only the birth of the Senior GI and his "deerhoof event" on day 0 of the era 4 *Ahau* 8 *Cumku* (13.0.0.0.) and the " 'sky' event at 0.0.1.9.2" (Lounsbury 1985). Although the glyph for GI looks very much like the Sun God, they are not the same. The Sun God and GI share features of Roman nose, large squarish eyes, and protruding upper incisors. However, only GI—and not the Sun God—displays the cheek barbel (side whiskers), the hook-shaped eyeball, and the shell ear ornament (fig. 12).

One year after the birth of the First Father, the Ancestral Goddess (dubbed "Lady Beastie" by Floyd Lounsbury [1976:219]) was born, on 12.19.13.4.0 8 *Ahau* 18 *Zec* (3121 B.C.), as stated on the Tablet of the Temple of the Cross at A17, B17, C1 (Lounsbury 1980:99), and she ascended to rule on 2.1.0.14.2 9 *Ik* 0 *Yax* (2305 B.C.). The Bird Emblem Glyph is the glyphic name of "Lady Beastie," mother of the Palenque Triad Gods. This Bird Emblem Glyph seems to be a proclamation of the divine origins of the Palenque lineage or the divine function of the site (Schele 1987:51).

The Celestial Bird (Bardawil's 1976 Principal Bird Deity) is the icon that ties together the entire Maya belief system. Karl Taube (1987:1) found the first recognized example that this bird deity persisted well into the Late Postclassic period as portrayed in the Paris Codex, page 1. On the Sarcophagus Cover, the Tablet of the Temple of the Cross, and

the Tablet of the Temple of the Foliated Cross, this bird is perched at the top of the sacred tree whose roots reach from the Earth Monster, the Underworld Sun, at the entrance to the Underworld. In each version, the tree emerges from the bowels of the earth and ascends through the living world and into the heavens, where it stands with the Celestial Bird at its top, performing its role of binding the three worlds of the Maya together. It is easy to see why the Maya today, as well as in ancient times, revere the quetzal, the bird that flies into the heavens out of sight and is rarely seen by humans, but when it is seen has beauty so overwhelming that the modern Maya are certain it carries their messages from earth to the gods in the heavens above.

The First Father cohabited with "Lady Beastie," the Ancestral Goddess, and the Palenque Triad Gods GI, GII, and GIII were the resulting offspring. This took place seven and one-half centuries after the birth of the Senior GI and the Ancestral Goddess (Lounsbury 1985:51). The Ancestral Goddess was 761 years old when she gave birth to her first child, GI, who was born on 1.18.5.3.2 9 *Ik* 15 *Ceh* (October 21, 2360 B.C.). Her second twin, GIII, was born on 1.18.5.3.6 13 *Cimi* 19 *Ceh* (October 25, 2360 B.C.). Four days apart does not seem unreasonable for twin births in mythicocosmological times. GII was born on 1.18.5.4.0 1 *Ahau* 13 *Mac* (November 8, 2360 B.C.). It is GI and GIII who are considered the twins, although actually they are two of triplets. "GI, the firstborn of the triad, is understood to be the manifestation at Palenque of Hunahpu, cognate to the character of that name in the *Popol Vuh*," points out Lounsbury (1985:56). Dieter Dütting (1982:234-35) tells us that the birth of "Lady Beastie" is linked with Pacal's birth date, 9.8.9.13.0 8 *Ahau* 13 *Pop*, by a number of days that is "an integral multiple of seven different important Maya periods. Particularly interesting is its divisibility by 819, or even better, by 4 times 819, or 3276. Thus the initial date of the Temple of the Cross, with the adjoining specification of its position 20 days after a south station in the 4 x 819-day cycle, duplicates exactly the position of Pacal's birth date in the same cycle."

IDENTITIES OF THE TRIAD GODS

The firstborn of the Triad Gods, as inferred from the inscriptions of the Temple of the Cross and explained in the inscriptions of the *alfardas* (balustrade slabs) of the Cross Group temples (fig. 13), was GI. Lounsbury (1980:111) points out that each *alfarda* has twenty-four glyphs in the inscription and that it is from these slabs that the firstborn god can be surely identified. He avers that the Junior GI of the Triad was not the same as the other GI, the Senior GI. The Junior GI, who turns out to be Hunahpu of the *Popol Vuh*, was the patron god of the Temple of the Cross. His father was the Senior GI, the First Father, and his mother was the Ancestral Goddess, "Lady Beastie." He is most frequently apotheosized as the Sun and as the Morning Star and is associated with the east (day). Some, however, do not see GI as the Sun. Kelley (1976:96) sees GI as Nine Wind (Ik), the Venus God, a name of Quetzalcoatl/Kukulcan (1976:97; 1980), although he does not believe he was actually read as Kukulcan (1965:122). Schele (1976:29) also sees GI as

Venus, as do Lounsbury and Thompson. Dütting (1982) sees GI as a sky god associated with water and equates him with Saturn, but also (1984:12) suggests that "the elder GI was conceived as Venus–Morning Star, the younger GI as Venus–Evening Star" at inferior conjunction, and the elder GI "was conceived by the Maya as a deity with jaguar attributes (GIII) in contrast to the fish and serpent of GI."

Dütting (1982:254) argues for a phenomenon "in the southern sky at 8 p.m. local time after twilight's end, A.D. 690, July 19-20, showing a lineup from west to east (lowest to highest in the sky as they go down in the west): Mars-Jupiter-Saturn and the 8 or 9 day old (waxing gibbous) Moon. A few degrees below the southeast of the group lies Antares, the brightest star in Scorpio" (fig. 14).

There has been considerable uncertainty as to just who Hunahpu and Xbalanque actually were. Coe (1973:13) refers to the Hero Twins as the Sun and the Moon, but does not specifically state which twin is GI and which is GIII. Schele refers to GI as Hunahpu but points out the complications associated with these gods and their contradictory astronomical associations and the fact that they appear as different gods; for example, GI was "born on 9 Ik, the birth date associated with Venus throughout Mesoamerica, yet he appears at Quirigua as the number 4, normally personified by the Sun God." Lounsbury (1985:52) adds that in the folklore of Middle America there are three competing versions of the "relationship" between the Sun and the Moon: "They are elder brother and younger brother (sometimes twins), or they are brother and sister, or they are husband and wife (or sweethearts)."

GIII, Xbalanque, the second-born of the First Father and the Ancestral Goddess, is recorded in two successive passages in the Temple of the Sun Tablet (Lounsbury 1980:110). He is the patron god of the Temple of the Sun, and it is this god who, after defeating the Lords of the Underworld, most scholars believe rose to the sky as the Moon. Lounsbury (1985:54) suggests that one reading for Xbalanque of the *Popol Vuh* is "jaguar-sun." Kelley (1965:120) reads this as "lord of Xibalba," Lord of the Underworld, and as Thirteen Death, a war god. Dütting (1982:239) sees GIII as representing Mars.

The identifying characteristic of the glyph for GIII is a "checkerboard" glyph that Lounsbury (1985:47) more aptly refers to as the "plain-weave" glyph and that is often seen with a youthful-appearing head to the left in a cartouche, as in the Temple of the Sun Tablet at D6. GIII, the second-born, he adds (1985:51), is the Sun God of the *Popol Vuh*, which merely states that "one is the sun, and the other of them is the moon." The Edmonson translation agrees (1971:144). Lounsbury convincingly argues for GIII being the Sun-Xbalanque using linguistic, mythological, and hieroglyphic evidence.

GII, the last-born of the children of the ancestral gods, is known as God K, Smoking Mirror, who has the axe or celt in his head or the smoking mirror on his forehead. God K was first identified by Schellhas (1897:34; 1904) based upon the long proboscis, and was later identified by Seler (1902-1923:I, 377-78), who associated God K with rain. God K was securely identified by Michael Coe, who sees him, as did Seler and Kelley (1976:97), as Ah Bolon Tzacab. GII was born on 1.18.5.4.0 1 *Ahau* 13 *Mac* (2360

B.C.). He is considered to be the patron god of dynasties at Palenque and the patron deity of the Temple of the Foliated Cross. Kelley (1965:129) identifies GII's Temple of the Foliated Cross as being dedicated to (Ah Bolon?) Tzacab, and he doubts that GII was called Tzacab, but sees him as a god of agriculture and also possibly a Sun deity. God K became a god of the utmost importance and a patron deity of Pacal during his reign. God K is shown on the manikin scepters of the stucco guards on the walls of the Temple of the Inscriptions Tomb (fig. 15), on the manikin scepters held by the standing figures on the piers of House A, and on the tiered panels of the North Palace Substructure. Pacal on the Sarcophagus Cover has the hairstyle of God K with the axe in his forehead in his position of falling into the Underworld. He is shown as a living god-child (Chan-Bahlum) held in the arms of the principal figures on the four central piers of the Temple of the Inscriptions (Greene Robertson 1979b:131), and God K is the god in the open jaws of the left (west) head of the serpent that undulates across the world tree on the Sarcophagus Cover. Early examples of God K appear on the Leiden Plaque (8.14.3.1.12 5 *Eb* 0 *Yaxkin*; September 17, A.D. 320) on the end of the serpent-bar held in the figure's right hand; and on Tikal Stela 4 (8.17.2.16.17 2 *Caban* 10 *Yaxkin*; September 13, A.D. 379), where God K is the god floating in the sky over the figure's headdress (fig. 16). For a more detailed discussion of God K, see Robicsek (1972:59-107).

It has been shown that the belief system of the Maya identified with the gods and celestial bodies of the cosmos. It has long been believed in Mesoamerica that the Moon is a rabbit, and, sure enough, a crouching rabbit can clearly be seen in profile in the full moon in the southern skies. The First Father has been identified with Venus as Morning Star and the Ancestral Goddess with the Moon. Thompson (1970:242, 243) noted that the Moon Goddess is widely held to be the Sun's wife. It should be noted, however, that some Maya groups regard the Moon as male. "Contemporary Quichés," says Tedlock (1985:46), "regard the full moon as a nocturnal equivalent of the sun, pointing out that it has a full disk, is bright enough to travel by, and goes clear across the sky in the same time it takes the sun to do the same thing." Kelley (1980:S40) notes that "apparently all deities of the visible Moon were conceived as women except the invisible 'dead' Moon at conjunction, seen only at solar eclipses, was the male conch shell god."

Another ruler of the mythical past was U-Kix-Chan, born thirteen and a half centuries after the birth of the Triad Gods, on 5.7.11.8.4 1 *Kan* 2 *Cumku* (993 B.C.), who acceded to the throne of Palenque on 5.8.17.15.17 11 *Caban* 0 *Pop* (967 B.C.). U-Kix-Chan was the offspring of GI of the Palenque Triad. His name phrase on the Temple of the Cross Table at F13-F16 indicates that this is a personal name of a deity (Schele 1979:66). Kelley (1965) first referred to the Triad God GI as the prototype of Kukulcan. Kelley (1976:96) notes that Kukulkan, "rather than being an imported Mexican concept, was an imported deity of the Classic Period." Schele (1976:10) sees these Triad Gods as "divine descendants of Kukulcan and perhaps as living manifestations of the Hero Twins, Hunahpu and Xbalanque, who by cunning, power and self-sacrifice protect their people from the devastation of the Death Gods of the Underworld." Bricker (1985:191) brings out some

interesting privileges accorded the Triad Gods, namely the "large *baktuns*." "Since *baktuns* are normally composed of only 20 units, namely *katuns*, it seems reasonable to infer that the 'large' *baktuns* initiated by the gods, GII and GIII, contained an extra *katun*. This would explain the epithet, 'twenty-one is his cycle' (*hun-uinac u-cuc*), before the names of GI-GIII." As Bricker points out, "the Maya made a distinction between sacred *baktuns* of 21 *katuns* and secular, or historical *baktuns* composed of 20 *katuns*," and the epithet "twenty-one is his baktun," or "twenty-one is his cycle," indicates that the cycles of the gods GI, GII, and GIII are longer by one-twentieth than the cycles of mortals like Pacal, Lady Zac-Kuk, and Shield Jaguar.

IDENTIFYING CHARACTERISTICS OF THE TRIAD GODS

GI
Roman nose
Tau tooth (protruding incisor)
Large, squarish spiral eyes, spiral downward from upper
 lid
Scalloped eyebrows
Shell earplug
Quadripartite Monster headdress
Fish fins on cheek, forehead, or limbs
Identified with Sun God and Venus

Full-figure version adds:
 A shell diadem with infixed crossed bands
 Akbal vase
 An axe

Chac-Xib-Chac
Identical to GI, except zoomorphic
Hair gathered on forehead and falling forward
Shell diadem in addition to shell earplug

GII
God K
Flare God
Manikin scepter god
Bolon Tzacab
Axe or celt in forehead or smoking mirror in forehead
Serpent-footed
Serpent nose
Reptilian features
Always zoomorphic

GIII
Roman nose
Tau tooth (protruding incisor)
Large, squarish squint eyes
Scalloped eyebrows
Long shank of hair falling forward
Kin on cheek
Daytime Sun
God of Number 4

GIII as Jaguar God of the Underworld
God of Number 7 (identical to GI except face different;
 spiral eyes go upward from lower lid; cruller
 twisted between and under eyes; hair a knot curled
 over the jaguar ears)
War God
Underworld Sun

Associated with GIII
Baby Jaguar
 Has a jaguar tail, feet, hands associated with blood-
 letting and *tau* tooth
Waterlily Jaguar
 Zoomorphic
 Waterlily on top of head
 Wide scarf at neck

IDENTITY OF THE FIGURES ON THE CROSS GROUP TABLETS

Each of the Cross Group tablets has a human figure standing on either side of the tree icon. One is a tall figure and the other is a much shorter figure dressed in unusual garb for Palenque. It is the tall figure that we know the most about. He is Chan-Bahlum, son

of the illustrious Pacal. He is named in the secondary text directly in front of his face on the Tablet of the Cross. It states here that on 8 *Oc* 3 *Kayab* 9.12.11.12.10 (at L2) Chan-Bahlum was made *zac uinic* of the succession (at L3, M1) *Mah K'ina Chan-Bahlum* (at M1-N1). Then the glyphic text directly behind the figure relates how Chan-Bahlum was named *Ah Pitz* ("the ballplayer") *Bac-balam-ahau* ("Palenque Lord Jaguar" title) (at O1). Chan-Bahlum, then, was a ballplayer, as David Stuart discovered when he was able to decipher the glyph for the ballplayer (*pa pitzil*). From the Palace Tablet (at L8) we now know that Pacal was also a ballplayer, although with a clubfoot he must have had some difficulty. On that tablet, the text from J6 to L9 states that 12 days, 6 uinals after he (Pacal) died, the lord (Chan-Bahlum) on 8 *Oc* 3 *Kayab* was seated as *Ahpo* Rodent-bone, "He the ballplayer" (at L8), *Mah K'ina Chan-Bahlum*. Then further on, at L11, we learn that this was the katun of ballplaying (*katun pitzal*).

It seems that being a ballplayer was one of the feats allotted to royalty. On the genealogical tree of the Yucatecan Maya Xiu family of Mani, just off the main branch to the left, the *Ahau uip Xiu-Zisaxe* (Morley 1946:pl.22) is named, and directly above it on top of the blossom at the end of that branch, the text again says "*Ah pitz X'iu*" (the *Ahau* Ballplayer Xiu). So "ballplayer" was an important title given to the royal line in other parts of Mesoamerica too.

The short figure (fig. 26) is not specifically named; as the text refers to "he of the Pyramid" and as the pyramid glyph is shown in other inscriptions, such as the tablets of the Temple of the Inscriptions, it has been generally assumed that the short figure is Pacal. George Kubler (1972:320) first identified the tall figure as "Snake Jaguar" and the short figure as "he of the Pyramid" or "Pyramid-Maker." He points out that "the name seems non-Maya, like the costume," and further identifies the "outlandish cold-weather costume" as resembling types known at Teotihuacan (Kubler 1967:45; 1969:19; 1974). The short figure shows no signs of aging, as the tall figure does, he noted (1972:323). Whoever he is, it seems to have been the intent that the short figure be represented at one point in time. Schele has always felt that the short figure was Pacal, not only because of the references in other tablets to this figure as the "pyramid figure," but also because at Palenque it has always been the parent who is shown alongside the offspring. Precedents are the Oval Accession Plaque, the Tablet of the Slaves, and the Palace Tablet, as well as the Dumbarton Oaks Tablet, where the parent Pacal is shown along with the protagonist.

In 1974, shortly after the First Palenque Round Table when a group of us working on Palenque met at Dumbarton Oaks, Floyd Lounsbury disagreed with the identification of the short figure. He felt then, and still does, that the short figure has to be Chan-Bahlum when he was six or seven years old. He argues that the short figure is always adjacent to the 9 *Akbal* 6 *Xul* event designation in the text (fig. 25) and that the tall figure is next to the 8 *Oc* 3 *Kayab* event, the date of Chan-Bahlum's installation on the throne. For these reasons, the short figure, he argues, can be no other than Chan-Bahlum at a younger age.

Recently Karen Bassie (1986) independently proposed the same thing that Lounsbury did some years ago: that the short figure is Chan-Bahlum and that we are looking at two

spaces and two moments in time. She also brings out that the height of the short figure is 75 percent of that of the taller figure, which I find is correct.

Another proposal was made by Tom Jones at the 1987 Texas Glyph Conference (and personal communication). He proposes that the short figure is Bahlum-Kuk, the first Palenque Jaguar King and founder of the Palenque ruling lineage. Bahlum-Kuk was born on 8.18.0.13.6 5 *Cimi* 14 *Kayab* (A.D. 397). He became ruler of Palenque on 8.19.15.3.4 1 *Kan* 2 *Kayab* (A.D. 431). Bahlum-Kuk, the ancestor for whom Chan-Bahlum was named, was the first king of Palenque who can be placed in historical time. His birth is recorded on the right side (the historical side) of the Tablet of the Temple of the Cross at P4-P7, and his accession is recorded at Q7-Q9, where he is named Blood *Ahau* of Palenque. Jones supports his argument by noting: (1) The Temple of the Cross panel records the birth and accession of Bahlum-Kuk (the historical founder of Palenque). (Schele [1976:29] acknowledges Bahlum-Kuk as a historical person and founder of the lineage.) (2) The Temple of the Sun panel records Chan-Bahlum's dedication naming the temple *K'inich K'uk-na*; three days after the dedication there is a blood-letting involving a reference to *K'uk'te-witz*. (3) The Temple of the Foliated Cross records the same Chan-Bahlum dedication date with the name of the temple *Mah K'ina K'uk'na* and with a memorial reference to Bahlum-Kuk I, complete with emblem glyph. (4) The Early Classic step under Temple 11 at Copan reveals that the building was named after the founder of the Copan lineage by one of his successors in exactly the same manner as Chan-Bahlum was to name the Cross Group after the founder of the lineage.

Flora Clancy (1986:18) proposes a radically different approach, saying that "the present iconography suggests that the short figure is the father of the patron-gods in the Palenque Triad [the First Father], and an important celebration, an anniversary event, rather than accession, is the major inspiration for the imagery." Her argument is based upon the fact that the chronological order Temple of the Cross, Temple of the Sun, and Temple of the Foliated Cross, which is the order of the birth of the Triad Gods, is also the order of the listed events important in the life of Chan-Bahlum.

I feel now that the short figure must be Chan-Bahlum at between six and seven years of age. This figure was sculptured the same height on all three tablets, 98cm tall, just 6cm less than that calculated for the flexed figures on the four central piers of the Temple of the Inscriptions. That is the size of a Chol child today between the ages of six and seven. As can be seen when the short figure is taken off the pedestal base, he comes to chest height on the taller figure on all of the tablets (fig. 27). Why was the child on the Inscriptions piers not depicted as an adult? The small person held in the arms of the standing figures on those piers was not intended to represent a human child, but rather a god-child, a God K. I have shown that the head of that child would have been that of God K (Greene Robertson 1979b). The intent was to show that Chan-Bahlum was made God K at the age of six in the 9 *Akbal* 6 *Xul* ceremony and that by implication he had always been this god. Maya art does not show childlike features; indeed, it is anomalous that the child on the Inscriptions piers has the body of a human child. Children were portrayed with adult

heads and bodies (for example, the many figurines of women holding adult-looking infants in their arms). The child on the dais in the Bonampak murals, Room 3, is shown as a small adult (M. E. Miller 1986:pl. 3). The Cross Group temples were not meant to show the actual 9 *Akbal* 6 *Xul* event. Chan-Bahlum was already king of Palenque. What is being shown is that at this early age he was the protagonist in a ceremony that legitimized his being God K. On the Cross Group tablets this moment is being recorded. He does not want anyone to forget it. He recorded two moments in time, one moment when he became God K at an early age and another when he became king.

We must remember that Chan-Bahlum had waited a long time to have the honor of being king of the dynasty. For all the years he had been involved in management and building under his father, he was undoubtedly waiting for the moment when he would become ruler. Chan-Bahlum was a jealous king. He made sure that it was his own right to rule that was well portrayed in the Temple of the Inscriptions, and not his father's. So again he portrays himself, this time twice on each of the three tablets.

The text of the three tablets concerns the birth of the Palenque Triad Gods and their parents and events that took place either during the life of Chan-Bahlum or that of his ancestors or the gods, especially events connected to his genealogical past, so the story does not change because there is uncertainty about the short figure's identity. I agree with Schele (1976:28) that the Cross Group tablets are "present pictorial records of the transfer of power from the dead ruler Pacal to his successor" regardless of who the short figure may be.

THE TEMPLE OF THE CROSS
(figs. 17, 18, 19, 20)

The Temple of the Cross sits on top of the largest pyramid substructure of the group and from its terrace provides a view of the center of Palenque not afforded by either of the other two temples in the group. The view encompasses the entire Cross Group, the Palace, and the Temple of the Inscriptions. In ancient times the view would have included Temples XVII, XVIII and XVIIIa, and XXI straight across to the south as well as a partial view of the multitude of temples that hugged the southern hillside. To the west could be seen Temples XIV and XV (built later than the Cross Group temples) just to the north of the Temple of the Sun. Behind the Temple of the Foliated Cross, almost devouring it, Mirador rises abruptly into the sky. As almost all of Palenque's plazas and open spaces were paved in stucco, vistas would have been uninterrupted by trees and foliage; and man-made structures would have blocked the view of Palenque's many distinct groups of structures.

The Temple of the Cross is a small temple, 15.3m across the front facade (south) and 9.45m in depth. It is oriented at 211° 45′ at the facade base (Aveni 1980:314). The corners are not at true right angles, resulting in the rear (north) wall being 50cm shorter than the front facade. A platform 60cm wide upon which the temple rests extends all the way

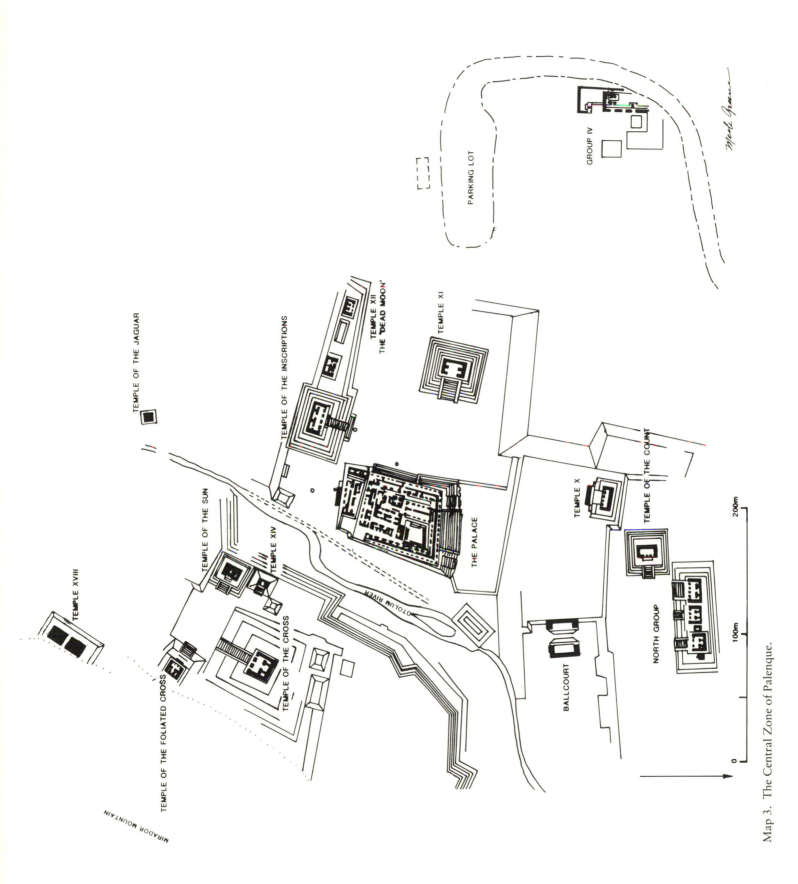

Map 3. The Central Zone of Palenque.

MIRADOR MOUNTAIN

TEMPLE XVIII

TEMPLE OF THE FOLIATED CROSS

TEMPLE OF THE CROSS

TEMPLE XIV

TEMPLE OF THE SUN

TEMPLE OF THE JAGUAR

TEMPLE OF THE INSCRIPTIONS

TEMPLE XII
THE "DEAD MOON"

TEMPLE XI

OTOLUM RIVER

THE PALACE

BALLCOURT

TEMPLE X

TEMPLE OF THE COUNT

NORTH GROUP

PARKING LOT

GROUP IV

0 100m 200m

around the building. Exterior walls are 90cm thick, and the interior center wall is 127cm thick. It is this inner wall that carries the weight of the roofcomb, besides dividing the interior space. The southern (front) half of the interior is one long room, but the rear interior of the structure is divided into three spaces: two narrow, dark rooms, one on the west and one on the east, each approximately 200cm wide with a wall 55cm thick dividing it from the central sanctuary room.

The sanctuary room, 810cm by 320cm, is largely taken up by the structure within the room, the "sanctuary," the most important part of the interior of the temple. This structure is independent of the building as a whole. It has its own self-supporting walls and its own roof; in other words, it is a tiny building within a larger building. The sanctuary is one step up from the floor of the temple proper. The inner rear wall of the sanctuary (323cm across) is entirely taken up with the bas-relief sculpture known as the Tablet of the Temple of the Cross (figs. 9, 10). It is on this tablet that two human figures, the tall figure and the short figure that I have been referring to, are carved. I shall go into detail about these further on.

The interior of this temple has some very intriguing details, both in its construction and in small details within the rooms that lead to interesting speculations about what purpose the rooms served. Large keyhole openings, so evident in the buildings of the Palace Complex taken up in Volumes II and III of this series, are an integral part of the architecture of this building too (fig. 21). These large, unusually shaped openings penetrate the vaults of the central wall of the structure, relieving the inner weight-bearing wall and vault of a considerable amount of heavy stone and mortar. As can be seen by the holes left in the vault, there was a double row of zapote beams connecting the span across the inner rooms. The vault between the inner and outer rooms is the high corbeled arch in the middle of the center wall. Keyhole arches (see section drawing [fig. 19]) penetrated the roof of this temple as well as the other temples of the Cross Group. As in all of these temples, the slope of the mansard roof follows almost exactly the slope of the inner vault.

As the front of the temple has mainly fallen, only two piers remain, Piers A and B (fig. 22) on the western side of the south face of the temple. Very little stucco sculpture remains on either of these piers. At one time heavy doors shut off the entrances to the inner portion of this temple, as evidenced by three very large postholes and posts on the inner (north) side of Pier A and six posts of the same size on Pier B. The holes measure approximately 29cm wide by 19cm high and up to 34cm deep and hold stone posts approximately 10cm in diameter. Curtain holes are spaced all around the inside of the temple at the vault overhang, indicating that the interior was curtained off in several ways. Curtains would have lined the entire height of the walls, making the interiors of the rooms quite dark, especially when the large doors were closed. The interior of the temple was indeed a private sanctum.

A narrow doorway butting up against the west wall of the structure leads into the small northwest room. Inside the room there are two sets of cordholders set 60cm and 194cm up from the floor. It is difficult to tell just what these would have been used for. On the

rear (north) wall an *Ik* opening juts into the east wall of the room at the exact junction of the rear and east walls just under the vault overhang. The leg of the *Ik* was filled in during ancient times, but the outline is clearly visible. One *Ik* opening is on the west wall of this room, and another is on the same wall in the outer (south) entrance room to this temple.

The northeast room had an entrance the same width as the one on the northwest room, but it was later built over so that the blockage is at the north end of the center wall. This narrow blockage is notched in such a way as to make the entrance barely wide enough for a person to squeeze through. The door itself is cut so that the door appears to be almost cut in half (fig. 23). Two large cordholders are set in the wall between the door and the partition wall. An *Ik* window is on the east wall, and an *Ik* opening was at one time in the north wall. This *Ik* is now partially blocked so that it does not look like an *Ik* on the interior, and a stone slab sits across the horizontal extension of the *Ik*. Two crudely shaped *Ik* openings are set 257cm and 255cm up from the floor on the west wall of this room. The rear side (north) (fig. 24) of the temple is unbroken except for two *Ik* openings placed very high up on the wall (one on the east and one on the west), too high to have been of any practical use unless they were for ventilation. The one in the north wall of the west room butts directly into the wall separating the west room and the sanctuary room, which makes me wonder whether at one time the east room, west room, and sanctuary room were all one room across the rear of the temple. Katherine Peterson (1985) has done an exhaustive study of these *Ik* openings at Palenque.

No sculpture remains on the South Roof or the East Roof, but some of the finest roof sculpture at Palenque remains on the West Roof, and small portions remain on the North Roof. The roofcomb is the highest at Palenque and the only one with a stairway leading to its upper part. (House D does have an opening into its roofcomb, but only to the first level.) The upper portion of the roofcomb in this temple would have made an excellent lookout station, affording a view over the whole city center, and it is sufficiently big inside for a tall man to stand comfortably on either the lower level or the upper level. When I stood there myself, there was plenty of room and the view was spectacular. As in all of the temples, a stone structure forms the framework upon which the stucco sculpture was worked. Only small amounts of sculpture remain on the roofcomb.

THE TABLET

THE CROSS/TREE ICON *(fig. 8)*

The Tablet of the Cross and the Tablet of the Foliated Cross, as well as the Sarcophagus Cover in the Temple of the Inscriptions, have as their central icon a stylized tree. On the Sarcophagus Cover, the tree rises from the Quadripartite God, the Underworld Sun Monster. The tree emerges from the bowels of the earth and reaches to the heavens at the top of the cover, where the Celestial Bird is perched. Jeweled serpents form the crossbar of the tree on the Sarcophagus Cover as they do on the Tablet of the Cross, where the tree also rises from the Quadripartite Monster. On the Tablet of the Foliated Cross, the tree

becomes a corn plant, and the side branches hold human heads rather than serpents. The Celestial Bird is again at the top cross in the center of the Tablet of the Cross. The tree emerges from behind the Quadripartite God, who is stationed in the far foreground. The cross is very much like the one on the Sarcophagus Cover in that it also displays double-headed serpents on either side with open mouths who display *tau* teeth, molar teeth, fangs, beards, eyes, supraorbital plates, nose plugs, and, just as on the Sarcophagus Cover, beaded upper jaws. Serpents on both icons are fleshed—of the Middle World, the living world. The short figure stands back from the jeweled serpents, his scepter-god staff almost touching the serpent, but not quite, while, opposite, Chan-Bahlum's stomach extends over to the jeweled serpent and his arms extend over the serpent bar, almost reaching the center upright extension of the cross. Three-petal floral disks attach the serpent heads to the cross and form the pedestal upon which the Celestial Bird perches at the top. The bird's elaborate necktie falls in front of the cross, indicating that the bird must have his head turned, as he is definitely standing on the cross.

A chain of *yax* and jade symbols forms a rectangular border, open-ended at the bottom, around the center portion of the cross, going behind the jeweled serpent figures and cross-ing over in front of the cross at the upper level. This tells us that the three-petal floral elements are intended to be in the full round and that the jeweled serpent heads issue from their centers and that the *yax* and jade string falls behind the jeweled serpents and the floral elements. The entire composition of this tablet is one of placement within the cos-mos wherein certain elements are shown in distinct perspective by means of spatial orga-nization (fig. 30).

The Quadripartite God at the base of the cross is exactly like the monster at the base of the Sarcophagus Cover (Greene Robertson 1983:58, 59) except for a few very minor differences. The normal crossed bands (on the west side of his cap) are replaced by a *cimi* sign (a sign of death) on the Sarcophagus Cover, and on the Cross Tablet depiction of the monster there are stylized serpents with bone-*ahau* attachments directly on top of the crossed bands and the shell. The shell, however, is behind the god's cap. Bone-*ahau* figures emerge from the earplugs of the Quadripartite God and dangle beneath as well (fig. 31).

The Quadripartite God is of all three Maya worlds: He is of the Underworld and of the Middle World and is the vehicle for connections to the Upper World, or the heavens. He is a version of the Underworld Sun in his passage from the world of mortals to the depths of Xibalba. His lower jaw is skeletal, as it is on the Sarcophagus Cover. He is in control of the action taking place on this tablet by his placement in space: He is the furthest forward of all the elements in the composition. He is in front of the cross and in front of the skyband border at the base of the tablet. He is three gods in one; when divided down the center, each half forms a profile view of the same god. The skyband border has on the west the symbols of the night sky *Akbal*, Moon, and Venus, while on the east are the day symbols of Sun, *kin* (day), and sky.

The two profile-view serpents with open jaws face the figures standing at the sides of the cross, and are in some way related to the serpent-bird in the Celestial Bird standing

on top of the cross. The serpents have all of the elements of the Principal Bird Deity (Bardawil 1976) except the feathers beneath their upper jaws. Here they each display the upper tooth, *tau* tooth, and molar tooth (fig. 32). The *ahau* symbol, the mat symbol, and the string of jade, bell, long beads, bone-*ahau*s, and cloth tie ends are the same as on the necktie of the bird of the heavens above.

Behind all of these symbols are hieroglyphs and numerous unnamed elements such as three-ball elements, bone-*ahau*s, *Spondylus* shells, and a jeweled *ahau*.

THE COSTUME OF THE SHORT FIGURE (*fig. 28*)

The clothing worn by the short figure has been the cause of much discussion. Nothing like it is shown anywhere else at Palenque. It is not tropical-weather clothing. The twisted muffler is certainly out of place at Palenque; it is more like a costume worn in the Valley of Mexico. The round glyph with four-way hatching tied close to the ends of a second muffler worn by the figure is from Teotihuacan (Kubler 1972:320).

The man also wears a short apron with the front hanging considerably lower than the sides. Over this clothing a layered protective garment is worn hugging the chest and hanging loose at the sides. The rear of this garment gathers above the waist, with four round balls securing it at the back. Over this vestlike garment a cloth necklace is worn that is bound with a mat symbol at the top and that then falls into two long streamers; the shorter portion is made up of rattlesnake segments, and the mid-calf portion is of twisted cord with a tassel. The intricate hat has seven folds of cloth, three of which are embroidered and have tassels that flop to the front and side. An upright stem with three leaves curls up from the rear of the hat. A small bead necklace is worn tight under the chin, and a jade earplug with a long bead pierces the ear but has no round flare as does the earpiece worn by Chan-Bahlum. The anklets and wristlets are of cloth tied on with a cord—the type worn only by gods. Pacal and Bahlum-Kuk, rulers now deceased, would both be privileged to wear this type of anklet and wristlet, as their status would be that of gods. Chan-Bahlum in his role of god-king would have been allowed these also. The figure wears no footgear. One gets a false sense of height when looking at the short figure, because he is standing on the head of God M, Nine Death, an important Underworld god, here in skeletal form, another indication that the god is depicted in the Underworld.

Glyph T656, the four-way-hatching glyph (text illus. g) that is on the knotted ends of the scarf, is a glyph reported by Kubler (1972:320; 1969) to have its center of distribution in Early Classic times. It appears in a feathered diadem, incised on a candelero, and in feathers surrounding a bird's-eye sign at Teotihuacan as well as in numerous other places. It appears three times on the Piedra Labrada, Veracruz Stela 1 (text illus. h), a monolith 2.02m tall and averaging 35cm broad. The monster glyph above the three T656 glyphs is what Lehman (in Blom and La Farge 1926:41) calls the glyph for Teotihuacan; he says that the Piedra Labrada monument is Toltec.

The four-way-hatching glyph remained in use over a long time. I am curious about its appearance twice on each of the depictions of the short figure. Could it be that the short

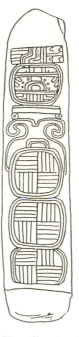

Text illus. g. Glyph
T656, the four-way-
hatching glyph.

Text illus. h. Glyph
T656 on the Piedra
Labrada, Veracruz
Stela 1.

figure was from the Valley of Mexico, the *cold* country, a speculation first mentioned to
me by Kubler? I hardly believe it would be comfortable or necessary to wear such bulky
clothing at Palenque unless this was the symbol noting the wearer's native land. It is the
case today in almost all Maya communities in highland Mexico and Guatemala that one
can tell which village a person comes from by the clothing he or she wears.

THE COSTUME OF THE TALL FIGURE (*fig. 29*)

In contrast to the short figure, Chan-Bahlum has very little clothing. He wears a short
hip cloth over which a triangular apron hangs to knee length in the front and goes only
halfway around the thigh. The long ends of the apron are folded under the triangular
portion and flopped over the side at waist level with no knot. An undergarment can be
seen just above the triangular apron. The longer ends of the loincloth hang in front to
below knee level. The shorter end of the loincloth can be seen hanging below the hip cloth
in the rear.

He wears a necklace of very large beads hanging to waist level, two of which are seen
at the back of his neck. A string of twelve slightly smaller beads hangs from the center of
the neck down the back and is secured by a tassel at the end. His anklets and wristlets are
made up of long beads and bone-shaped beads. His earplugs are the tubular type where a
large round plug is inserted in a hole in the lobe of the ear and then a long bead is inserted
in the throat of the flare, much like those described as Type B earflares by Kidder, Jen-
nings, and Shook (1946:figs. 144, 145). Two jade balls and a bone-*ahau* bead hang to the
rear.

Chan-Bahlum's hat consists of a stiff cloth wrapped around his head and gathered at the rear. Extending through the opening in the top, several elements can be seen—a two-stack round piece through which protrudes an angled piece and a curved piece at the rear which seems to function as a holder for either the hair or feathers protruding beyond it. Out of this same tubular piece a three-leaf floral piece on a long curving stem can be seen. A flat piece in the form of a mat symbol holds the hair (or feathers) inside the tube. The typical male haircut can be seen at the back of Chan-Bahlum's neck, where there is a shaved area located at ear height with about a 5cm section of clipped hair falling below. At the center of the shaved area a long pigtail is held in place by being pulled through a tube bead pushed securely against the head. This is exactly the same way rubber bands and fancier gadgets are used by girls today to hold both pigtail and side strands of hair in place.

Chan-Bahlum, the tall figure, holds the jester god (one of the principal gods of rulership at Palenque), who lies supine on a cushion or cloth that, Elizabeth Benson (1976:45) noted, "appears to be twisted, and knotted on one end." The short figure holds the perforator god, also known as the scepter god, with the "ceremonial blood-letting instrument" (Joralemon 1974) in front of him. This is an instrument of auto-sacrifice, specifically penis perforation, an act that was considered essential to accession to the throne. The head of the god as shown here is the same as the rear head of the celestial monster, the Quadripartite God of the Bicephalic Room of House E of the Palace. On the Cross Tablet, however, the god is shown in upright position, whereas in House E the god is shown upside down.

The god's headdress is made up of the quadripartite symbols: the crossed bands, the shell, and the flattened U and three-part element on the left. The stingray spine is indicated by the perforator; in this instance the god may be said to be the perforator god. The god as depicted here is jawless, with water or blood flowing from the mouth. A half-completion sign is on the liquid flowing downward.

TEXT OF THE TABLET (figs. 9, 10)

The text of the Tablet of the Temple of the Cross is divided into two parts, the left panel being mythological events and the right, historical events. The text starts with the Initial Series Introductory Glyph (I.S.I.G.) giving the name of the patron of the month *Zec*, followed by the time frame 12 baktuns, 19 katuns, 13 tuns, 4 uinals, and 0 kins, with the day 8 *Ahau* and the month 8 *Zec*. We are told that the eighth Lord of the Night is in office, that the moon is 5 days old and that the second lunation has ended; that is, the moon has been in the south quadrant of the sky for 5 days. The directional color would have been yellow, the color of the south. Each quadrant has a color (text illus. i). We are told that 29 days are left in the lunation. Then the earliest 819-day count is recorded as 1 *Ahau* 18 *Zotz'* (12.19.13.3.0). All of this leads to the birth of "Lady Beastie," the Ancestral Goddess and mother of the Triad Gods. Later on, her accession is recorded 815 years later, but in calculating the date the scribe "counted the Distant Number for 819-day count station, rather than from the date of birth and in using the table of twenty comput-

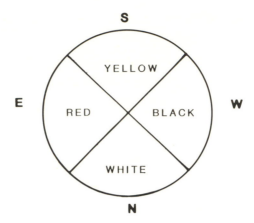

Text illus. i. The four color quadrants of
the sky.

ing years to find the name of the day of the Calendar Round system, he stopped one line
short, obtaining the wrong position. He wrote 0 Zac, but wanted to write 0 Yax" (Schele
1987:59 n.47).

Then we are told of the birth of the First Father GI on 12.19.11.13.0 1 *Ahau* 8 *Muan*,
and on 4 *Ahau* 8 *Cumku* (13.0.0.0.0) the "deer hoof" event took place. A "sky" event
also took place. GI the First Father's glyphic names are shown. On 13 *Ik*, end of *Mol*
(13.0.1.9.2), he erected or lifted the sky up from the earth so they were separated. Then
we see the North Glyph followed by GI (at D11), who entered the sky and God C, who
took part in the sky event in his house at C12, D12. David Stuart, as a result of his 1986
summer work at Copan, noted that monuments are all given proper names, many of
which terminate with the God C glyph. Its presence here preceding a house glyph proba-
bly means he sets up or raises the stone tree, the icon of the center of this tablet, and
dedicates his north house (the Temple of the Cross).

"Lady Beastie" is then recorded as having been seated as ruler on 9 *Ik* in the month
Zac. Both personages are saying that human beings are to their mothers as the gods were
to their mothers. GI of the Palenque Triad is linked to the Ancestral Goddess by birth and
to her accession to rulership. She was 761 years old when her first child was born and
815 years old at her accession.

The birth of U-Kix-Chan on 5.7.11.8.4 1 *Kan* 2 *Cumku* (March 11, 993 B.C.) is re-
corded, along with his accession on 5.8.17.15.17 11 *Caban* 0 *Pop* (967 B.C.). This
would have been within the time frame of the Olmec civilization at San Miguel, 40km
southeast of La Venta, as revealed by the recent work in that area by William Rust (1988).
This is not an unreasonable distance from Palenque. We know that there was Maya oc-
cupation there in the past, and Rust's new evidence shows Olmec-Maya contact at San
Miguel and Maya motifs showing up clearly on San Miguel pottery. The fact that there
would have been knowledge by Palencanos of the peoples at San Miguel is not surprising.

Information about U-Kix-Chan is on both sides of the tablet. His birth is recorded on
the left side (mythological time), and his accession is recorded on the right side of the

tablet, in historical time. I think that he was deliberately recorded in this manner to legitimize the descent of Bahlum-Kuk and likewise Chan-Bahlum II from U-Kix-Chan and the Mother Goddess. If U-Kix-Chan was born in the mythical past, his relationship to the Mother Goddess was legitimized. By recording his accession in historical time, the tablet linked him to Bahlum-Kuk and proved the latter's legitimate birth.

Bahlum-Kuk's birth is then recorded as 8.18.0.13.6 *5 Cimi* 14 *Kayab* (A.D. 397), followed by his accession at thirty-four years of age on 8.19.15.3.4 1 *Kan* 2 *Kayab* (March 11, A.D. 431) right after the record of accession of U-Kix-Chan.

The next king to have his birth recorded is the king dubbed "Casper," who was born on 8.19.6.8.8 11 *Lamat* 6 *Xul* (August 9, A.D. 422). "Casper" may have a new name, however, as Alfonso Morales has discovered that the character used for the glyph of this king is none other than a manatee (text illus. j). The manatee, a now endangered species of mammal, not long ago was common along the tropical Gulf and Pacific coasts of Mesoamerica. Manatees inhabit the shallow waters of bays, lagoons, estuaries, and rivers such as the Usumacinta, very close to Palenque (only 35km away). (Sharks also are known to travel all the way up the Usumacinta River into the Tulija River as far as Tila in Tabasco.) Manatees were common there and so were surely known to the Palencanos. The manatee has a small squarish snout and a muzzle dotted with small holes where the stiff whiskers protrude. This is exactly what the Maya were portraying in this glyph. Bristle-like short hairs are scattered singly over the body at intervals of about 1.25cm. The upper lip is deeply split, and each half is able to move independently. The eyes are small, and there are no external ears (Nowak and Paradiso 1983:1152-54). Landa (Tozzer 1941:190-91) writes about the manatee and states that because of the "large amount of fish or meat which they have, they make a good deal of lard, excellent for cooking food. Of these sea-cows marvellous stories are told." He tells of how Gonzalo Fernández de Oviedo y Valdes, the author of *Historia general de las Indias* (1535), relates that "an Indian lord who lived in the Isla Espanola reared one in a lake so tame that he came to the shore of the water when called by the name which they had given him, which was *Matu*." Landa adds, "What I say about them is that they are so large that one gets more meat from them than from a good big yearling calf, and a great deal of fat. They beget like animals and have for the sexes members like a man and a woman, and the female always bears two—neither more nor less." He says that "they have a face very like that of an ox, and they raise it out of the water to feed on the grass on the shores. And the

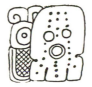

Text illus. j. The glyph for "Casper": the manatee.

bats are accustomed to prick them in a round flat snout, which they have which turns back on their face and they die from it as they are wonderfully full of blood, and they lose much blood from any kind of wound." About the blood of the manatee he further states that "they are so full of blood, they go about disturbing the mud, and they bleed very freely."

It is possible that one reason the manatee was chosen for the name of this king was because of its great power of blood-letting. Blood-letting is a prime requisite for rulership; if you were named for the creature capable of giving far more blood than any other known creature, your credibility would certainly be great.

In Yucatec, James Fox tells me, the word for manatee is *baklam* (Moran 1935), and it is *kum way* in both Cholti and Chol. (*Way* is a root for the verb "to sleep" or "to dream.") So possibly King "Casper" would better be known by a more dignified name such as Baklam or Kum Way.

We are then told of the birth and accession of Palenque's next king, Manik, whose birth is recorded as 9.1.4.5.0 12 *Ahau* 13 *Zec* (A.D. 459) and his accession as 9.2.12.6.18 3 *Etz'nab* 11 *Xul* (A.D. 487). He was twenty-eight years old at accession.

Following the records of Manik, we are told of the birth and accession of Chaacal I, who was born on 9.1.10.0.0 5 *Ahau* 3 *Zec* (A.D. 465) and acceded to the throne on 9.3.6.7.17 5 *Caban* 0 *Zotz'* (A.D. 501). Kan-Xul is the next king recorded, with birth at 9.2.15.3.8 12 *Lamat* 6 *Uo* (A.D. 490) and accession at 9.4.14.10.4 5 *Kan* 12 *Kayab* (A.D. 529).

Chaacal II then has his birth and accession noted at 9.4.9.0.4 7 *Kan* 17 *Mol* (A.D. 523) and 9.6.11.5.1 1 *Imix* 4 *Zip* (A.D. 565). Each of the recorded kings of Palenque has so far had his birth linked to accession within a single lifetime, but with Chan-Bahlum II, the birth is linked to that of Chaacal I, partly to mark Chaacal II and Chan-Bahlum I as siblings, states Schele (1987:79). Kathryn Josserand points out that this is the most important event in the text (Schele 1987). The birth of Chan-Bahlum I is recorded as 9.4.10.1.5 11 *Chicchan* 13 *Chen* (A.D. 524), and then his accession is given as 9.6.18.5.12 10 *Eb* 0 *Uo* (A.D. 572). Many titles are given to Chan-Bahlum II, including the title *Ah Pitz* ("he of the ballgame") (text illus. f), just recently deciphered by David Stuart. He is named Jaguar Lord of Palenque and child of the father *K'ina* Pacal and child of the mother Lady Ahpo-Hel. Just behind Chan-Bahlum's head he is named *Mah K'ina Chan-Bahlum-Ah Pitz* ("the ballplayer") *Bac-balan-ahau* ("Palenque Lord Jaguar").

THE JAMBS

THE WEST JAMB *(figs. 33, 34)*

Now, when we include the outer jambs to this temple, action takes place. The instrument of office, the scepter god held by the short figure on the inner tablet, is given to Chan-Bahlum. On the jamb it is held upside down, but with all of the same elements

present as on the inner tablet. This perforator god, or scepter god, is the rear head of the celestial monster, probably its "Sun head." Chan-Bahlum now presents the celestial monster to God L, the god identified by Michael Coe (1978:16) as one of the chief Underworld gods.

On the West Jamb, Chan-Bahlum is no longer in scanty attire (figs. 33, 34). Here he is decked out in full kingship regalia and weighed down by an enormous amount of jade, a headdress that towers one-third of his body height above his head, and other paraphernalia necessary to his office. Chan-Bahlum wears a top-heavy multitiered headdress composed in part of a jawless long-lipped god fastened to the head by a double row of beads. The enormously long lip of the god has the stingray spine extending straight out in front of Chan-Bahlum's head, making the blood-letting instrument the motif furthest forward and the one of greatest importance. This is the same blood-letter that is directly above in the name glyph of U-Kix-Chan, the ancestor way back in prehistory. I feel that having U-Kix-Chan's glyph on the text framing Chan-Bahlum's face and in the most prominent position on the headdress legitimizes Chan-Bahlum's right to rule the city and pushes the legitimacy back as far as it can go—to Olmec times. This also tells us that blood sacrifice, a prerequisite for rulership, was practiced as far back as any living mortal could remember having been told about it in oral history.

Chan-Bahlum's costume is remarkably similar to that worn by the figures on House A of the Palace, although the proportions of the human form are much more realistic than on House A, where figures are seven heads high and elongated in the midsection (Greene Robertson 1975). Almost exact duplications can be found in the beaded cape, pectoral, leggings, earplug, and fish nibbling on shells in the headdress.

Hanging from the neck is a necklace of very large beads attached to a bead-encircled pectoral with a front-facing bat with upturned nose. Just above the bat is a long-beaked creature upon which the chin of Chan-Bahlum rests. This is the chin guard attached to the earplug extension, the earplug, and the piece that connects with the side of the headdress. There is an identical contraption on the other side. All of this keeps the headdress from toppling (fig. 35). The beaded band around the forehead is the anchor. Above this rests the long-lipped monster head with netted brow and jaguar markings, crossed bands, and stingray spine on its upper lip. More framed crossed bands like the ones worn by the stucco tomb guards on the Inscriptions Tomb walls (Greene Robertson 1983), another stingray spine in profile, a turtle shell, a cormorant eating a fish, two little fish nibbling at shells, and a massive array of feathers make up the rest of this splendid headdress and chin guard (fig. 36).

The very short leather skirt or kilt (figs. 37, 38) is so brief that the crease of Chan-Bahlum's buttocks shows below it. The bottom is slit up about 8cm at wide intervals all the way around. The undergarment can barely be seen just above the belt. On top of the underwear a jaguar-skin hip cloth is worn, also slit along the bottom edge. On top of these three garments is the wide belt with alternating crossed bands and Lounsbury's

(1974b:5) "quincunx" glyph. At the front a massive jaguar head weighs the belt down. The jaguar is part of Chan-Bahlum's name (*bahlum*). Beneath the beautiful jaguar head is the expected mat symbol of royalty and the mirror below it.

The little god hanging from the string of *yax* and jade symbols that hangs from Chan-Bahlum's belt (figs. 39, 40) is a version of the Jaguar God of the Underworld, here shown with his left arm thrust through a *cauac* cartouche, signifying both rain and the Underworld. He has the gathered hair, shell ear, curled eye, *tau* tooth, and long nose with bone symbols and nose curl of this god. This figure on the end of a chain hanging from the belt reminds me of other Maya figures wearing the same type of hanging belt, such as the very early Leiden Plaque (though in that case the hanging figure is not a god, but a stylized serpent); that representation also has the bell with three long bones and bone-*ahau*s. On Stela 28 from Tikal a crouching figure at the end of the chain has his arm through a cartouche; on Tikal Stela 1 there is a little god head hanging from a knee-length chain; and on Uolantun Stela 1 a little crouched figure with his arm through a cartouche is also hanging from a chain. On the west side of the Western Court at Palenque, God K also has his left arm through a cartouche (see Vol. III of this series).

The god head behind Chan-Bahlum (fig. 41) seems not to be part of the costume of the ruler, but a separate god floating in space. He has lashed eyes, netted brow, tied hair on top, the bone jaw of death, and an elaborate frame of mat symbols at the back of his head and under his chin. An enormous array of feathers issues from the back of the head, and at the end of a twisted jaguar skin another display of feathers falls far below. These back feathers issue from the god and are not worn by the standing figure. I think that this Underworld god is in space *behind* Chan-Bahlum to let us know that all of the power and duties of rulership just given to him as a god and shown on the inner tablet still belong to the god; and deference is being paid to the gods under the aegis of God L of the Underworld.

The text framing the head and headdress of Chan-Bahlum starts out with the D.N. (Distance Number) 10th day and then lists Event 1 (*y-och te acal*), the heir designation, and then Event 2, naming U-Kix-Chan and the agent Chan-Bahlum *bac le balam-ahau Ah Pitz*. The text ends by stating that Chan-Bahlum is the child of the father Pacal—Blood Palenque *ahau*.

THE EAST JAMB *(figs. 42, 43)*

God L, one of the principal gods of the Underworld (Coe 1973:14), takes position on the outer temple jamb opposite Chan-Bahlum on the West Jamb. God L would represent a deceased king now in the Underworld. His tied-on cloth anklets and wristlets signify his god status. He is portrayed as an old man, toothless, as can be seen by the lines under his lower lip, and very thin. He has the outlined eye of a god with a scroll eyeball and a double flare protruding from his forehead. His jaguar ear can be seen above his earplug assemblage. He is smoking what Robicsek (1978:117) terms a "large funnel-shaped cigar."

He is scantily dressed in a very short hip cloth with cut or pleated edge bordered with

feathers just above the pleats, and with a *cauac* symbol on the side. He wears the same type of belt that Chan-Bahlum wears, with crossed bands, but instead of the jaguar at the front, God L wears the "quincunx" glyph as his buckle. He wears a jaguar cloak made of the skin of the animal with tail hanging to just below the knee. The cloak is bordered in the center of the back by elements shaped like long beads and is tipped with the fluffy tail, which has a cross-hatched section. Just below this is a little upside-down *ahau* figure with two bone-*ahau*s attached to it. A second string of beads hangs down the back to waist level and to below the knee in front, where the beads become very large. A light scarf hangs from the god's neck, and it is this that forms the mat symbol, shown front view with a shell (shown in profile) hanging from it. The scarf is pleated to form the mat, and the two end pieces join again where they started forming the pleat and fall down in front of the god's body. It would have been difficult to portray this mat element correctly in profile, so the front view was selected. It was important to convey the message of there being a mat.

A long scroll with footprints along its length curves over the long-lipped head in front of the figure, and an identical one curls over another head behind the god. This coil is the loincloth, secured at the waist and wrapped around the middle of the figure. The long-lipped gods behind and before God L have the bell assemblage beneath the jaw, and two long, elaborate ribbons fall nearly to the ground with "mirrors" taking up the bottom section of each.

The headdress worn by God L (fig. 44) is an elaborate array of muan bird (an Underworld bird) feathers with the Underworld muan bird at the top with curved beak, scroll eye, long whiskers, and prominent muan feathers issuing from the earplugs. This undoubtedly represents the harpy eagle (*Harpia harpyja*) (Brown and Amadon 1968:II, 632-36 and pl. 110). The number 12 cartouche on top of the bird's head has two flares from which issue a large plantlike element with an infixed inverted Sun God with *cimi* (death) sign on the cheek and mirror in the forehead.

An inscription ran across the entire entrance to the sanctuary, but the section over the doorway into the sanctuary was on a wooden lintel that no longer exists. The text over Chan-Bahlum on the West Jamb panel contains four glyphs, the first three reading *Wac ah Chaan*, *u* God C-in-hand, and *u chumul* (residence, house). (The same name is recorded on both the *alfardas* and doorjambs of this temple.) The text continues over God L on the East Jamb, with glyphs for God L, the child of *Mah K'ina* Chan-Bahlum, and Blood Palenque *ahau*. "This is the exact name recorded on the *alfardas* and the doorjambs" of the temple (Schele 1987:141).

THE SANCTUARY ROOF

The Sanctuary Roof of the Temple of the Cross had a monster mask on the south-facing roof (the front). This was undoubtedly a portrayal of the Underworld Sun Monster, as in the Bicephalic Room of House A of the Palace. All that remains is the wing portion on

the eastern end (figs. 45, 46) and a smaller portion on the western end. Large well-modeled feathers extend to the edge of the sloping hip-molding of the upper zone, which forms a frame around the entire upper zone. This frame was sculptured with celestial and terrestrial elements along the upper and lower borders, and the sloping hip-moldings on the ends were sculptured with bicephalic monster heads very similar to the one on the west wall of the Bicephalic Room and the East Subterranean Vault of the Palace. The east and west ends of the Sanctuary Roof are stucco-sculptured, with a quatrefoil cartouche containing the bust of a human figure and stylized serpents on each side of the cartouche.

The West Sanctuary Roof (figs. 47, 48, 49) shows the deeply sculptured quatrefoil cartouche and the chest and shoulders of a human. The head is missing. A tassel hangs over the figure's right shoulder, and remnants of a bead necklace can be seen. Parts of the serpent can be seen on each side (fig. 48). Note the *tau* tooth and the balls of the serpent wing as well as the triple cartouche form. The separation between cartouches is marked by an exceedingly deep groove. A mirror with eight dots around it can be seen on each side. A downward-facing saurian creature, almost identical to the saurian monster in House E, makes up the left (north) border. All but three of the skyband border elements are intact. The right frame (south) shows the remains of an upside-down *ahau* figure (fig. 50), and below it, on the protruding bottom border, there are remnants of a monster face surrounded by a feather border (fig. 51).

The East Sanctuary Roof (fig. 52) displays the same central quatrefoil cartouche as the west side with the bust of a human figure inside. Here the hair ribbons on each side are intact, and although the head of the person is missing, the roughed-up area against which the head rested can be identified. On the Sanctuary Roof of this temple, the cartouches with the busts within are portraying exactly the same thing as the medallions with their serpent cartouches on the wall of House A of the Palace. Giant serpents fill the space on each side of the quatrefoil cartouche (fig. 53). A good deal of paint remains in these cartouches, again the same as on the House A medallions (see Vol. I of this series). Red paint is on the bust, the hair ribbons, and the background of the cartouche. Blue paint is also on the background area. All but one of the skyband elements are intact (fig. 54), here showing considerable blue paint, with red paint on the background area.

The Roof
(figs. 55, 56)

The West Roof of the Temple of the Cross is so elaborately sculptured that although only small amounts remain on the other sides, we can assume that the entire roof was decorated in very high-relief stucco sculpture. A giant Underworld Earth Monster's head and forearms occupied the West and North roofs. Today very little of the monster's head remains. Exposed as the West Roof is to the tropical rains and sun, it is amazing that so much of the saurian creature's arms and the fish remain (figs. 57, 58), especially when the

stucco is so deeply sculptured. The little fish (actually the fish on this roof are extremely large) just to the right of the shell forming the elbow of the monster is curled around in a manner indicating extreme action. The arm of the monster is like the arm of the Bicephalic Monster in House E, complete with shell elbow and scales on the arm (fig. 59). This roof tells us that at least the giant fish and arms were made with armatures, large flat stones used so often at Palenque to support the weight of the stucco placed upon it (fig. 60).

The North Roof of the temple has only a few isolated pieces of sculptured stucco, but those that do remain are in good condition. Standing on the North Roof was so precarious that it was difficult to get pictures, but just feeling the deep cuts in the stucco sculpture made me appreciate what the Maya had to do to accomplish such astounding sculpture on their buildings. The pieces are deeply incised, some cuts being 10cm deep, but the large free-swinging scrolls were what impressed me the most. The sculptors had to be exceedingly proficient to achieve such unlabored-looking curves. When I think of the vast amounts of stucco that were swung in one swoop, I marvel that it could have been done at all.

THE ROOFCOMB
(fig. 61)

The towering Roofcomb was once covered with painted stucco sculpture, but all that remains now is the framework of stone upon which the stucco was laid. (Taking the photo required climbing a very tall tree to the south, balancing on the branches, and using a telephoto lens.) This is the only temple of the Cross Group that has a stairway inside the Roofcomb that enables one to climb to the top story. Each level is considerably higher than one's head and much larger than it looks, with plenty of room to move around inside (fig. 62). A sentinel could have observed the entire Palace and surrounding area from this high vantage point without being detected.

The framework of the roofcomb is made of vertical columns of stone and mortar supported by horizontal thin slabs of stone that follow a course across the roofcomb and extend well beyond the edge of the structure (fig. 63). The rectangular openings formed by these horizontal and vertical courses are so precisely laid out that it looks as though the structure was planned with a ruler. Indeed, I am certain that the Maya used a measuring device for this and other construction.

On the front (south side) of the Roofcomb, evidence remains of a serpent-scale border just like the serpent border on the piers of House A of the Palace. Also on the south side a giant stucco fish complete with fins, split tail, and crosshatched body can be seen at the very top of the building (fig. 64). To the left of the fish, the curved portion of a serpent just like the one found in the Temple of the Sun remains, and a well-modeled curve (part of a serpent) is still intact (fig. 65).

An Underworld theme is evident throughout the iconography of this temple, especially

on the west side (fig. 66). The entire Roof and Roofcomb display much evidence of the Underworld monster and fish. This theme, with huge fish swimming in a watery Underworld, was meant to be seen by the Palenque populace and not just by the elite hierarchy who were granted permission to enter sanctuaries. Imagine the impact this display of giant creatures and giant fish, all in vivid color, would have made on all who gazed up at it.

THE *Alfardas*
(fig. 13a)

The Temple of the Cross balustrades tell us that on *9 Ik 15 Ceh* (1.18.5.3.2) GI was born and that it was 7 baktuns, 14 katuns, 14 tuns, 11 uinals, and 10 kins (7.14.14.11.10) later, on *5 Eb 5 Kayab* (9.12.19.14.12), that Chan-Bahlum took part in the "house event" where he let blood. His father, *K'ina* Pacal, is named, and his mother, Lady Ahpo-Hel, is named. Then the anniversary event of the world took place. The name was *Wac ah Chaan* (V 1-Sky), exactly the same as is recorded on the lintel over Chan-Bahlum's head on the West Jamb panel and on the doorjamb of this temple.

PALENQUE'S STELA 1

Palenque's only known sculptured stela (figs. 67, 68) (there is one plain one in the forest) at one time stood in front of the Temple of the Cross, as can be seen by the small white spot in the photograph by Maudslay (fig. 69). Figure 70, a photograph also taken by Alfred Maudslay, shows the stela lying on the steps to the Temple of the Cross. Today the stela stands in front of the Palenque museum. From pedestal base to the top of the headdress, it stands 240cm high; the figure is 202cm tall. The method of carving this stela was like that employed for Tonina stelae (Monument 5 [Mathews 1983] is typical) and some Copan stelae as well. The deep front and shallower back of the figure were carved out almost in the round, leaving remains of the original shaft of stone two-thirds of the way toward the rear. The stela appears not to have been finished.

The figure stands with feet apart and toes facing outward and to the front, as on the figure piers of the Temple of the Inscriptions. The right arm is bent at the elbow and raised to the neck, while the left arm crosses the waist as if holding or dropping something. The headdress is immense, with feathers splaying to the side. An animal head forms the main portion of this massive sculpture. The figure wears extremely large earplugs with very large holes through which flexible pieces seem to drop. It wears a capelet with very large beaded collar, a short tiered skirt, and a wide loincloth reaching to the ground in front. The belt piece is a front-facing head almost as large as a human head, probably a shrunken trophy head. The bottom of the loincloth has a mirror element on the front. There is a glyph on the pedestal beneath the feet, but it is not possible to detect what it represents.

THE TEMPLE OF THE SUN
(figs. 71, 72, 73, 74, 75, 76)

The Temple of the Sun, although it is situated on the lowest mound of the Cross Group, nevertheless acts as a barrier between the central zone of communication of Palenque and the Cross Group temples. The rear of the temple (fig. 77) faces toward the Temple of the Inscriptions, while the front, oriented at 119° 28', faces the small court shared by all the Cross Group temples. This small temple has long been of major interest to explorers and archaeologists, probably because it is better preserved than the other two temples and is also more easily accessible. Note how intact it appears to be compared with the Palace in the photograph taken by Alfred Maudslay in 1889 (fig. 78). Only the center of the east roof has fallen in (figs. 80, 81). The photograph taken by Walter Groth in 1934 shows the repair to the east roof by Miguel Angel Fernandez as well as the top of the roofcomb (fig. 79).

Rather than being raised high above the plaza, necessitating a long climb to the temple proper, this temple requires a climb of only seventeen stairs to a 350cm platform and then another climb of seven stairs to the 64cm platform directly in front of the temple entrance. One final step puts one directly on the temple floor. Balustrades are at the sides of the seven-stair section (figs. 82, 13b).

Like the other two temples, this one is divided into two corridors separated by two sections of 114cm wall. The front half, now open, was at one time divided into at least two rooms. The rear half is very much as in the other two temples: A central room contains the free-standing sanctuary building, and there is a small, dark room on the south and the same on the north.

Two *Ik* openings are on the north wall of the building, and two are on the south wall, all four penetrating the wall but positioned 230cm up from the floor to the bottom of the leg of the T, making them useless for sighting. The west wall has two approximately 24cm squarish holes that penetrate the wall, and the south wall has a similar hole next to the *Ik* opening angling off in a westerly direction. As in the other temples, keyhole openings in the vaults reduce the mass of masonry in the central roof area where the pressure is on the central bearing wall.

Cordholders run all the way around the building on the outside just under the eaves overhang. There are 18 cordholders on the south side, 21 on the west side, 16 plus places for 2 more on the north side, and 22-26 on the east side, the front. It is difficult to tell exactly how many there were on the east side because of the reconstruction of the roof. We can see curtains being used over areas with doorways or other openings; but on the south, west, and north sides of this temple, where cordholders run the full length under the eaves overhang, there is nothing to cover—no windows or even a mural. It is possible, of course, that banners of some kind were hung all the way around the building.

The small side rooms in the rear of the temple are extremely interesting. One enters the

small room on the northwest corner through a low doorway simulating a vault (fig. 83) having a stone lintel 80 x 15 x 7.5cm embedded in the vault on the east side only, just 205cm above the floor. In the southeast corner of this room a shelf has been built 178cm above the floor (fig. 84). A vertical stone is embedded in the east wall, and a horizontally tilted top piece is embedded in the south wall. Just 7.9cm below this shelf, a doughnut-type cordholder 10cm in diameter juts out from the wall. Presumably a vessel was kept on the shelf and another was hung from the cordholder below it. In the northwest corner of this room two doughnut-shaped rings of stone extend from the walls 183cm and 190cm from the floor. These also were evidently used for suspending a jar or some other piece (fig. 85). They are not aligned vertically, however; one is on the west wall and the other on the north wall.

The entrance to the southwest room is similar but does not have a lintel. In the northeast corner of this room a 20cm stone post 31cm long is embedded in the wall just 10cm from the corner and 78cm down from the vault spring (fig. 86). It is intriguing to imagine the activities that took place in these rooms with all of their shelves, suspension rings, oddly shaped doors, and uneven openings (fig. 87).

The sanctuary building in the central rear corridor is like the tiny free-standing building in the other two temples. Very little is left of the stucco sculpture on the sanctuary roof, but the front (east-facing) roof (fig. 88) at one time had a central Earth Monster, probably similar to the one over the north doorway of the Bicephalic Room of House E of the Palace. The South Sanctuary Roof is the better preserved (fig. 89); however, there is nothing left of the Earth Monster suggested by Maudslay's sketch (fig. 90). The bottom border consists of a series of god's heads one next to the other (fig. 91*a*, *b*, *c*), and at the west end the vertical panel starts with the upside-down head of the Quadripartite God (figs. 92, 93). The upper border has a number of parts of a skyband (fig. 94*a-g*).

THE TABLET
(figs. 95, 96)

The protagonists of the Temple of the Sun are again a tall figure, Chan-Bahlum, and a short figure, referred to as Pacal, a younger Chan-Bahlum, or Bahlum-Kuk (Palenque's first ruler)—the same two figures as on the other Cross Group tablets. The text is concerned with the "lineal descent of the ruler, with his divinity, and with the rites necessary to delineate his historic right to the 'seat' at Palenque." It goes into the "819-day count augury of Chan-Bahlum and the rite which occurred to him at 6 years old" (Schele 1976:26). This rite took place on 9.10.8.9.3 and marks the date when he became heir apparent to the throne. The same event took place for his ancestor Kan-Xul, his great-great-great-great-grandfather, also at the age of six. The other important date, 8 *Oc* 3 *Kayab*, is the accession date of Chan-Bahlum, the date when the transfer of power being depicted on this tablet took place.

THE COSTUME OF THE SHORT FIGURE (*fig. 97*)

The short figure wears the same costume in all three temple depictions. The only variations are length of scarf and minor details. The embroidery on the cap is one of the differences here (figs. 98, 99), as is the leaf curving up at the back of the head. Whereas in the Temple of the Cross the figure holds a Quadripartite scepter face downward, and in the Temple of the Foliated Cross he holds the perforator god facing up, here he holds, in outstretched hands, the flint-shield god, a symbol of the Palenque dynasty (fig. 100). The shield god is a form of the jester god with two separated leaves making up his cap. He is associated with lineage ancestry and the divinity of the ruler. He is seated here on a folded and bound mat, and balancing under his hands is a *xipe* (flayed face) shield bordered with feathers and bound reed or leather.

The short figure stands on the kneeling figure of the god with square eyes, *tau* tooth, and god markings on thigh, arm, and back (fig. 101). The tall figure stands on a god figure in a seated position with straight back and elbows on the floor. This god, the god of merchants, has *ahau* markings on the thigh, arm, and back (fig. 102).

THE COSTUME OF THE TALL FIGURE (*fig. 103*)

Chan-Bahlum, a much slenderer figure than the one portrayed on the Temple of the Cross Tablet, stands on the north side of the tablet facing south. In his outstretched hands he holds God K seated with crossed arms on a folded cloth, one end of which falls to the level of Chan-Bahlum's waist (fig. 104). Here, as in many places at Palenque, Chan-Bahlum can be recognized by his protruding lower lip. He wears a simple oval jade ear spool and dangle with a bone hanging below. A tightly caught pigtail hangs at the back of his head with the hair at shoulder length. He wears a simple loincloth like the one he wore on the Temple of the Cross Tablet. Undergarments can be seen above the draped kilt, which hangs to a point in front and has a short fringed part in back barely covering the buttocks. One of the fringed ends loops over the apron at the waist, and the other end hangs below the knee. Whereas Chan-Bahlum was barefoot on the other two tablets, on this one he wears elaborate fringed buskins with mat sole that are tied on with a loop at the ankle. A necklace of large beads is worn around his neck, the rear portion, of smaller beads, falling down his back and ending in a tassel. Jade wristlets and the simple folded-cloth turban with a mat symbol of royalty and the *le* leaf of ancestry protruding from the top complete his costume.

THE SHIELD ICON (*fig. 105*)

The main icon on this tablet is the "shield," the Underworld Jaguar God of Number 7. Shown in frontal view, he displays scroll eyes, cruller over the nose and under the eyes, *tau* tooth, fangs at the corner of the mouth, and curled shank of hair at the forehead. Four *Imix* glyph water-plant flowers with three feathers each are at the corners of the shield.

Crossed behind the shield are two spears, each with a snaggletooth dragon with flint knife protruding from the forehead at the end. The snaggletooth dragons are the same as those on the medallions of House A and the roof of this temple. The flint knives are the same as shown on the East Roof of House B (Vol. II, this series). Surrounding the shield is a wide border of jaguar pelt.

The ends of the spears rest upon a serpent bar, a sign of rulership from earliest times (fig. 106). At each end of the bar there is an open-mouthed serpent with tongue in the shape of a leaf and full repertory of molar teeth, incisor teeth, curled eye, nose bone, ear curl, and curled supraorbital plate. The center of the serpent bar is taken up by a large "Smoking Jaguar," recognized as such by Coe (1973:107). The eyes are curled, and the mouth is wide open with tongue hanging down. Jaguar spots are conspicuous all over the face. A tiny *ahau* figure with very large plant foliation at the top of its head is on top of the "Smoking Jaguar."

The bar is held up by two gods, God L on the left (fig. 107) and God M, as identified by Kelley (1965:105), on the right (fig. 108). Both gods are associated with war and death. God L wears a long jaguar-pelt cape and jaguar skirt. Crossed bands form his belt. His neckpiece has been pleated into a mat symbol with a shell hanging from the center. His headdress consists of muan bird feathers, a jaguar ear, a serpent, and plant foliation. A bone-*ahau* dangles from the nose. He is holding up the serpent bar with his left hand, and his right hand rests flat on the floor in front of him.

God M is holding up the right side of the serpent bar with his right hand while his left hand rests flat on the floor. He also wears a mat pectoral with shell hanging from it and has a pack on his back and a headdress of a bird with shell earpiece. The bird headdress appears to incorporate the Quadripartite Badge in its motifs. The shell is in the earpiece; the flattened U with plant foliation is in two places, one below the ear dangle and the other at the end of the long piece that stretches out over the bird's head and has the crossed bands in it. The stingray spine may be the eroded piece directly over the bird's eye and below the crossed bands.

The God of Number 7 and the God of Number 9 (figs. 109, 110) are in the vacant spaces between the Jaguar God shield and the standing figures. These gods play prominent parts at Palenque as well as at other sites, as noted by Kubler (1977:8). The numerals distinguishing these gods can be seen in front of God 7's forehead and on top of God 9's head, but, as Kubler points out, they are also distinguished by their affixes, the *kan* cross for God 7 and the *mol* for God 9. These god pairs also appear on the East Roof of this temple, but their positions change, God 7 being on the north and God 9 on the south.

The glyphic text in the center of the tablet directly over the Jaguar God of Number 7 shield (fig. 111) recalls the 8 *Oc* 3 *Kayab* (9.12.11.12.10) event, the accession of Chan-Bahlum to the throne of Palenque. It states that he was made *zac uinic* of the succession, *Mah K'ina* Chan-Bahlum. He was given the maize title *Balama-Ahau* and is named child of the father the 5 katun *ahpo Mah K'ina* Pacal. It names his mother as Lady Ahpo-Hel, *ahpo* of Palenque (Schele 1984:110).

TEXT OF THE TABLET (fig. 96)

The text starts out with the I.S.I.G. with the patron of the month *Ceh* named, and then we have 1 baktun, 18 katuns, 5 tuns, 3 uinals, 6 kins on 13 *Cimi* 19 *Ceh* (1.18.5.3.6). GIII was in office. It was 26 days into the lunation. This is when the Triad God GIII was born. He was born *Mah K'ina Tah Balam-Ahau* (GIII) and is given many names, including the headless jaguar, a fire name, *Mah K'ina Ahau K'in*, and also Lord of the Underworld, as proposed by Kelley. He is recorded as the child of the Ancestral Goddess "Lady Beastie." GI was born on 9 *Ik* (Nine Wind), and GIII, the second child, was born on 13 *Cimi* (Thirteen Death). GIII is the Sun God, but an Underworld Sun God. He is associated with sacrifice and blood-letting, and Freidel and Schele (personal communication) have identified him with the proto-Classic mask on the very early facade at Cerros.

The 2 *Cib* 14 *Mol* event and the 819-day count have always been a problem for epigraphers, but Lounsbury discovered why the Maya wrote this text the way they did. He saw that the 819-day count is also the correct station for 2 *Cib* 14 *Mol* and found that the date corresponds to a spectacular Jupiter hierophany, in which Jupiter and Saturn were frozen in their points less than 4' apart in the sky. 2 *Cib* 14 *Mol* was the first day in which Jupiter's movement could be detected with the unaided eye (Lounsbury in Schele 1986:278). This 819-day-count passage, he explains, "was designed to signal this Jupiter association, but obviously the normal reader would not have understood. It was a message for the highly skilled and perhaps for the gods themselves."

Then the text names GIII as *Mah K'ina Ahau K'in* or *Mah K'ina* Xibalba (Lord of the Underworld). The next day the *K'uk'-na* (*K'inich K'uk'* temple)—the name of the Group of the Cross—was dedicated, and Chan-Bahlum, in his temple, was named Blood Palenque *ahau*.

Later more blood-letting occurred and more honors were bestowed on Chan-Bahlum. The tablet records the event when he was 6 years and 47 days old, the 9 *Akbal* 6 *Xul* event. Chan-Bahlum's father, Pacal, waged war for him. This same thing happened in Naranjo and is recorded on the Bonampak murals (M. E. Miller 1986:24 n. 11), where the event record clearly states that the action is taking place for the child, not yet old enough to perform the act himself.

THE JAMBS
(*figs. 112, 113*)

The Jambs of the Temple of the Sun were first drawn by Frédéric Waldeck (figs. 114, 115) and published by Maudslay (1896-1899). The South Jamb is the less complete of the two, but it does show Chan-Bahlum in a uniform very much like that worn by the figures on the piers of House A—crossed-band leggings, jaguar sandals, jaguar skirt with tail hanging down at the back, and bouffant feather disk at his back with a god's head pouring out water or, more likely, blood. Even the headdress, judging by its outline, looks

as though it is similar. The same shank of hair pulled through a loop at the forehead as in the figures on the House A piers is shown here also. The south border consists of corn plants and an upside-down long-lipped god at the top with a corn plant emerging from the head. A *Cauac* Monster with a spear in its mouth is at the bottom of the left border. He has the cluster of grapes of the *cauac* sign on his forehead and a dot-encircled element on his nose and a flint knife in his mouth. Blood-letting is definitely indicated. The creature's eye is lashed. The right side (north) of this jamb is a series of stacked gods like the series on the Sanctuary Roof of this temple.

The North Jamb shows Chan-Bahlum in full dress. Because of the recording of the Palenque bodega by Linda Schele and Peter Mathews in 1974 (Schele and Mathews 1979) and the fact that they found numerous pieces of the jamb (figs. 116, 117), we know much more than we otherwise would about the nature of this piece. Fairly recently two other pieces, the knee portion and the piece with both of the figure's hands, turned up (figs. 118, 119), adding to our knowledge of this tablet. The figure (Chan-Bahlum) wears the Palenque House A–type elaborately beaded shoulder cape reaching to mid chest and a very short hip cloth, also elaborately beaded and bordered with *oliva* shells over a slightly longer gathered undergarment. Underneath the hip cloth he wears a pointed loincloth falling to the knee in front and gathered into a double knot at the back. The open-mouthed-jaguar pectoral hangs from a necklace of large beads that falls at the figure's back and has a tassel at the end. He wears a small backpack about the size schoolbooks are carried in today. The jaguar-skin straps on his legs are also like those of the figures on the House A piers, crossed once and tied with a bow at knee level. His boots are the high-backed jaguar-pelt type. The similarities to the dress of House A figures include the incense bag the figure carries over his left wrist. It is secured by a knot at the top, has a "smoking *ahau*," and has a knotted tassel emblazoned with an *Ik* at the top. I cannot tell what the contraption is that hangs at the figure's left side. It seems to be netted and knotted. Perhaps it is a bag caught together and held in a convenient location until needed. The figure's left hand is holding a staff that, with so many other similarities to the House A piers, probably had a God K at the top as on all the staffs of the House A piers. The left border of this jamb is made up of a stacked row of gods just as on the South Jamb. The right border repeats the corn foliation and *Cauac* Monster motif. A *Cauac* Monster is at the top, and an upside-down long-lipped god is at the center with a fire glyph in his cap and a corn plant issuing from it. At the bottom, another *Cauac* Monster with knife in mouth is identical to the god on the South Jamb.

The South Jamb panel cannot be read; the North Jamb text ends with the statement of Chan-Bahlum's parentage.

THE PIERS

There are four piers on the east facade of the Temple of the Sun (fig. 74). Very little remains of these piers, but we know that the outer ones were glyphic and the two center ones had standing figures.

PIER A (*figs. 120, 121*)

This pier has two huge quatrefoil cartouches one above the other. A *le* leaf was in each of the corners. Only the one on the lower right of the top cartouche remains, but it is in an excellent state of preservation. The border of the pier is the serpent segments common on other piers at Palenque. In the upper cartouche there were three glyphs. The upper one was the I.S.I.G.; as the top portion is missing, we do not know what the patron of the month was. Only the tun sign remains. Below it were two glyphs side by side, but only the outlines are left. In the lower cartouche there were once six glyphs, but all that remains of this inscription are three bars, the head variant (a bat), and three dots under the head variant. The Long Count date on this pier is *5 Eb 5 Kayab*, the same as on the *alfardas* and the doorjambs. This is probably the dedication date of the interior sanctuary.

A considerable amount of paint remains on the cartouches. The glyph blocks were blue, as were the *le* motifs. The inner part of the cartouches is red. The border with serpent markings is blue along the lines, and the rest is red.

PIER B (*figs. 122, 123*)

All that remains on Pier B are the two splayed legs and the right foot of a figure whose body faced forward. The foot is flat and does not protrude beyond the border as feet do on the piers of the Temple of the Inscriptions. Some of the 11cm border is intact; it is the same as on Pier A. There is a 7cm coat of stucco forming the border as it meets the stone core of the pier. All of the background paint is a very deep red. Portions of the boot where it meets the foot are blue.

On the north side of Pier B a figure was sculptured in stucco facing east toward the front of the temple (fig. 124). Very little remains, but we can detect the beaded cape area, shoulders, and neck of a person and the upper back portion of a throne on the upper portion of the pier (fig. 125). Small amounts of blue paint remain on the cape and on all of the remaining sculptured portions of this pier. In one area six layers of paint can be counted, the first a light pink wash (on the bearing wall), the second red, the third white, the fourth red, the fifth a 5mm white layer, and the sixth a thick layer of red. No armatures are on this pier.

PIER C (*figs. 126, 127*)

An elaborately dressed figure once adorned the front of this pier, as evidenced by the towering headdress overflowing with a multitude of unusual serrated feathers (fig. 128). This is the only instance of feathers of this kind at Palenque. Another unusual item of equipment for Palenque is the rectangular wrist shield worn on the figure's left arm (on the right side of the pier next to the border frame) (fig. 129). The frame of the shield is bordered with a row of fine interlocking feathers and a wider, larger row of feathers outside the inner layer. All around the shield, long blue serrated feathers tipped with tapered red ends fall in profusion. A wide blue mosaic wristlet of jade beads hugs the body next to a double row of large round beads. The shield has been laid on top of a

background already painted red. The feathers were first painted blue, and then red was added on top. The circular area of bone-*ahau*s and round beads is all blue.

The iconography of this pier is almost exactly the same as that of Pier D of House C, except that the figure on this pier would have been standing instead of being seated on a throne as in House C. Toward the top of the headdress, one can see the exact same parts as in the House C pier (figs. 130, 131). The jester god above this element is also the same, as is the gaping-mouthed jester god, barely discernible on this pier. The method of forming the complicated headdress feathers is exactly the same on the two piers (see fig. 247, Vol. II of this series). A good deal of red, blue, and yellow paint remains on the sculptured elements of this pier. The foot, including a well-formed ankle bone, can be seen almost completely covered with a thick buildup of stucco (fig. 132).

THE ROOF
(figs. 133, 134)

In 1942, Miguel Angel Fernandez removed some of the debris from the walls, piers, and roof, and in 1945 he consolidated the roof (personal communication from Augusto Molina Montes). Having climbed all over the Temple of the Sun roof and roofcomb, and having taken hundreds of photographs of details, including those taken by attaching my camera to a telescope anchored at the Temple of the Foliated Cross, and having spent considerable time in the British Museum going over all of the Maudslay negatives to discover parts of sculpture no longer there, I have now documented just about everything that remains on this roof and roofcomb. If it had not been for all of this investigation, I could not possibly reconstruct the sculpture on this temple.

The action takes place between a god personage seated on a throne and two deities, the Number 7 God and the Number 9 God, shown on the tablet in the sanctuary in the rear room of this temple. Since I first published the reconstruction drawing of this temple in 1979 in *Maya Archaeology and Ethnohistory*, edited by Hammond and Willey, I have come across a ceramic incense burner (fig. 135) with a three-dimensional God K on the front that I am certain is the same figure the sculpture of the Temple of the Sun Roof was intended to portray. Enough stucco remains on the roof that points to exactly the same hair appendages and other elements around the face to convince me of the identification. The moment I saw the ceramic piece, I knew it was Chan-Bahlum in his role as God K who is portrayed on the Temple of the Sun Roof.

The action is being carried out through a serpent—or, more exactly, two bicephalic serpents, one undulating behind the back of the main figure and the other stretching across the top of the roof just under the overhang and then abruptly turning downward and ending in a snaggletooth dragon head just like those portrayed on the House A medallions. In fact, all of the serpents on this roof and roofcomb are the snaggletooth type of House A (see Vol. III).

Chan-Bahlum, in his role as God K, wears a short beaded collar and beaded wristlets.

It is not possible to tell what his anklets are made of. His belt is the disk-and-crossed-bands type so often worn at Palenque and shown being worn by God K also. His folded undergarment can be seen just above the belt. Most of the head is missing, but portions of feathers and side wing feathers remain, as well as the top portion of the head and a piece of stucco that projects too far forward for a human nose but that would be correct for a God K representation.

The 7 God, on the north side of the seated figure (figs. 136, 137), is almost intact and displays all of the characteristics of this god, including the *kan* cross on the forehead. The 9 God has little remaining stucco, but the identifying forelock and the clusters of balls designating *mol* are there. The snaggletooth dragon heads overlap the serpent body on both the south (fig. 138) and north sides.

At the far extremities of the roof, there are benches with kneeling figures presenting offerings. A good deal remains of the bench and figure on the north, but I have had to reconstruct the complete figure on the south side. Very little is left of the throne, but one can see how the stone piece was embedded in the roof to support the heavy figure resting on it (fig. 139).

THE ROOFCOMB

A great deal of stucco sculpture remains on the roofcomb; considerably more was there at the time Maudslay was at Palenque. In the Maudslay photographs it looks as though the entire top row of stuccoed stones is missing, but this is not so. The only parts missing are on the far south. The rest is intact and has a considerable number of sculptured border elements remaining. Only portions of the stucco can be picked up where the *Cauac* Monster takes up the center of the roofcomb, and only small portions of the stucco remain where I have reconstructed the seated figure. I do not know if this roofcomb figure had a human head or a god's head.

Four *bacabs* were holding up the sky. Remnants of all of them are on the roofcomb (fig. 140). A serpent weaves in and out among the *bacabs*, ending in snaggletooth-dragon heads overlapping the skyband borders on both the south and north sides. Portions of the skyband border remain on all three border extremities and on the central horizontal skyband (fig. 141). If all of the roofs of the Cross Group temples were as elaborately sculptured with as much iconographic information as this temple and the Temple of the Cross West Roof, the city must have been a magnificent display of colorful information, like a series of giant billboards. This was definitely public art. The people could have their secret ceremonies in such dark places as the curtained-off rooms of House E, the subterranean chambers of the Palace, and the inner sanctuaries of the three temples of the Cross Group, where only a privileged few could enter or witness solemn events. Tablets, murals, and sculpture in these hidden places can be considered private art. But Palenque did have great public art. Witness the colorful sculptured piers on the fronts of almost all of Palenque's buildings and the towering roofcombs embellished with painted stucco sculpture.

The west side of the roofcomb of the Temple of the Sun was also sculptured with a personage seated on a throne (fig. 142). In most cases the stone framework used to support the stucco sculpture on this roofcomb was very carefully stacked in vertical columns and horizontal stretchers. In reconstructing this portion of the roofcomb, modern builders were not nearly so careful (fig. 143).

All that remains on the North Roof of this temple are portions of two giant masks (figs. 144, 145). The one on the east displays a jutting chin, two formidable curled teeth on the lower jaw, sunken eyes, and a squashed-in nose. The mask on the west side is the same size; the mouth portion is missing. It portrays a monkey.

In ancient times the Temple of the Sun would have been a blaze of color from its base to the top of its roofcomb (fig. 146). The exterior of the structure was painted a deep red, and the stucco-sculptured roof, roofcomb, and piers would have been in vivid reds, blues, and yellow. The Temple of the Sun is the only temple with enough information remaining on its roof, roofcomb, and piers for us to be able reasonably to reconstruct what the building may have looked like when the city was at the height of its glory.

THE TEMPLE OF THE FOLIATED CROSS
(figs. 147, 148)

With its facade oriented at 312° 35′ (Aveni 1980:314), but otherwise very much like the other two Cross Group temples, the Temple of the Foliated Cross is also a small structure with a sanctuary building within the rear portion of the structure (figs. 149, 150, 151). The temple is built against the high mountain we call Mirador. David Stuart and Stephen Houston have identified the mountain as *K'uk-te'-Witz* in the Palenque glyphic text. It was on this mountain that a very important "scattering rite" took place.

As in the other temples, the front chamber is one long room, while the rear half of the structure is divided into a larger central room with the sanctuary building inside it and two very small rooms, one on each side. Originally, the small side rooms were probably alike, but over the years the Maya made changes. The northeast room has been blocked in a way that cuts off not only passage to the interior, but also light. One must enter this room by a very narrow passage that is difficult for even one person to get through (fig. 152). Over half of the space taken up by the width of the central wall has been blocked on the outer side, leaving a tiny passage on the left. The same has been done on the inner side, the passage into the back room being on the opposite side (the right). Only one person at a time can stand in the tiny anteroom between the passages.

Inside this dark room, there are two niches on the south wall 36cm high and 44cm and 46cm wide that are 80cm apart and 210cm above the floor. There is an *Ik* opening on the east wall that butts up against the partition separating this room from the central sanctuary room. There is another on the north wall. I believe that originally the rear room was one long room with the sanctuary building in it, and that it was not until later that walls were erected dividing the rear half of the temple into three rooms. The small room

on the south is basically the same as the room on the north except that the entrance to the south room was never blocked.

The roof of the Temple of the Foliated Cross has been badly damaged, and very little sculpture remains on it; in fact, none can be seen from below. The roofcomb is missing, except for the base elements at the center top of the roof. With the front of the building destroyed, the keyhole arches are conspicuous here, as they are also in the Temple of the Cross.

THE TABLET
(*figs. 153, 154*)

This temple records life, death, and rebirth, as will be seen below. Blood sacrifice performed by Chan-Bahlum is indicated in the iconography. The patron deity of this temple is GII (God K), the god of lineages and rulers.

This tablet, like the other tablets of the Cross Group temples, features two figures, a tall person and a short person flanking a foliated and embellished cross. The tall figure is again Chan-Bahlum, and the short person is either a younger Chan-Bahlum, the deceased ruler Pacal, or the deceased first ruler and founder of the Palenque lineage Bahlum-Kuk. This time, however, the tall figure is on the left and the short figure is on the right. But the Maya did not think of these figures as being placed on the left or right. Moisés Morales was the first to call our attention to the fact that what is important about their positions is that the short figure always faces either north or east (north on the Temple of the Sun and the Temple of the Foliated Cross tablets, and east on the Temple of the Cross Tablet), and Chan-Bahlum always faces either south or west (south on the Temple of the Sun and the Temple of the Foliated Cross tablets, and west on the Temple of the Cross Tablet). It is only in our Western way of thinking that we stand in front of a tablet and immediately label the figures as being on the left or right.

THE COSTUME OF THE SHORT FIGURE

The short man, who faces the cross, is dressed in the same attire he wears in the Cross and Sun tablets (see fig. 28). The only differences are that his hip cloth is more of a wraparound affair with a pointed end at the side, and the knot on his scarf is decorated with two lines on all four sections instead of multiple lines as in the Temple of the Cross and Temple of the Sun tablets. He holds the perforator god, or deified blood-letter, with three knots at the top of his head in front of him. As on all three tablets, he wears a hat of complicated folds with decorated ends that, after coming out the top of the hat, tie in a bow and flop over the hat (fig. 155). In all three portrayals of the short man, a long-stemmed *le* leaf (an emblem designating ancestor rights) stands at the rear of his cap.

In the Cross Tablet, only the short figure stood on a pedestal head, but on this tablet both figures are elevated on large pedestals. The short figure stands on corn foliation issuing from a shell and sheltering a human head. Inside the shell, God K has one hand

pulling the corn plant and the human head—the head of a deceased king—into the Underworld (fig. 156) just as the Hero Twins did in the *Popol Vuh* and as shown on Chama vase #10 in Coe's *Lords of the Underworld* (1978). It was Moisés Morales who argued many years ago that the plant and head were being drawn into the shell and not emerging from it, as most persons saw it. The whole theme is rebirth through the corn plant. The Maya today still believe in rebirth through the corn plant. As evidence of this belief, an interesting story was told to Moisés by a Maya tending his milpa in the valley. He was telling Moisés that, yes, it was true that persons were reborn through the corn plant, and as proof he took him to a spot in the milpa where he had buried his wife just the year before. Sure enough, on top of his wife's grave mound, a corn plant grew that towered above all the other plants in the field.

THE COSTUME OF THE TALL FIGURE

Chan-Bahlum's costume has changed from the one he wore on the tablets of the other two temples. He stands on a *Cauac* Monster, indicative of rain, water, and the Underworld. Hieroglyphs form the pupils of the monster's eyes, and Venus symbols are in the loops above the brow, part of the corn foliation surrounding the *Cauac* head. *Cauac* Monsters are prevalent at Palenque, notably in House B (the *Cauac* throne in the southwest room and the masks on the roof), on the roofcomb of the Temple of the Sun, and probably on House C (Vol. III of this series). An identifying characteristic of this monster is that it always has circles or grapelike clusters near the eyes.

His headdress, wristlets, chain of beads down the back, and earplugs remain basically the same (fig. 157). It is his hip cloth, loincloth, and pectoral that have changed. On this tablet Chan-Bahlum wears a very short apron or hip cloth elaborately embellished with beads sewn in a diagonal pattern, more like the patterns of beadwork worn by women. His belt of jade beads sags markedly at the front, not only from the weight of the beads but also from the weight of the elaborate *xoc* belt emblem (fig. 158). The *xoc*, as noted by Jeffrey Miller (Schele and Miller 1974:154), is a flattened fish head grasping a *Spondylus* shell that "occurs on waists of female figures." Schele (1979:46) resolves Chan-Bahlum's position in wearing the *xoc* by explaining that in the tablet text he "is named in a relationship to the gods of the Palenque Triad which is the same relationship between mother and child." In other words, she says, the three gods are called "the children of the woman, Chan-Bahlum." This same belt piece is worn by the woman on the right who faces Pacal on Pier D of House D of the Palace, and is the motif held in the hand of the left male figure on Pier C of House D.

A knee-length loincloth of the same type of material as the hip cloth hangs before this figure next to his body. A shell and jade beads are just below the *xoc*. The typical Palenque assemblage of jade beads, bell flower, and three long beads with bone ends falls from the shell in front and from the belt in back. In this case, a long-lipped jawless god hangs between the bell flower and the long beads. At the sides and rear of the beaded belt, tubular flowers are fastened, and below the one shown on the right side of the belt a

Spondylus shell hangs to considerably below the hip cloth. The figure's underclothing can be seen above the beaded belt, and folding over it are end pieces of the front and back of the loincloth. The same long-nosed god surrounded by beads is worn as the pectoral.

Chan-Bahlum's outstretched arms hold the jester god (fig. 159) with *tau* tooth and fish barbel (the marks of GI) seated on a cloth cushion, this time with arms folded across the chest. Chan-Bahlum and the jester god both face south toward the cross motif in the center. As a matter of fact, the eye of the jester god seems to look directly into the eye of the cormorant-god perched on top of the cross.

Chan-Bahlum stands on a pedestal base of a *Cauac* Monster, a deity of rain, lightning, and Underworld activities. The main characteristic of this monster is the circle-cluster motif, which Eric Thompson (1960:274) took as raindrops or beads of water. Dicey Taylor (1979:79) brings out the vegetation associated with this creature by pointing out that "at Palenque and Copan the circle motifs frequently have small leaves attached to them."

THE CROSS/TREE ICON

The tree, known as the "foliated cross" (the *raison d'être* for this temple's designation), rises from the Earth Monster (fig. 160) or *Ah-Uuc-ti-Cab*, "Lord Seven Earth, and earth monster," as noted by Thompson (1960:276). He has Sun God attributes: square crossed eyes, *tau* teeth, and fangs at the corners of his mouth. His headdress is a large *kan* cross, the *kan* meaning water, jade, or precious. Corn foliation emerges from the earplugs and all around the *kan* cartouche.

The corn plant rising from the Earth Monster at the base of the tree becomes a three-dimensional Sun God at the top (fig. 161). The front head is at the top of the cross. The rear head, as first pointed out by Morales in 1973, is meant to be behind the front head, as the hair and foliation at the very top of the front head actually belong to the god in the rear. The gods shown on either side of the plant just above the Earth Monster's head at the base are heads of the Sun God in profile. So what we have here is actually a three-dimensional god's head—or even a fourth dimension: *up*. The corn foliation that branches to either side at the center of the plant and just above the profile heads (fig. 162) on the stalk of the plant cradles living reborn human heads, signifying rebirth through the corn plant from the depths of the earth. The *caban* (earth sign) is repeated all along the baseline of this tablet. The necklace worn by the Sun God at the top of the plant consists of large round beads from which hang a pectoral of the frontal-view, bead-encircled head of a woman with the Palenque stepped haircut. A bell-shaped floral element with mirror infix and bone-*ahau* beads to the sides falls below the woman's face, and from the center of the bell flower hangs another Sun God with crossed eyes, bones protruding from the nose, and cross-section of a shell issuing from the mouth, completing this long necklace. The cormorant or Principal Bird Deity with the long-lipped-monster mask perches on the Sun Monster's head. This Celestial Bird with the long-lipped mask is the same as the one on the Sarcophagus Cover and the Tablet of the Temple of the Cross except for slight, but important, differences. The pectorals are different. Here the bird wears a shell pecto-

ral hung from a single strand of alternately long and round beads. On the Cross Tablet the pectoral worn by the bird is a shell and floral element slung from a double strand of round beads, and on the Sarcophagus Cover the pectoral is a choker with a typical floral element. This bird has strange plant foliation at the ends of two long stems issuing from its mouth. All three birds have the inverted serpent wing on the back and a shell ornament at the top of the hair arrangement.

It is interesting to note how the different iconographic parts are placed in space on this tablet. The furthest back in space is the row of *caban* signs upon which everything rests. The hieroglyphic text is on the next plane. Next in space are the tall and short figures and their pedestal bases. The Earth Monster and the foliated tree are meant to be on the plane nearest to the viewer. The completion sign just to the rear of Chan-Bahlum's heels is also on this forward plane. On all of the tablets the two figures are on the same plane, possibly telling us that they are the same person, whose legitimate rights to the throne are being proclaimed.

TEXT OF THE TABLET

The text starts with the I.S.I.G. with the patron of the month *Mac* and then states in head-variant glyphs 1 baktun, 18 katuns, 5 tuns, 4 uinals, and 0 kins 1 *Ahau* 13 *Mac* (2360 B.C.), the birth date of GII. The 819-day count is then given. The Lord of the Night (Glyph 8) was in office, the fifth lunation had ended, and the moon was 10 days old. The rabbit was in his house. GII's ball-game title is given, and blood-letting is indicated in association with the ball game. Blood-letting also took place with the birth of this third child of "Lady Beastie." Blood-letting undoubtedly started with the gods, the first officiate being the Ancestral Goddess, the mother of the Triad, and so blood-letting became a prerequisite for rulership among mortal kings. The Temple of the Foliated Cross was dedicated on 3 *Caban* 15 *Mol* 9.12.18.5.17 (A.D. 690) as the *Mah K'ina K'uk'-na* temple by *Mah K'ina* Chan-Bahlum, *Ahau* of Palenque. Then on the third day the blood-letting event took place when an obsidian lance was taken from the bundle of blood-letting equipment.

The Triad Gods took part in an "inverted sky" event along with four other deities: GIV, GV, GVI, and GVII. The last text on this tablet locks all of the historical events into the katun ending 9.13.0.0.0 (A.D. 692) and, as Schele (1987:112) suggests, "seems to reflect the function of Maya rulers as 'nourishers' of the gods through the act of blood-letting."

The secondary text behind Chan-Bahlum tells again that he became ruler on 8 *Oc* 3 *Kayab* and refers to the event as a "memory of" or "remembered" event (i.e., an echo of an event) in the life of Bahlum-Kuk I, the founder of the Palenque lineage. Again on the lower text he is remembered, and "his house," the Temple of the Foliated Cross, is dedicated in a blood-letting ceremony.

The text framing the short figure (fig. 163) starts out by referring to the "enterer" of

the succession, and he is displayed as God K and as the child of the father *Mah K'ina* Pacal, *Ahpo* of Palenque, and the child of the mother Lady Ahpo-Hel.

THE *Alfardas*
(fig. 13c)

The *alfardas* tell of the birth of GII, God K; again name the parents of Chan-Bahlum; and end by recording an anniversary event that was meant to encompass the entire Maya world.

THE JAMBS
(fig. 164)

The doorjambs to this temple indicate the transfer of power from Chan-Bahlum's ancestors to him, if we accept Schele's (1976:23) explanation. I feel that there is no doubt that this is what is taking place and that it does not matter whether the short figure is Pacal or the dynasty founder, Bahlum-Kuk I. Chan-Bahlum received part of this transfer at the 9 *Akbal* 6 *Xul* event, when he was not yet seven years old. The transfer of power is being shown in a manner involving blood sacrifice by Chan-Bahlum's act of perforation of the virile organ. Blood sacrifice was probably the most important part of the rites involving the transfer of power not only at Palenque but at the other Maya cities as well, especially at nearby Bonampak and Yaxchilan.

On the South Jamb, Chan-Bahlum holds the perforator god or scepter god in his hands, as he does on the North Jamb. His uniform is very similar to the one he wore on the Temple of the Cross jambs, the one worn by the sentinels in stucco on the walls of the tomb in the Temple of the Inscriptions and on the figures on the piers of House A of the Palace. His pectoral on the North Jamb is worn high on the chest, and is composed of a bar with a bird (possibly the Palenque Emblem Glyph bird) on one end and a strange creature at the other end. The pectoral looks like a long piece sticking out in front of the chest, but actually this is the front view of a long horizontal bar with a bird's head at each end. Chan-Bahlum wears a human head at his back, very much like the ones worn on the figures of the House A piers. The lower portion of his costume can be seen better on the South Jamb, where his belt with jaguar front piece and full-figure god in a quatrefoil *cauac* cartouche hangs from a low-slung string of jade and *yax* beads. The leg straps here are like those worn by the figures on the House A piers. Chan-Bahlum wears no skirt on the South Jamb—only a wide jaguar skin under his crossed-bands belt. His private parts are covered by the elaborate belt and loincloth. A cormorant eating a fish emerges from the headdress in his portrait on the South Jamb, as on the House A piers.

The borders of the jambs of this temple are made up of stylized serpents and cross-hatched areas. Large *kan* crosses are at the center of both the top and bottom borders of

the South Jamb and probably were on the other jamb too, as pairs of *kan* crosses appear on the left border of that sculpture.

THE SANCTUARY ROOF

A serpent body in a zigzag pattern is sculptured on the North and South Sanctuary Roof of this temple (fig. 165). The overhanging upper border and the lower border both depict a serpent, as do the vertical end borders (figs. 166, 167). Sculptured heads and shoulders of a person were centered below the inverted V formed by the serpent's body, but all that remains now are the neck and shoulders of these figures, who wear choker necklaces of large round beads. These were probably similar to the busts sculptured on the Sanctuary Roof of the Temple of the Cross. Although Maudslay shows a *kan* cross at the centers of the upper and lower border and at the four corners of each Sanctuary Roof—and this is what one would expect because of the *kan* crosses on the jambs of this temple—what they appear to be is *chuen* glyphs in a circular cartouche with bone-*ahaus* at the sides (fig. 167). The initial marker for this glyph can be seen as two vertical scratch lines on the upper border.

ROOF AND ROOFCOMB

The front half of the roof of this temple fell long ago, as did the roofcomb. There are no photographs showing the roofcomb, but we can assume that it looked very much like that of the other two temples, possibly with a different theme. Could it have been rebirth through the corn plant?

2

Temple XIV

The small Temple XIV (fig. 168) does not belong with the Cross Group temples. Before it was excavated by Jorge Acosta in 1967 (Acosta 1973), it looked like any other mound at Palenque (fig. 169). It was built directly to the north of and right next to the Temple of the Sun (fig. 170), blocking direct access to and from the civic center of the site (figs. 171, 172)—that is, the Palace complex and the Temple of the Inscriptions. Chan-Bahlum would certainly not have disrupted the architectural symmetry of his three Cross Group temples by building another structure practically on top of one of them. Temple XIV was probably built by Chan-Bahlum's brother Kan-Xul II, who became the ruler after his death and ruled from 9.13.10.6.8 5 *Lamat* 6 *Xul* (A.D. 702) until 9.14.8.14.15 (A.D. 711), when he was captured by Tonina (see Vol. III of this series). After the death of Chan-Bahlum, the Group of the Cross was apparently deliberately blocked off from the rest of the city. Rather than building a wall, which would have been alien to Maya practices, they built a temple to honor the arrival of Chan-Bahlum at and conquest of Xibalba, and placed it directly in the path where one would enter the Cross Group. Blockage to the sacred precinct was thus achieved. One feels this even today when one makes the climb up to the level of the three temples and upon reaching the platform has to clamber over the stones and debris where the Temple of the Sun and Temple XIV meet.

Temple XIV is a low structure, smaller than the Temple of the Sun but resembling it in some ways. Instead of the substructure being composed of three aprons, Temple XIV has only two (fig. 173), each having balustrades to the sides of the center stairs. There were four piers on the front face, but nothing remains of them except their bases. A small sanctuary room is at the rear of the temple, and small rooms are on either side. The models were the Cross Group temples, but the result was much smaller.

THE TABLET

The tablet (figs. 174, 175, 176, 177) is a wonderful panel detailing the iconographic belief system that is the focus of this temple. The temple and tablet were placed here after the death of Chan-Bahlum by his brother, the ruler who followed him (Kan-Xul II); the motif is, as Schele (1980b) phrases it, "a dance after death." The protagonists are Chan-Bahlum and his mother, Lady Ahpo-Hel. The action takes place in the watery Underworld

with the two figures respectively standing and kneeling above a watery Xibalba, as portrayed by stacked bars, waterlilies, water plants, and shells. This is the same representation as is seen on the House D piers, where the action also takes place in the watery Underworld (see Vol. III of this series). Chan-Bahlum dances while his mother offers up the God K manikin. Chan-Bahlum has conquered the Lords of the Underworld just as the Hero Twins did in the *Popol Vuh* in mythical times. Chan-Bahlum has now become God K.

THE FIGURES

Lady Ahpo-Hel (fig. 178), Chan-Bahlum's mother, who had died twenty-eight years earlier, is in a side-view, half-raised position greeting the deceased king, her son, and is holding the God K manikin (fig. 179) on a folded cloth in an unusual position: God K faces the donor and not the recipient. Lady Ahpo-Hel was of royalty herself and the mother of the king, and it would be only natural that the God K manikin should face her until it is received by Chan-Bahlum, for at that point it would be facing away from him in the normal position. His mother hands him the royal manikin as the symbol of his new identity as God K. What we see here is Chan-Bahlum doing a dance of greeting to his mother as he rises from the Underworld. This is just what the Hero Twins did when they conquered the Lords of Xibalba and then rose to the sky and became the Sun and the Moon. Chan-Bahlum is now becoming God K—*Ahau K'in*, the Sun God.

Chan-Bahlum (fig. 180), recognized by his protruding lower lip, wears a headdress of a long-lipped god without a lower jaw, with a *kin* (sun) sign at the top with foliation and bone-*ahau* beads issuing from it. Long blue feathers fall to the rear in motion, which can also be seen in the sway of his loincloth. His pectoral is a squarish cartouche with a round bead in the center and four lines of long and round beads radiating to the four corners. The flattened U with three-part plant motif is on either side. The pectoral, characteristic of GI and GIII, is tied around his neck by what look like leather bands held together at intervals by being drawn through a bead. His wide belt (fig. 181), with the Jaguar God of the Underworld in front, is worn over a beaded belt and a very short hip cloth. He is barefoot and wears anklets of long beads and bone-*ahau* beads with a great deal of blue paint remaining on them (fig. 182). He is portrayed here in his role of Jaguar God of the Underworld.

The woman, Lady Ahpo-Hel, wears a beaded skirt and shoulder cape similar to the one Lady Zac-Kuk wears on Pier C of House A. This cape is made of mosaic beads and fringed with feathers, whereas the House A cape is beaded in a diagonal pattern, the same as the skirt here. The *Ik* medallion worn as a pectoral on the House A pier is here sewn on the right side of the shoulder cape, and we may assume on the left side too. Lady Ahpo-Hel wears a wide belt of crossed bands alternating with the "quincunx" glyph (death), tied on with a bow at the back; the "quincunx" is appropriate, for this scene takes place in the Underworld. An undergarment, presumably a long folded cloth, is worn over the chest and midriff and tied in a large loop in front. Her headdress (fig. 183) is the Quadripartite

God with long sweeping feathers falling to her waist. The serenely awed expression on her face is very beautiful indeed.

THE HIEROGLYPHS

The large hieroglyphs on this tablet are some of the most beautiful at Palenque. The bottom four glyphs on the right give Chan-Bahlum the title of Jaguar Lord and name him Lord Chan-Bahlum, "Blood Lord of Palenque." The text (fig. 177) begins with an event taking place on 9 *Ik* 10 *Mol*, a date in the far-distant past that cannot be placed in the Long Count. The event took place 932,174 years before the rising of Chan-Bahlum from Xibalba. A Distance Number recalls this event, in which the Moon Goddess displayed God K in mythological time, and brings the text date to 9 *Ahau* 3 *Kankin* (November 6, A.D. 705), exactly three years of 365 days and one cycle of 260 days after the death of Chan-Bahlum on February 20, A.D. 702 (Schele 1986:273). It therefore took Chan-Bahlum nearly four years to complete his Underworld journey. The protagonists were Chan-Bahlum and his mother, Lady Ahpo-Hel. Chan-Bahlum is acting the role of GIII, the Jaguar God of the Underworld. A second event taking place on 9 *Ik* 10 *Mol* is recorded, this in the recent past. Schele (1986:272) interprets the center row of glyphs interspersed by series of dots below the figures thus: "The first [glyph] contains *nicte* (the glyph for a sacred plant) and the *Imix* compound which marked a supernatural location on the Huehuetenango blood-letting bowl, the second in the form of water-lily, and the third is undeciphered." The lower band of this Underworld scene spells the word for "water-lily, and large bodies of water."

Vivid blue paint and red paint are on the glyphs at the upper left corner of the tablet (fig. 184); see especially the blue on glyphs B3 and B4, the Moon Goddess. The last glyphs at the lower right (fig. 185) tell of the 9 *Ahau* 3 *Kankin* event, the date when Chan-Bahlum dances out of the Underworld. GI and GIII are shown, and the Goddess of Number 2, and the god 1 *Ahau*, and finally the blood-letting with Chan-Bahlum, "Blood Lord of Palenque." The background is red. Glyph D9 is 1 *Ahau*, father of the Triad and an especially appealing glyph (fig. 186).

THE JAMBS
(figs. 187, 188, 189)

The two jambs of Temple XIV are set directly on the floor of the small sanctuary room. Both depict human figures. The figure on the South Jamb is in frontal position with legs splayed. The feet are set directly on the floor, but do not project outward. As only the sculpture on the lower half of the jamb remains, all we know about this pier is that the figure wore an elaborately woven loincloth with a crosshatched portion bordered with round beads, plus three varying widths of fringe above and below this area. The boots worn by the figure are the high jaguar-pelt type with open heel (fig. 190). The legs are formed in much the same manner as the legs on the House A and Temple of the Sun

figures, flat on the front surface with edges meeting the background surface at abrupt angles. Directly below the feet of the standing person, on the basal platform of the sanctuary floor, there is the large sculptured head of what appears to be a boar with a skeletal lower jawbone.

Very little is left of the North Jamb (fig. 191). The composition of these two jambs is unusual in that the South Jamb depicts a personage whose body is in frontal view, while the North Jamb depicts a personage in profile facing south toward the doorway into the sanctuary. Portions of the loincloth hanging before and behind are about all that remains. The flat, bare feet are simple and unadorned. The right foot can be seen slightly behind the left foot; both are in profile, and the left foot has a prominent ankle bone. Below this figure, on the basal platform of the sanctuary room, Underworld iconography is depicted (figs. 192, 193). Waterlily and *Dorstenia contrayerva* plants are featured all along this lower band. *Dorstenia contrayerva* has leaves with raised and serrated edges and tiny bumps forming ridges on the surface. The plants, along with Underworld motifs such as turtle shells, shown in crosshatched patterns, appear often in Maya iconography, especially at Palenque. The plant grows in profusion at Palenque today, as it did in ancient times, and, as reported by R. L. Roys (1931:222-395), has many medicinal qualities. John Bowles (1974:121-26) brings out a great deal about this plant. Interspersed among the plants in the band are heads of long-lipped gods with bone lower jaws, again pertaining to the Underworld and death. At present they are becoming covered with a lime incrustation that casts a white glow over the whole sculpture. Even worse, they are becoming so covered with black scab from acid rain that it is almost impossible to tell anymore what is on this panel.

3

Temple of the Jaguar

The Temple of the Jaguar (figs. 194, 195, 196, 197) is a very small temple directly behind the Temple of the Inscriptions. As one climbs a series of uneven stairs to a narrow path, it seems as though one is entering another world of Palenque, a quiet, lonely jungle area where one usually never sees another person. One follows this steep, tree-covered path for several minutes until a small temple comes into view. This is the so-called Temple of the Jaguar, named for the jaguar throne on the stucco-sculptured tablet on the wall. The temple is situated high on the bank above the Otolum River. So dense is the jungle growth now that it is difficult to even spot the river below. Those of us working there have often sat in the doorway of the temple and thought about the people who used this remote shrine in ancient times, and we have always ended up feeling that it must have been a private place of worship for an elite lord as well as his burial temple. Today it is on the trail that leads to Naranjo, a Maya community over the Sierra de Palenque, and every day Maya Indians carry their loads of corn on tumplines on their heads down to where the tourist bus picks up people at the entrance to the ruins and thence down to the town of Palenque.

This small temple is approximately 645cm across the front and approximately 585cm deep, with the inner rear room approximately 514cm by 450cm. The floor space is divided into two long rooms by a central wall 68cm thick. The doorway into the rear corridor is 152cm wide. A good part of the building has fallen, and some walls are such that exact measurements cannot be taken. Only the east side of the central wall provides any evidence of what was once the entrance room. Remaining stucco on each side of the central doorway into the rear room tells us that there was a bordered panel of hieroglyphs on each side (fig. 198). On the south side there was an Initial Series Introductory Glyph plus a double row of twelve glyphs. A good portion of the borders remains intact, and red paint covers much of the surface.

The sculpture in the rear room has attracted attention ever since Captain Antonio del Rio wrote an account of his visit to Palenque in 1786 and the romanticized drawing by Waldeck (Jean Frédéric Maximilien, the self-styled Comte de Waldeck) was published in 1822 in his *Description of the Ruins of an Ancient City, Discovered near Palenque, in the Kingdom of Guatemala, in Spanish America* (fig. 199) (Del Rio 1822). The sculptured panel, 205cm by 251cm high, was in the center of the west wall of the temple. A border

9cm wide bounds all four sides of the panel and is still in excellent condition. All we have to go by other than Waldeck's drawing are a front paw and the bow tie around one neck of what was once a giant double-headed jaguar holding up a throne upon which a figure was seated (fig. 200). The jaguar wears an anklet made of a woven mat tied around the ankle and on top of it a row of clipped feathers with inlaid "death eyes" that Waldeck made look like sleigh bells. A strap with a hole in it connects the top of the anklet and the back of the leg. A large bow tied around the creature's left neck connects the portion of the throne upon which the figure is seated to the jaguar's body. In other words, what the Maya did was the same thing we do when a parade float is carried down the street by people who act as locomotion. If we could see the other side of the jaguar, we would see that the animal is in the middle, the framework for the platform upon which the throne for the seated person is built is around it, and a flat piece across the top of the animal's body holds the small throne. In the center of the wall, and likewise in the center of the framed panel of the double-headed jaguar, there is a window 18cm wide by 24cm high that penetrates the west wall.

A similar opening in the far upper-left (southwest) corner of this wall likewise penetrates the wall (60cm thick). Openings this same size are in the north and south walls 13cm up from the floor. The one in the north wall does not quite penetrate, but the one on the south goes all the way through. The east wall of this rear room (fig. 196) has two holes 19cm x 29cm and 20cm x 22cm on the north and south ends respectively. Neither penetrates the wall; they go back only 55cm. A peculiar four-sided recess in the south end of the wall at floor level, 66cm across the bottom, 77cm high, and 15cm across the top, goes into the wall for 44cm. From its odd shape, it must have been built there to fit precisely some now unknown bit of paraphernalia. At the southern end of this room a very steep stairway goes down eight steps to a subterranean chamber. The opening in the floor is 77cm wide by 109cm and is constructed 30cm from the west wall, with the top step being only 58cm from the south wall. This leaves very little room for a person to enter the stairs. This is the way the stairs were built in the small western room of House G of the Palace that was the entrance to the South Subterranean chambers.

The stairs in the Temple of the Jaguar give access to a chamber 193cm wide by 282cm long. To the east of the stairs, a 58cm corridor leads back 117cm to another small room, probably a crypt, 103cm wide and running 255cm in an east-west direction. A low sill acts as a barricade to this chamber. There is a small niche in the west wall of this room 17cm wide, 40cm high, and 35cm deep and 101cm up from the floor. The entrance room of the crypt has a low vault, the vault spring being 174-176cm up from the floor. An *Ik* opening goes all the way through the north wall and can be seen in Figure 202.

4

The North Group

The North Group (fig. 203) was our favorite spot to sit at the end of a day's work to enjoy a cold drink that managed to be in our cold bag for film, munch some Ocosingo cheese, and discuss life in Palenque in ancient times. Tourists had left the ruins, and the only ones who broke the serenity were the howler monkeys that sometimes let their whereabouts be known to others of their species. An occasional butterfly would flit by, but this was no-man's-land for mosquitoes and other bothersome insects, probably because there is always a slight breeze. Sometimes there were just my husband, Bob, and I; at other times my companion was Linda Schele or Alfonso Morales or John Bowles. Many of the problems of Palenque were solved on these steps—but for the most part they had to be solved again the following night.

I have always said that if I were a Maya looking for a piece of real estate to buy, I would without hesitation purchase the North Group. Had I been a Maya ruler, I would have lived there, and possibly Kan-Xul did. Why? The North Group has all of the advantages of any spot in the city and none of the disadvantages. First of all, one is away from the mob, separated from the Palace by the large Waldeck Court and the larger North Palace Platform. It would have been to the plaza below that traders came from the northern plains by way of the Otolum Cascades and from Naranjo, Tulumpa, Sulumpa, and other nearby sites over the mountain (fig. 204). It would have been a perfect place to watch all of this but not necessarily take part in it. Activity directed toward the north end of the Palace Complex with its wide entrance stairway would have been a focal point, and the Temple of the Inscriptions further in the distance would have been under surveillance too. Signals sent from the Tower could be seen. On the north side of this group of buildings, a view would be afforded all the way across the northern plain where the people trading with the city of Palenque lived in late times.

Secondly, one would have been able to sit at the center of the far eastern building, Temple II, and watch the ball game directly in front on the plaza below (fig. 205). The game could also have been seen from the small oratory that is Temple III, but I doubt if this small shrine was used for that purpose. The Ballcourt is small, the playing alley being only 3m wide and 18m long, veering just a few degrees west from due north-south (Ruz 1952b:30, 32; 1962a:44-46). Only 36cm high, it is one of the lowest benches known for ballcourts. The bench levels off for nearly 3m before rising in a 45° slope to the platform

where the Ballcourt buildings would have been. This is not a ballcourt in which very many contestants could play. During the excavations by Ruz in 1951 (Ruz 1952c), thirty fragments of ball-game yokes were found that would probably have added up to fifteen whole yokes. Two hache stones were also found. It is believed that none of this ball-game paraphernalia came from Palenque; more than likely it was from the Veracruz area.

Although they are barely discernible now, in ancient times the long series of elevated range-like buildings flanking the Michol River could have been seen just to the north (fig. 206). As one looks at the map of Palenque (map 3 in Vol. I of this series), it becomes apparent just how large this site really was. These buildings along the Michol are on the northernmost extremity of the city, almost on the same level as the northern part of the Group III buildings and those nestled along the lower (north) Murcielagos, Balunte, and Otolum river systems (see also map 1).

THE NORTH GROUP TEMPLES

The Group of the North includes Temple VII (the Temple of the Count) and five temples in a row elevated above the plaza floor.

The five temples are arranged right next to each other but on two levels. Temples I and II are on a higher elevation than the others (fig. 207). Only the foundation of Temple I remains.

Temple II, with the widest stairway (fig. 208) leading up to it from the plaza, has four piers, two on the corners of the building and two equally spaced across the south-facing front. These piers were all stucco-sculptured. Pier A, forming the corner on the southwest, was sculptured with a figure in front view (figs. 209, 210) with legs and arms spread out like a paper doll. No clothing is on the figure, but we must remember that Palencanos sculptured their figures naked, painted the body, and only then sculptured the clothing on the personage in layers just as if one were getting dressed. A light-red paint covers the only slightly rounded body parts. The figure was laid right on the stone backing of the pier over a very thin coat of stucco. The stones on the wall are quite well worked, and there are no armatures anywhere, even under the 5.5cm-thick chest area. The top of the shoulders extends out 3.5cm, while the arms round off slightly at the edges to 2cm. The thigh is thicker, 6cm. The right calf at the edge of the leg is almost perpendicular to the base wall, just the way legs are sculptured on the jambs of the southwest room in House B. The figure holds a staff in the left hand, but not enough remains to tell whether or not this staff had a God K at the top like other staffs at Palenque.

Piers B, C, and D were also sculptured, but only a small amount of sculpture remains on them. Piers C and D have small remnants of feathers but no paint. A plain border 10cm wide bounded the piers. A considerable amount of the border remains on Pier A, and much red paint is still in evidence. The south face of Pier B has red background paint, feathers painted first red and then blue, serpent scales in red, and the remains of a God K body and face in blue. The shell portion of a Quadripartite God is red. A fine coat of 6mm to 13mm stucco was laid on the front and sides of the piers before sculpturing. There is

evidence that all of the piers were first painted red. The entire outside of the building is painted a deep red. On the north wall of the central room there is a wide deep-red band that continues under and over the vault spring. This band continues on the wall of the small room to the west. As the wall between these rooms is not completely intact at present, we have an opportunity to note that the band continued along the wall the full length of the structure, suggesting that the wall between the rooms was added later. All of the outer and inner walls of the North Group buildings were painted a deep red; the paint is especially noticeable on the west wall. Much paint is still in evidence.

TEMPLE III

Temple III (fig. 211) is a small sanctuary or family shrine approximately 4m square set between Temples II and IV (fig. 212). There is a hole in the floor just under the eaves overhang and another above on the eaves, and we always thought that some kind of banner was hung there until I saw from a photograph taken by Maler in 1903 (fig. 213) that we could never inspect the roof and be sure. The temple is set back so that its rear wall aligns with the rear wall of Temple IV and is on the same level as this larger structure. A small plaza extends in front of Temple IV and this small shrine. Stairs lead directly to the east as one descends from the small temple and ascends to the platform of Temple II. There is hardly enough space to squeeze between the two buildings.

TEMPLE IV

Temple IV (fig. 214) is built very much like Temple II, but is wider. The front half of the structure has fallen, leaving only the east wall, part of the west wall, and the lower portions of four piers that were across the front of the building. Balustrades are at the sides of the badly broken-up stairs in front. On the east side of the wide entrance to the rear room, there is a large block with three carved glyphs, once part of another structure (fig. 215). The glyphs name Pacal.

Another reused glyph block was set upside down in the south wall between the rear central room and the rear west room (figs. 216, 217). No wall remains to create a room on the east of the rear central corridor, although there is a door to it at the far east. A low sill acts as a barrier into this room. Apparently in late times, when Palenque structures were being camped in, a very crude circular barrier was set up just to the east of the central doorway. There is carbon on the floor: At some time in the past this was used for a fire area.

TEMPLE V

The far-western structure of this group is Temple V (fig. 218), set back from Temple IV at the front but lining up precisely with that temple at the rear. Only the central wall and the east wall of this building remain. The V-shaped central portion of the vault still hangs

together despite the great weight with nothing to support it except the central wall (figs. 219, 220). Even great portions of the capstone remain in place. This is true also on the south portion of the vault. The vault in the north part of the structure shows the large recessed stepped vault that is typical of this early building. In the small northwest room of this structure, a bench or bed of stone has been built into the corner. This could possibly have been a bed for the guard who may have been entrusted with some important item kept in this room, a bed for a visiting dignitary (for the structure is palace-like), a bed or bench for an important prisoner, or a bench for important paraphernalia. We will never know. Another bench, slightly larger, is against the wall in the northeast corner of the outer corridor of this building.

The Temple of the Count (Temple VII)
(figs. 221, 222)

The Temple of the Count is named after Jean Frédéric Maximilien, Comte de Waldeck, who is supposed to have lived in this temple when he was exploring Palenque in 1832. It stands atop an immense pyramid substructure, the base of which is by far the largest in this northern part of the city. A wide stairway with balustrades rises in three tiers to a large platform that forms the base for the temple, and a narrower stairway rises five more steps to the entrance to the temple proper. The Temple of the Count, like the range of the five other North Group structures, had an excellent view of the North Palace Plaza, the Waldeck Court, and the other buildings of this group. It also stood out, because of its height, when viewed from the Tower and the Temple of the Cross. The southwest room has a blocked entrance, and it is necessary to go through a doorway on the south to enter a small anteroom with doorway on the north to gain access to this darkened room. There is a square opening in the wall through which it is possible to look directly at the Temple of the Inscriptions, the court in front of the Inscriptions, and the north end of the Palace. Blom (Blom and La Farge 1926:179) describes the roof of this temple as having "fragments of huge stucco masks," only very small details of which remain today.

5

Temples X and XII

TEMPLE X
(fig. 223)

Directly to the southwest of the Temple of the Count, with their substructures almost abutting, lies Temple X facing the Temple of the Inscriptions. All that remains visible of this structure are the wide southern stairway and the six piers on that side.

Because of its location on the Inscriptions Court and its direct proximity to the Palace and the Temple of the Inscriptions, it must have been of significance during the reign of Palenque's major rulers.

TEMPLE XII, OR THE TEMPLE OF THE DYING MOON

Temple XII, or the Temple of the Dying Moon (figs. 224, 225), the small temple to the west of the Temple of the Inscriptions, is the first temple visitors see today upon entering the ruins of Palenque. The unique thing about this temple, and the thing that captures everyone's eye, is the immense skeletal mask (figs. 226, 227) at the base of Pier B. This is the mask of a rabbit—hence the temple's name. Remember how at the end of the escapades of Hunahpu and Xbalanke they defeated the Lords of the Underworld in the ball game and rose into the sky, and one became the Sun and the other the Moon. If we then have the Temple of the Inscriptions as the Temple of the Dead Sun/Xbalanke, this temple by its iconography is the Temple of the Dead Moon/Hunahpu. The Sun in Maya iconography is identified with the deer and the Moon with the rabbit. This temple, then, the Dead Moon, should be identified with the rabbit—and a dead rabbit at that—and that is indeed what we have. An iconographic complication is that the ear of the deer and the ear of the rabbit look alike even though these animals are otherwise very different. An ear would not normally be shown on a skull, but, as Schele points out (1975:52), "while it was necessary to portray the ear of the animal, it was equally imperative to show that the ear has also succumbed to the effects of death." Michael Coe (1975) has shown that the crosshatched spots are like "death eyes" and associated with death and the Underworld. The rabbit skull has the characteristic protruding front incisors and a bone as the lower jaw. Rabbit skulls are shown many times in Maya iconography, but at Palenque this is by far the largest representation.

6

Group IV

The Tablet of the Slaves was found in Group IV by road workers in 1950 and excavated under the direction of Alberto Ruz in 1950 (Ruz 1952b). Group IV is 300m west of the main plaza of the site (see map 2). B. C. Rands and Rands (1961:87), who conducted the ceramic investigation in Group IV in 1951, term this a cemetery: "a corner of a plaza used over an extended period of time for a series of superimposed burials," in some cases one burial having been built directly atop another, as when "three burials occurred in crypts which were constructed on top of the [stucco-paved] floor." As Rands and Rands say, "this one small area of Palenque was used as a burial place of many individuals, both old and young." Robert Rands communicated to me that "this may have been a large private area of an elite Palenque group."

THE TABLET OF THE SLAVES
(figs. 228, 229, 230)

The Tablet of the Slaves portrays Chac-Zutz', an elite lord who until recently was thought to have been a king of Palenque but who is now believed by Schele (1986) and others to have been a *Cahal*, meaning something like "Territorial Governor" and "important lineage head subordinate to the king." It has always been acknowledged by most of us, including Schele, Mathews, Lounsbury, Kelley, and Michael Closs, that Chac-Zutz' was not treated in the manner usual for Palenque kings. He never carried the *Mah K'ina* title, as did known kings. Chac-Zutz' was born on 9.11.18.9.17 7 *Caban* 15 *Kayab* (January 22, A.D. 671) and died after 9.15.0.0.0 4 *Ahau* 13 *Yax* (A.D. 731). Chaacal did not die pre-9.14.11.12.14 8 *Ix* 7 *Yaxkin*, as originally thought, but lived until at least 9.15.0.0.0, as found by new evidence presented by Peter Mathews at the Fifth Palenque Round Table in 1983 concerning the capture of Kan-Xul, king of Palenque, by a king of Tonina. Additional evidence was presented by Schele (1985:89), who noted that Chaacal's accession was the last recorded in the dynastic history of Chac-Zutz'.

Three war events took place in which Chac-Zutz' was the protagonist: a "capture" of Ah Manik on 9.14.11.17.6 9 *Cimi* 19 *Zac* (September 15, 723) and two "axe-war events," one on 9.14.13.11.2 7 *Ik* 5 *Zec* (May 3, 725) and the other on 9.14.17.12.19 2 *Cauac* 2 *Xul* (May 19, 729) (Schele 1985:88). These same "axe-war events" are found at Quirigua, Dos Pilas, and Aguateca in the recording of captures of

foreign rulers, which leads Schele to speculate that Chac-Zutz' was "an accomplished war chief." Chac-Zutz' was born seven years and eight months before his brother Chaacal III. It seems that one brother became ruler of Palenque and the other had an important royal appointment.

The text of the tablet starts out with the accession of Pacal on *5 Lamat 1 Mol* and the birth of Chac-Zutz', linked to the accession of Chaacal, not to his own. Chac-Zutz' was over seven years old when Chaacal was born, yet Chaacal, the younger brother, was the one who acceded to the throne. Chaacal and Chac-Zutz', then, must have been half-brothers. The woman's name in Temple XVIII also appears next to the woman on the Tablet of the Slaves. Schele (personal communication) informed me that the younger offspring of this woman became king, while the older son became head of his father's lineage and a very high official in government. She suggests that the right of kingship here was apparently through the mother's lineage.

THE FIGURES OF THE TABLET OF THE SLAVES

Chac-Zutz' in blood-letting attire is seated on a cushion supported by two bound captives and is flanked by his parents, as rulers are commonly depicted at Palenque—though in this case the protagonist is not a ruler but a very high official of royal status. He faces his father (possibly because this may be whence he receives his *Cahal* status), by whom he is being presented with a royal Palenque crown. This is a crown for kings. Palenque must have had some very special privileges accorded their highest-ranking officers to have this royal paraphernalia presented to one not a king. Chac-Zutz' wears a royal haircut, similar to that worn by Chan-Bahlum on Pier D of House A and on the Tablet of Temple XIV, and that worn by Pacal and Lady Zac-Kuk on the Oval Palace Tablet, as well as in numerous other depictions of royalty at Palenque (Greene Robertson 1985b:39).

His earplug is the simple jade tubular piece with hanging cord and jade three-piece drop, the same as the one worn by his father on this tablet. His necklace and pectoral consist of a double string of round beads, a pectoral emblem of an open-mouthed jaguar with the typical four strands of long beads and bone-*ahau* beads dangling from it. His wristlets are also jade and have bone-*ahau* beads attached. It is not possible to tell whether or not he wears anklets, as this area is covered by the incense bag. This incense bag with knots at top and bottom has the image of the Palenque Emblem Bird on it with smoke or blood coming from the bottom. He is carrying the bag by a folded cloth with holes in it attached to the top of the bag. His undergarment barely shows above the fringed hip cloth, which is carefully draped over each knee. The loincloth is wound around his midsection and brought up and over his undergarments to fall in front; that fold is decorated with a quatrefoil cartouche with knotted mat symbol (another royal diagnostic) and has a fringed bottom.

The bound prisoners on whom Chac-Zutz' is seated wear their hair tied up in the manner of prisoners, wear flexible ear pendants, also as worn by prisoners, and have the ropes binding them around their arms and backs, also diagnostic of prisoners. Similar attire is

worn by the figures on the Tablet of the Orator, the Tablet of the Scribe, and the Tablet of Temple XVIII. They are crouched in a position that puts the soles of their feet to the side and their elbows on the floor in an elevated position, not a relaxed one.

The figure on the left, the father of Chac-Zutz', wears attire similar to that of his son, although no pectoral can be seen. Both this figure and the woman on the right wear the shell-winged dragon on top of their hairdos. This is the dragon prominent in the large fret motif on the wall in the southeast room of House B of the Palace. The father holds the high drum-major headdress in his hands as if ready to present it to the protagonist. An open-mouthed jester god, attached to the front of the headdress, is facing the father, just as the one like it is held by Lady Zac-Kuk in the presentation scene on the Oval Palace Tablet. On the Oval Palace Tablet, Lady Zac-Kuk was herself royalty, still queen of Palenque at the time the presentation was taking place. The father of Chac-Zutz' must have been of royal status. He is seated on the crouched figure of what is probably GI of the Palenque Triad and patron deity of the Temple of the Cross. The figure has god markings (the mirror) on his back, arm, and thigh. The face is that of GI: Roman nose, square eye, long swept-back hair, and mirror in the forehead. The lips are distended, with serpent teeth in the upper jaw, and a fish barbel appears at the corner of the mouth.

The figure on the right, presumably the mother of Chac-Zutz', is likewise seated on a crouching figure, this time a brocket deer, a creature indigenous to Palenque. This heavy-set woman has long hair worn much in the manner of Lady Zac-Kuk on the north end of the Sarcophagus in the crypt of Pacal in the Temple of the Inscriptions. Her dress is worn high on her ample bosom and is fringed at the top, but does not cover her shoulders. The gown, at first glance, seems to be a short huipil type, fringed at the bottom, but upon close examination of the carving, it is evident that she is wearing a long tight skirt underneath the fringed huipil. Two pairs of crease marks at the top of the leg and one pair below the buttocks attest to this identification. She wears a bead choker and the same type of earplug worn by the other two figures: tube inserted in the ear with cord holding the three-piece bead drop behind the ear.

She holds a shield made of a flayed face with crosshatching around the cartouche. A flint-shield god with bone lower jaw, wide-open mouth showing incisor and *tau* teeth, and the headpiece a flint with *cauac* markings is anchored on top of the flayed face. A waterlily is tied on her forehead, as one also is on the seated figure on the left. In fact, the manner of arranging the hair is the same for the two figures except that one is designed for a man (the shorter hair and the shaved area at the nape of the neck) and the other for a woman (longer hair). Both hairdos are tied up in the same way at the top of the head with a ribbon, and both have the waterlily tied on in the same manner.

The carving on this pale-cream limestone tablet is very shallow compared with other Palenque tablet carvings. The incised lines are delicate but not beveled as on the superb carving of the Tablet of 96 Hieroglyphs or the Creation Tablet. The tablet was made in three pieces, a narrow piece on either side and a large center piece framing Chac-Zutz'.

7

The Olvidado

The Olvidado (figs. 231, 232), or "Forgotten Temple," on the western periphery of Palenque, one-half kilometer from the center of the main area of the site as we know it, is a temple that newcomers or visitors rarely get to see. There is no path, and the half-kilometer seems like several kilometers by the time one wanders over mounds in dense jungle, crosses the Motiepa and Piedras Bolas rivers, gets lost, and starts over again. No wonder it is called the Forgotten Temple. Indeed it has been forgotten by archaeologists and is not even protected from the elements and natural jungle deterioration. Until 1987 nothing had been done to ensure its stability. It is, however, a very important temple, the earliest known standing architecture at Palenque. It was probably built by the illustrious King Pacal.

Heinrich Berlin wrote an important article about the temple in 1944 ("Un Templo Olvidado en Palenque"). Frans Blom had reported on it in *Tribes and Temples*, and García-Moll in turn reported on Blom (1982), but nothing had been published since Berlin until in 1981 Peter Mathews and I realized the importance of completely recording this temple (Mathews and Greene Robertson 1985). There had been tremendous damage to the temple the year before we worked on it due to extremely heavy rainfall, and it was doubtful if it would stand much longer.

In 1974 I had photographed and taken many measurements of this temple, but when severe new damage threatened the stability of the structure, Peter Mathews and I decided that if the Olvidado was ever going to be recorded it had to be done immediately. With the help of Chencho (Ausencio Cruz Guzmán), Lee Jones, and Charlotte Alteri, we spent considerable time remeasuring and photographing every detail of this temple—a precarious task, as we were not sure just how safe were some places that needed measuring. One vault had only a tree branch holding it up; if it fell, the entire Pier B and much of the roof would go with it. The interior was already full of rubble fallen from the most recent storm.

As we shall soon see, much of Palenque's architectural development started with this early temple that has not had much attention paid to it over the past century. Maudslay knew of its existence but commented only briefly on it (Maudslay 1896-1902:34, 35) as a north-facing two-gallery building "with somewhat clearly-defined terrace walls." He referred to the "remains of a hieroglyphic inscription within an interwoven scroll border" and remarked that there were "traces of human figures moulded in stucco" on the inner

piers and that "the roof has been ornamented with a decorative frieze moulded in stucco, and on the summit there are traces of stone latticework, which has supported stucco decoration as in the more important temples." Obviously, this small temple did not compare in importance to the magnificent Temple of the Inscriptions, the Palace, and the Cross Group temples that he recorded so beautifully in photography and drawings.

Frans Blom (Blom and La Farge 1926:189) described the temple as "lying on the mountainside between Group H and Group F," although in the Palenque map (Vol. I of this series) it can be seen that the Olvidado lies on the west ridge southwest of the Temple of the Inscriptions and close to Group F where the Picota runs through the aqueduct. Blom drew a plan and elevation of it (fig. 233) showing one merlon left on the roofcomb, which he refers to as "a roof element of unusual form." He reported that the "temple faces north and stands on a terraced pyramid." Two stucco hieroglyphs on the outside of the building were reported by him. He noted also that the temple had "two parellel galleries, and [that] no vestiges of carved tablets or stucco hieroglyphs were found on its back wall." He does state that only a condensed report was given during his stay at Palenque, "the object being merely to place this work on record for the benefit of future explorers of Palenque." His implied hope unfortunately was regularly ignored by almost everyone.

Heinrich Berlin came to Palenque in May 1940 and produced the only real record of the Olvidado up until then (Berlin 1944). He recognized that this temple was very early and suggested several possible dates between 9.7.0.5.13 (A.D. 578) and 9.10.14.5.10 (A.D. 647).

A portion of the Sierra de Palenque mountain slope along a steep escarpment was leveled off and partially filled in to accommodate this temple, with a series of three staired terrace platforms leading up to the final platform upon which the temple was built. The rear of the temple almost abuts the side of the mountain, a practice that proved to be the norm at Palenque when building along the side of a hill. Other recognizable temples built this same way include the Temple of the Inscriptions, the Temple of the Foliated Cross, and the Temple of the Jaguar. For the Olvidado, the first platform (measuring at the building's front, the north side) was built 290cm high, the second 240cm high, the third 130cm high, and the last 84cm up to the platform upon which the temple stands. These platforms continue from the front of the building around the west side at each level, going further back as the terraces get steeper. The first two terraces are completely filled in on the front and dig into the hillside at the rear (south). Because of the steepness of the hillside, there are only two terraces and no stairs to the south. The heights of the terraces on the south are not the same as on the north. There is no second terrace on the south, unless it has been filled in with debris. The first terrace on the south, which is the third terrace on the north, rises 170cm from the hillside floor. On the south, the fourth terrace, the one on which the building is built, is 37cm up from the terrace below it, while on the north there is a rise of 84cm up to the building platform.

The small temple, 12m x 5.65m, sits on a base that extends out 30cm from the building. It has only one entrance (on the north), approached by a wide, centrally positioned stair-

way of five steps with balustrades 84cm wide at the sides. The walls are not all the same thickness, being 100cm thick on the west, 102-104cm on the south, and 109-110cm on the front, where the piers are. The building is constructed of irregularly shaped flat lime-stone blocks and stone and clay rubble fill covered with lime plaster. It cannot be deter-mined whether or not there were paintings on the walls. No evidence remains today. Two pillars the size of the piers and directly behind Piers B and C are at the center of the temple. There is no central wall as in other Palenque temples—only the two support pillars. The only openings into the temple other than the three openings surrounding the two piers on the north were seven small nearly square (21cm x 23cm) openings in the walls, three on the south wall (only two going completely through), two on the west wall, and probably two on the east wall, now almost all collapsed. The westernmost opening on the south wall penetrates the wall to a depth of only 93cm, leaving 11cm of the wall unpierced. We examined the wall carefully on the outside at this point and could find no evidence that the opening ever went all the way through.

It is almost as though the temple was constructed as one large room rather than as two lateral galleries divided by square pillars in the center where a wall would normally be. The southern gallery is 127cm wide, and the northern 133cm wide. Four piers slightly thicker than the 100cm walls of the building formed the front facade of the structure. Piers B and C are 110cm thick, and Pier D is 109cm thick. Piers A and D form closed corners at the ends of the structure. There is stucco sculpture remaining on all four piers.

THE VAULTING SYSTEM

The vaults of the Olvidado are quite different from other vaults at Palenque (fig. 234). Rather than sloping in a straight line toward the capstone as other Palenque vaults do, the Olvidado vaults form two separate curves (fig. 235). The lower portion of the vault sweeps in an arc of radius 120cm, stopping at a point about 40 percent of the way to the capstone, and then another curve is formed above the 4.5cm inverted step. It seemed to us that this ledge must have been where a stringer was laid on top of the lower vault beams to facilitate construction of the upper vault and to stabilize it (figs. 236, 237). This is probably why the inward/outward thrust changes so abruptly in these vaults. It is ob-vious that the builders were experimenting in vault construction. The Olvidado vault became modified later in the ogee arch of House A's eastern entrance and again in the Palenque keyhole arches.

At the time in Palenque's history (9.10.14.5.10) (A.D. 647) when the Olvidado was built, a great deal of experimentation in construction techniques was going on. The very low vault ceiling of the South Subterranean structure of the Palace was not what Palen-canos wanted. They were striving for a higher vault, and actually they could have built this subterranean vault twice as high as they did if we accept Lawrence Roys's (1934) finding that a vault could be constructed safely if the height from the vault spring was no more than the thrust inward. The ratio of room width to height from floor to capstone is

1 to 1.5, and the inner thrust of the vault in the subterranean building is 43°, a ratio of 1:1 for vault height.

The Olvidado vault height is 3.5 times the width of the room. They had constructed a high vault and a very narrow room, but they needed a wider room. A vault thrust such as that used for the Olvidado would ordinarily result in an unstable vault, but in the Olvidado they built the wall thicker and higher and propped it with vault beams. They could have constructed the wall to almost any height they wished as long as they built the wall thick enough. Their 18.5° is 8.5° less than Roys's model. In constructing a taller building they (1) made the walls higher (206cm), (2) made the rooms narrow (120-127cm), and (3) made the inner thrust only 60-63.5cm. The rooms could have been built safely only up to 390cm rather than their 435cm if they had kept to an ideal 1:2 ratio.

The capstone of the Olvidado vaults is only 9cm wide. The stones spanning this short distance are large flat thin, irregularly shaped stones that broke from the weight of the roof on top of them. The stone forming the vault itself was a combination of squared stones, boot-shaped stones, and thick and thin stones precariously placed. It is amazing that they stand up today (note especially fig. 238). The fill between the vaults is likewise a conglomerate of variously sized stones and rubble.

It is evident that the builders of Palenque were experimenting with new ways of constructing vaults and that much was learned from the building of this temple. Cross-vaulting doorways in central walls was an innovation that was to be practiced in later buildings (note the cross-vaulting system in the Temple of the Inscriptions tomb). If we look at the vaults and room widths and heights (fig. 239 and Appendix II) of Palenque buildings, it can be seen that there is a definite increase of temple heights as time goes on. The early South Subterranean Building had a room width twice that of the Olvidado—in fact, a width that was exceeded in known buildings only by the Cross Group temples. But this early building reached nowhere near the height of the Olvidado. I believe that the South Subterranean Building of the Palace was built first, and that then came the Olvidado, where new techniques in construction were tested and where some ideas, like higher vaults and cross-vaulting, were kept and used in later construction, and others, such as narrow rooms and unstable vaults, were rejected. The early South Subterranean Building was constructed of mud mortar and rubble, and the distance from floor to capstone was very small (338cm). House E, the earliest building of the upper Palace terrace, benefited in many ways from the knowledge gained in construction of the Olvidado. Here in House E the ideal, according to Roys's model, was achieved, height of the vault to the thrust being a ratio of 1:2 with a vault face angle of 27°. The spacious room width was kept in Houses B and C, and then the vault rose even higher in the Temple of the Inscriptions, but the room width was slightly diminished. Houses A and D maintained the height and had the additional advantage of a little more width to their rooms. The greatest height was reached when the Cross Group temples were built. Wide rooms and low vaults did not return to Palenque until very late in its history (in Houses G, H, and F), when decadence had taken over and construction techniques did not match the glories of the building boom under Pacal, Chan-Bahlum, and Kan-Xul.

THE ROOFCOMB

The roofcomb on the Olvidado is unique. Eight large six-sided stone merlons (fig. 240), equidistantly spaced, were set on stone legs, four on the front of the roof facing north and four on the rear. These large stones, measuring 51cm high, 120cm across their widest axis, and 58cm thick, all had two holes 20.5cm in diameter drilled all the way through them like two eyes. Berlin (1944:72) proposed that these merlons represent owls, and Mathews and I agree. These eight owls could have been sentinels easily seen by those approaching from the north. We feel that the Palencanos could very likely have referred to this temple as the Temple of the Owls. There is considerable red paint on the outside of these stones as well as inside the holes. The merlon that we investigated in detail had fallen at the north of the building down to the third terrace from the foot. Undoubtedly the rest of them are in the rubble and caved-in fill to the north of the temple.

THE PIERS

There were four piers across the north facade of the building, Piers A and D forming closed corners. The two outer piers were stucco-sculptured with two entwined cartouches containing glyphic blocks. The two central piers had human figures sculptured on them.

PIER B (fig. 241)

All that remains of the sculpture of the front-facing figure on this 129cm x 235cm pier are the feet clothed in high-topped sandals, the lower portions of the legs, the bottom of a long, elegant jaguar-pelt cloak (fig. 242), a few feathers at the top center of the pier, a small element in the center of the pier, and the bottom of the loincloth. The feet and very flat legs were completely modeled first and then the boots were added (fig. 243). A jaguar cloak trails on the ground behind the figure's legs and to the sides. Deep slashes indicate fur. The plush fur can also be seen in an elaborate pattern between the legs where the cloak falls to the ground. Small holes with depressions around them cover the entire cloak area, and the center bottom portion indicates two separate sections of the tail. Stucco remains of the left foot indicate that the boots were at least ankle height and had thick layers of feathers on the heel. A stone armature is used to form the sole of this 31cm foot, which extends out 10cm from the stucco background. There is some blue paint on the feathers at the top of the pier.

PIER C (fig. 244)

If we are to go by the style of the elaborate fur cloak trailing on the ground around the figure's legs (fig. 245), a figure identical to the one portrayed on Pier B was apparently at one time on this pier too. The portion of the cloak that falls between the legs of the figure has lines indicating fur, and a deep curved depression at the very bottom is the animal's tail. Above this depression are small holes drilled in a circular pattern and two deeply depressed holes 2cm and 2.5cm in diameter. Very thick stucco formed the foot and boot

on the right foot (fig. 246) and the left foot as well. All that remains of the left foot are the angled stone armatures conforming to the shape of the foot, very thick plush ties that go between the toes, and the thick stucco forming the heel portion (fig. 247).

PIER D (*figs. 248, 249, 250*)

The circular double-serpent cartouches that intertwine on this pier were repeated later in Medallion 11 of the Gallery in House A of the Palace, even to being the same size (63cm on the inside). The only difference is that in the Olvidado medallions the serpent body is 12.5cm wide, whereas in the House A medallion it is 7.5cm thick; the serpent scales around the circumference in the Olvidado medallions are 7cm wide (fig. 251), and the ones on the House A medallions measure 12.5cm. It is interesting to speculate whether the Maya transposed their measurements when sculpturing the House A medallions. It is possible, especially when we remember that they made some other mistakes in the House A medallions, as noted in Volume III of this series. The Olvidado medallions contained glyph blocks within the cartouches, while the House A medallions had heads of persons within them. At the very base of Pier D, a scalloped element with deeply cut arc and deep holes, reminding me of the bottoms of the jaguar cloaks on Piers B and C, is sculptured in stucco (fig. 252). There is a considerable amount of deep-red and yellow and blue paint on Piers B, C, and D.

TEXT ON THE PIERS

There were originally eighteen glyph blocks on both Pier A and Pier D, a total of thirty-six blocks, as first argued by Berlin (1944). At the present time there are thirteen complete or almost complete and incomplete glyph blocks plus fragments of seven more. Thus there now exist the remains of twenty of the thirty-six glyphs that originally made up the inscription, as noted by Mathews (Mathews and Greene Robertson 1985:13). About half of these glyphs are now in the Palenque bodega (Mathews and Greene Robertson 1985), one is in the Palenque museum, and most of the others are in the Museo Nacional de Antropología e Historia in Mexico City. Mathews (ibid. 13-17) has reconstructed the hieroglyphic inscription on Piers A (fig. 253) and D (fig. 254) for the first time in a convincing order, stating, however, that a few glyphs are placed provisionally (fig. 255). There is only one date, 9.10.14.5.10, on the Olvidado piers, but three persons are named, Pacal, Lady Zac-Kuk, and Kan-Bahlum-Mo'. Two of these, Lady Zac-Kuk and Kan-Bahlum-Mo', were already dead. The text on Piers A and D then records: (1) The I.S.I.G. the date 9.10.14.5.10 3 *Oc* 3 *Pop*; (2) the name of Pacal, who lived from 9.8.9.13.0 until 9.12.11.5.18; (3) the name of Kan-Bahlum-Mo', the father of Pacal, who died on 9.10.10.1.6; (4) the name of Lady Zac-Kuk, the mother of Pacal, who ruled Palenque from 9.8.19.7.18 to 9.10.7.13.5.

The parentage statement with the relationship of Lady Zac-Kuk and Kan-Bahlum-Mo' to Pacal is the most important part of the inscription, because it confirms what is only

implicit in other Palenque monuments (Mathews and Greene Robertson 1985). It names Lady Zac-Kuk as mother of Pacal and Kan-Bahlum-Mo' as his father. This is the earliest recorded date concerning Pacal after his accession thirty-one years earlier. The glyph at D2 is probably the least securely placed in the reconstruction text (ibid.). The reason for placing the inscriptional text on these piers was apparently the bestowing of some new title on Pacal. Numerous dates in the lives of the protagonists that lead up to the date on the Olvidado temple are shown in the table.

DATES LEADING TO THE OLVIDADO

A.D.	Maya Calendar Date		Event	Protagonist	Inscription
603	9. 8. 9.13. 0	8 Ahau 13 Pop	Birth	Pacal	TI Sarc., TI3
604	9. 8.11. 6.12	2 Eb 20 Ceh	Death	Lady Kan-Ik	TI Sarc.
605	9. 8.11. 9.10	8 Oc 18 Muan	Accession	Aahc-Kan	TI1
606	9. 8.13. 0. 0	5 Ahau 18 Zec	PE	Aahc-Kan	TI1
610	9. 8.17. 9. 0	13 Ahau 18 Mac	PE?	"Personage A"?	TI1
611	9. 8.17.15.14	4 Ix 7 Uo	?	"Personage A"?	TI1
612	9. 8.18.14.11	3 Chuen 4 Uayeb	Death	Pacal (I)	TI Sarc.
612	9. 8.19. 4. 6	2 Cimi 14 Mol	Death	Aahc-Kan	TI Sarc.
612	9. 8.19. 7.18	3 Etz'nab 6 Ceh	Accession	Lady Zac-Kuk	TI1
613	9. 9. 0. 0. 0	3 Ahau 3 Zotz'	PE	Lady Zac-Kuk	TI Sarc., TI1
615	9. 9. 2. 4. 8	5 Lamat 1 Mol	Accession	Pacal	TI3 etc.
626	9. 9.13. 0. 0	3 Ahau 3 Uayeb	(PE)	Lady Hel-Ahaw	TI3
626	9. 9.13. 0.17	7 Caban 15 Pop	Accession	Lady Hel-Ahaw	TI3
635	9.10. 0. 0. 0	1 Ahau 8 Kayab	PE, blood-letting	Lady Zac-Kuk	TI Sarc., TI1
			PE, blood-letting	Pacal	TI1
635	9.10. 2. 6. 6	2 Cimi 19 Zotz'	Birth	Chan-Bahlum	TS, TFC
640	9.10. 7.13. 5	4 Chicchan 13 Yax	Death	Lady Zac-Kuk	TI Sarc.
641	9.10. 8. 9. 3	9 Akbal 6 Xul	Heir designation	Chan-Bahlum	TC, TS
642	9.10.10. 1. 5	13 Cimi 4 Pax	Death	Kan-Bahlum-Mo'	TI Sarc.
643	9.10.10.11. 2	1 Ik 15 Yaxkin	819-day-count augury	Kan-Xul II	Pal. Tab.
644	9.10.11.17. 0	11 Ahau 8 Mac	Birth	Kan-Xul II	Pal. Tab.
647	9.10.14. 5.10	3 Oc 3 Pop	?	Pacal	Olvidado

PE	Period-ending	TS	Tablet of the Sun
TI	Temple of the Inscriptions (number following "TI" refers to tablet number)	TFC	Tablet of the Foliated Cross
		TC	Tablet of the Cross
Sarc.	Sarcophagus	Pal. Tab.	Palace Tablet

8

Other Tablets and Sculpture

THE TABLETS OF THE SCRIBE AND ORATOR
AND TEMPLE XXI

Two tablets, the Tablet of the Scribe (figs. 256, 257) and the Tablet of the Orator (figs. 258, 259), originally flanked a large sculptured mural on the south side of the Tower, the Tablet of the Orator on the left and the Tablet of the Scribe on the right. In this small courtyard, a platform consisting of three wide, shallow steps was built up against the Tower to the height of the molding around the building (fig. 260). On the lower step there is a recessed space where the Tablet of 96 Hieroglyphs was embedded. This must have been a very special and elite courtyard. It is small; only 350cm separate the step at the Tower base and the bottom step into House I across from it. The Oval Palace Tablet, the accession plaque of Palenque kings, is directly across from the opening doorway into House E just to the east, a few meters from the stairway platform. Everything about this small courtyard speaks of solemn and privileged rites. It was probably off-limits to Palenque plebeians. For that matter, the entire interior space of the Palace was probably off-limits to all but the elite, those having diplomatic functions there, and those entrusted with taking care of the Palace.

Schele (1979, 1986) sees these tablets as portraits of rulers or high-ranking officials in blood-letting attire of great humility, without any of the glamorous paraphernalia appropriate to their offices. Baudez and Mathews (1979:37) see these personages as prisoners, as they have the characteristics representative of captives, namely "kneeling position, costume reduced to loincloth, holding a banner with cut-out holes, flexible ear pendants, arm bands, knotted long hair"; the "Orator" is "making the hand-against-the-mouth gesture, which is a submissive attitude." Benson (1976:51) also sees these tablets as being scenes of blood-letting rituals and sees the cloth the figures carry as the "ritual cloth" of kings.

TABLET OF THE SCRIBE

The Tablet of the Scribe has the name of Chac-Zutz' in the glyph at A6 and at C1 calls the event "blood sacrifice" with Chac-Zutz' named as the protagonist (Baudez and Mathews 1979:38). The figure is kneeling with the right hand raised and holding what ap-

pears to be a stylus, quill, or perforator. His left hand holds a banner with circular holes cut almost through the cloth; the attached circular cutouts fall in a way that would be normal for a piece of cloth. This same type of cloth with cutout holes is seen on Monument 108 at Tonina (fig. 261) and on other monuments at Tonina, worn as a cloth draped over the shoulder, not used as a banner (Benson 1976:48, 49, 53). The bulky loincloth worn by the figure on the tablet looks loosely secured around the waist and is tied in a loose double knot in front. Another bulky cloth having many slit segments is piled over the right arm. A single piece of cloth is tied around both arms just below the armpits. The piece that goes around the back of the figure joining the two tied armbands can be seen next to his body by the right armband. He wears no sandals, anklets, wristlets, beads, or jewelry of any kind. His earplugs are flexible strips of bark or cloth drawn through the earlobe. His hair is tied on top of his head in the manner shown on prisoners. There is scarification on the cheek. All of these attributes are indicative of prisoners. A very interesting feature of this figure is that he is polydactyl just like Chan-Bahlum: He has six toes on his left foot. This is not very surprising. Polydactyly follows a predictable pattern, and it is not uncommon for it to show up in siblings who are the offspring of affected parents or grandparents (Greene Robertson, Scandizzo, and Scandizzo 1976).

TABLET OF THE ORATOR

The Tablet of the Orator is named Chaacal in the accompanying text at D1, where the figure is named *Mah K'ina* Chaacal and again named Chaacal at E6. B1 designates blood sacrifice, and C1, D2, and D3 are titles (Baudez and Mathews 1979). Now that Schele and Mathews have found a number of the missing pieces of this sculpture (in the Palenque bodega when they were cataloguing there in 1974—Schele and Mathews 1979), much more is known about this piece. The hieroglyphs are now there and many portions of the figure as well, making it much more possible to construct a correct portrayal of this figure. His attire is almost exactly the same as that worn by the Tablet of the Scribe figure.

TABLET OF TEMPLE XXI

The Tablet of Temple XXI (figs. 262, 263) is another figure sculptured in the same manner as on the two tablets just described. The figure is named Chaacal at C1 in the text; then a Palenque Emblem Glyph occurs at D4 and titles at C2, D1, and D3. His attire is the same, but there is more woven detail in the cloth than on the other figures. It is not possible to tell if this figure is kneeling, as the lower portion is cut off above the knees. He carries the standard in his right hand, and there seems to be a stiff (wooden?) staff supporting the cloth. The staff does not support the entire length of cloth, however—the top portion is looped down in a flowing curve. His left arm with the segmented cloth slung over it is raised, and in his hand is a bunch of reeds or the bottom portion of a fan or some other kind of paraphernalia that would have had the handle bound together. The

same type of long cloth or bark strip is drawn through his ear, except in this case there are bead drops dangling behind the ear. The hair is tied in somewhat the same manner as the first two, except that here it is tied in one large loose loop and a piece of wide embroidered cloth is drawn through the loop. He wears a short hip cloth split on the sides with a loose loincloth tied on top of it. This is the only figure of these three who wears a neckpiece, this time a bulky cloth the ends of which are drawn through two large beads in front.

All three of these tablets are carved in very shallow relief, and even though the figures are life-size, it is difficult to see just what the details are without a raked light.

TABLET OF 96 HIEROGLYPHS
(figs. 264, 265)

The Tablet of 96 Hieroglyphs is the latest known inscriptions tablet from Palenque. It was found just a short distance from its original position on the platform on the south side of the Tower, upside down in rubble from the courtyard. Workers, not knowing it was a piece of sculpture, dug their picks into it several times, breaking it in a number of pieces, before they realized what they had. The tablet fits perfectly into the sunken space on the lower step of this platform on the south side of the Tower. The steps on this platform must not have been walked upon, or if they were stepped on during important occasions, it was with great care and by people wearing soft-soled sandals or with bare feet, for the carving is in perfect condition except for having recently been broken.

However, there seems to be a better explanation for the pristine condition of the carving, and that is that it was not permanently kept on the stairs by the Tower. The tablet measures 136.5cm across by 58.8cm high. There are cordholders in each of the four corners, a pair of cordholders in the top center of the stone, and a single cordholder in the center of the bottom up just 1cm from the edge. The bottom right corner has a single cordholder up 1cm from the bottom edge and in 4cm from the side of the stone. The other three corners have pairs of cordholders set in from the edge between 5.5cm and 6.7cm and in 2.7cm from the top edge. This makes one wonder whether the plaque was anchored while on the step, or, more logically, whether it was only placed on the step for very special occasions and then removed and hung somewhere else. I tend to favor the latter possibility, not only because of the ten cordholders but also because of the stone's exquisite state of preservation.

This is the most beautiful hieroglyphic carving at Palenque or any other Maya site. The calligraphic style recalls Maya writing cursively drawn freehand, the style appearing at Palenque after 9.14.0.0.0 (A.D. 711). It is indeed beautiful to behold, and it is amazing how such delicate workmanship could have been achieved with flint and obsidian tools. The limestone is perfectly smooth and flat, almost like the Bavarian stone used for etchings. The glyphs are incised and highlighted by beveling, just as was done in the calligraphic writing in the Maya codices. The writers made their strokes of the knife clean and

swept them in the manner that forms a curve that undulates from thin to thick in one stroke, in the same way they wrote their bark books. The swing of the knife had to be true the first time; this cursive writing or carving could not be labored over. Strokes, once made on the stone, could not be corrected. This type of carving is so difficult to do that it is no wonder there are not more examples of it. We see this type of carving also on the Creation Tablet and the Tablet of the God from the Palace.

The text of the Tablet of 96 Hieroglyphs starts out by saying that on 12 *Ahau* 8 *Ceh* the 11th katun was completed during the reign of *Mah K'ina* Pacal, he of the pyramid, *Ahpo* of Palenque. It then states that it was 11 days, 1 month, and 2 tuns until 9 *Chuen* 9 *Mac*, when Pacal took part in a fire event where he dedicated the white house in his house and is named the 5 katun *Ahpo*. There then is a D.N.I.G. (Distance Number Introductory Glyph) (at C2) *kin-akbal* (the change was day and night) and the statement that it was 17 days, 4 months, 8 tuns, and 2 katuns until Kan-Xul was seated as *ahpo* of the succession, III Jaguar-God, Emblem Glyph Bird name, and *Mah K'ina* Kan-Xul, *Ahaual* of Palenque. Kan-Xul was seated on the Jaguar throne with the *zac-cauac* title. Another D.N.I.G. appears at D8 with a skeletal *ahau*, and the text goes on to state that it was 14 days, 15 months, and 19 tuns until 9 *Ik* 5 *Kayab*, when *Mah K'ina* Chaacal, *Ah Nabi*, *Ahpo* of Palenque, was installed as ruler. At E7 another D.N.I.G. appears (star to moon) stating that it was 5 days, 14 months, 2 tuns, and 2 katuns until 9 *Manik* 15 *Uo*, when Kuk *Balam ahau, Mah K'ina, Ahpo*, he of the maize title, was installed. At G6 the last D.N.I.G. appears (*Ik* to *Imix*, or air to water), and it was 1 katun until 7 *Manik*, the seating of *Pax* was completed, and he (Kuk) completed his first katun as *Ahpo, Balam-ahau* of Palenque. His titles are listed—the maize title, *Xahau-te, Mah K'ina*, the 1 katun *ahau, bacab*. The text names him the child of the father Chaacal and the child of the mother Lady Men-Ahau, a lady of title. At L1 it states that it was 7 days since 13 *Ahau* 13 *Muan*, the Oxlahuntun (13 katuns) since he completed the first katun as *ahau* of the line of succession. The text refers again to the *Mah K'ina* Pacal, who is dead, and repeats that it was the first katun of Kuk as *ahau* of the succession of kings (after Schele 1985:95-100).

THE CREATION STONE
(*figs. 266-273*)

This beautiful fine Bavarian-type limestone tablet was found in the Tower Court by Miguel Angel Fernandez in 1963 near the spot where the Tablet of 96 Hieroglyphs was found. The tablet contains two more or less rectangular quatrefoil cartouches with a god figure wearing a mask of the god Chac-Xib-Chac in the right cartouche (figs. 267, 268) and a human figure in the same cross-legged pose in the left cartouche. Unfortunately, the stone was broken when found; the piece on the left with the human figure had been exposed to the elements and is badly eroded except for the lower right corner. The right piece was also broken, and a small section containing the figure's right foot is missing.

However, this right half of the stone was protected under soil, and the carving is in excellent condition. The complete stone is 95.5cm wide at its widest point and 68cm high. The right cartouche is 38cm x 32.6cm and the left one is only 0.7cm less in height. Above each cartouche is a glyphic panel, the inside dimensions of which are 34.2cm across by 7.8cm high for the right inscription and 25cm x 8.2cm for the left.

The figure in the right cartouche is the god Chac-Xib-Chac, the name being identified by David Stuart from the hieroglyphs on a Classic Maya plate illustrated in Schele and Miller's *Blood of Kings* (1986), Plates 122 and 122b. This god has many of the characteristics of GI and may possibly be related to him in some way we do not understand. He is the same god who is on the Tikal bone drawings and on the Metropolitan pot shown in Coe's *Lords of the Underworld* (1978), Vase #4 (fig. 269), and who is the central figure on the Dumbarton Oaks Tablet. The diadem worn by the god on the Creation Tablet is almost identical to the one shown on each of the named representations of Chac-Xib-Chac. Each figure has the vegetal scroll diadem in the form of the world tree with flourishing foliation and infixed crossed bands at the front, and each has the shell earpiece.

The god is seated on a cushion of a *Cauac* Monster with elaborate grape cluster under the eye, delicate strands of hair crossing over the lower part of the face, and a huge speech scroll issuing from the mouth in an outlined blob just like the one cartoonists use. The god is seated with the left leg folded in front of him; the right leg has the knee raised and the foot resting in front of the left foot. The ends of his loincloth lie across the head of the *Cauac* Monster. The position taken by the god is full of action even though he is seated. His head is thrust forward with mouth wide open as if he is delivering some terribly important or ominous verdict. Motion is indicated by his movement to the right and by the action displayed by both hands. The left arm is held out from the body with the forearm horizontal and the palm of the hand raised perpendicularly. The right arm is flung up and back away from the body.

The god's head (fig. 267) has the long upper lip with nose curl with bone extensions on top of it that is more commonly identified with God K. The fangs at the side of the mouth are embellished with dots, as is the ear curl. The scroll eye is encircled with a wide scroll outlining the eye, and small dots are underneath it. The long, slender speech scroll ends in a *le* leaf, an ancestral diagnostic, and probably rightly so, as the message could be an ancestral deliverance of great import to a new ruler or a message being spoken by a ruler impersonating the god. The hair is the curled topknot diagnostic of Chac-Xib-Chac. Surely the very best artist available carved this stone. The fine equidistant lines of the hair are perfectly controlled as they sweep in undulating curves to form the massive headpiece. Each little strand of hair is carved in a perfect zigzag. Corn foliation and plant leaves issue from both the hair and the headband. A streamer with crosshatched end is flung up behind the hair.

The figure wears the flexible wristlets of gods tied around the wrist with a knotted cord holding in place a strand of fibre that does not quite reach around the wrist. Water and shell symbols, characteristic of the Underworld, are on the god's arms and legs. The god wears an oval pectoral with a woven design in the center and flattened U's at each end,

the left one decorated with a pattern of close chevrons and the right one with just one line down the center. Three plant-foliation symbols are attached to each flattened U, the one on the left having a stylized bone-*ahau* attached to it. The pectoral is suspended by a wide macrame band. The god's belt is the type with crossed bands and jade symbol, tied on with three knots. The bone-*ahau* symbols are not the ordinary type, but more resemble stylized stingray spines with three sharp points and close-cut chevrons all the way down the center of the one dangling from the ear.

The figure in the left cartouche (figs. 270, 271) is a human seated in the same position as the god on the right on top of a cushion in the form of two gods. The left one is probably God C, and the one on the right is probably the head-variant form of GIII.

It is difficult to identify all of the clothing worn by this figure because of the very bad condition of the carving. The headdress is formed in a tightly pulled-up hairdo with what looks as if it might be a serpent form at the back. The front of the headpiece has a large shell with a three-lobed bell below it. Just below that is the typical shank of hair drawn through a jade bell and flopped down in front in the manner shown in the figures on the piers of House A. A huge disk is to the rear of the head from which long fine-feather streamers with beaded ends fall. All that can be seen of the pigtail is the long straight shank of hair held together by bead cylinders with tiny bone-*ahau*s on each side. The bottom is drawn through a larger bead and let fall in long flowing strands. The wristlets are the typical long-and-short-bead kind; however, the lower half of the wristlet appears to be made of a softer material, possibly fur, as shown on the right wrist. The figure wears a multiple necklace composed of a choker of very small beads tied around the neck with a cord and then a double strand of long and round beads. The pectoral is attached to the round beads and, like the one worn by the god in the other cartouche, is oval and has flanges to the sides. The figure wears a short skirt that is possibly made of a gauzelike material, indicated by fine wavy lines. The very bottom of the skirt can be seen at the left buttock where tiny wavy lines with small dots occur. The frontal belt piece is a shieldlike emblem with three curling flanges at the bottom.

In his right fist the figure holds a long coiled strand of hair that seemingly comes from the frontal hairpiece pulled through the bell flower. The ends coil through his fingers and separate into two parts, one being in the form of a serpent near the end. Just above the hand, the strands of hair separate and a long rod with claw end is thrust through. It is possible that this is meant to be an axe thrust through the figure's forehead hairpiece. The two figures in the cartouches on this stone have their backs turned to each other. Centered above each is a framed hieroglyphic inscription (figs. 272, 273).

GLYPHS FROM TEMPLE XVIII
(figs. 274, 275, 276)

The eighty large glyphs measuring approximately 12.5cm x 14.5cm each are, without exception, the most interesting and unusual group of glyphs at Palenque. They are all formed in high relief with deep cuts and undercuts. All of us at Palenque have always

dubbed them "cookie cutter" glyphs because they look as if they were made with a huge cookie cutter. Each one is a work of art in itself. As they were found in the debris of Temple XVIII, just south of the Temple of the Foliated Cross along the steep hillside, we do not know their proper order and so cannot read the inscription. We do, however, know what each glyph stands for. What a beautiful tablet they must have formed! They have much of the original paint still on them in the colors red, blue, and yellow. Most other painted glyphs are in only one color—red or blue, and sometimes in the two together.

The method of forming these glyphs was very different from the way most other glyphs were made. Most texts are carved in relief on limestone tablets (the Cross Group tablets and the text in the Temple of the Inscriptions) or incised into the stone (the Tablet of 96 Hieroglyphs). These were formed in stucco and then placed on the background. The text of Pier A of House A is made up of glyphs formed in this same manner. There some of the red paint on the background of the pier can still be seen where once there was a glyph. In other words, the Palencanos made stucco glyphs the same way they clothed figures. They first painted the surface upon which the glyph was to be placed and then adhered the individual glyph to that surface with stucco. Stucco glyphs placed within the boundaries of piers were also formed this same way.

LIMESTONE HUMAN BODY WITHOUT HEAD
(fig. 277)

This life-size human figure without head, carved in the round from white limestone, is from Temple II of the North Group. A male figure with very small waist and broad shoulders is seated cross-legged with hands bent across the knees. The body is bent forward at the waist. The arms are unusually massive in relation to the waist. The leveled-off base of the neck area is very large, indicating that the head must have been massive too. The carving is crude. The fingers of the hands are indicated by deep straight cuts. The figure is 49.5 cm high.

LIMESTONE TORSO
(fig. 278)

The body of this male figure in the round is about the same size as Figure 277 but is without limbs. It too is carved from a nearly white limestone. A large round-bead necklace hangs around the neck suspending a horizontal bar with the top portions of what were three long beads hanging from the pendant. No clothing is evident except the portion of the loincloth wrapped around the waist and the part that hangs over the front. The figure is 55 cm high.

HEAD AND MASK OF AN *INCENSARIO*-TYPE FIGURE
(*figs. 279, 280, 281*)

This beautiful incense burner stand from the Temple of the Foliated Cross is carved from white limestone in full-front view until it reaches the back of the head, where it becomes flattened out. The principal figure is the human head resting on the jawless head of a god and wearing the headdress of another god. It is very much like the clay *incensarios* so abundant at Palenque and recorded by R. L. Rands (1968) and B. C. Rands and Rands (1959) (fig. 282). It was the view of Proskouriakoff (in R. L. Rands 1968:521-22) that there was a sculptural tradition having basic affiliations with Tonina that influenced Copan significantly midway in the Formative Phase with figures using deep relief and full-front representation of the human figure. Rands outlines three traditions, or trait complexes, as he calls them, that involve frontal representation of the head. The first tradition that he brings out is "deep relief sculpture, almost in the round." We see this on many pieces from Tonina, and we saw it on the atypical Palenque Stela 1 where the stone shaft is left intact up the sides of the stela. Although this piece involves only the head, I believe that this tradition involving front-facing figure and a shaft of stone left at the sides has been carried out here and also in the clay incense burners as well. The flanges at the sides, highly carved both on the incense burners and on figural sculpture such as this piece, take the place of the stone shafts left at the centers of stelae.

The second tradition that Rands brings out concerns the "superimposition of grotesque masks, in tier-like arrangements, in the headdress," such as we have here. The lower mask is the jawless knot god with scroll eyes, and the headdress mask is the waterlily god, also jawless. The headdress god wears a shell with crosshatching in the center and a bow knot tied across it. Curled fangs and *tau* teeth extend from the nonexistent mouth. The end of the snout of the god has been broken off.

The human head, beautifully sculptured, had its nose broken off in ancient times, probably "killing" the individual. A band of long beads tipped with bone-*ahau* beads is worn across the forehead, the five at each side being longer. The stepped haircut of the human is shown only by eight wavy strands of hair on each side, but the stepped haircut can be seen on the headdress god.

The third tradition, the "convergence of patterned arrangements," can be seen on this piece, as well as on Palenque incense burners, especially on the flanges. At the base of the flange there is the serpent-wing motif, the knot god over the crossed-bands cartouche, square earplugs with serpent snout, and, above the earplug, another knot god, this time inverted. The side of the remaining flange on the right side is delicately carved in a hieroglyphic text (fig. 283).

The smooth white limestone has been carefully polished. The top of the knot under the figure's chin is perfectly level and is polished. There is red and blue paint on the figure. The back of the piece is painted red. The sculpture stands 46cm high.

DEATH HEAD MONUMENT
(*figs. 284, 285, 286*)

The stone Death Head Monument was found by Alfred Maudslay about fifteen meters southwest of the Temple of the Foliated Cross. It stands 68cm high and is 56cm broad. It was in two pieces, one more or less in the shape of a chair, with an inscription of twelve glyphs on the front and another of four glyphs on each side. The second piece, sculptured in the form of a "death head," a skeletal piece, was made to fit on top of the chairlike stone. In the photograph by Maudslay there appear to be two vertical pieces below the jaw. These, explains Maudslay (1896-1902:32), are not part of the sculpture but were put there by him to keep a piece of the broken-off stone in place. The skeletal form is not that of a human but of a monkey. The hieroglyphs are carefully cut, but the death head itself is quite crudely fashioned.

EPILOGUE

We have been looking at Palenque at the height of its florescence, during the reign of Chan-Bahlum, but including also references to the reign of his father, Pacal the Great. The history of Pacal's reign was taken up in detail in Volumes I and II of this series, but the first mention of his relationship to his parents, Lady Zac-Kuk and Kan-Bahlum-Mo', is in this volume in the story of the Olvidado. His parents had already died, but records that reinforced the legitimacy of Pacal's birth were inscribed in this small structure. The Olvidado is the earliest known architectural structure at Palenque, and it was around its vicinity that the site probably first evolved, shortly afterwards relocating in the area we now know as the center of Palenque, around the Temple of the Inscriptions, the Palace, the Cross Group, and the North Group.

The story of Pacal ends with the building of the Temple of the Inscriptions, and all references after that are posthumous—references in the inscriptions that provide proof of the legitimacy of the rulers of Palenque who followed after him. This has been the book of Chan-Bahlum and the story of the building of his life monument, the Cross Group temples. Chan-Bahlum has taken us further back than any other king. In the inscriptions in these three temples, he has gone into great detail in telling the story of the birth of the gods, his rightful ancestors. He did not consider them mythical. They were very real, but it had never before been recorded just when the father of all the gods (the Senior GI), the Mother Goddess, and their offspring, the triplets GI, GII, and GIII, were born, and in what order. With GII being the patron god of ancestors at Palenque, Chan-Bahlum recognized the need to record his history, a history undoubtedly known by all, but only in rhetoric.

We know a great deal about Chan-Bahlum and the numerous events that were part of his life, but there is nothing said in the inscriptions about a wife. As we know who the spouses of other kings were, we can only assume that Chan-Bahlum never took a wife.

We have seen how Palenque grew from a minor ceremonial center to a major metropolis during the reigns of Pacal and Chan-Bahlum. It continued to flourish during the reign of the next king, Chaacal III, until the time of his capture by lords of Tonina.

In ancient times Palenque was undoubtedly as famous for its public sculpture as it is today, especially for its fine sculptured portraiture in painted stucco. Portraiture started under the direction of Chan-Bahlum on the piers of the Temple of the Inscriptions and House A of the Palace, and was continued in bas-relief sculpture and sculptured piers in the Cross Group temples. After his death, Chaacal III continued this new type of public art in Temple XIV and on the piers of Houses D and A-D of the Palace. Although other sites—Comalcalco, for instance—tried to follow this trend of artistic expression, none came anywhere near comparing to it.

After the death of Chan-Bahlum in A.D. 702, Palenque continued as a major center for another hundred years, with the later years showing decline in public art. Palenque was one of the first centers on the western periphery to fall, and although it seems to have been abandoned, there is evidence of people living there after the fall. The gods who had looked after it all of the centuries could help no more. Why? Probably the Palencanos of ancient times asked just that question.

APPENDICES

APPENDIX I
COLOR NOTATIONS ACCORDING TO THE
MUNSELL BOOK OF COLOR

TEMPLE OF THE CROSS

Building walls red 10R 3/8, 5/8, 7/4; some red under
 blue
Pier B, south side
 Background red 10R 3/8, 3/6
 Feathers blue 2.5B 5/4 to 4/4 (darkest); 10R 3/6
 (lightest)
Pier B, east side
 Background wall red 10R 3/8, 7/4, 5/8 (10 layers of
 paint can be counted, last layer 7mm thick)
 red 10R 3/6 on stones of pier fill
 where stucco would be covering them; also on
 stones 10R 5/8, 6/8
Clothing and paraphernalia
 Bow red 10R 2/6, 5/8
 Feathers blue 7.5BG 6/4, 2.5B brightest; some red
 10R 7/4; some red under blue 10R 7/4 under
 7.5BG 6/4
God
 Lip red 10R 3/8
 Nose curl red 10R 6/8
Glyph blocks
 Glyphs blue 2.5B 5/4
 Underneath glyphs red 10R 3/6
Tablet in sanctuary
 Red 7.5R 3/6

TEMPLE OF THE SUN

PIER A

 Background red 10R 4/8, 3/8, 3/6
 Background of cartouche red 10R 3/6
 Inner side of cartouche red 10R 3/6
 Glyph blocks blue 2.5BG 5/4
 Under glyph blocks red 10R 3/6
 Le blue 7.5BG 5/4
 Border with serpent markings blue 2.5B 4/4
 Inner side of border red 10R 4/8

PIER B

 Background red 10R 3/6
 Border blue 7.5BG 5/4
 Leg red 10R 3/6
 Boot blue 7.5BG 5/4
 Sole of boot red 7.5R 3/6

PIER B, NORTH SIDE

 58cm up from bottom on right:
 1st paint on bearing wall of pier red wash 7.5R
 4/8
 2d red 10R 5/6, 5/8 1mm thick
 3d white
 4th red 10R 5/6, 5/8 0.125mm thick
 5th white
 6th red 10R 5/6 0.125mm thick
 Then numerous alternating layers of paint (6-10),
 the white getting thicker on the outer layers until
 8mm is reached
 Further up the layers become up to 1.3cm thick
 Area just below throne (up 157cm):
 1st red 10R 5/6
 Last red 10R 3/6-10R 2/6 (very dark) at a depth
 of 5mm
 Figure
 Beads on cape blue 2.5B 4/4
 Serpent blue 2.5B 4/4
 Feathers blue 2.5B 4/4
 Feathers on dress blue 2.5B 4/4

PIER C

 Background wall red 10R 3/6
 Wall below shield red 10R 3/8, 3/6
 Border red 7.5R 3/6
 Figure
 Body red 10R 4/8, 7.5R 5/6
 Wristlets blue 2.5B 3/6
 Shield red 10R 4/8
 Feather border Blue 2.5B 3/6
 Center red 7.5R 3/6
 Beads blue 2.5B 3/6
 Round wrist shield blue 2.5B 3/6
 Headdress blue 2.5B 3/6
 Serpent red 10R 6/6
 God blue 2.5B 3/6; 7.5BG 5/4
 Jaguar tail yellow 7.5YR 6/10

TABLET IN SANCTUARY

 Only remains red 7.5R 3/6
 Sanctuary vault and under vault spring red 7.5R 3/6
 15mm thick

TEMPLE OF THE FOLIATED CROSS

Background walls some red 7.5R 3/6
Sanctuary roof red 10R 5/8, 5/6, 4/4, 3/4
Tablet red 7.5R 3/6

TEMPLE XIV

Background red 10R 4/8, 3/8; 5YR 5/10
Border red 10R 4/8
Glyphs vivid blue 7.5BG 5/6, 4/3, 3/6, 3/4; 2.5B 5/4,
 6/4
 Figure
 Face red 10R 5/6
 Body red 10R 5/6, 5/4
 Clothing
 Skirt beads blue 7.5BG 4/4
 Mask on belt blue 7.5BG 4/4
 Loincloth blue 2.5B 3/4
 Anklets blue 2.5B 3/4
 Feathers blue 7.5BG 4/4
 Headdress feathers blue 2.5B 5/4
 Belt blue 2.5B 5/4
 Skirt red 7.5R 5/6

TEMPLE OF THE JAGUAR

Background red 7.5R 3/6, 4/8
Border blue 7.5BG 5/4
Jaguar
 Leg blue 7.5BG 5/4
 Anklet blue 7.5BG 5/4
 Feet blue 7.5BG 5/4
 Bow tie blue 7.5BG 5/4

NORTH GROUP TEMPLES

Background red wash 10R 9/2, 8/2
Interior walls red 7.5R 4/8, 3/6; 10R 6/6, 4/8, 4/6
Exterior walls red 7.5R 3/6, 4/8

TEMPLE II

 Pier A, south face
 Background red 10R 7/4, 6/6
 Border red 10R 7/4
 Figure red 10R 6/6; 7.5R 5/6
 Feathers under arm red 7.5R 7/4
 Pier B, south face
 Background red 10R 5/6
 Feathers 1st red 10R 5/6
 2d blue 7.5BG 5/4; 2.5B 3/4
 Serpent
 Feathers 1st red 10R 5/6
 2d white
 3d blue 7.5BG 4/4
 Scales red 7.5R 6/4
 God K
 Body blue 7.5BG 4/4
 Face blue 7.5BG 4/4
 Shell on Quadripartite God blue 2.5B 5/4, 7/4

OLVIDADO

Almost all of the remaining paint is a very dark red 7.5R
 6/4
 Many layers of repainting:
 1st red wash 7.5R 8/12
 2d red 7.5R 4/6, 4/3
 3d white
 4th red 7.5R 3/6
 5th white
 6th red 7.5R 4/6
 The last layer is much finer than the earlier layers
 (up to 0.5cm thick)
 Piers B and C
 Cloak pink wash red 7.5R 6/4
 Foot red 7.5R 3/6, 6/4
 Sole of boot red 7.5R 3/4, 3/2
 Pier D
 Background red 7.5R 3/4, 3/6
 Serpent cartouche red 7.5R 3/4, 3/6

APPENDIX II
ARCHITECTURAL DATA

(in centimeters)

Structure	Room Width	Wall Thickness		Floor to Capstone	Floor to Vault Spring	Vault Spring to Capstone
		Outer	Inner			
South Subterranean Building	237	83	80	338	218	120
Olvidado	120-128	100		435	200	235
House E	244	59	60	503	262-264	239
House B	240 NE	95	82	456	315	141
	219 NW					
House C	270-275	91	82	492	297-300	192
House A	230 W	91		584	300	284
	225 E					
House D	215	90.5		600	300	300
Houses G and H	98	62	65	338	213	125
House F	250	57	67	328	216	112
Temple of the Inscriptions	200	118		600	307	293
Temple of the Cross	288	90	114-127	646	325	321
Temple of the Sun	288	96	114	650	323	327
Temple of the Foliated Cross	303	90	137	620	320	300
Temple of the Jaguar	195	60	60	400	250	150

APPENDIX III
CORRECTIONS TO THE
MAUDSLAY DRAWINGS

The Maudslay drawings are incredibly well done, especially considering the circumstances under which they were made. However, there are a few minor changes.

TEMPLE OF THE CROSS

TABLET

Left figure

Headdress: There are leaf veins in all three leaves.
There is a design in all three cloth flaps, but different from the Maudslay design.

Bead necklace: There are five definite beads.

Quadripartite scepter: There is a stingray spine in the center.

Right figure

Skirt: The fringe is not the same.

Jester god: The face is definitely there.
A foot is shown.

Hat: There are veins in the leaves.

WEST JAMB

Headdress: There are teeth in the heron's mouth.
There are serpent markings on the heron's body.
There is a mirror in the snout of the long-lipped god.
There are jaguar markings on the long-lipped god.

Belt: There are three jaguar marks in the jaguar's eye.

Leggings: There is a band with jaguar marks around the ankle.

TEMPLE OF THE SUN

RIGHT JAMB

Shoulder cape: The beaded pattern is quite different.

Pectoral: The two protuberances shown are not there.

Skirt: The fringe is quite different.
The beaded pattern is different.

Bag: A very different bag is depicted.

Wristlets: The beads are square, not round.

Backpack: The straps that hold it on are shown.

Loincloth: The bottom and top ribbons are different.
There is a double knot on front and back.

Leg straps: A horizontal jaguar band is at the bottom.

Shoes: There are many more jaguar spots, and they are in a random pattern.

TABLET

Left figure

Hat: The design on the flaps is different.

Muffler: There are no circular holes at the bottom.

Right figure

The male haircut shows.

Horizontal bar: There are teeth in the jaguar's open mouth.

The *ahau* on top of the jaguar head is not upside down.

TABLES

TABLE I
GENEALOGY OF THE GODS AT PALENQUE

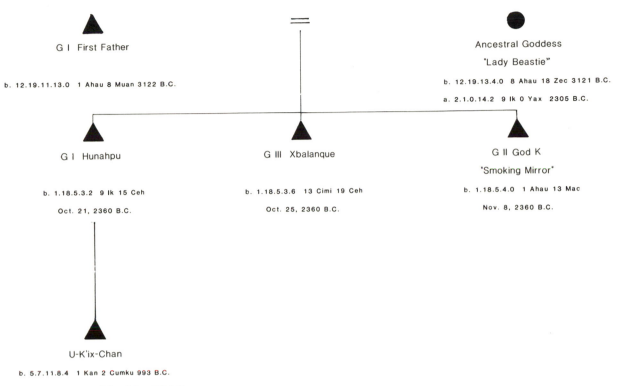

G I First Father

b. 12.19.11.13.0 1 Ahau 8 Muan 3122 B.C.

Ancestral Goddess

"Lady Beastie"

b. 12.19.13.4.0 8 Ahau 18 Zec 3121 B.C.

a. 2.1.0.14.2 9 Ik 0 Yax 2305 B.C.

G I Hunahpu

b. 1.18.5.3.2 9 Ik 15 Ceh

Oct. 21, 2360 B.C.

G III Xbalanque

b. 1.18.5.3.6 13 Cimi 19 Ceh

Oct. 25, 2360 B.C.

G II God K

"Smoking Mirror"

b. 1.18.5.4.0 1 Ahau 13 Mac

Nov. 8, 2360 B.C.

U-K'ix-Chan

b. 5.7.11.8.4 1 Kan 2 Cumku 993 B.C.

a. 5.8.17.15.17 11 Caban 0 Pop 967 B.C.

TABLE II
GENEALOGY OF RULERS AT PALENQUE

HISTORICAL ANCESTORS

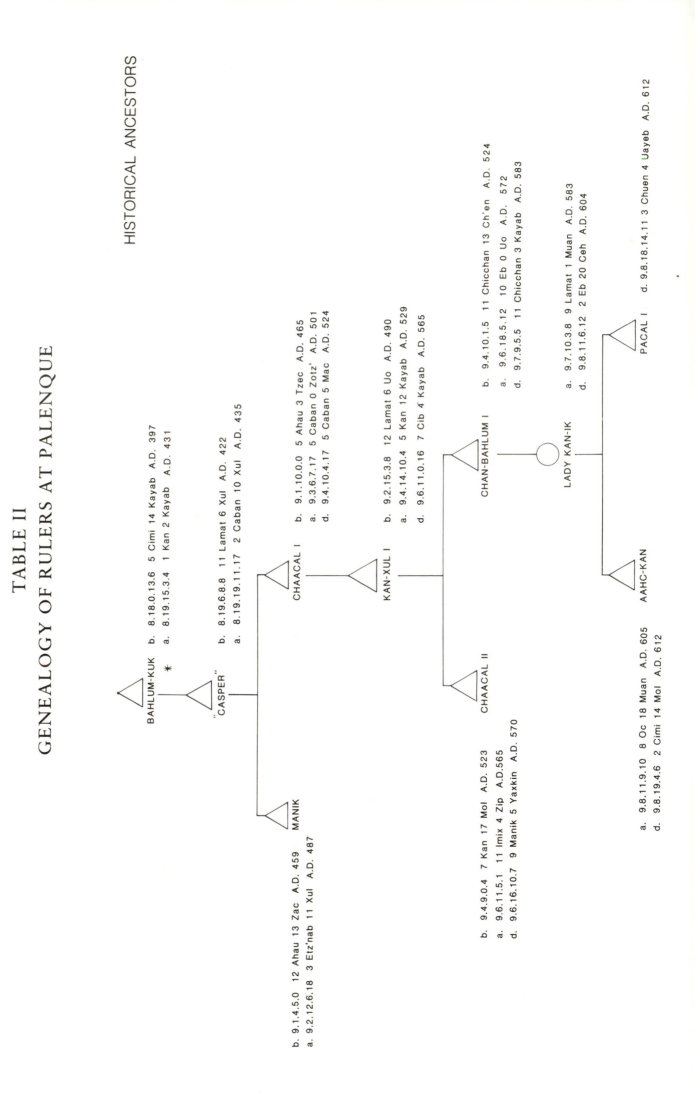

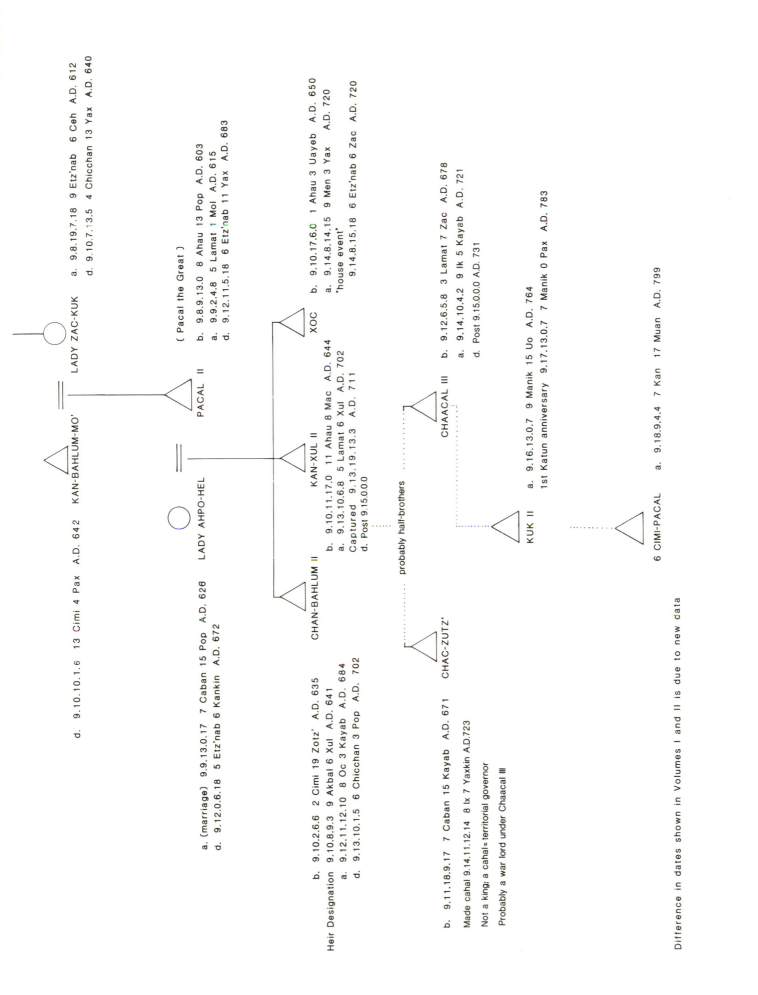

Difference in dates shown in Volumes I and II is due to new data

BIBLIOGRAPHY

Acosta, Jorge R.

1973 "Exploraciones en Palenque, 1968, 1970." *Anales del Instituto Nacional de Antropología e Historia.* Vol. III, No. 51. México, pp. 21-70.

1975 "Exploraciones en Palenque, 1970." *Anales del Instituto Nacional de Antropología e Historia.* Vol. IV, No. 52. México, pp. 347-373.

1976 "Exploraciones en Palenque temporada 1973-1974." *Anales del Instituto Nacional de Antropología e Historia.* Vol. V, No. 53. México, pp. 43-62.

American Society for the Testing of Materials

1974 *Standard Methods for Visual Evaluation of Color Differences of Opaque Materials.* The Annual Book of ASTM Standards, Philadelphia.

Attinasi, John Joseph

1973 "Lak T'an: A Grammar of the Chol (Mayan) Word." Ph.D. dissertation, University of Chicago.

Aveni, Anthony F.

1980 *Sky Watchers of Ancient Mexico.* University of Texas Press, Austin.

Bardawil, Lawrence W.

1976 "The Principal Bird Deity in Maya Art—An Iconographic Study of Form and Meaning." In *Segunda Mesa Redonda de Palenque,* Part III. Merle Greene Robertson ed. Pre-Columbian Art Research Center, Robert Louis Stevenson School, Pebble Beach, California, pp. 195-209.

Barrera Vásquez, Alfredo

1980 *Diccionario Maya Cordemex.* Ediciones Cordemex. Mérida, Yucatan.

Barthell, Thomas S.

1961 "Die Inschriftenanalyse als Hilfsmittel zur Rekonstruktion der klassischen Mayageschichte." In *Homage to Hermann Beyer. El México Antiguo.* Vol. 9. México, pp. 173-181.

Bassie, Karen

1990 *From the Mouth of the Dark Cave: Commemorative Art of the Late Classic Maya.* University of Oklahoma Press, Norman.

Baudez, Claude, and Peter Mathews

1979 "Capture and Sacrifice at Palenque." In *Tercera Mesa Redonda de Palenque,* Vol. IV. Merle Greene Robertson general ed. Donnan Call Jeffers ed. Pre-Columbian Art Research Center, Palenque, Chiapas, México, pp. 31-40.

Benson, Elizabeth P.

1976 "Ritual Cloth and Palenque Kings." In *Segunda Mesa Redonda de Palenque,* Part III. Merle Greene Robertson ed. Pre-Columbian Art Research Center, Robert Louis Stevenson School, Pebble Beach, California, pp. 45-58.

Berlin, Heinrich

1944 "Un Temple Olvidado en Palenque." *Revista Mexicana de Estudios Antropología.* Vol. VI, Nos. 1-2. Sociedad Mexicana de Antropología, México, pp. 62-90.

1963 "The Palenque Triad." *Journal de la Société des Américanistes.* Vol. LII. Paris, pp. 91-99.

1965 "The Inscriptions of the Temple of the Cross at Palenque." *American Antiquity.* Vol. XXX, No. 3. Menasha, Wisconsin, pp. 330-342.

1968 "The Tablet of the 96 Glyphs at Palenque, Chiapas, Mexico." In *Middle American Research Institute,* Pub. 26. Tulane University, New Orleans, pp. 135-149.

1977 *Signos y significados en las inscripciones Mayas.* Instituto Nacional del Patrimonio Cultural de Guatemala, Guatemala.

Berlin, Heinrich, and David H. Kelley

1970 "The 819-Day Count and Color-Direction Symbolism among the Classic Maya." In *Middle American Research Institute,* Pub. 26. Tulane University, New Orleans, pp. 9-20.

Beyer, Hermann

1937 *Studies on the Inscriptions of Chichén Itzá.* Carnegie Institution of Washington. Pub. 483, Contribution 21. Washington, D.C.

Blom, Frans, and Oliver La Farge

1926 *Tribes and Temples: A Record of the Expedition to Middle America Conducted by Tulane University of Louisiana in 1925.* Vol. I. Middle American Research Institute. Pub. 1. Tulane University, New Orleans.

Bowles, John H.

1974 "Notes on a Floral Form Represented in Maya Art and Its Iconographic Implications." In *Primera Mesa Redonda de Palenque,* Part I. Merle Greene Robertson ed. Pre-Columbian Art Research Center, Robert Louis Stevenson School, Pebble Beach, California, pp. 121-128.

Brasseur de Boubourg, Charles Etienne

1851 *Lettres pour servir d'introduction à l'histoire primitive des nations civilisées de l'Amérique Septentrionale, adressées à Monsieur le Duc de Valmy. Cartas para servir de introducción a la historia primitiva de las naciones civilizadas de la America Septentrional.* M. Murguía, México.

Bricker, Victoria

1985 "Notes on Classic Maya Metrology." In *Fifth Palenque Round Table, 1983,* Vol. VII. Merle Greene Robertson general ed. Virginia M. Fields ed. Pre-Columbian Art Research Institute, San Francisco, pp. 189-192.

1986 *A Grammar of Mayan Hieroglyphs.* Middle

American Research Institute, Tulane University. Pub. 56. Tulane University, New Orleans.

1987 "Landa's Second Grapheme for *u*." In *Research Reports on Ancient Maya Writing*, No. 9. Center for Maya Research, Washington D.C., pp. 15-18.

Brown, Leslie, and Dean Amadon

1968 *Eagles, Hawks and Falcons of the World*. Vol. II. Country Life Books, London.

Campbell, Lyle

1984 "The Implication of Mayan Historical Linguistics for Glyphic Research." In *Phoneticism in Mayan Hieroglyphic Writing*. John N. Justeson and Lyle Campbell eds. Institute for Mesoamerican Studies. Pub. 9. State University of New York at Albany, Albany, pp. 1-16.

Carlson, John B.

1981 "A Geometric Model for the Interpretation of Mesoamerican Sites: An Essay in Cross-Cultural Composition." In *Mesoamerican Sites and World-Views*. Publication of a conference at Dumbarton Oaks, October 16 and 17, 1976. Dumbarton Oaks, Washington, D.C., pp. 143-211.

Catherwood, Frederick

1965 *Views of Ancient Monuments in Central America, Chiapas and Yucatan*. A limited edition of 500 copies published by Barre Publishers, Barre, Massachusetts, and printed by the Meriden Gravure Company, Meriden, Connecticut, from a hand-painted set of the 1844 London edition in the library of Edwin M. Shook, Harvard University, Cambridge, Massachusetts. L.C.C. No. 65-16659.

1978 *Visión del mundo Maya—1884 Frederick Catherwood*. Mario de la Torre y Rabasa ed. Carton y Papel de México, México.

Chang, K. C.

1983 *Art, Myth, and Ritual: The Path to Political Authority in Ancient China*. Harvard University Press, Cambridge, Massachusetts.

Clancy, Flora

1986 "Text and Image in the Tablets of the Cross Group at Palenque." In *Rez*. Vol. XI (Spring). Peabody Museum of American Archaeology and Ethnology, Harvard University, Cambridge, Massachusetts, pp. 17-32.

Closs, Michael

1987 "Bilingual Glyphs." In *Research Reports on Ancient Maya Writing*, No. 12. Center for Maya Research, Washington, D.C., pp. 5-12.

Coe, Michael D.

1973 *The Maya Scribe and His World*. The Grolier Club, New York.

1975 "Death and the Ancient Maya." In *Death and the Afterlife in Pre-Columbian America*. Publication of a conference at Dumbarton Oaks, October 27, 1973. Elizabeth Benson ed. Dumbarton Oaks, Washington, D.C., pp. 87-104.

1978 *Lords of the Underworld: Masterpieces of Classic Maya Ceramics*. Princeton University Press for the Art Museum, Princeton University.

Cohodas, Marvin

1973 "The Iconography of the Panels of the Sun, Cross, and Foliated Cross at Palenque, Part I." *Sociedad Mexicana de Antropología*. México.

1974 "The Iconogaphy of the Panels of the Sun, Cross, and Foliated Cross at Palenque, Part II." In *Primera Mesa Redonda de Palenque*, Part II. Merle Greene Robertson ed. Pre-Columbian Art Research Center, Robert Louis Stevenson School, Pebble Beach, California, pp. 95-108.

1976 "The Iconography of the Panels of the Sun, Cross, and Foliated Cross at Palenque, Part III." In *Segunda Mesa Redonda de Palenque, 1974*, Part III. Merle Greene Robertson ed. Pre-Columbian Art Research Center, Robert Louis Stevenson School, Pebble Beach, California, pp. 155-176.

Del Rio, Captain Antonio

1822 *Description of the Ruins of an Ancient City, Discovered near Palenque, in the Kingdom of Guatemala, in Spanish America*. Henry Berthoud, London.

Dütting, Dieter

1980 "Aspects of Classic Maya Religion and World View." *Tribus*. No. 29. Linden Museum, Stuttgart, pp. 106-167.

1982 "The 2 Cib 14 Mol Event in the Inscriptions of Palenque, Chiapas, Mexico." *Zeitschrift für Ethnologie*. Vol. CVII. Berlin, pp. 233-258.

1984 "Venus, the Moon, and the Gods of the Palenque Triad." *Zeitschrift für Ethnologie*. Vol. CIX, Part 1. Berlin.

1985 "On the Astronomical Background of Mayan Historical Events." In *Fifth Palenque Round Table, 1983*, Vol. VII. Merle Greene Robertson general ed. Virginia M. Fields ed. Pre-Columbian Art Research Institute, San Francisco, pp. 261-274.

Edmonson, Munro

1971 *The Book of Counsel: The Popol Vuh of the Quiche Maya of Guatemala*. Middle American Research Institute. Pub. 35. Tulane University, New Orleans.

Evreinov, E. V., Y. G. Kosarev, and V. A. Ustinov

1961 "Investigation of Ancient Mayan Manuscripts with the Aid of an Electronic Computer: Methods; Investigation . . . Computer: Algorithms and Programs; Investigation . . . Computer: Preliminary Results; Foreign Developments in Machine Translation and Information Processing." Mimeographed. U. S. Department of Commerce, Office of Technical Services. No. 40. Washington, D.C.

Fahsen, Frederico

1987 "A Glyph for Self-Sacrifice in Several Maya Inscriptions." In *Research Reports of Ancient Maya Writing*, No. 11. Center for Maya Research, Washington, D.C., pp. 1-4.

Feuchtwang, Stephan D. R.
 1974 "An Anthropological Analysis of Chinese Geo-
 mancy." In *Collection "Connaissance de l'Aisie,"*
 Vol. I. Vithagna, Vientiane, Laos.
Förstemann, Ernst
 1892 *Commentar zur Mayahandschrift der König-
 lichen Öffentlichen Bibliothek zu Dresden.* Dres-
 den. (For English translation, see Förstemann
 1906.)
 1894 "Die Mayahieroglyphen." *Globus.* Vol. LX.
 Braunschweig, pp. 30-32.
 1906 *Commentary on the Maya Manuscript in the
 Royal Public Library of Dresden.* Papers of the
 Peabody Museum of American Archaeology and
 Ethnology, Harvard University. Vol. 4, No. 2.
 Cambridge, Massachusetts.
Fox, James A., and John S. Justeson
 1984 "Polyvalence in Maya Hieroglyphic Writing." In
 Phoneticism in Mayan Hieroglyphic Writing.
 John S. Justeson and Lyle Campbell eds. Institute
 for Mesoamerican Studies. Pub. 9. State Univer-
 sity of New York at Albany, Albany, pp. 315-
 362.
Freidel, David A.
 1985 "Knot Skull and Shining Seed: Death, Rebirth,
 and Heroic Amplification in the Lowland Maya
 Ballgame." Paper delivered at the International
 Symposium on the Mesoamerican Ballgame, Tuc-
 son, Arizona, November 20-23.
García-Moll, Roberto
 1982 *Las ruinas de Palenque por Frans Blom.* Insti-
 tuto Nacional de Antropología e Historia, Mé-
 xico.
Gates, William
 1931 *An Outline Dictionary of Maya Glyphs.* Maya
 Society, Baltimore.
Goetz, Delia, and Sylvanus G. Morley
 1950 *Popol Vuh: The Sacred Book of the Quiche
 Maya.* From the translation of Adrian Recinos.
 University of Oklahoma Press, Norman.
Greene Robertson, Merle
 1975 "Stucco Techniques Employed by Ancient
 Sculptors of the Palenque Piers." *Actas del XLI
 Congreso Internacional de Americanistas, Mé-
 xico, 2 al 7 de septiembre de 1974.* Vol. I. Mé-
 xico, pp. 449-472.
 1977 "Painting Practices and Their Change through
 Time of the Palenque Stucco Sculptors." In *Social
 Process in Maya Prehistory: Studies in Honour of
 Sir Eric Thompson.* Norman Hammond ed. Ac-
 ademic Press, London, pp. 297-326.
 1979a "A Sequence for Palenque Painting Tech-
 niques." In *Maya Archaeology and Ethnohistory.*
 Norman Hammond and Gordon R. Willey eds.
 University of Texas Press, Austin, pp. 149-171.
 1979b "An Iconographic Approach to the Identity of
 the Figures on the Piers of the Temple of the In-
 scriptions." In *Tercera Mesa Redonda de Palen-
 que,* Vol. IV. Merle Greene Robertson general ed.

Donnan Call Jeffers ed. Pre-Columbian Art Re-
 search Center, Palenque, Chiapas, México, pp.
 129-138.
 1983 *The Sculpture of Palenque.* Vol. I: *The Temple
 of the Inscriptions.* Princeton University Press,
 Princeton, New Jersey.
 1985a *The Sculpture of Palenque.* Vol. II: *The Early
 Buildings of the Palace and the Wall Paintings.*
 Princeton University Press, Princeton, New Jer-
 sey.
 1985b *The Sculpture of Palenque.* Vol. III: *The Late
 Buildings of the Palace.* Princeton University
 Press, Princeton, New Jersey.
 1985c "57 Varieties: The Palenque Beauty Salon." In
 Fourth Palenque Round Table, 1980, Vol. VI.
 Merle Greene Robertson general ed. Virginia M.
 Fields ed. Pre-Columbian Art Research Institute,
 San Francisco, pp. 29-44.
Greene Robertson, Merle, Marjorie Rosenblum Scan-
 dizzo, and John R. Scandizzo
 1976 "Physical Deformities in the Ruling Lineage of
 Palenque and the Dynastic Implications." In *Se-
 gunda Mesa Redonda de Palenque,* Part III.
 Merle Greene Robertson ed. Pre-Columbian Art
 Research Center, Robert Louis Stevenson School,
 Pebble Beach, California, pp. 59-68.
Grube, Nikolai, and David Stuart
 1986 "An Investigation of the Primary Standard Se-
 quence on Classic Maya Ceramics." Paper pre-
 sented at the Sexta Mesa Redonda de Palenque,
 Palenque, Chiapas, México, June.
 1987 "Observations on T110 as the Syllable *Ko.*" In
 Research Reports on Ancient Maya Writing, No.
 8. Center for Maya Research, Washington, D.C.,
 pp. 1-14.
Hammond, Norman, and Gordon R. Willey eds.
 1979 *Maya Archaeology and Ethnohistory.* Univer-
 sity of Texas Press, Austin.
Hopkins, Nicholas
 1985 "On the History of the Chol Language." In *Fifth
 Palenque Round Table, 1983,* Vol. VII. Merle
 Greene Robertson general ed. Virginia M. Fields
 ed. Pre-Columbian Art Research Institute, San
 Francisco, pp. 1-5.
 1990 "Classic and Modern Relationship Terms and
 the 'Child of Mother' Glyph (T:606.23)." In
 Sixth Palenque Round Table, 1986, Vol. VIII.
 Merle Greene Robertson general ed. Virginia M.
 Fields ed. University of Oklahoma Press, Nor-
 man.
Houston, Stephen D.
 1983 "A Reading for the Flint-Shield Glyph." In *Con-
 tributions to Maya Hieroglyphic Decipherment,*
 No. 1. Stephen D. Houston ed. Human Relations
 Area Files, Inc., Books, NV4-001, Language and
 Literature Series. Human Relations Area Files,
 Inc., New Haven, Connecticut, pp. 13-25.
 1986 "Problematic Emblem Glyphs: Examples from
 Altar de Sacrificios, El Chorro, Río Azul, and

Xultun." In *Research Reports on Ancient Maya Writing*, No. 3. Center for Maya Research, Washington, D.C., pp. 1-11.

Houston, Stephen D., and Peter Mathews

1985 *The Dynastic Sequence of Dos Pilas, Guatemala*. Monograph 1. Pre-Columbian Art Research Institute, San Francisco.

Jones, Tom

1987 Discussion of the rulership glyphs, Texas Glyph Conference, Austin, March.

Joralemon, David

1974 "Ritual Blood-Sacrifice among the Ancient Maya: Part I." In *Primera Mesa Redonda de Palenque,* Part III. Merle Greene Robertson ed. Pre-Columbian Art Research Center, Robert Louis Stevenson School, Pebble Beach, California, pp. 59-75.

Josserand, Kathryn

1987 In Linda Schele, *Notebook for the Maya Hieroglyphic Writing Workshop at Texas.* University of Texas, Austin.

1990 "The Narrative Structure of Hieroglyphic Texts at Palenque." In *Sixth Palenque Round Table, 1986,* Vol. VIII. Merle Greene Robertson general ed. Virginia M. Fields ed. University of Oklahoma Press, Norman.

Justeson, John S.

1984 "Interpretation of the Mayan Hieroglyphs. Appendix B." In *Phoneticism in Mayan Hieroglyphic Writing.* John S. Justeson and Lyle Campbell eds. Institute of American Studies. Pub. 9. State University of New York at Albany, Albany, pp. 315-362.

Kelley, David H.

1962 "A History of Decipherment of Maya Script." *Anthropological Linguistics.* Vol. IV, No. 8. Bloomington, Indiana, pp. 1-48.

1965 "The Birth of the Gods at Palenque." *Estudios de Cultura Maya.* Vol. V. México, pp. 93-134.

1976 *Deciphering the Maya Script.* University of Texas Press, Austin.

1980 "Astronomical Identities of Mesoamerican Gods." In *Archaeoastronomy. Journal for the History of Astronomy,* supplement to Vol. II. Science History Publications Ltd., Buckinghamshire, England, pp. S1-S54.

Kelley, David H., and K. Ann Kerr

1973 "Mayan Astronomy and Astronomical Glyphs." In *Mesoamerican Writing Systems: A Conference at Dumbarton Oaks, Oct. 30th and 31st, 1971.* Elizabeth P. Benson ed. Dumbarton Oaks, Washington, D.C., pp. 179-215.

Kidder, Alfred V., Jesse D. Jennings, and Edwin M. Shook

1946 *Excavations at Kaminaljuyu, Guatemala.* Pub. 561. Carnegie Institution of Washington, Washington, D.C.

Knorozov, Yuri V.

1967 *Selected Chapters from "The Writing of the Maya Indians."* Sophie Coe trans. Tatiana Proskouriakoff collaborating ed. Russian Translation Series of the Peabody Museum of American Archaeology and Ethnology, Vol. IV. Harvard University, Cambridge, Massachusetts.

Kubler, George

1962 *The Art and Architecture of Ancient America: The Mexican, Maya, and Andean Peoples.* Penguin Books, Baltimore.

1967 *The Iconography of the Art of Teotihuacán.* Studies in Pre-Columbian Art. No. 4. Dumbarton Oaks, Washington, D.C.

1969 *Studies in Classic Maya Iconography.* Memoirs of the Connecticut Academy of Arts and Sciences. Vol. XVIII. New Haven, Connecticut.

1972 "The Paired Attendants of the Temple Tablets at Palenque." In *Sociedad Mexicana de Antropología: Religión en Mesoamerica: XII Mesa Redonda.* México, pp. 317-328.

1973 "The Clauses of Classic Maya Inscriptions." In *Mesoamerican Writing Systems: A Conference at Dumbarton Oaks, Oct. 30th and 31st, 1971.* Elizabeth P. Benson ed. Dumbarton Oaks, Washington, D.C., pp. 145-164.

1974 "Climate and Iconography in Palenque Sculpture." In *Art and Environment in Native America.* Mary Elizabeth King ed. Special Publications, The Museum. Texas Tech University, Lubbock, pp. 103-113.

1977 *Aspects of Classic Maya Rulership on Two Inscribed Vessels.* Studies in Pre-Columbian Art and Archaeology. No. 18. Dumbarton Oaks, Washington, D.C.

Landa, Diego de

ca. 1566 *Relación de las cosas de Yucatan.* See Tozzer 1941.

Lounsbury, Floyd G.

1973 "On the Derivation and Reading of the 'Ben-Ich' Prefix." In *Mesoamerican Writing Systems: A Conference at Dumbarton Oaks, Oct. 30th and 31st, 1971.* Elizabeth P. Benson ed. Dumbarton Oaks, Washington, D.C., pp. 99-144.

1974a "Pacal." In *Primera Mesa Redonda de Palenque,* Part I. Merle Greene Robertson ed. Pre-Columbian Art Research Center, Robert Louis Stevenson School, Pebble Beach, California, p. ii.

1974b "The Inscriptions of the Sarcophagus Lid at Palenque." In *Primera Mesa Redonda de Palenque,* Part II. Merle Greene Robertson, ed. Pre-Columbian Art Research Center, Robert Louis Stevenson School, Pebble Beach, California, pp. 5-20.

1976 "A Rationale for the Initial Date of the Temple of the Cross at Palenque." In *Segunda Mesa Redonda de Palenque,* Part III. Merle Greene Robertson ed. Pre-Columbian Art Research Center, Robert Louis Stevenson School, Pebble

Beach, California, pp. 211-224.

1980 "Some Problems in the Interpretation of the Mythological Portion of the Hieroglyphic Text of the Temple of the Cross at Palenque." In *Third Palenque Round Table, 1978*, Vol. V. Merle Greene Robertson ed. University of Texas Press, Austin, pp. 99-115.

1983 "Glyphic Values: T99, 155, 279, 280." In *Contributions to Maya Hieroglyphic Decipherment*, No. 1. Stephen D. Houston ed. Human Relations Area Files, Inc., Books, NV4-001, Language and Literature Series. Human Relations Area Files, Inc., New Haven, Connecticut, pp. 44-49.

1985 "The Identities of the Mythological Figures in the Cross Group Inscriptions of Palenque." In *Fourth Palenque Round Table*, Vol. VI. Merle Greene Robertson general ed. Elizabeth P. Benson ed. Pre-Columbian Art Research Institute, San Francisco, pp. 45-58.

Mathews, Peter

1983 *Corpus of Maya Hieroglyphic Inscriptions*. Vol. VI, Part 1: *Tonina*. Peabody Museum of American Archaeology and Ethnology, Harvard University, Cambridge, Massachusetts.

1984a "A Maya Hieroglyphic Syllabary." Appendix A in *Phoneticism in Mayan Hieroglyphic Writing*. John S. Justeson and Lyle Campbell eds. Institute for Mesoamerican Studies. Pub. 9. State University of New York at Albany, Albany, pp. 311-314.

1984b "Patterns of Sign Substitution in Maya Hieroglyphic Writing: The Affix Cluster." In *Phoneticism in Mayan Hieroglyphic Writing*. John S. Justeson and Lyle Campbell eds. Institute for Mesoamerican Studies. Pub. 9. State University of New York at Albany, Albany, pp. 185-231.

Mathews, Peter, and Merle Greene Robertson

1985 "Notes on the Olvidado, Palenque, Chiapas, Mexico." In *Fifth Palenque Round Table 1983*, Vol. VII. Merle Greene Robertson, general ed. Virginia M. Fields ed. Pre-Columbian Art Research Institute, San Francisco, pp. 7-17.

Mathews, Peter, and Linda Schele

1974 "Lords of Palenque: The Glyphic Evidence." In *Primera Mesa Redonda de Palenque*, Part I. Merle Greene Robertson ed. Pre-Columbian Art Research Center, Robert Louis Stevenson School, Pebble Beach, California, pp. 63-76.

Maudslay, Alfred Percival

1896-1899 *Biologia Centrali-Americana: Archaeology*. Vol. IV, Plates. R. H. Porter and Dulau & Co., London.

1896-1902 *Biologia Centrali-Americana: Archaeology*. Vol. IV, Text. R. H. Porter and Dulau & Co., London.

1974 *Biologia Centrali-Americana: Archaeology*. Vols. III and IV, Plates; Vol. V, Text. Francis Robicsek ed. Milpatron Publishing Corp., New York.

Miller, Jeffrey. *See* Schele and Miller 1974.

Miller, Mary Ellen

1986 *The Murals of Bonampak*. Princeton University Press, Princeton, New Jersey.

Moran, Pedro

1935 *Arte y diccionario en lengua Cholti*. A manuscript copied from the "Libro Grande" of Fray Pedro Moran of about 1625. Maya Society. No. 9. Baltimore.

Morley, Sylvanus Griswold

1915 *An Introduction to the Study of Maya Hieroglyphs*. Reprinted, Dover Publications, New York, 1975.

1916 "The Supplementary Series in the Maya Inscriptions." In *Holmes Anniversary Volume*. Washington, D.C., pp. 366-396.

1937-1938 *The Inscriptions of Peten*. 5 vols. Carnegie Institution of Washington. Pub. 437. Washington, D.C.

1946 *The Ancient Maya*. Stanford University Press, Stanford, California.

Munsell Book of Color

1966 *Munsell Book of Color*. Macbeth Division, Kolmorgan Corporation, Baltimore.

Needham, Joseph

1959 *Science and Civilization in China*. Vol. 3. Cambridge University Press, Cambridge.

Nowak, Ronald, and John L. Paradiso

1983 *Walker's Mammals of the World*. Vol. II. Johns Hopkins University Press, Baltimore.

Oviedo y Valdés, Gonzalo Fernández de

1535 *Historia general y natural de las Indias, islas y tierrefirme del mar oceano*. 4 vols. Seville, 1851-1855.

Peterson, Katherine A.

1985 "Observations on the Ik Windows at Palenque." In *Fifth Palenque Round Table, 1983*, Vol. VII. Merle Greene Robertson general ed. Virginia M. Fields ed. Pre-Columbian Art Research Institute, San Francisco, pp. 19-27.

Proskouriakoff, Tatiana

1950 *A Study of Classic Maya Sculpture*. Carnegie Institution of Washington. Pub. 593. Washington, D.C.

1960 "Historic Implications of a Pattern of Dates at Piedras Negras, Guatemala." *American Antiquity*. Vol. XXV, No. 4. Menasha, Wisconsin, pp. 454-475.

1963 "Historical Data in the Inscriptions of Yaxchilan." *Estudios de Cultura Maya*. Vol. III. México, pp. 149-167.

1964 "Historical Data in the Inscriptions of Yaxchilan, Part II." *Estudios de Cultura Maya*. Vol. IV. México, pp. 177-202.

1973 *"The Hand-Grasping Fish* and Associated Glyphs on Classic Maya Monuments." In *Mesoamerican Writing Systems: A Conference at Dumbarton Oaks, Oct. 30th and 31st, 1971*.

Elizabeth P. Benson ed. Dumbarton Oaks, Washington, D.C., pp. 165-178.

Rands, Barbara C., and Robert L. Rands

1961 "Excavations of a Cemetery at Palenque." *Estudios de Cultura Maya*. Vol. I. Universidad Nacional Autónoma de México, México, pp. 87-106.

Rands, Robert L.

1968 "Relationship of Monumental Stone Sculpture of Copan with the Maya Lowlands." In *XXXVIII Internationalen Amerikanistenkongresses, Stuttgart-München, 12. bis 18. August, 1968*, Vol. I. Pp. 517-529.

Rands, Robert L., and Barbara C. Rands

1959 "The Incensario Complex at Palenque, Chiapas." *American Antiquity*. Vol. 25, No. 2. Menasha, Wisconsin, pp. 225-236.

Recinos, Adrian

1950 *Popol Vuh: The Sacred Book of the Ancient Quiche Maya*. Delia Goetz and Sylvanus Morley trans. University of Oklahoma Press, Norman.

Robertson, Merle Greene. *See* Greene Robertson, Merle.

Robicsek, Francis

1972 *The Maya Book of the Dead: The Ceramic Codex*. University of Virginia Art Museum, Charlottesville.

1978 *The Smoking Gods*. University of Oklahoma Press, Norman.

Roys, Lawrence

1934 "The Engineering Knowledge of the Maya." In *Contributions to American Archaeology*, No. 6. Carnegie Institution of Washington. Pub. 436. Washington, D.C., pp. 27-105.

Roys, Ralph L.

1931 *The Etho-Botany of the Maya*. Department of Middle American Research, Tulane University. Pub. 2. New Orleans.

1933 *The Book of Chilam Balam of Chumayel*. Carnegie Institution of Washington. Pub. 438. Washington, D.C.

1954 *The Maya Katun Prophecies of the Books of Chilam Balam, Series I*. Carnegie Institution of Washington. Pub. 606, Contribution 31. Washington, D.C.

Rust, William F.

1988 "New Ceremonial and Settlement Evidence at La Venta, and Its Relation to Preclassic Maya Cultures." Paper given at the Sixth Annual Maya Weekend, April 9-10. Elin Danien coordinator. University Museum, University of Pennsylvania, Philadephia.

Ruz Lhuillier, Alberto

1952a "Exploraciones arqueológicas en Palenque: 1949." *Anales del Instituto Nacional de Antropología e Historia*. Vol. IV. México, pp. 49-60.

1952b "Exploraciones arqueológicas en Palenque: 1950." *Anales del Instituto Nacional de Antropología e Histora*. Vol. V, No. 33. México, pp. 25-45.

1952c "Exploraciones arqueológicas en Palenque: 1951." *Anales del Instituto Nacional de Antropología e Historia*. Vol. V. México, pp. 47-66.

1955 "Exploraciones arqueológicas en Palenque: 1952." *Anales del Instituto Nacional de Antropología e Historia*. Vol. VI. México, pp. 79-110.

1958a "Exploraciones arqueológicas en Palenque: 1953." *Anales del Instituto Nacional de Antropología e Historia*. Vol. X, No. 39. México, pp. 69-116.

1958b "Exploraciones arqueológicas en Palenque: 1954." *Anales del Instituto Nacional de Antropología e Historia*. Vol. X, No. 39. México, pp. 117-184.

1958c "Exploraciones arqueológicas en Palenque: 1955." *Anales del Instituto Nacional de Antropología e Historia*. Vol. X, No. 39. México, pp. 185-240.

1958d "Exploraciones arqueológicas en Palenque: 1956." *Anales del Instituto Nacional de Antropología e Historia*. Vol. X, No. 39. México, pp. 241-299.

1962a "Exploraciones arqueológicas en Palenque: 1957." *Anales del Instituto Nacional de Antropología e Historia*. Vol. XIV, No. 43. México, pp. 35-90.

1962b "Exploraciones arqueológicas en Palenque: 1958." *Anales del Instituto Nacional de Antropología e Historia*. Vol. XIV, No. 43. México, pp. 91-112.

Scandizzo, Marjorie Rosenblum, and John R. Scandizzo. *See* Greene Robertson, Merle, Marjorie Rosenblum Scandizzo, and John R. Scandizzo 1976.

Schele, Linda

1975 "The House of the Dying Sun." In *Native American Astronomy*. Anthony Aveni ed. University of Texas Press, Austin and London, pp. 41-56.

1976 "Accession Iconography of Chan-Bahlum in the Group of the Cross at Palenque." In *Segunda Mesa Redonda de Palenque*, Part III. Merle Greene Robertson ed. Pre-Columbian Art Research Center, Robert Louis Stevenson School, Pebble Beach, California, pp. 9-34.

1979 "Genealogical Documentation on the Tri-Figure Panels at Palenque." In *Tercera Mesa Redonda de Palenque*, Vol. IV. Merle Greene Robertson general ed. Donnan Call Jeffers ed. Pre-Columbian Art Research Center, Palenque, Chiapas, México, pp. 41-70.

1980a *Notebook for the Maya Hieroglyphic Writing Workshop at Texas*. University of Texas, Austin.

1980b "The Xibalba Shuffle." Paper presented at the Conference on the Style and Iconography of Classic Maya Vases, Princeton University Department of Art and Archaeology and Art Museum, November 8.

1982 *Maya Glyphs: The Verbs*. University of Texas Press, Austin.

1984 *Notebook for the Maya Hieroglyphic Writing*

Workshop at Texas. University of Texas, Austin.

1985 *Notebook for the Maya Hieroglyphic Writing Workshop at Texas.* University of Texas, Austin.

1986 *Notebook for the Maya Hieroglyphic Writing Workshop at Texas.* University of Texas, Austin.

1987 *Notebook for the Maya Hieroglyphic Writing Workshop at Texas.* University of Texas, Austin.

1988 *Notebook for the Maya Hieroglyphic Writing Workshop at Texas.* University of Texas, Austin.

Schele, Linda, and Peter Mathews

1979 *The Bodega of Palenque, Chiapas, Mexico.* Dumbarton Oaks, Washington, D.C.

Schele, Linda, and Jeffrey Miller

1974 *Accession Expressions from the Classic Maya Inscriptions.* Studies in Pre-Columbian Art and Archaeology. No. 25. Dumbarton Oaks, Washington, D.C.

Schele, Linda, and Mary Ellen Miller

1986 *Blood of Kings: Dynasty and Ritual in Maya Art.* George Braziller, New York, in association with the Kimbell Art Museum, Fort Worth.

Schellhas, Paul

1897 *Die Göttergestalten der Maya-Handschriften.* Berlin. (For English translation, see Schellhas 1904.)

1904 *Representations of Deities of the Maya Manuscripts.* Papers of the Peabody Museum of American Archaeology and Ethnology, Harvard University. Vol. 4, No. 1. Cambridge, Massachusetts.

Schlak, Arthur

1985 "The Gods of Palenque." Manuscript.

Seler, Eduard

1902-1923 *Gesammelte Abhandlungen zur amerikanischen Sprach- und Alterthumskunde.* 5 vols. A. Asher & Co., Berlin. (Index to Vols. I-III, 1914.)

1976 *Observations and Studies in the Ruins of Palenque, 1915.* Gisela Morgner trans. (from German). Thomas Bartman and George Kubler eds. Pre-Columbian Art Research Center, Robert Louis Stevenson School, Pebble Beach, California.

Stuart, David

1984 "A Note on the 'Hand-Scattering' Glyph." In *Phoneticism in Mayan Hieroglyphic Writing.* John S. Justeson and Lyle Campbell eds. Institute for Mesoamerican Studies. Pub. 9. State University of New York at Albany, Albany, pp. 307-311.

1985 "The Count of Captives Epithet in Classic Maya Writing." In *Fifth Palenque Round Table, 1983,* Vol. VII. Merle Greene Robertson general ed. Virginia M. Fields ed. Pre-Columbian Art Research Institute, San Francisco, pp. 97-102.

1987 *Ten Phonetic Syllables.* Research Reports on Ancient Maya Writing. No. 14. Center for Maya Research, Washington, D.C.

Tate, Carolyn

1988 "From Pictographs to Writing in Ancient America." Paper delivered at the Sixth Annual Maya Weekend, April 9-10. Elin Danien coordinator. University Museum, University of Pennsylvania, Philadelphia.

Taube, Karl A.

1987 "A Representation of the Principal Bird Deity in the Paris Codex." In *Research Reports on Ancient Maya Writing,* No. 6. Center for Maya Research, Washington, D.C., pp. 1-6.

Taylor, Dicey

1979 "The Cauac Monster." In *Tercera Mesa Redonda de Palenque,* Vol. IV. Merle Greene Robertson general ed. Donnan Call Jeffers ed. Pre-Columbian Art Research Center, Palenque, Chiapas, México, pp. 79-90.

Tedlock, Dennis

1985 *Popol Vuh: The Definitive Edition of the Mayan Book of the Dawn of Life and the Glories of Gods and Kings.* Simon and Schuster, New York.

Thompson, J. Eric S.

1950 *Maya Hieroglyphic Writing: Introduction.* Carnegie Institution of Washington. Pub. 589. Washington, D.C.

1960 *Maya Hieroglyphic Writing: An Introduction.* Civilization of American Indian Series. No. 56. University of Oklahoma Press, Norman.

1962 *A Catalogue of Maya Hieroglyphs.* University of Oklahoma Press, Norman.

1970 *Maya History and Religion.* Civilization of American Indian Series. University of Oklahoma Press, Norman.

Tozzer, Alfred M.

1941 *Landa's Relación de las cosas de Yucatan.* Papers of the Peabody Museum of American Archaeology and Ethnology. Vol. XVIII. Harvard University, Cambridge, Massachusetts.

von Hagen, Victor Wolfgang

1950 *Frederick Catherwood: Architect.* Oxford University Press, New York.

1967 *F. Catherwood: Architect-Explorer of Two Worlds.* Barre Publishers, Barre, Massachusetts.

Waldeck, Jean Maxmillien

1838 *Voyage pittoresque et archéologique dans la province d'Yucatan (Amérique Centrale), pendant les années 1834 et 1836.* Bellizard Dufour et Cie, Paris.

Zimmermann, Günter

1956 *Die Hieroglyphen der Maya-Handschriften.* Cram, de Gruyter, Hamburg.

INDEX

ILLUSTRATIONS

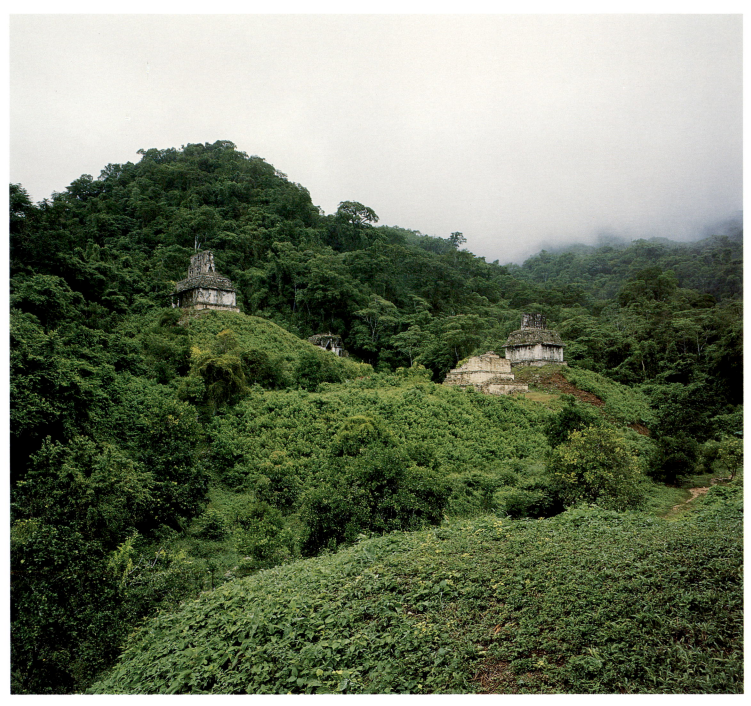

1. The Group of the Cross.

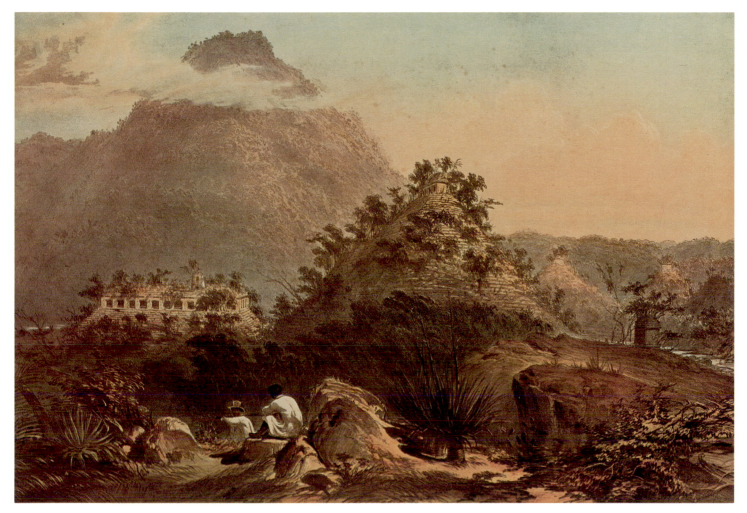

2. Catherwood's Temple of the High Hill.

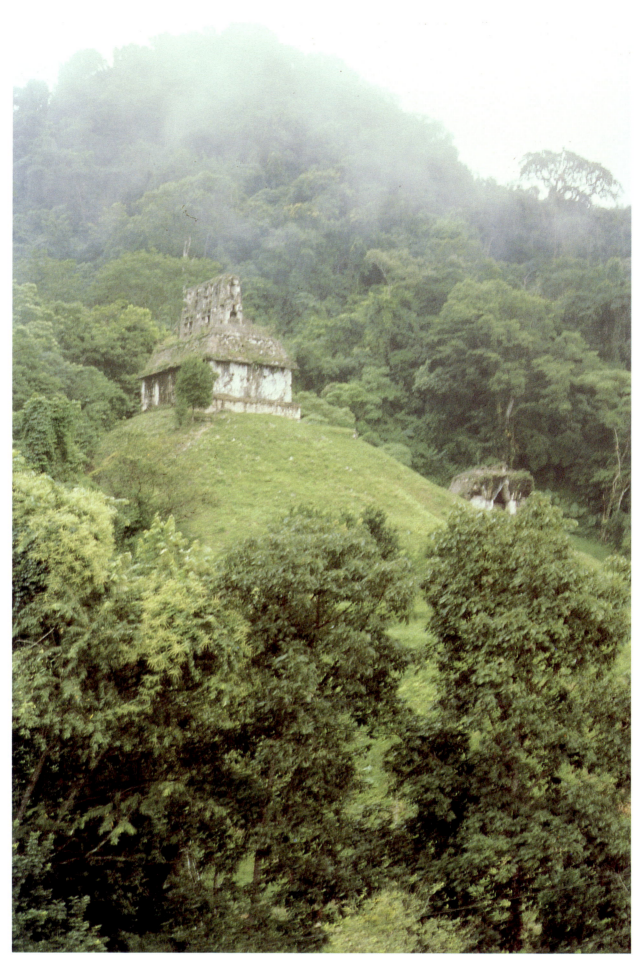

3. Mist rising over the Temple of the Cross.

4. Chan-Bahlum, king of Palenque A.D. 683-702.

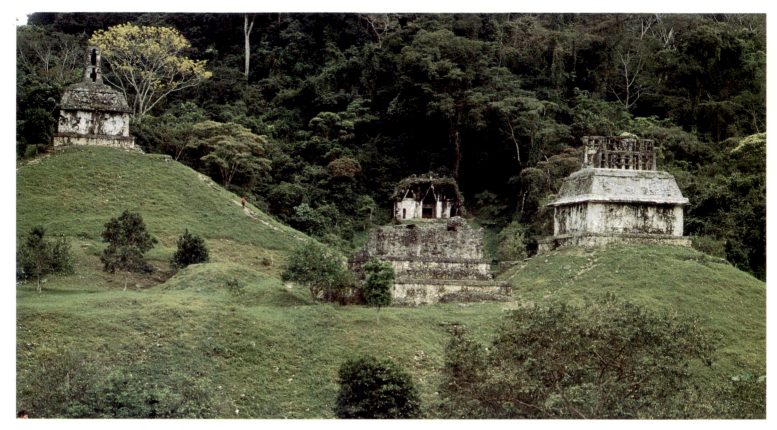

6. The Cross Group. Left to right: Temple of the Cross, Temple of the Foliated Cross, Temple XIV (foreground; not a Cross Group temple), Temple of the Sun.

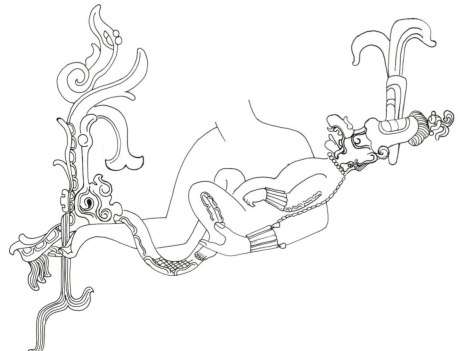

5. Chan-Bahlum as the serpent-footed God K.

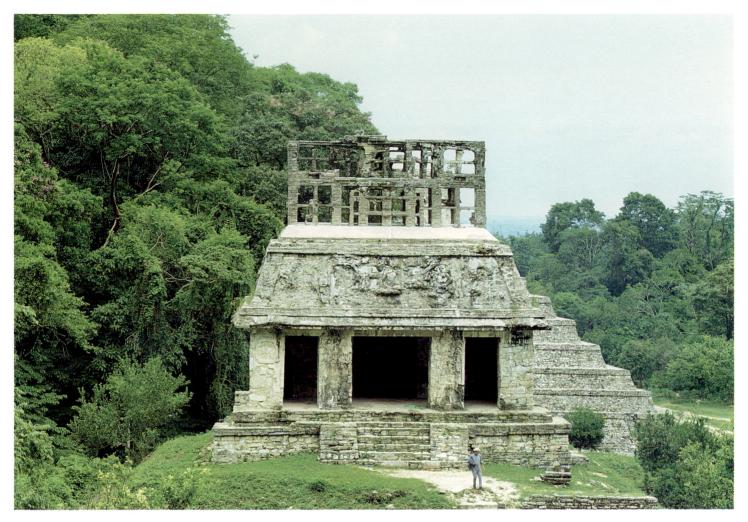

7. Temple of the Sun.

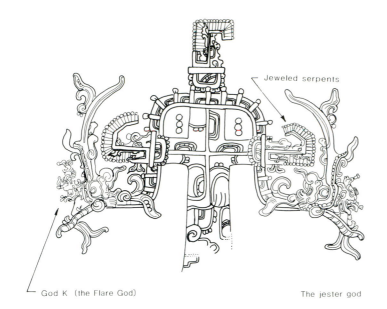

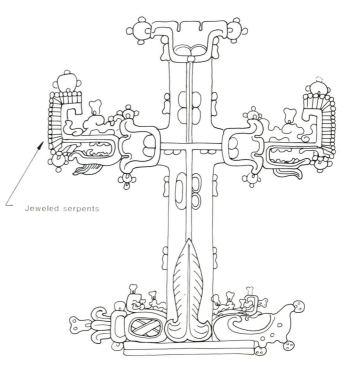

Jeweled serpents

God K (the Flare God)

The jester god

Jeweled serpents

THE SARCOPHAGUS COVER

THE TABLET OF THE CROSS

8. Comparisons of the cross/tree icon, or the world tree.

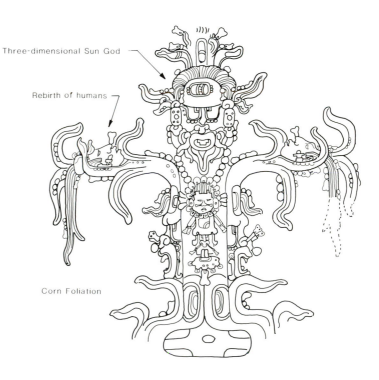

Three-dimensional Sun God

Rebirth of humans

Corn Foliation

THE TABLET OF THE FOLIATED CROSS

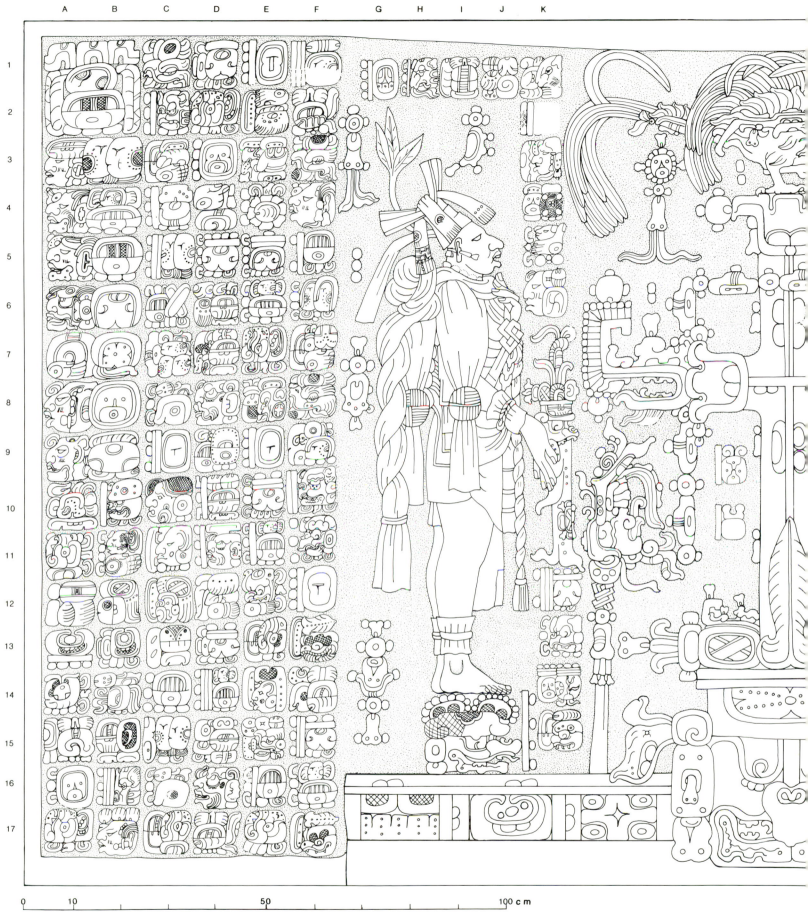

9. Temple of the Cross Tablet.

Left inset boxes (near figure):

(on) 8 (Ok)	4 Kayab (9.12.11.12.10)	he was made zac unic
of the succession		
Mah K'ina Chan-Bahlum		

Left vertical column:

- maize title, bac balan-ahau "Palenque" Jaguar Lord
- (it was) 6 days, 11 uinals
- 6 tuns (1.6.11)
- (since) he was made zac unic
- until he took part in an event
- (he ???) of
- one of the Triad (Triad: GI)
- on the third day
- he let blood
- part of verbal phrase
- part of verbal phrase
- he took or held the bundle
- Mah K'ina Chan-Bahlum
- Bac Balam-Ahau Palenque Jaguar Lord
- Ahpo of Palenque

Right grid (columns P–U):

P	Q	R	S	T	U
until he was made zac unic	of the succession	13 Ceh (9.0.0.0.0)	completion (?) of	(it was) 17 days, 4 uinals	2 tuns
U'K'IX-CHAN	(on) 11 Caban	-9 baktuns	special expression for Pt.? divisible by 5	3.4 katuns (2.2.4.17)	(since he) was born
seating of Pop (5.8.17.15.17)	R.E.G.	(it was) 18 days, 1 uinal	8 tuns	until he was made zac unic	of the succession
(on) 5 Cimi	14 Kayab	1 katun (1.8.1.18)	(since he) was born (on 9.1.4.5.0 13 Ahau 13 Zac)	name glyph	name glyph
was born	Bahlum-K'uk I	Names	MANIK	Chaacal, Ah Nabe	(on) 1 Imix
(it was) 14 days, 5 uinals	2 tuns, 1 katun (1.2.5.14)	until he was made zac unic	of the Succession	4 Zip (9.9.11.5.1)	(it was) 1 day, 1 uinal
(since) he was born	until he was made zac unic	(on) 3 Etz'nab	11 Xul (9.2.12.6.16)	1 tun (1.1.1)	(since he) was born
of the succession	(on) 1 Kan	(it was) 17 days, 7 uinals	16 tuns	name glyph	name glyph
2 Kayab	Ahpo of ????	1 katun (1.16.7.17)	(since he) was born	Chaacal, Ah Nabe	until he was born
(on) 11 Lamat	6 Xul (8.19.6.8.8)	(on) 5 Ahau	3 Zec (9.1.10.0.0)	Chan-Bahlum I	(on) 7 Kan
was born	'Casper'	Chaacal, Ah Nabe	until he was made zac unic	17 Mol (9.4.9.0.4)	(it was) 7 days, 4 uinals
(it was) 9 days, 3 uinals	13 tuns (13.3.9)	of the succession	on 5 Caban	8 tuns	2 katun (2.8.4.2)
(since) was born	'Casper'	seating of Zotz (9.3.6.7.17)	(it was) 16 days, 6 uinals	(since he) was born	Chan-Bahlum I
(until) 2 Caban	11 Xul (8.19.19.11.17)	19 tuns	1 katun (1.19.6.16)	on 11 Chicchan	13 Chen (9.4.10.1.5)
(it was) 3 days, 6 uinals	(since) he was made zac unic (on 2 Caban 14 Xul)	(since he) was born	K'uk-Xul I	(it was) 2 days, 8 uinals	(it be)
of the succession	'Casper'	until he was made zac unic	of the succession	(since he) was born	Chan-Bahlum
count until	8 Ahau	(on) 5 Kan	12 Kayab (9.4.14.10.4)	until he was made zac unic	of the succession (on 9.6.18.5.12 10 Eb 0 Uo)

Merle Greene 1983

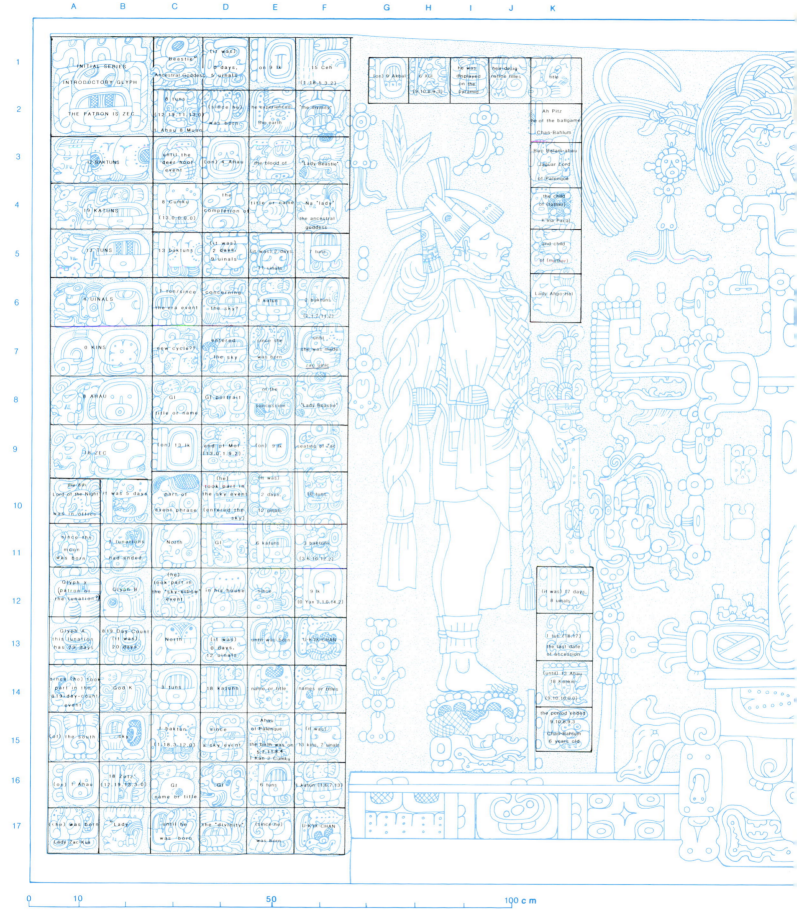

10. Temple of the Cross Tablet text.

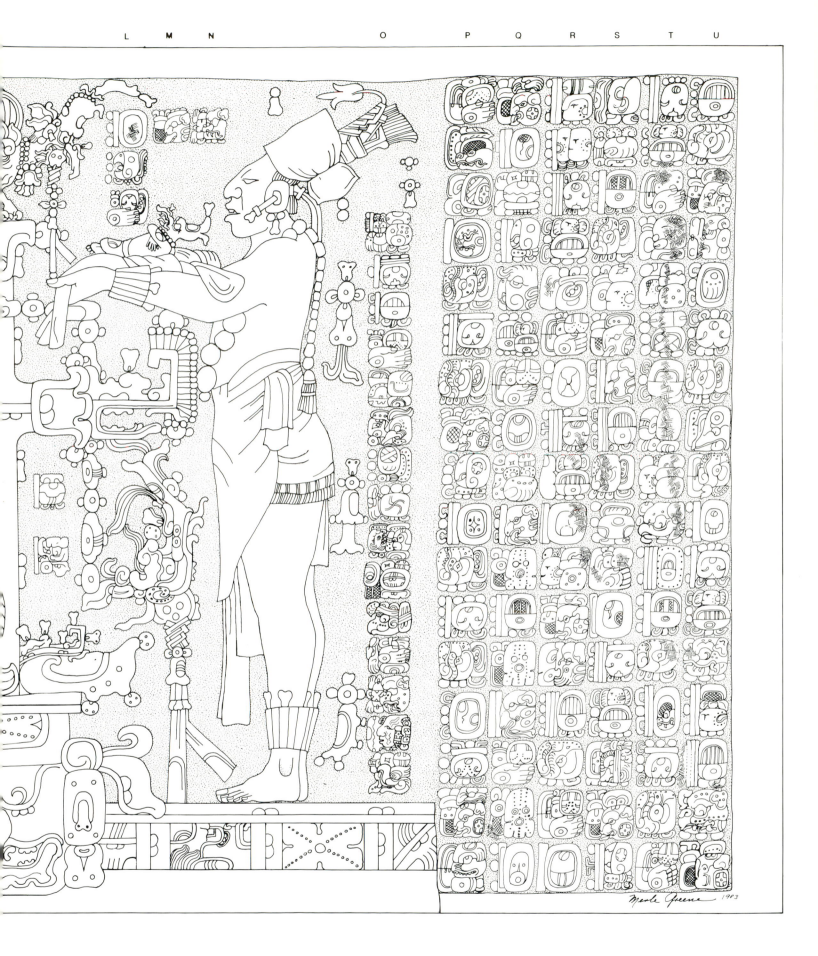

Merle Greene 1983

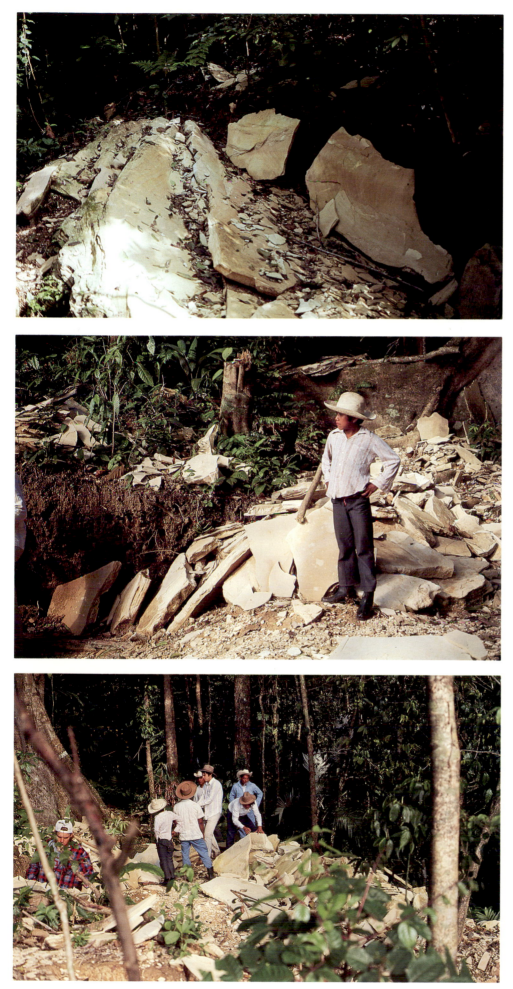

11. Quarrying stone at Palenque.

12. The Triad Gods.

GI GII GIII

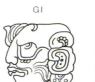 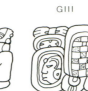

13. *Alfardas* of the Cross Group
temples.

A B C D E F

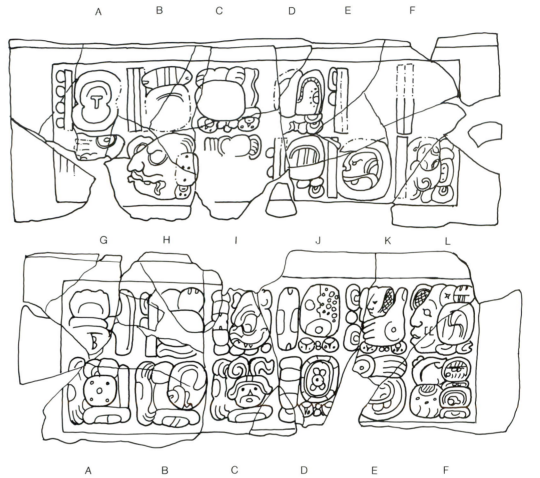

G H I J K L

	A	B	C	D	E	F
1	(on) 9 Ik	15 Ceh (1.18.5.3.2)	the divinity	(it was) (7) baktuns	11 uinals	10 days (7.14.14.11.10)
2	(he) was born	GI	(14) katuns	14 tuns	5 Eb	5 Kayab (9.12.19.14.12)

	G	H	I	J	K	L
1	he did the 'house' event	Wac ah Chaan (V 1-Sky)	K'ina Chan-Bahlum	Bac balam-ahau	the child of (mother)	Lady Ahpo-Hel
2	u pibnal	the blood of	the child of (father)	K'ina Pacal	the anniversary event took place	te naab chaan tan (the world)

13a. Temple of the Cross.

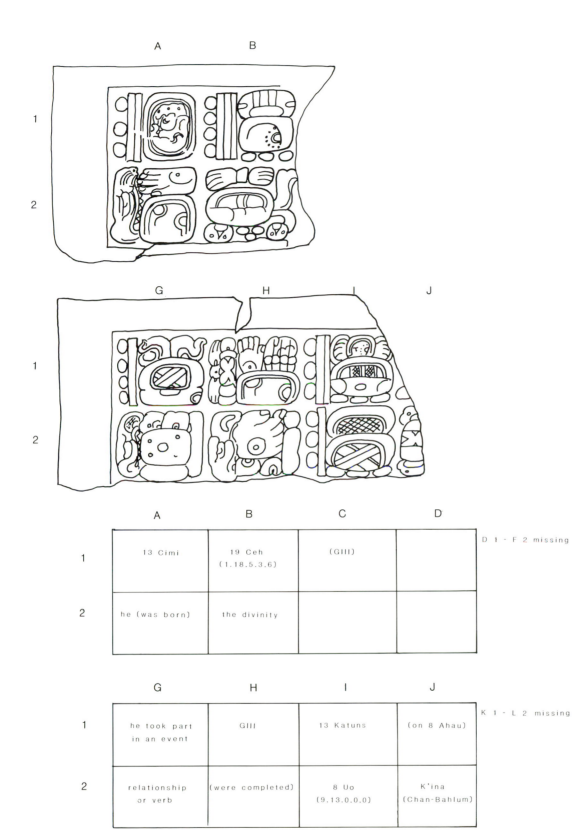

	A	B	C	D
1	13 Cimi	19 Ceh (1.18.5.3.6)	(GIII)	
2	he (was born)	the divinity		

D 1 - F 2 missing

	G	H	I	J
1	he took part in an event	GIII	13 Katuns	(on 8 Ahau)
2	relationship or verb	(were completed)	8 Uo (9.13.0.0.0)	K'ina (Chan-Bahlum)

K 1 - L 2 missing

13b. Temple of the Sun.

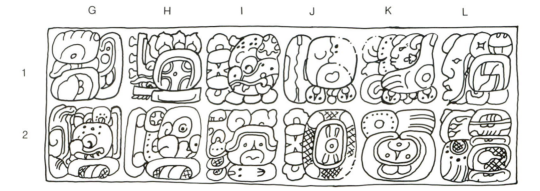

	A	B	C	D	E	F
1	(on) 1 Ahau	13 Mac (1.18.5.4.0)	GII God K	(it was) 7 baktuns	11 uinals (should be 10)	12 kins (7.14.14.10.12)
2	(he) was born	the divinity	14 katuns	14 tuns		

	G	H	I	J	K	L
1	he did the 'house' event	GII	K'ina Chan-Bahlum	Bac balam-ahau	child of (mother)	Lady Ahpo-Hel
2	u-pi-bi-na-il (u pibnal)	the blood of	child of (father)	K'ina Pacal	accession event took place	in the world

13c. Temple of the Foliated Cross.

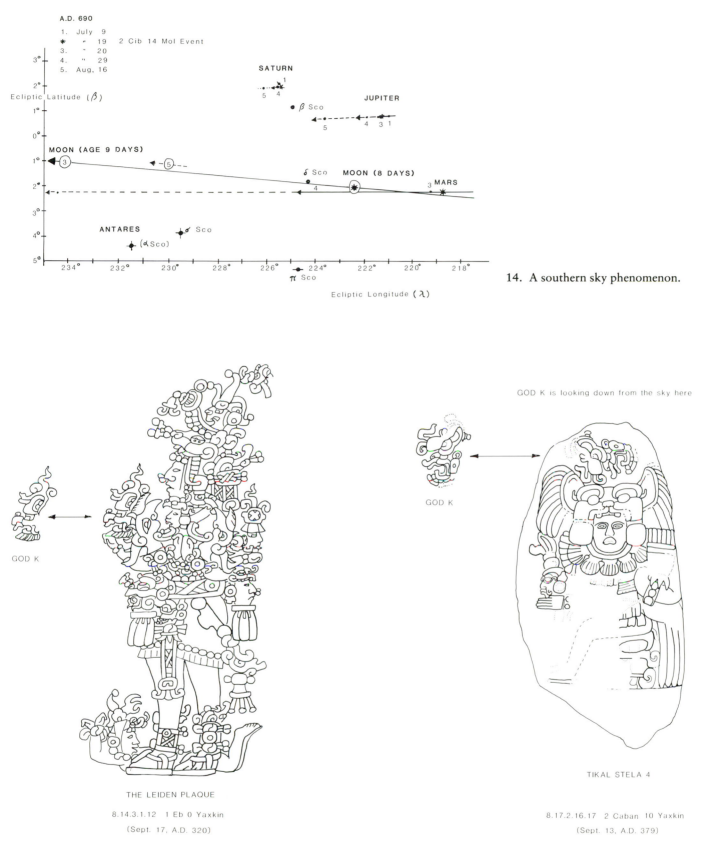

14. A southern sky phenomenon.

THE LEIDEN PLAQUE

8.14.3.1.12 1 Eb 0 Yaxkin

(Sept. 17, A.D. 320)

GOD K is looking down from the sky here

GOD K

TIKAL STELA 4

8.17.2.16.17 2 Caban 10 Yaxkin

(Sept. 13, A.D. 379)

16. Early examples of God K. The Leiden Plaque and Tikal Stela 4.

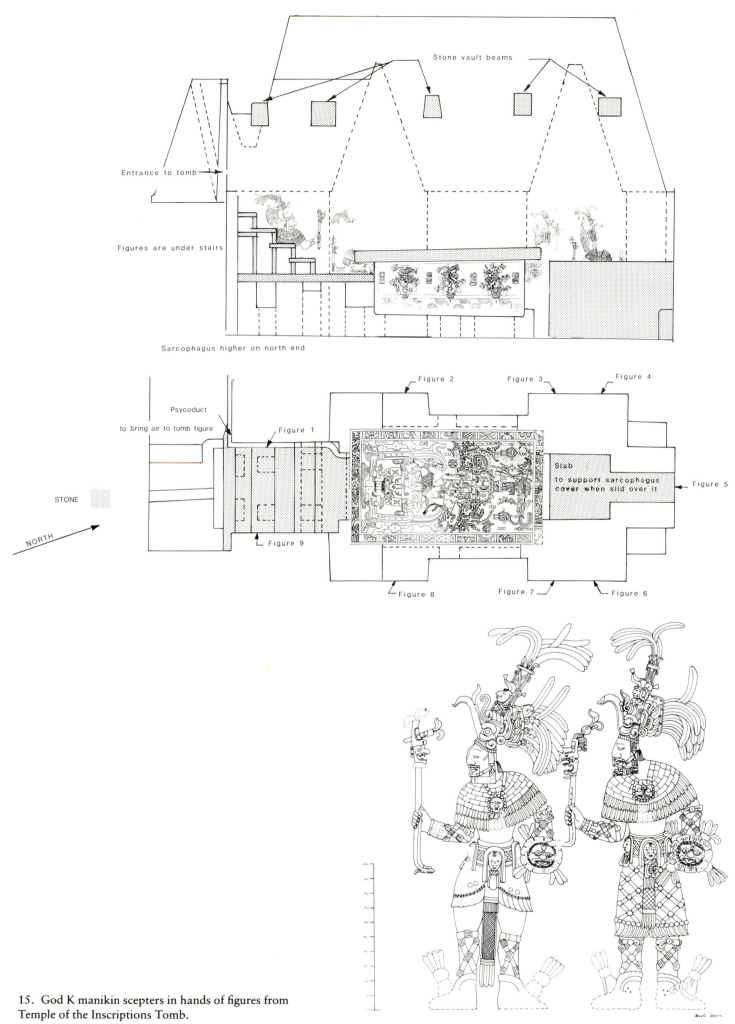

Stone vault beams

Entrance to tomb

Figures are under stairs

Sarcophagus higher on north end

Figure 2 Figure 3 Figure 4

Psycoduct
to bring air to tomb figure

Figure 1

STONE

NORTH

Figure 9

Slab
to support sarcophagus
cover when slid over it

Figure 5

Figure 8 Figure 7 Figure 6

**15. God K manikin scepters in hands of figures from
Temple of the Inscriptions Tomb.**

FIGURES 6 and 7 from the NORTHEAST NICHE

NOTE WIDTH OF STRUCTURE GREATER IN FRONT (east)

CLOSED OPENING (IK)

IK OPENING DIRECTLY BEHIND WALL

WALL ADDED LATER

ADDED WALL

VERY LARGE CORDHOLDER

SIMILAR TO THOSE IN HOUSE A

LOTS OF RED PAINT ON THIS REAR VAULT WALL

100cm 200cm 300cm

17. Temple of the Cross. Plan.

TRUE NORTH

MAGNETIC NORTH

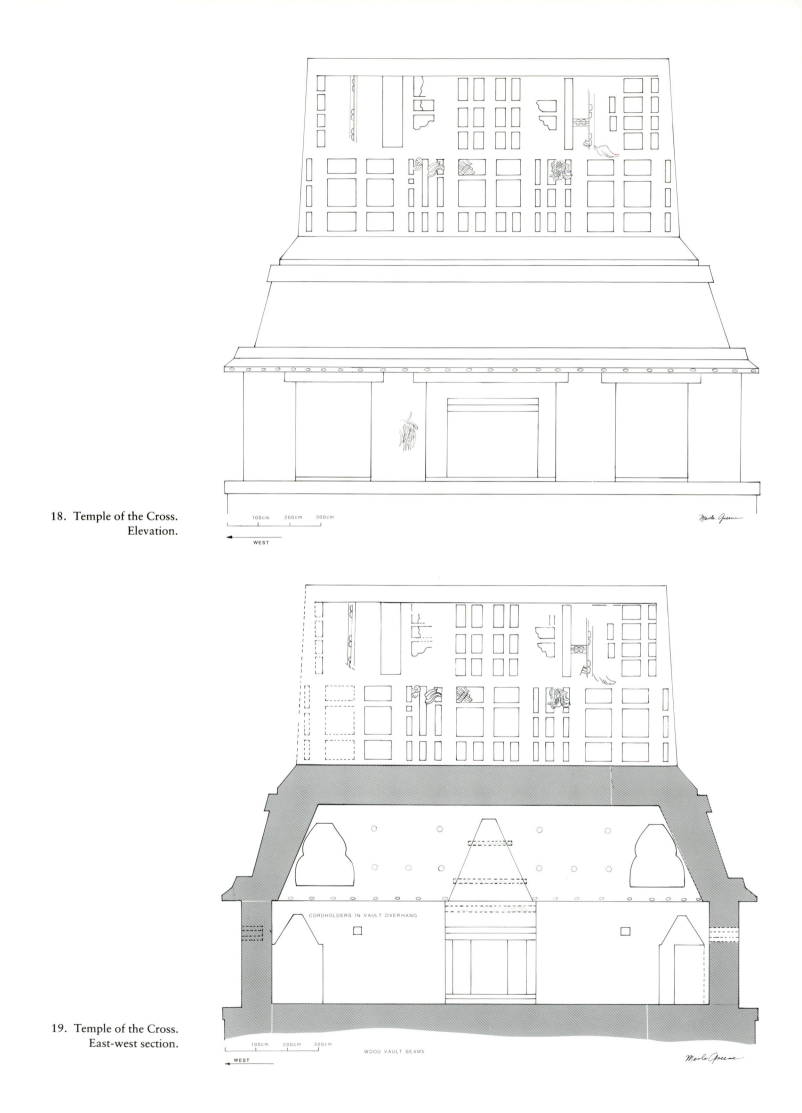

18. Temple of the Cross.
Elevation.

100cm 200cm 300cm

WEST

19. Temple of the Cross.
East-west section.

CORDHOLDERS IN VAULT OVERHANG

100cm 200cm 300cm

WOOD VAULT BEAMS

WEST

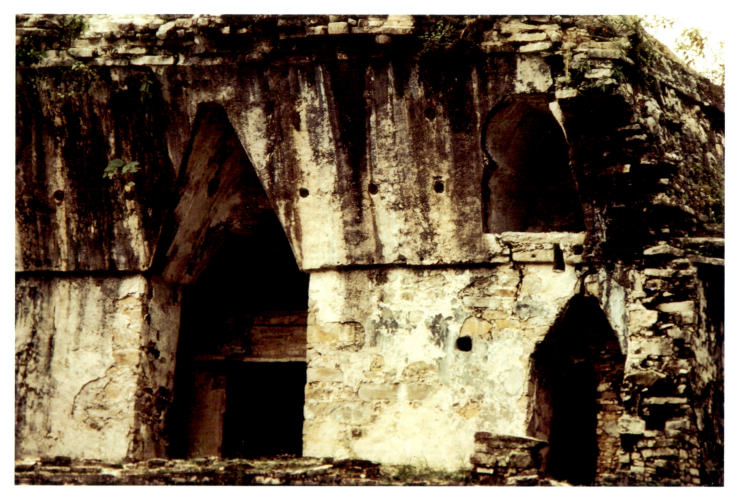

21. Temple of the Cross. Vaults and keyhole niches.

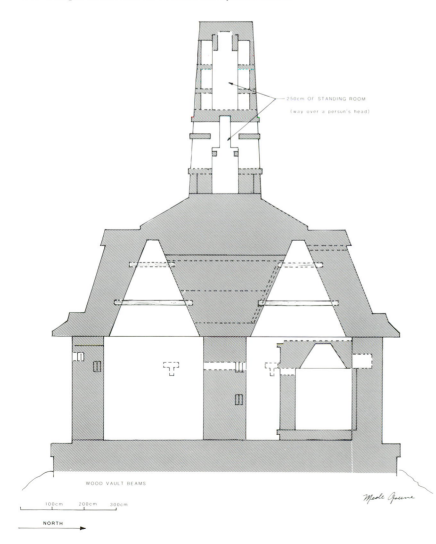

250cm OF STANDING ROOM
(way over a person's head)

WOOD VAULT BEAMS

100cm 200cm 300cm

NORTH

20. Temple of the Cross.
North-south section.

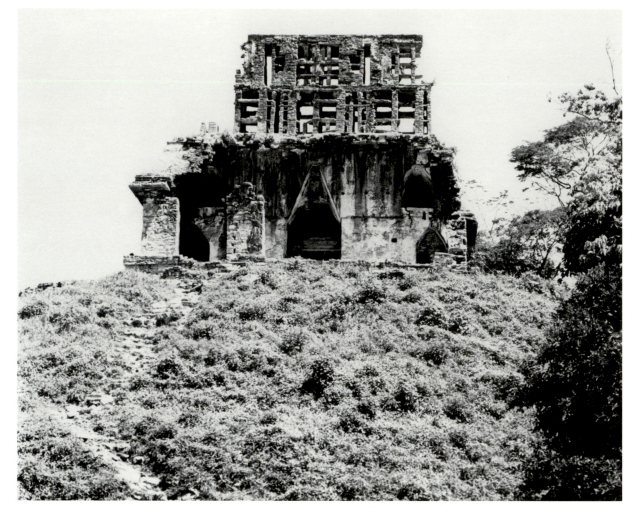

22. Temple of the Cross,
Piers A and B.

closed-over lk

closed-over lk

sockets
22cm deep

posts set back 8cm

wood beam

cord holders

23. Temple of the Cross,
northeast room.

24. Temple of the Cross. Photo by Alfred Maudslay, 1890.

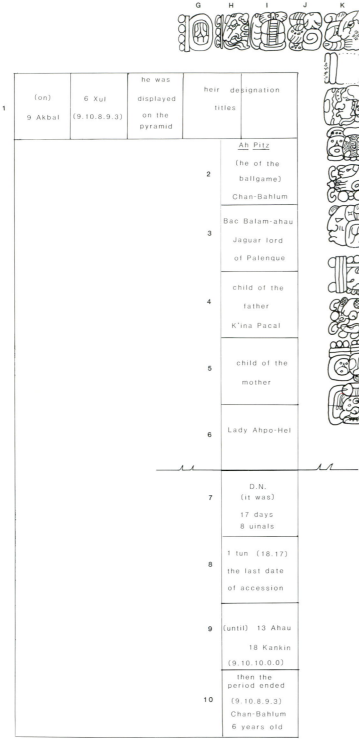

25. Temple of the Cross Tablet. Text framing head
of short figure.

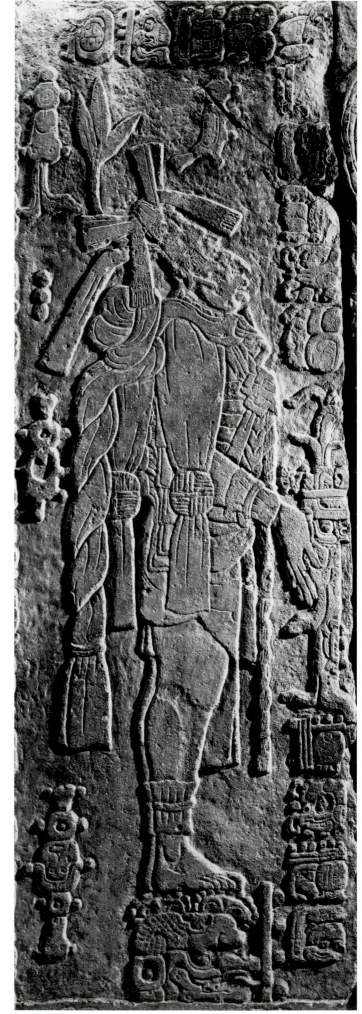

26. Temple of the Cross Tablet. The short figure.

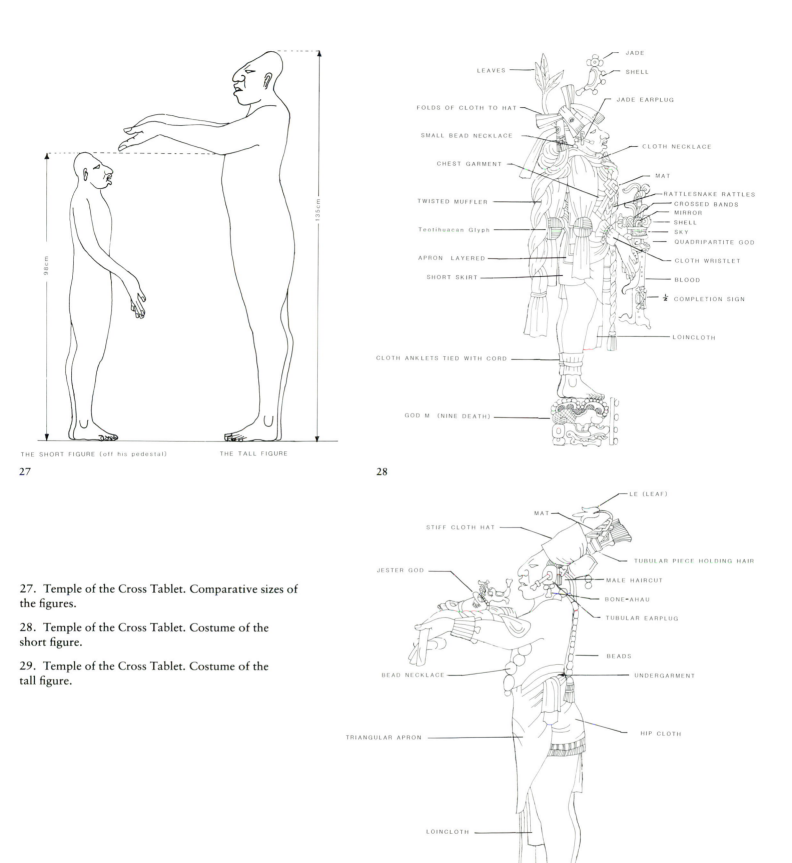

THE SHORT FIGURE (off his pedestal) THE TALL FIGURE

98cm 135cm

27

JADE
LEAVES
SHELL
FOLDS OF CLOTH TO HAT
JADE EARPLUG
SMALL BEAD NECKLACE
CLOTH NECKLACE
CHEST GARMENT
MAT
TWISTED MUFFLER
RATTLESNAKE RATTLES
CROSSED BANDS
MIRROR
Teotihuacan Glyph
SHELL
SKY
QUADRIPARTITE GOD
APRON LAYERED
CLOTH WRISTLET
SHORT SKIRT
BLOOD
½ COMPLETION SIGN
LOINCLOTH
CLOTH ANKLETS TIED WITH CORD
GOD M (NINE DEATH)

28

27. Temple of the Cross Tablet. Comparative sizes of the figures.

28. Temple of the Cross Tablet. Costume of the short figure.

29. Temple of the Cross Tablet. Costume of the tall figure.

LE (LEAF)
MAT
STIFF CLOTH HAT
TUBULAR PIECE HOLDING HAIR
JESTER GOD
MALE HAIRCUT
BONE-AHAU
TUBULAR EARPLUG
BEADS
BEAD NECKLACE
UNDERGARMENT
TRIANGULAR APRON
HIP CLOTH
LOINCLOTH
BEAD ANKLETS

29

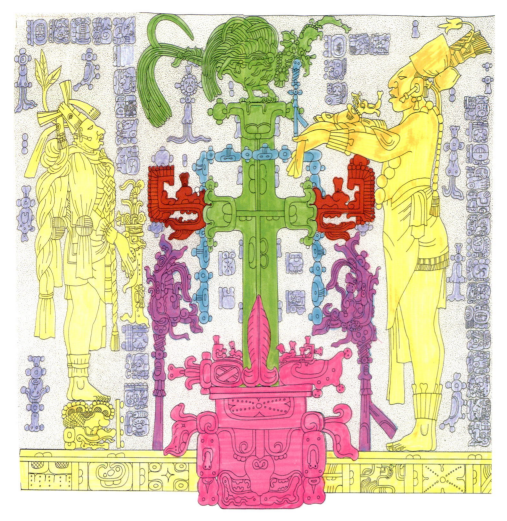

FURTHEST FORWARD
SECOND
THIRD
FOURTH
FIFTH
SIXTH
FURTHEST BACK

30. Temple of the Cross. Spatial arrangement of the tablet. Here the graphic text has been assigned the same level as the fillers. I expect, however, that the text was meant to be on a level of its own or to be on the same level as the figures (the second).

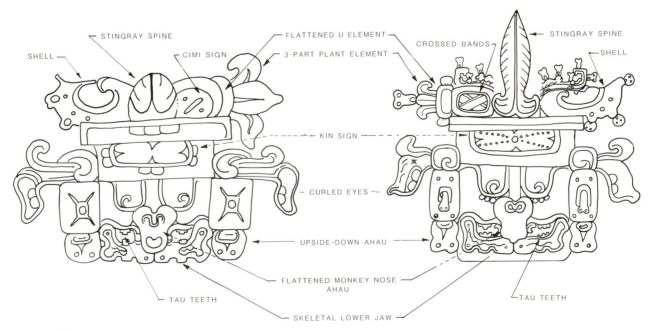

SHELL

STINGRAY SPINE

CIMI SIGN

FLATTENED U ELEMENT

3-PART PLANT ELEMENT

CROSSED BANDS

STINGRAY SPINE

SHELL

KIN SIGN

CURLED EYES

UPSIDE-DOWN AHAU

FLATTENED MONKEY NOSE AHAU

TAU TEETH

SKELETAL LOWER JAW

TAU TEETH

31. Quadripartite Monsters compared. Sarcophagus Cover (left) and Cross Tablet.

THE SARCOPHAGUS COVER

THE TABLET OF THE FOLIATED CROSS

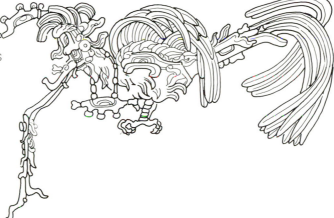

THE TABLET OF THE CROSS

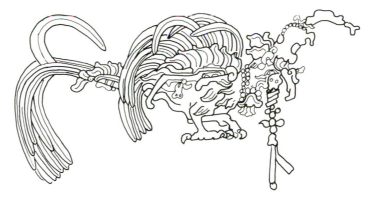

32. Principal bird deities (Celestial Bird) compared.

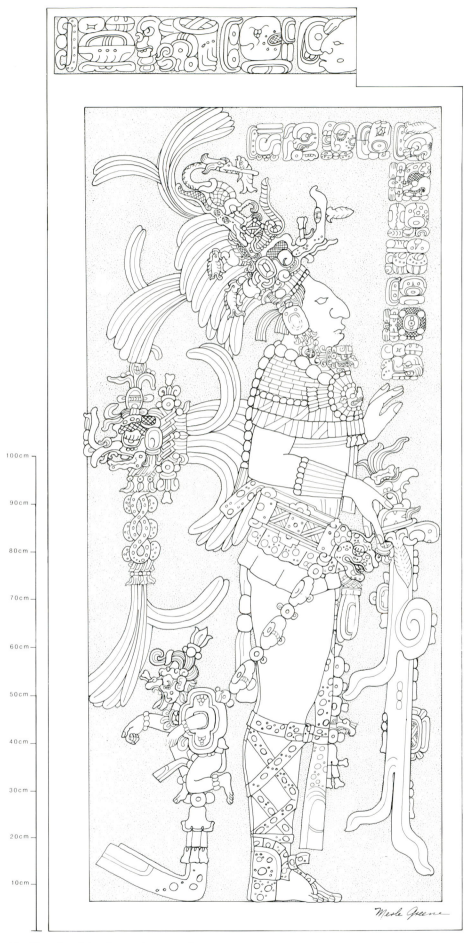

33. Temple of the Cross, West Jamb.

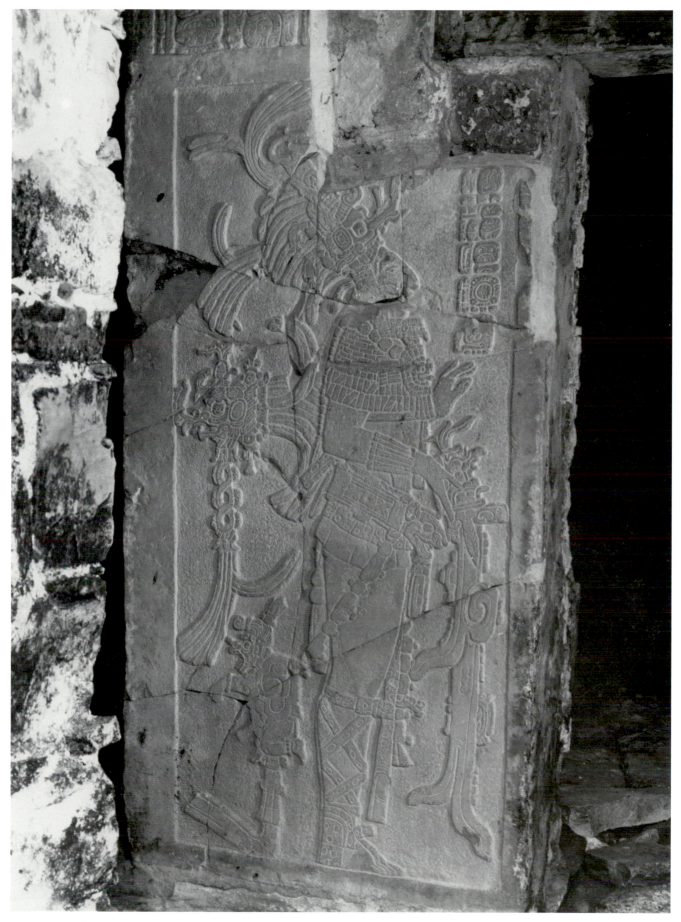

34. Temple of the Cross, West Jamb.

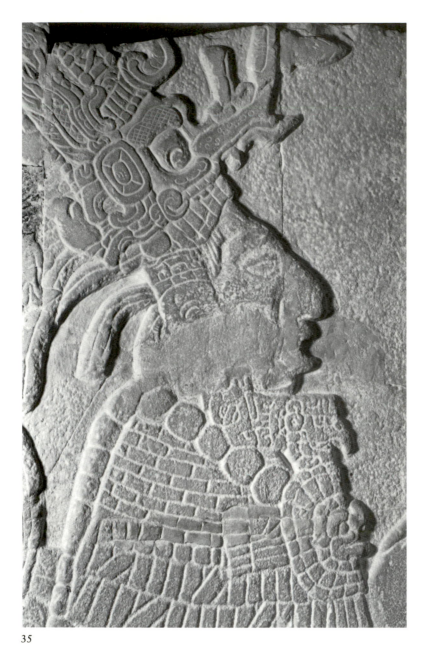

35

35. Temple of the Cross, West Jamb. Chan-Bahlum's chin guard and pectoral.

36. Temple of the Cross, West Jamb. Chan-Bahlum wears the headdress of the Jaguar God of the Underworld.

37. Temple of the Cross, West Jamb. Chan-Bahlum wears the royal belt of ancient kings.

38. Temple of the Cross, West Jamb. Chan-Bahlum's belt.

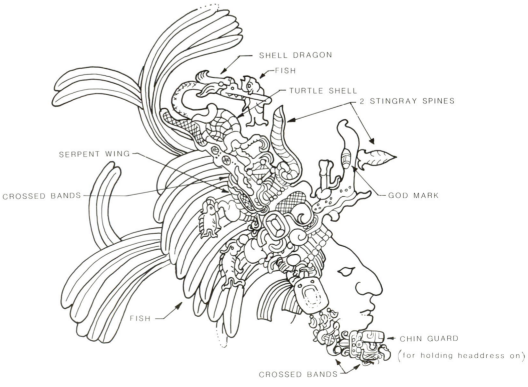

36

SHELL DRAGON

FISH

TURTLE SHELL

2 STINGRAY SPINES

SERPENT WING

CROSSED BANDS

GOD MARK

FISH

CHIN GUARD
(for holding headdress on)

CROSSED BANDS

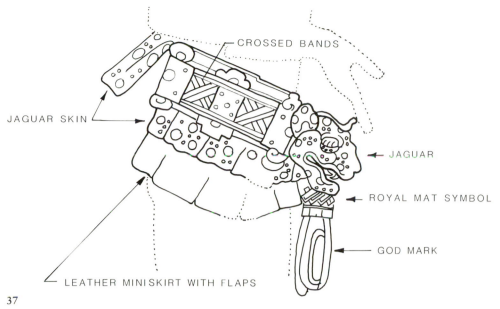

CROSSED BANDS

JAGUAR SKIN

← JAGUAR

← ROYAL MAT SYMBOL

← GOD MARK

LEATHER MINISKIRT WITH FLAPS

37

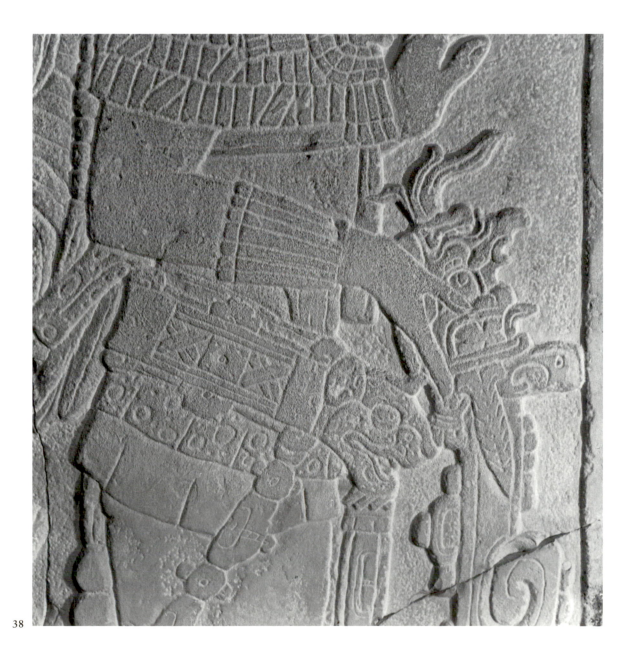

38

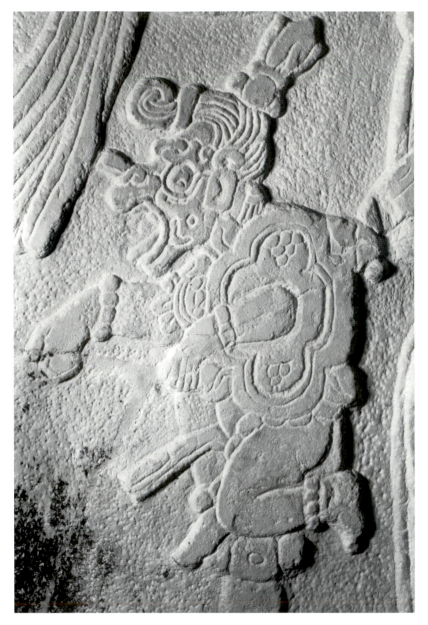

39. Temple of the Cross, West Jamb. God hanging from Chan-Bahlum's belt.

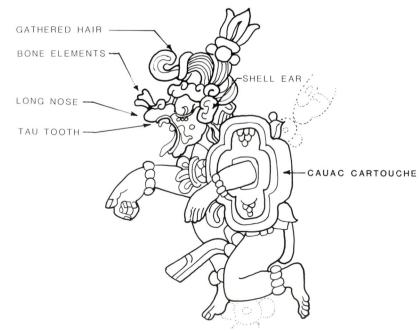

GATHERED HAIR

BONE ELEMENTS

SHELL EAR

LONG NOSE

TAU TOOTH

CAUAC CARTOUCHE

40. Temple of the Cross, West Jamb. Chac-Xib-Chac hanging from Chan-Bahlum's belt chain.

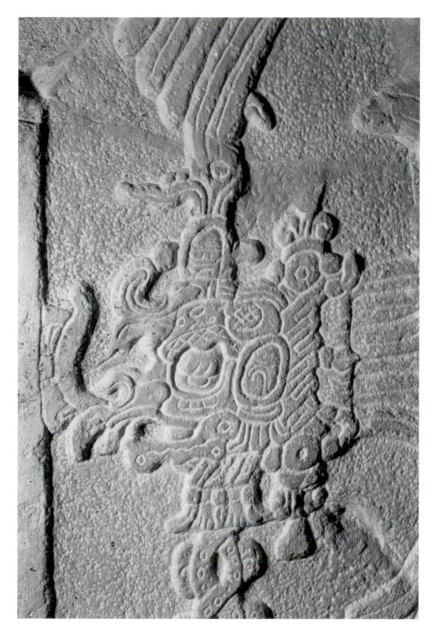

41. Temple of the Cross, West Jamb. The head of a god
behind Chan-Bahlum.

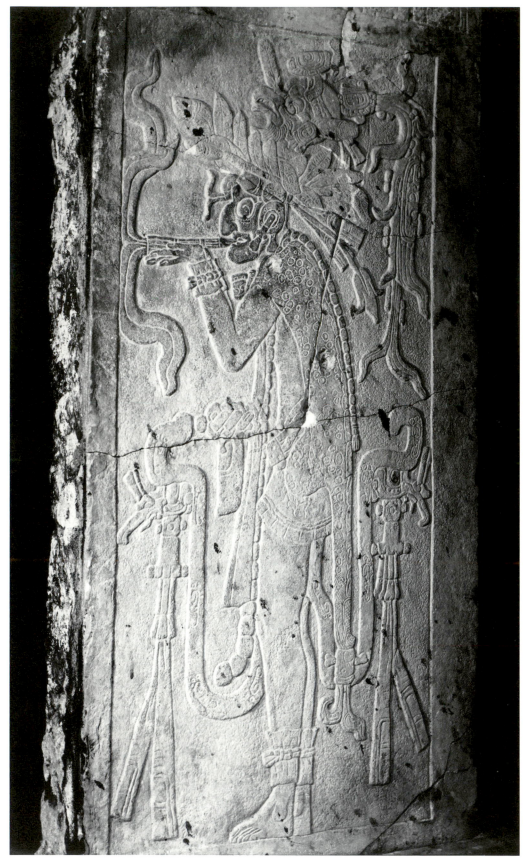

42. Temple of the Cross, East Jamb.

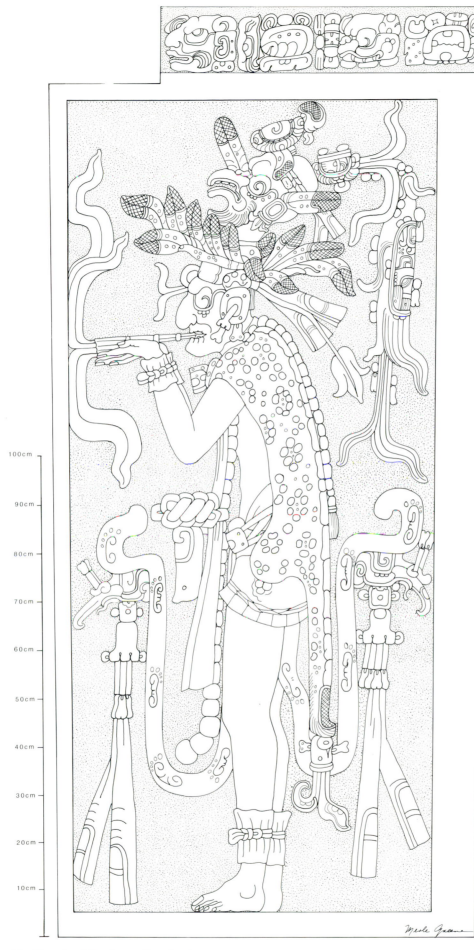

43. Temple of the Cross, **East Jamb**.

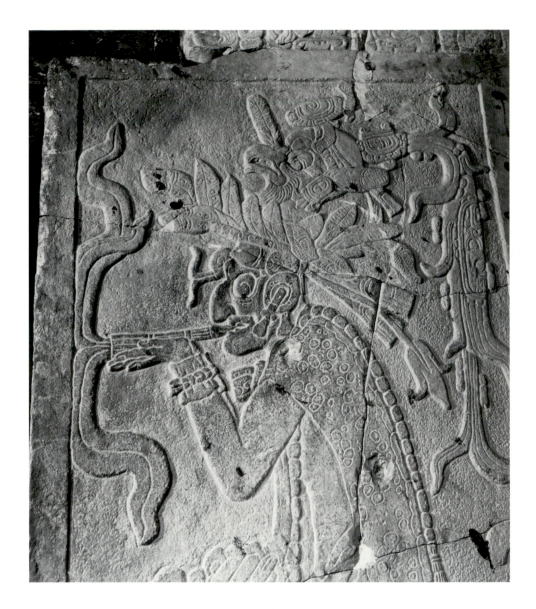

44. Temple of the Cross, East Jamb.
God L's headdress.

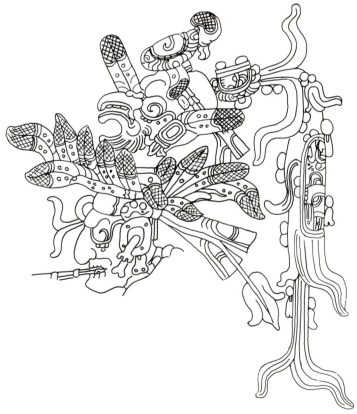

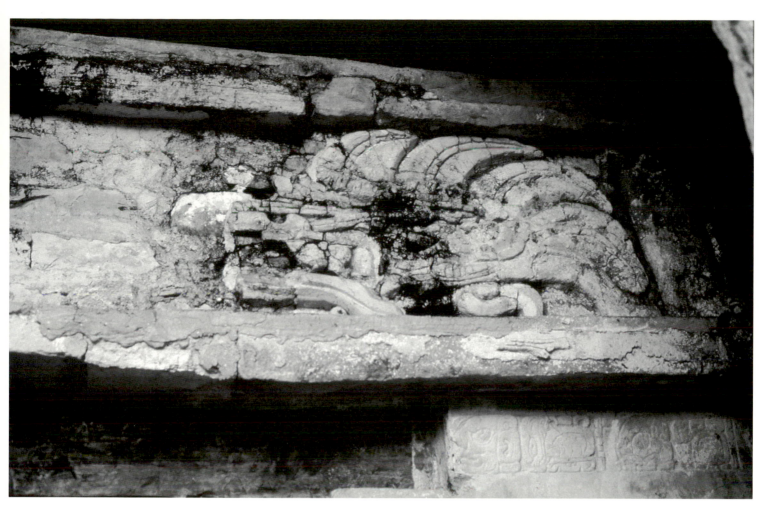

45. Temple of the Cross, South Sanctuary Roof. East end.

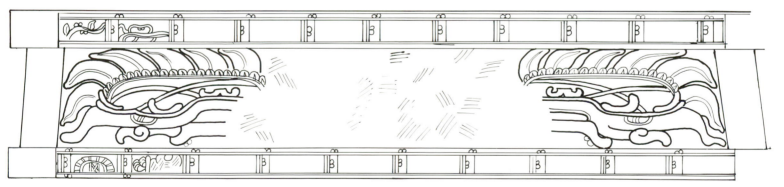

46. Temple of the Cross, South Sanctuary Roof. Drawn from Maudslay, 1890.

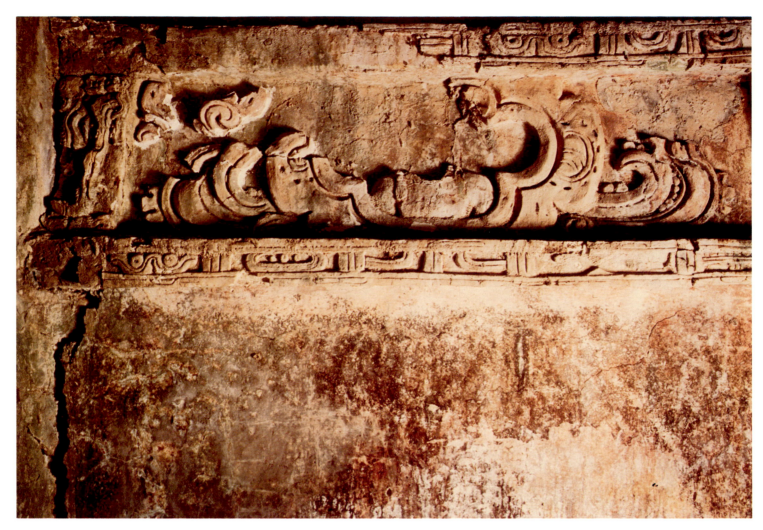

48. Temple of the Cross, West Sanctuary Roof.

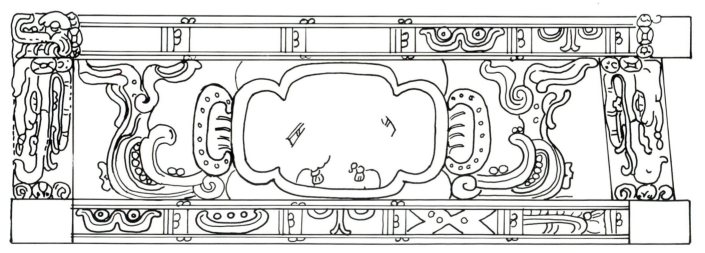

47. Temple of the Cross, West Sanctuary Roof.

49. Temple of the Cross, West Sanctuary Roof. Tassel hangs over the figure's shoulder.

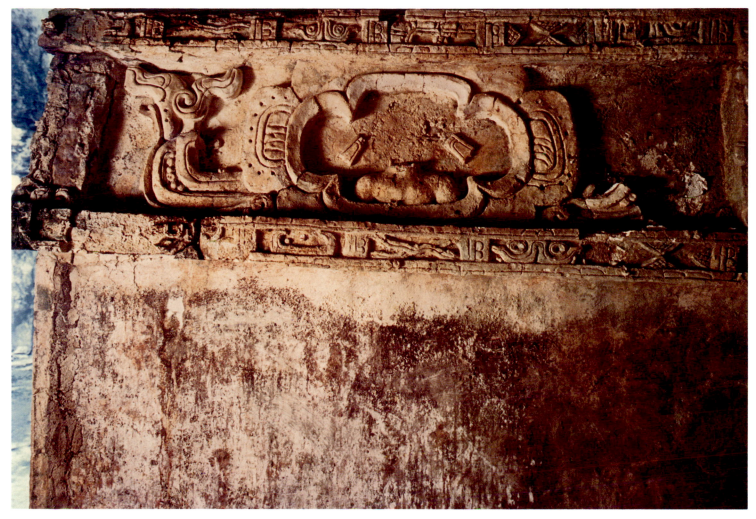

52. Temple of the Cross, East Sanctuary Roof.

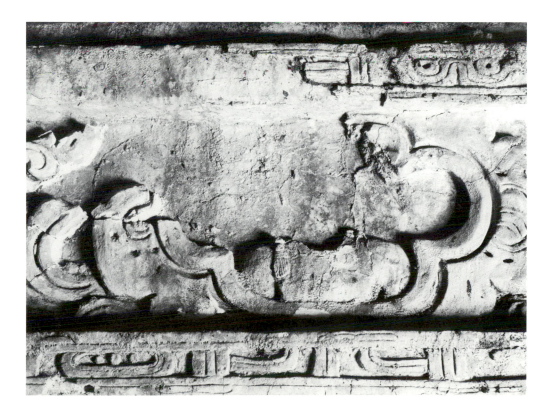

50. Temple of the Cross, West Sanctuary Roof. Upside-down *ahau* in right border.

51. Temple of the Cross, West Sanctuary Roof. Monster mask in border.

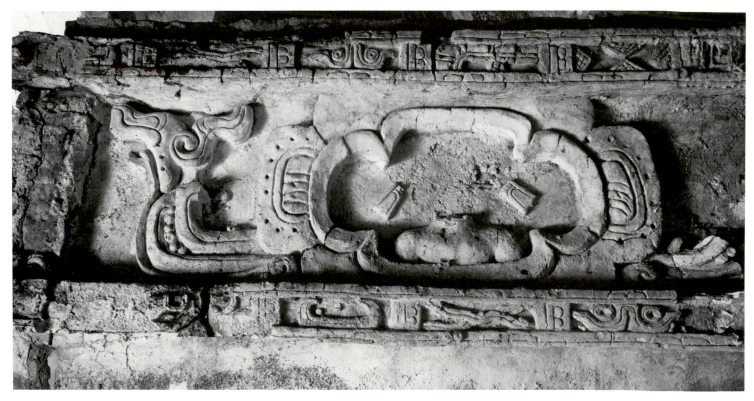

53. Temple of the Cross, East Sanctuary Roof. Giant serpents emerge from behind cartouche.

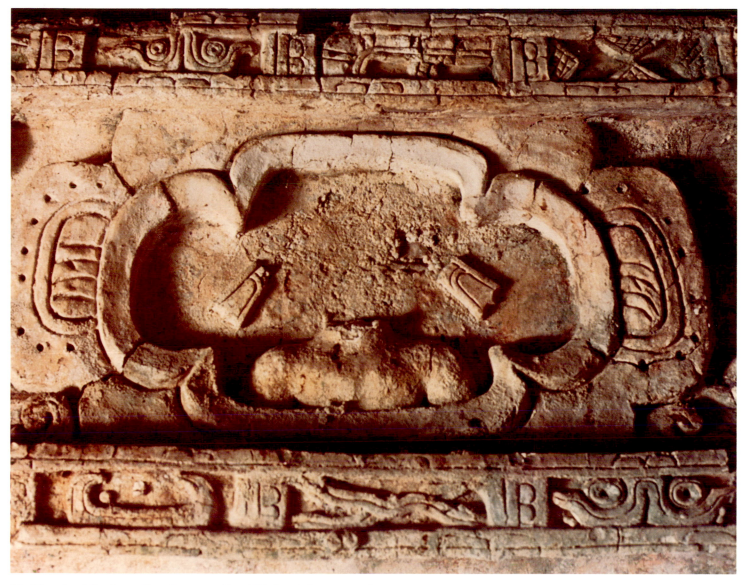

54. Temple of the Cross, East Sanctuary Roof. Skyband elements are intact.

55

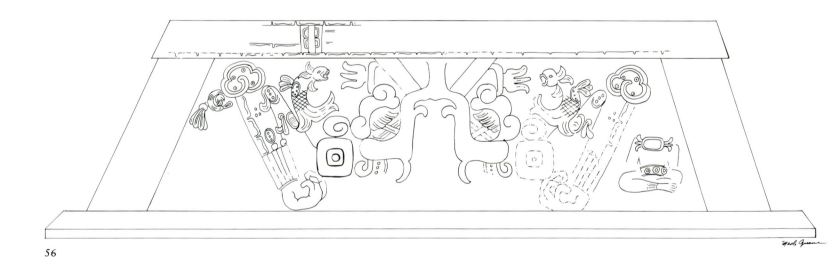

56

55. Temple of the Cross, West Roof.

56. Temple of the Cross, West Roof.

57. Temple of the Cross, West Roof (detail).

58. Temple of the Cross, West Roof.
Giant fish nestle in the saurian creature's arm.

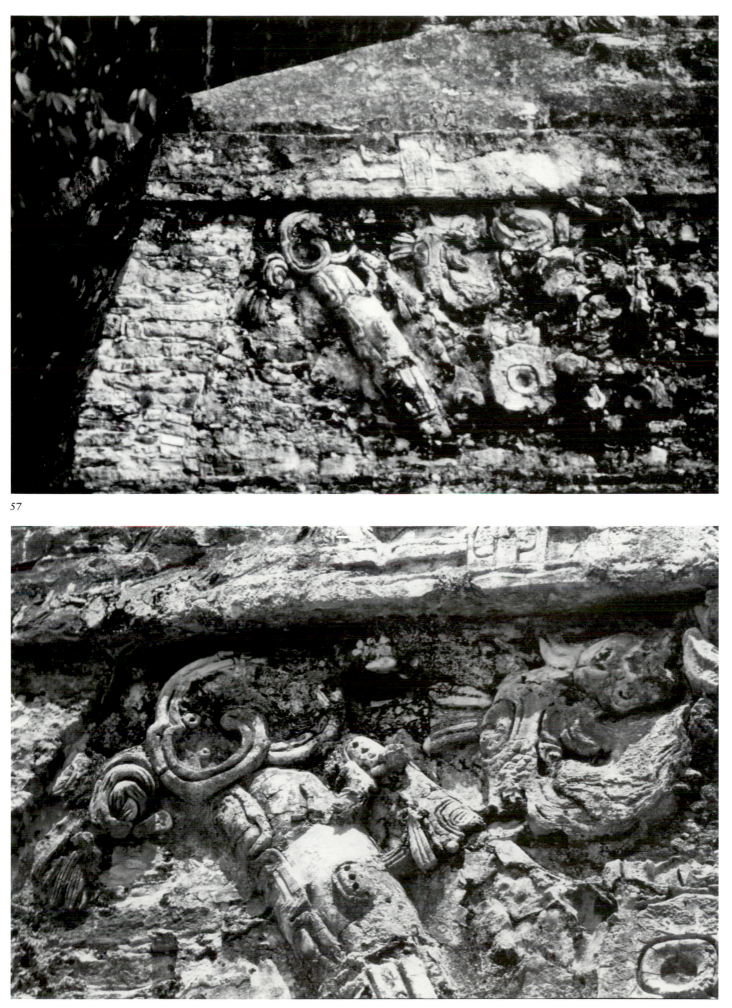

57

58

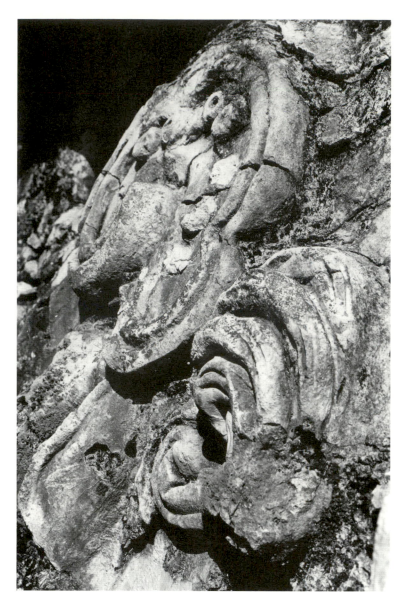

59. Temple of the Cross, West Roof. Note deep-cut elbow of the creature.

60. Temple of the Cross, West Roof. Stone armatures form arm.

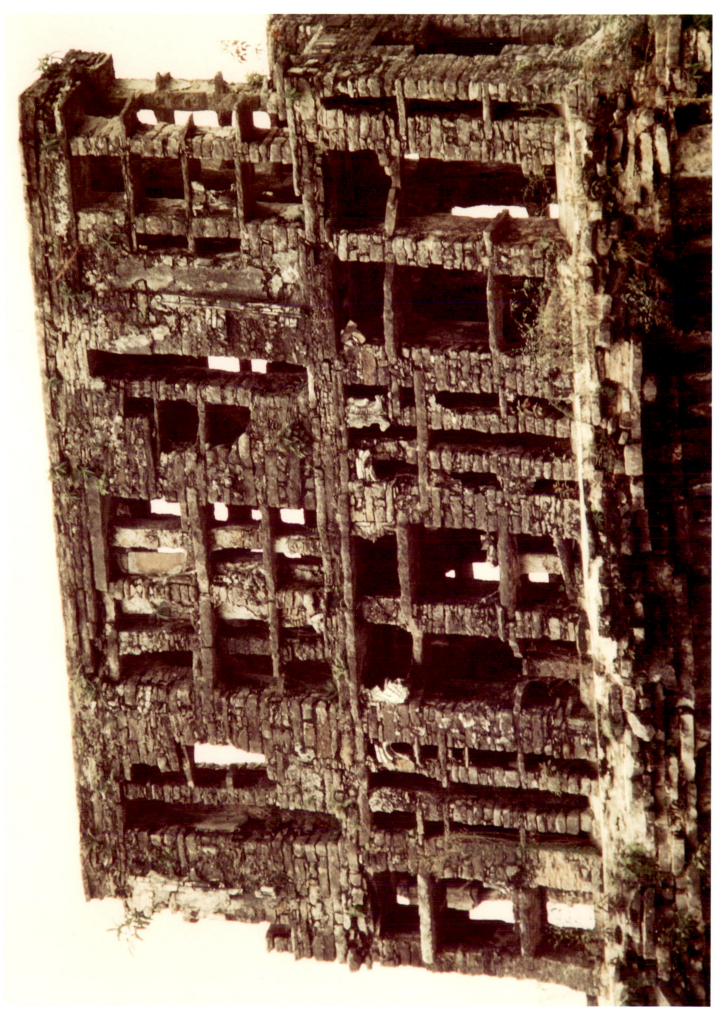

61. Temple of the Cross, Roofcomb.

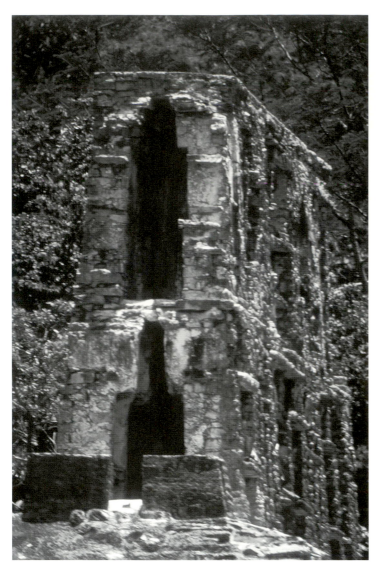

62. Temple of the Cross. Roofcomb is two full stories high.

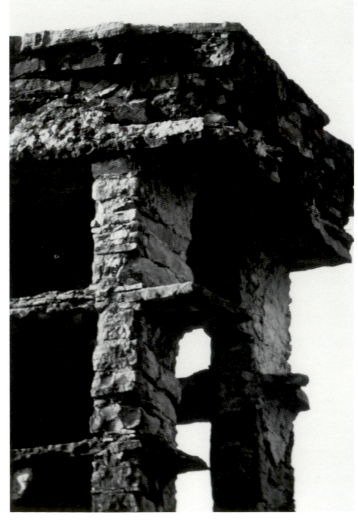

63. Temple of the Cross, Roofcomb. End slabs.

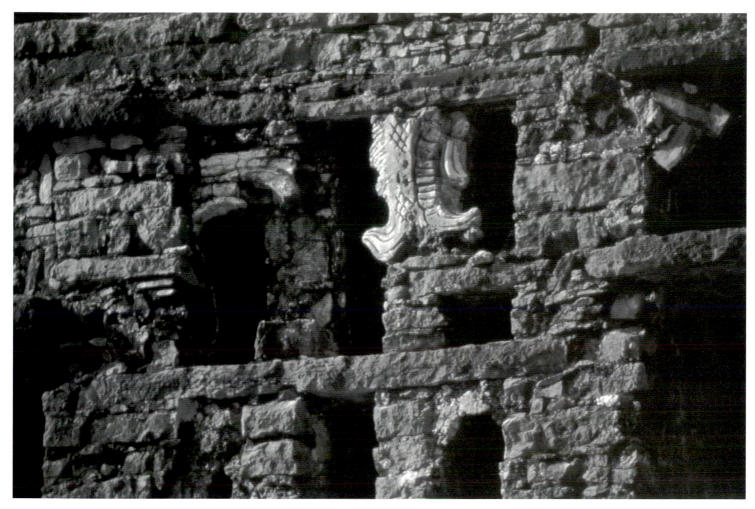

64. Temple of the Cross, Roofcomb, south side. Giant fish hangs from roofcomb.

65. Temple of the Cross, Roofcomb. Stucco sculpture on south side.

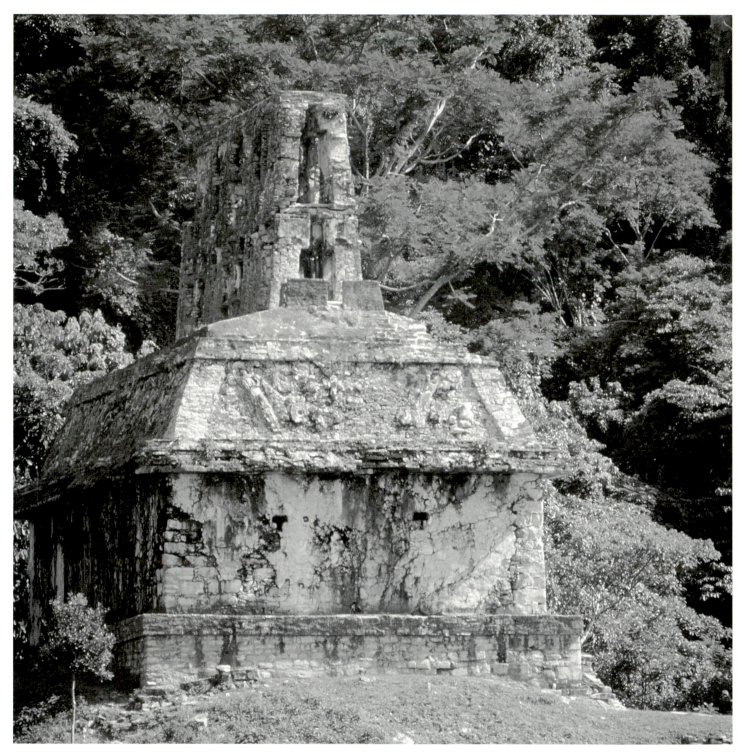

66. Temple of the Cross, Roofcomb, west side.

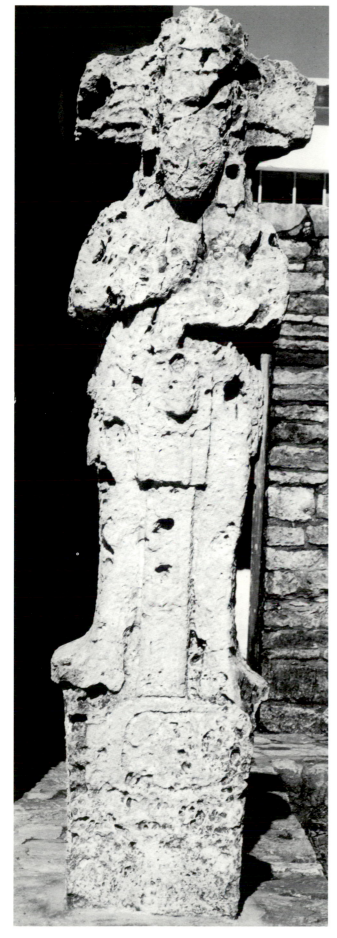

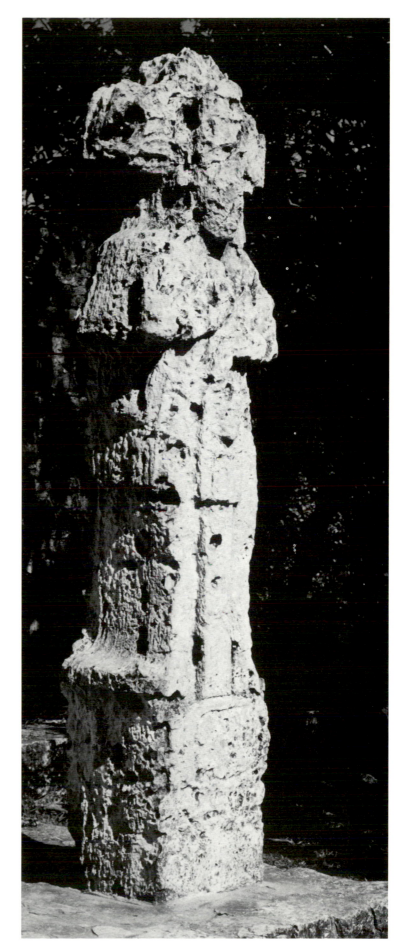

67. Stela 1. Front view.

68. Stela 1. Side view.

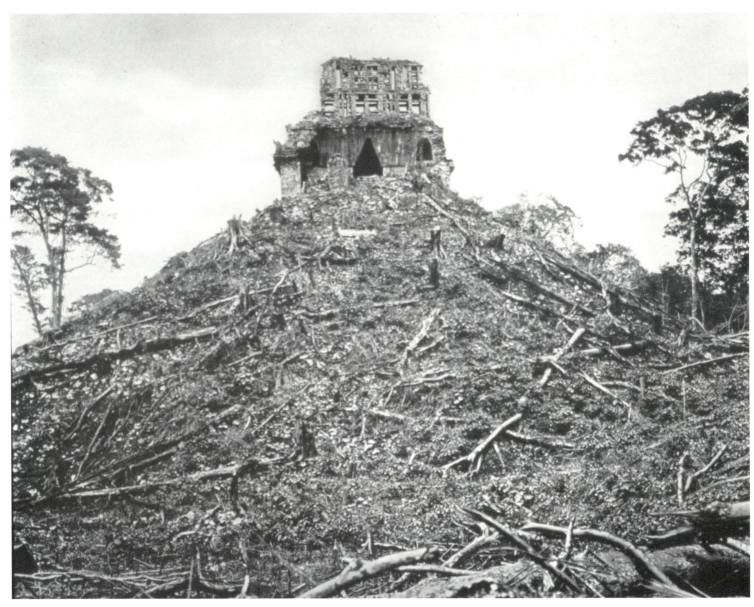

69. Temple of the Cross with Stela 1 lying in front. Photo by Alfred Maudslay, 1890.

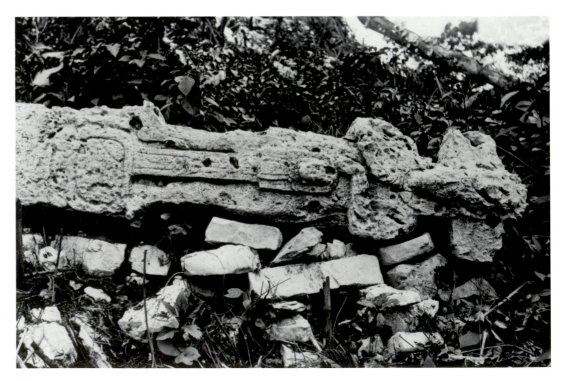

70. Stela 1 lying in front of
the Temple of the Cross.
Photo by Alfred Maudslay, 1890.

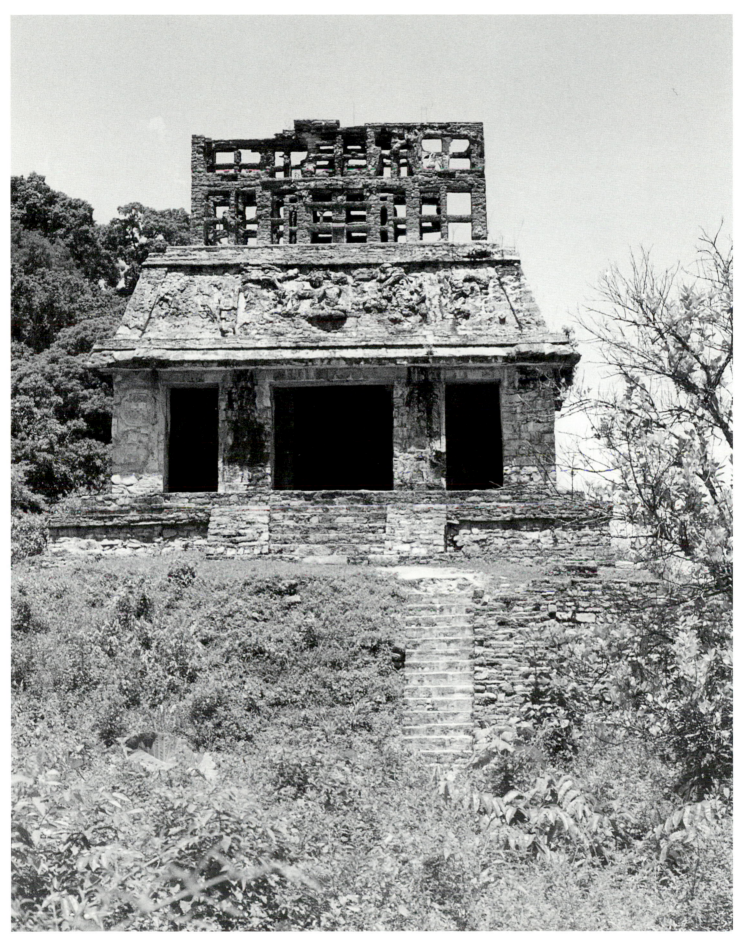

71. Temple of the Sun from the Temple of the Foliated Cross.

72. Temple of the Sun from inside the Temple of the Foliated Cross.

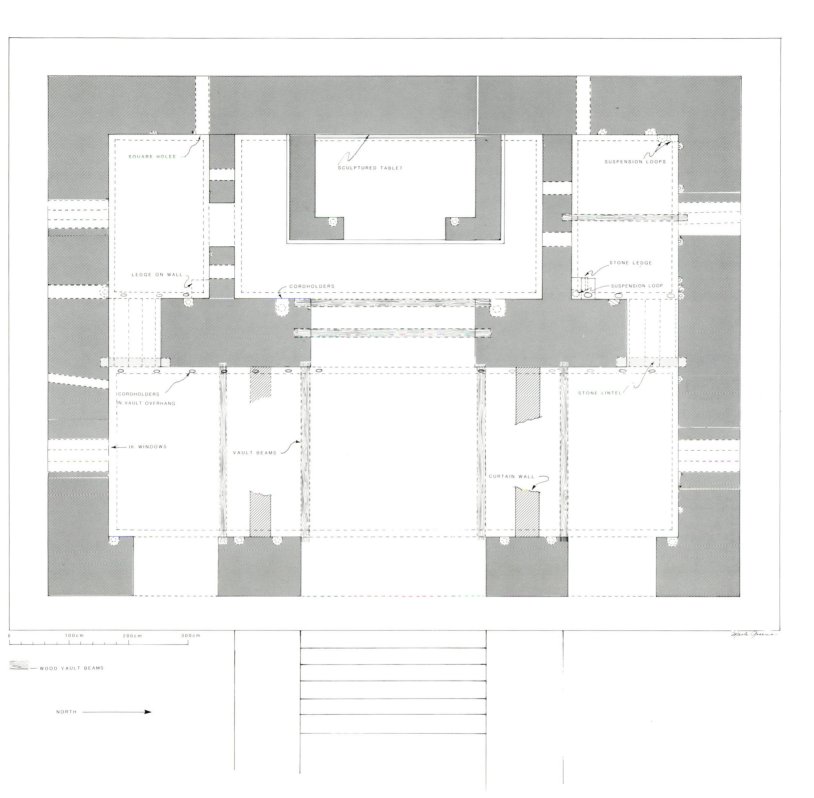

SQUARE HOLES

SCULPTURED TABLET

SUSPENSION LOOPS

LEDGE ON WALL

CORDHOLDERS

STONE LEDGE

SUSPENSION LOOP

ICORDHOLDERS
IN VAULT OVERHANG

STONE LINTEL

IK WINDOWS

VAULT BEAMS

CURTAIN WALL

0 100cm 200cm 300cm

WOOD VAULT BEAMS

NORTH ⟶

73. Temple of the Sun. Plan.

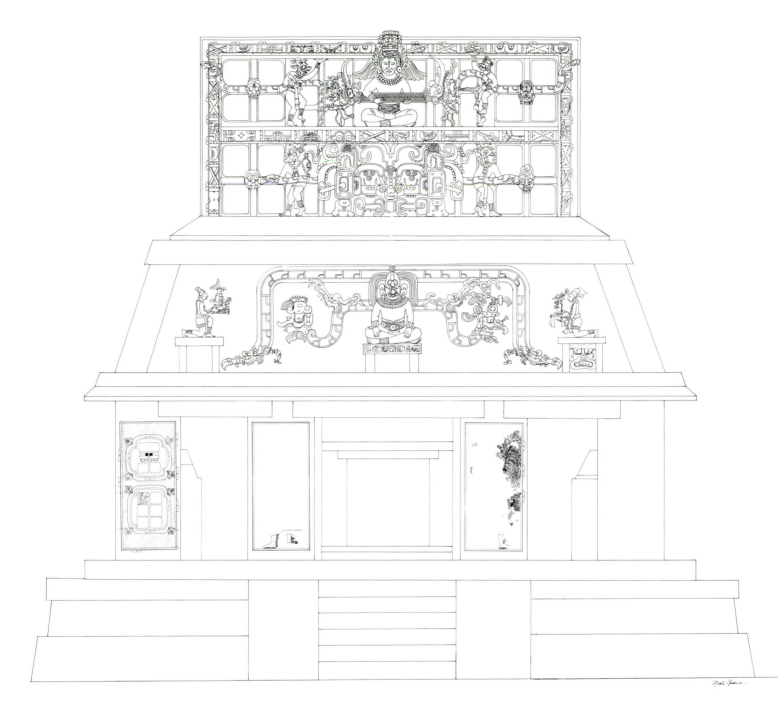

NORTH

74. Temple of the Sun. East elevation.

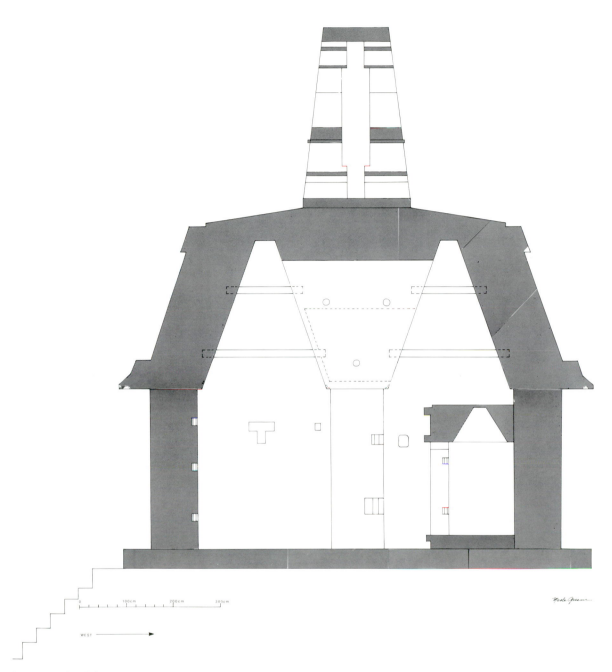

WEST ⟶

75. Temple of the Sun. East-west section.

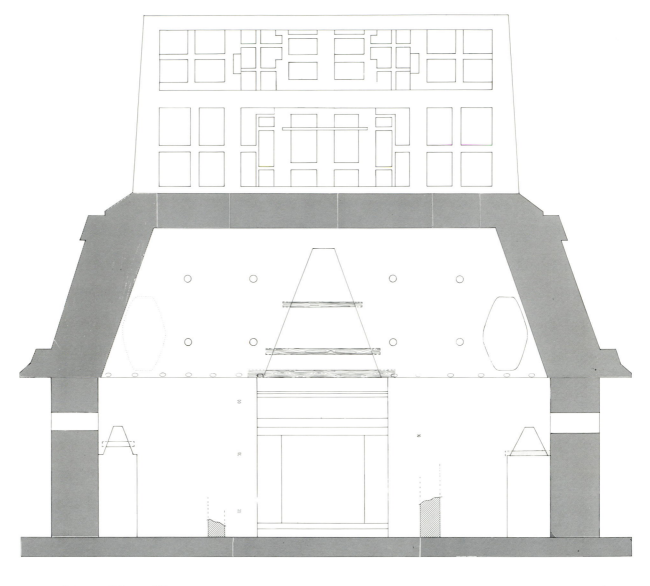

NORTH

76. Temple of the Sun. North-south section.

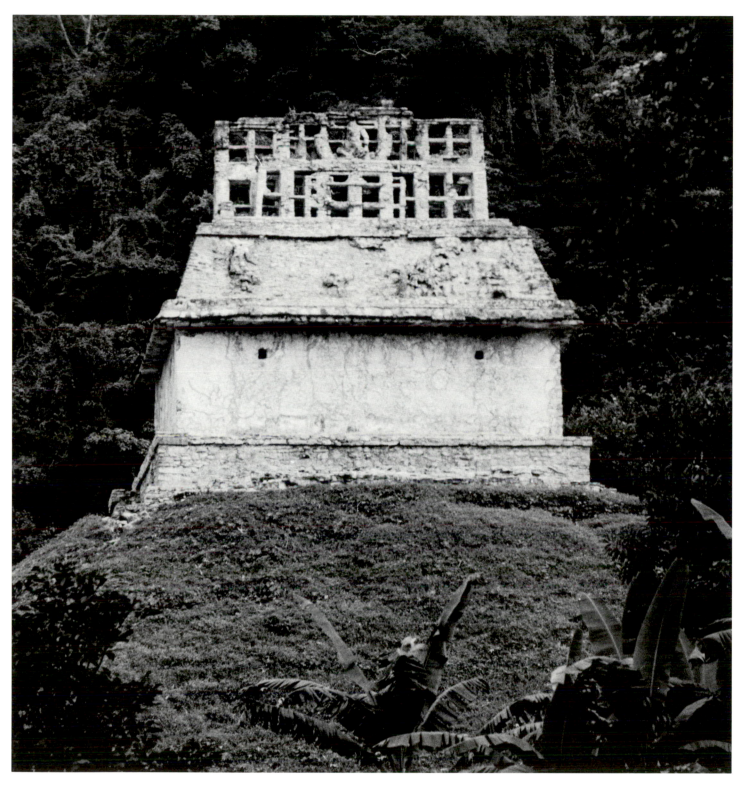

77. Temple of the Sun. West facade.

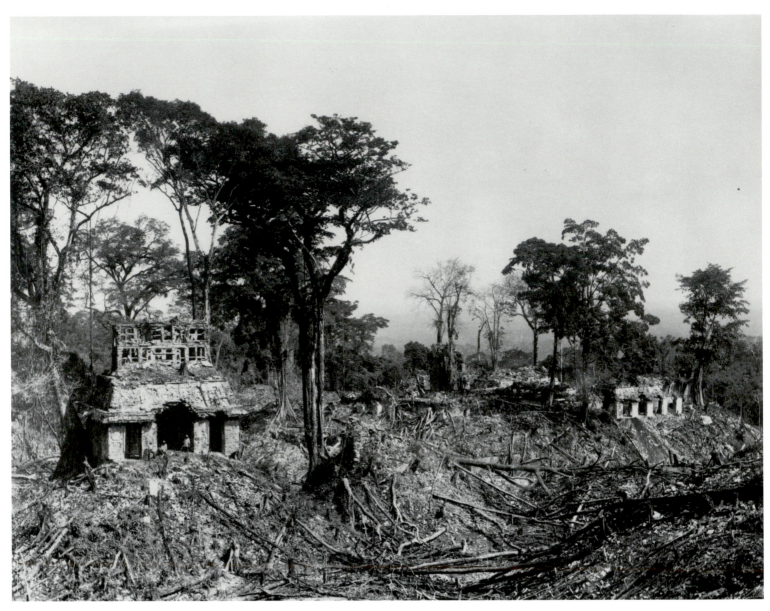

78. Temple of the Sun. Photo by Alfred Maudslay, 1889.

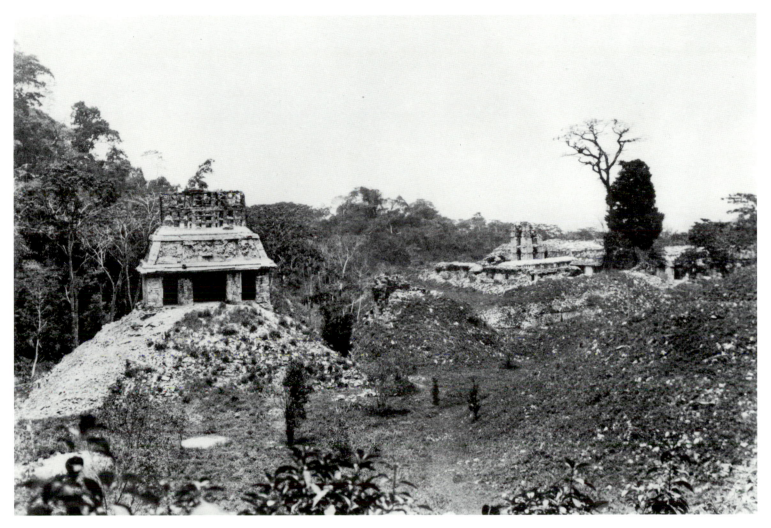

79. Temple of the Sun. Photo by Walter Groth, 1934.

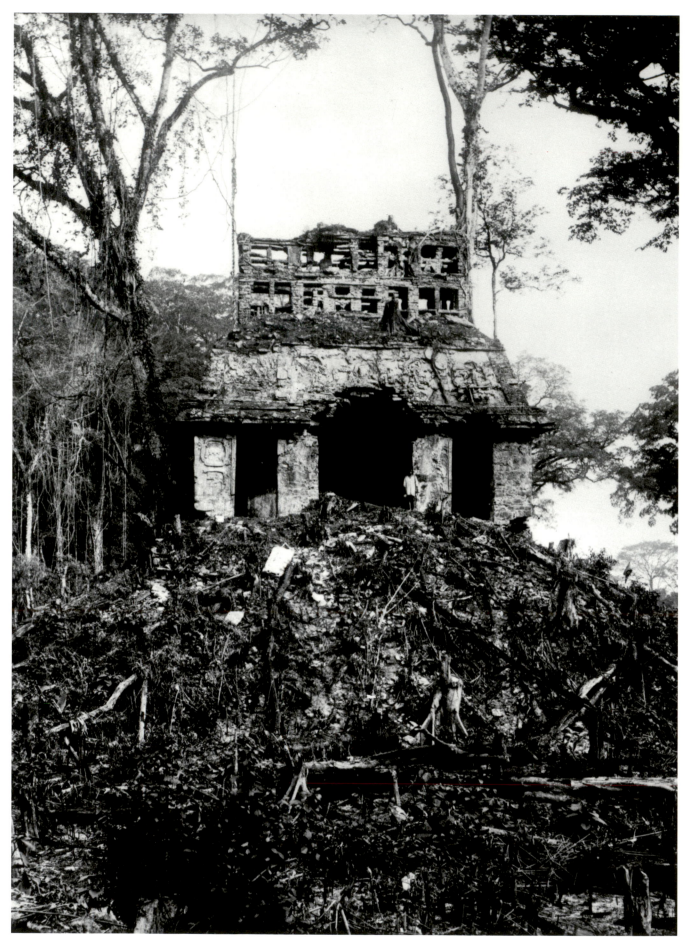

80. Temple of the Sun. Photo by Alfred Maudslay, 1889.

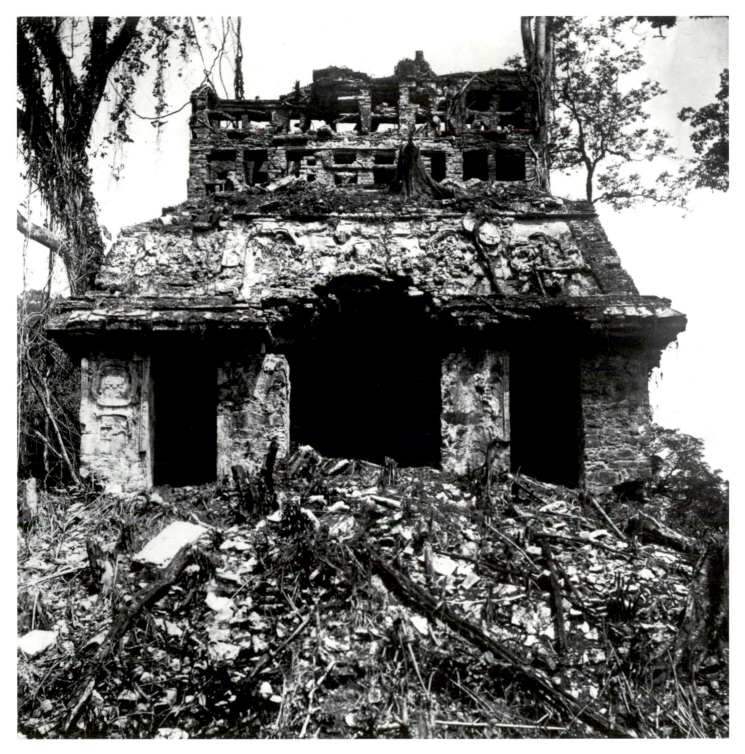

81. Temple of the Sun. Photo by Alfred Maudslay, 1889.

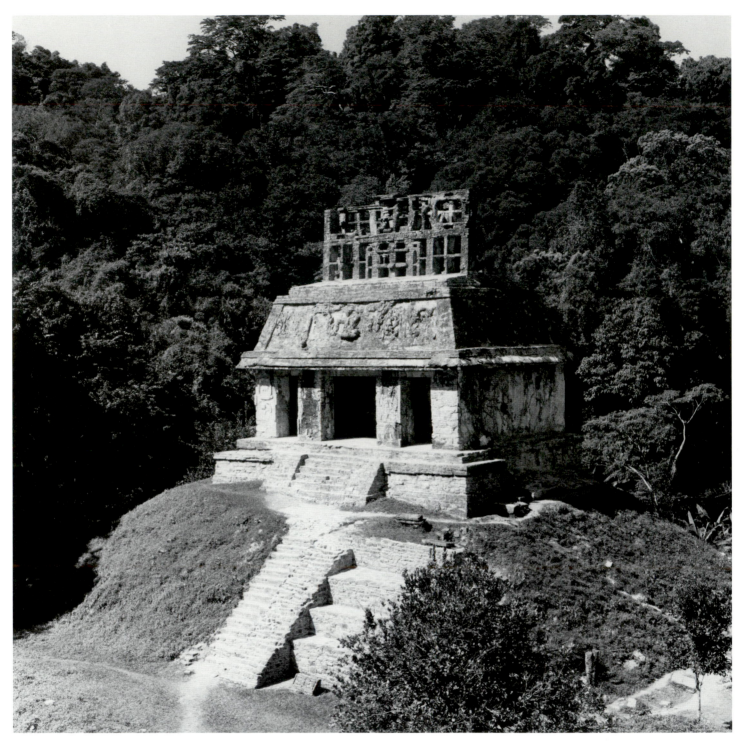

82. Temple of the Sun. Balustrades flank the upper stairs.

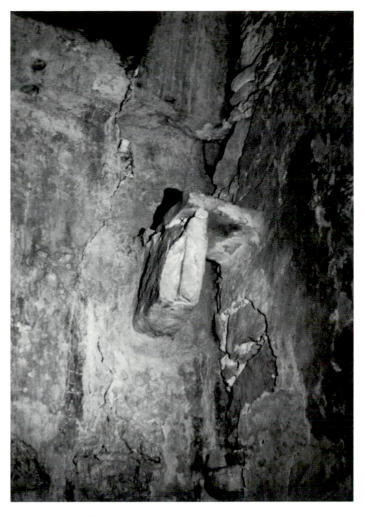

83. Temple of the Sun. Doorway to northwest room.

84. Temple of the Sun. Shelf in southeast corner of northwest room.

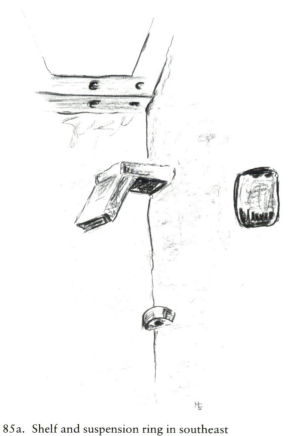

85a. Shelf and suspension ring in southeast corner.

85b. Suspension rings in northwest corner.

85. Temple of the Sun, northwest room.

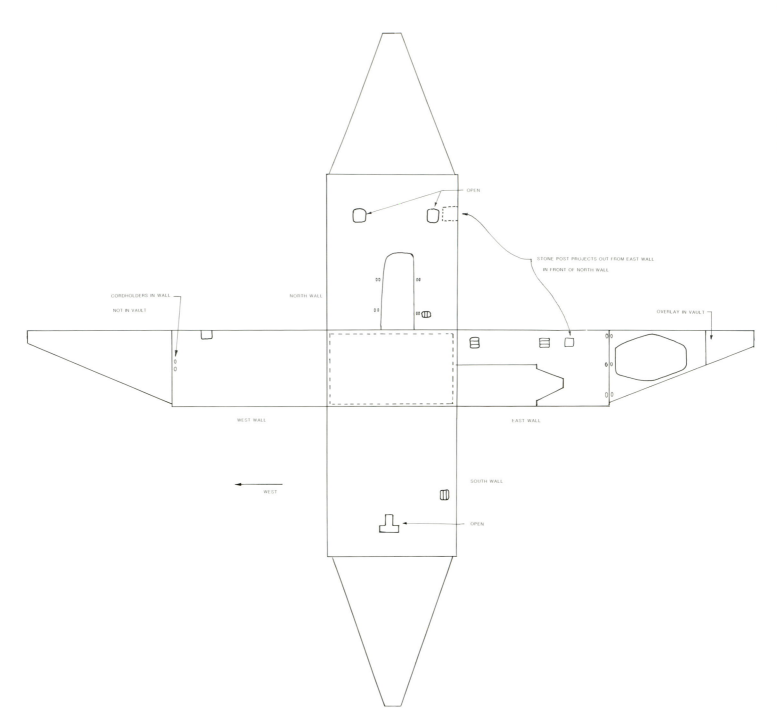

OPEN

STONE POST PROJECTS OUT FROM EAST WALL
IN FRONT OF NORTH WALL

CORDHOLDERS IN WALL

NORTH WALL

OVERLAY IN VAULT

NOT IN VAULT

WEST WALL

EAST WALL

WEST

SOUTH WALL

OPEN

87. Temple of the Sun. Walls of the southwest room.

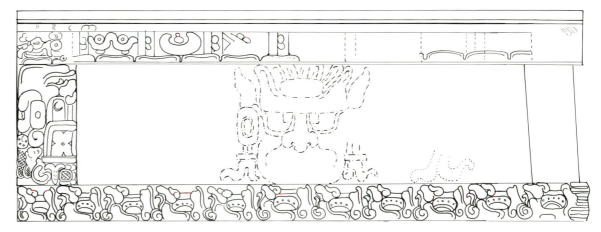

90. Temple of the Sun, Sanctuary Roof.

86. Temple of the Sun. Stone post in wall of southwest room.

88. Temple of the Sun, Sanctuary Roof, north and east sides.

89. Temple of the Sun, Sanctuary Roof, south side.

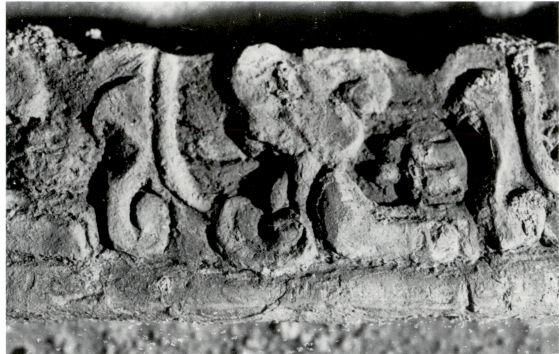

91a

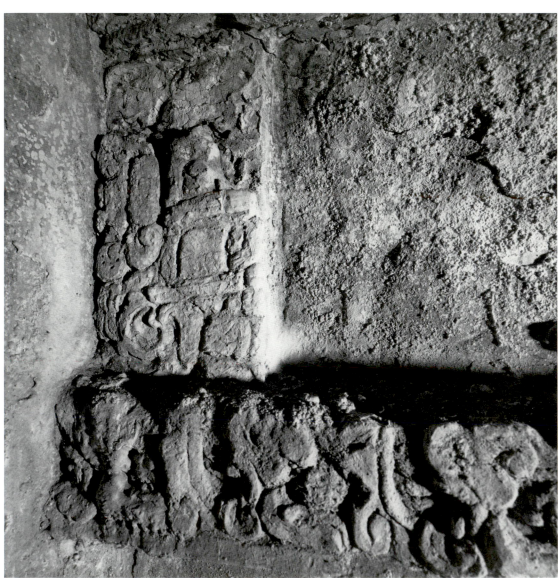

92

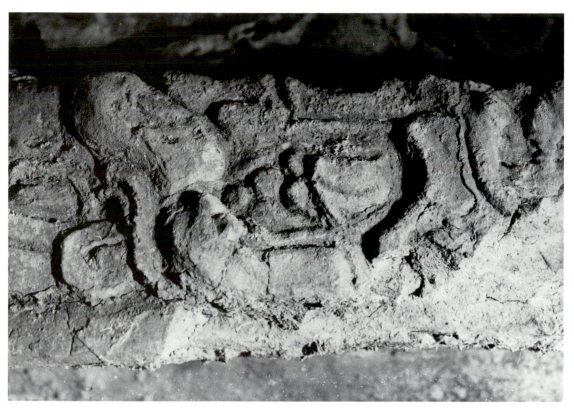

91b

91c

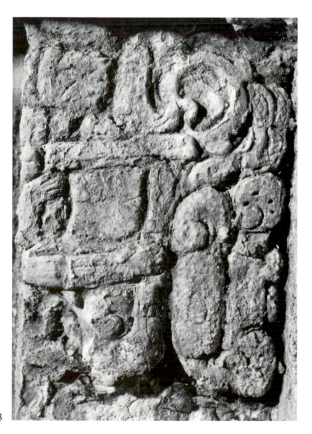

93

91. Temple of the Sun, South Sanctuary Roof. Gods' heads stacked next to each other.

92. Temple of the Sun, South Sanctuary Roof. Quadripartite God at the west corner.

93. Quadripartite God from fig. 92 shown right side up.

94a. South Roof.

94b. South Roof.

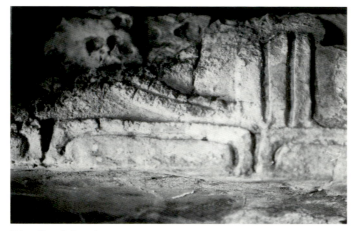

94c. South Roof.

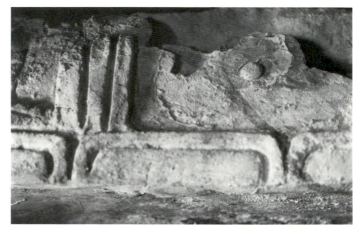

94d. South Roof.

94. Temple of the Sun, Sanctuary Roof. Parts of the skyband border.

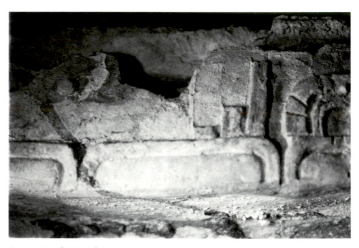

94e. South Roof.

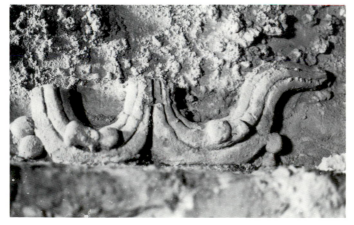

94f. North Roof.

94g. North Roof.

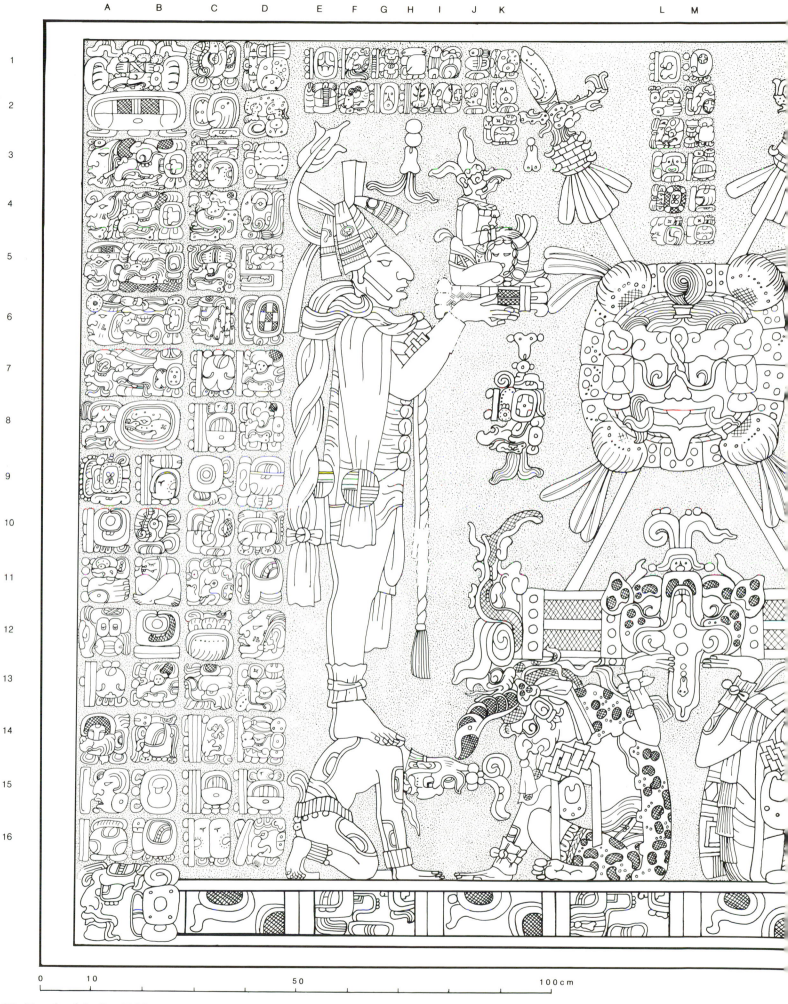

95. Temple of the Sun Tablet.

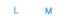

L	M
(on) 8 OC	3 KAYAB (9.12.11.12.10)
HE WAS MADE ZAC UINIC	OF THE SUCCESSION
MAH K'INA CHAN-BAHLUM	HE OF THE MAIZE TITLE BALAM-AHAU
THE CHILD OF (FATHER)	THE 5 KATUN AHPO
MAH K'INA PACAL	THE CHILD OF (MOTHER)
LADY AHPO-HEL	AHPO OF PALENQUE

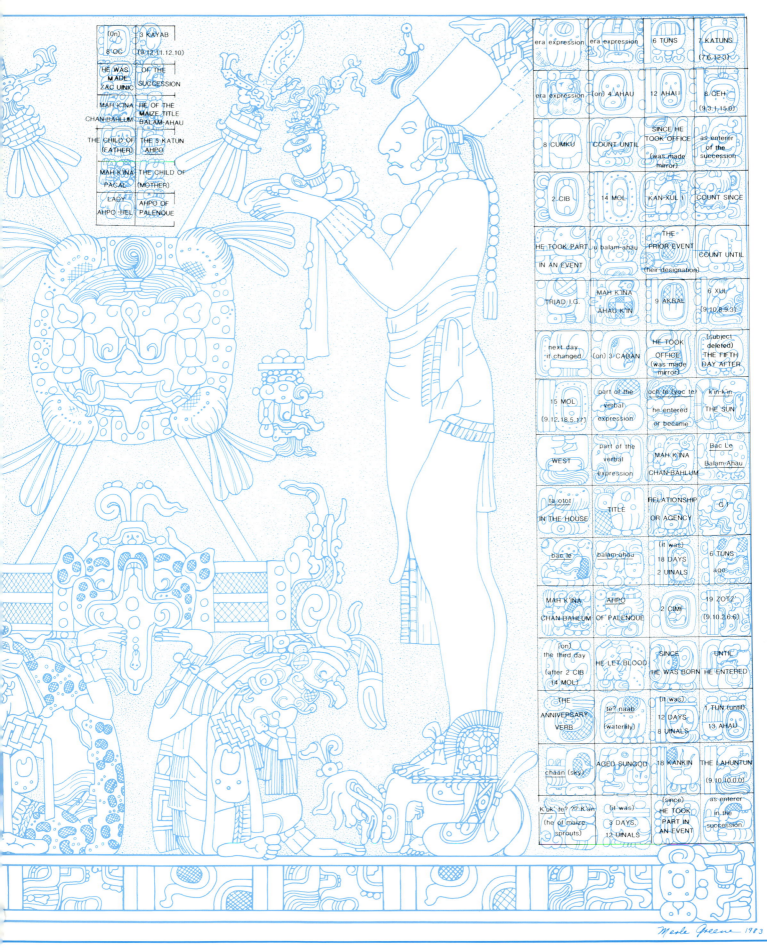

N	O	P	Q
era expression	era expression	6 TUNS	7 KATUNS (7.6.12.3)
era expression	(on) 4 AHAU	12 AHAU	8 CEH (9.3.1.15.0)
8 CUMKU	COUNT UNTIL	SINCE HE TOOK OFFICE (was made mirror)	as enterer of the succession
2 CIB	14 MOL	KAN-XUL	COUNT SINCE
HE TOOK PART IN AN EVENT	u balam-ahau	THE PRIOR EVENT (heir-designation)	COUNT UNTIL
TRIAD I.G.	MAH K'INA AHAU K'IN	9 AKBAL	6 XUL (9.10.8.9.3)
next day it changed	(on) 3 CABAN	HE TOOK OFFICE (was made mirror)	(subject deleted) THE FIFTH DAY AFTER
15 MOL (9.12.18.5.17)	part of the verbal expression	och te (yoc te) he entered or became	k'in-k'in THE SUN
WEST	part of the verbal expression	MAH K'INA CHAN-BAHLUM	Bac Le Balam-Ahau
ta otot IN THE HOUSE	TITLE	RELATIONSHIP OR AGENCY	G 1
bac le	balam-ahau	(it was) 18 DAYS 2 UINALS	6 TUNS ago
MAH K'INA CHAN-BAHLUM	AHPO OF PALENQUE	2 CIMI	19 ZOTZ (9.10.2.6.6)
(on) the third day (after 2 CIB 14 MOL)	HE LET BLOOD	SINCE HE WAS BORN	UNTIL HE ENTERED
THE ANNIVERSARY VERB	te? naab (waterlily)	(it was) 12 DAYS 8 UINALS	1 TUN (until) 13 AHAU
chaan (sky)	AGED SUNGOD	18 KANKIN	THE LAHUNTUN (9.10.10.0.0)
K'uk' te? ?? K'an (he of maize sprouts)	(it was) 3 DAYS, 12 UINALS	(since) HE TOOK PART IN AN EVENT	as enterer in the succession

Merle Greene 1983

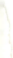

0 cm

| | A / B | C | D | E | F | G | H | I | J | K |
|---|---|---|---|---|---|---|---|---|---|---|---|
| 1 | INITIAL SERIES INTRODUCTORY GLYPH | HE WAS BORN | MAH K'INA TAH BALAM-AHAU (GIII) | (oh) 9 AKBAL | 6 XUL (9.10.8.9.3) | he of the maize title | ???? | he took part in an event | AS TITLE | le balam-ahau (CHAN-BAHLUM |
| 2 | WITH THE PATRON OF CEH | NAME | NAME | he was displayed on the pyramid | ta och te as entered | 13 AHAU | 18 KANKIN (9.10.10.0.0) | RODENT BONE KANKIN | TITLE | THE CHILD OF (father) AHAUAL OF PALENQUE |
| 3 | 1 BAKTUN | NAME | NAME | | | | | | | |
| 4 | 18 KATUNS | NAME | NAME | | | | | | | |
| 5 | 5 TUNS | NAME ("fire") | NAME | | | | | | | |
| 6 | 3 UINALS | MAH K'INA | AHAU K'IN | | | | | | | |
| 7 | 6 DAYS | (it was) 6 DAYS 3 UINALS | 5 TUNS | | | | | | | |
| 8 | 13 CIMI | 18 KATUNS | 1 BAKTUN (1.18.5.3.6) | | | | | | | |
| 9 | G3 was in office | 19 CEH (1.18.5.3.6) | SINCE THE ERA EVENT | CONCERNING THE SKY | | | | | | |
| 10 | (it was) 26 days | since the birth of the moon | UNTIL HE WAS BORN | THE DIVINITY | | | | | | |
| 11 | 4 LUNATIONS HAD ENDED | GLYPH X (patron of the lunation??) | THE BLOOD OF | | | | | | | |
| 12 | GLYPH B (the rabbit was in the house) | FOR 30 DAYS | NAME OR ATTRIBUTE | LADY (Na) | | | | | | |
| 13 | (THE I.S. DATE WAS) 11 DAYS 2 UINALS | 1 TUN (since 1.18.4.0.15 5 Men 13 Yax) | BEASTIE | AHPO OF PALENQUE | | | | | | |
| 14 | HE TOOK PART IN THE 819-DAY-COUNT EVENT | GOD K | (it was) 16 DAYS | 5 UINALS | | | | | | |
| 15 | NORTH | (on) 1 IK | 18 TUINS | 12 KATUNS | | | | | | |
| 16 | 10 ZEC (1.6.14.11.2) | IT WAS MANIFESTED | 9 BAKTUNS (9.12.18.5.16) | (since) the era event | | | | | | |

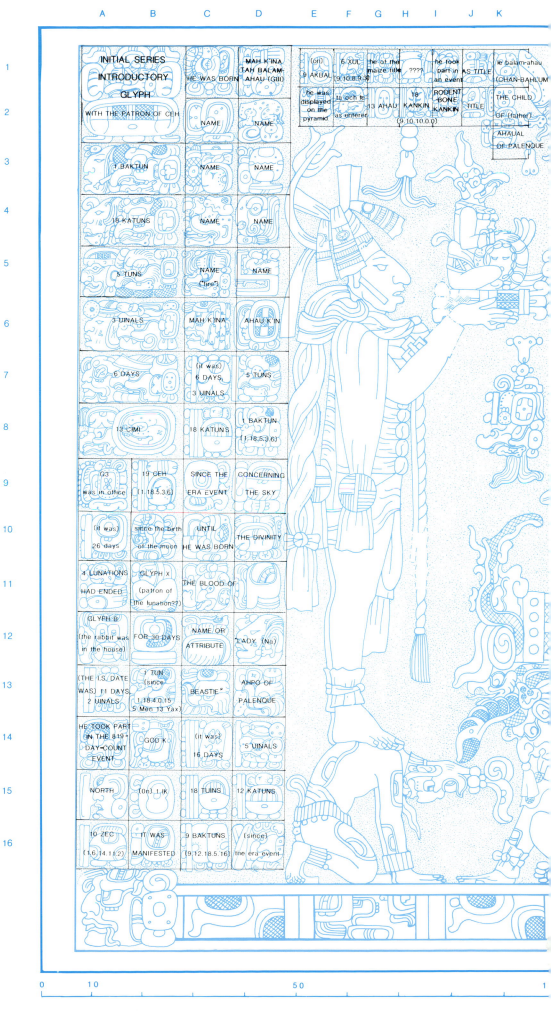

0 10 50

96. Temple of the Sun Tablet text.

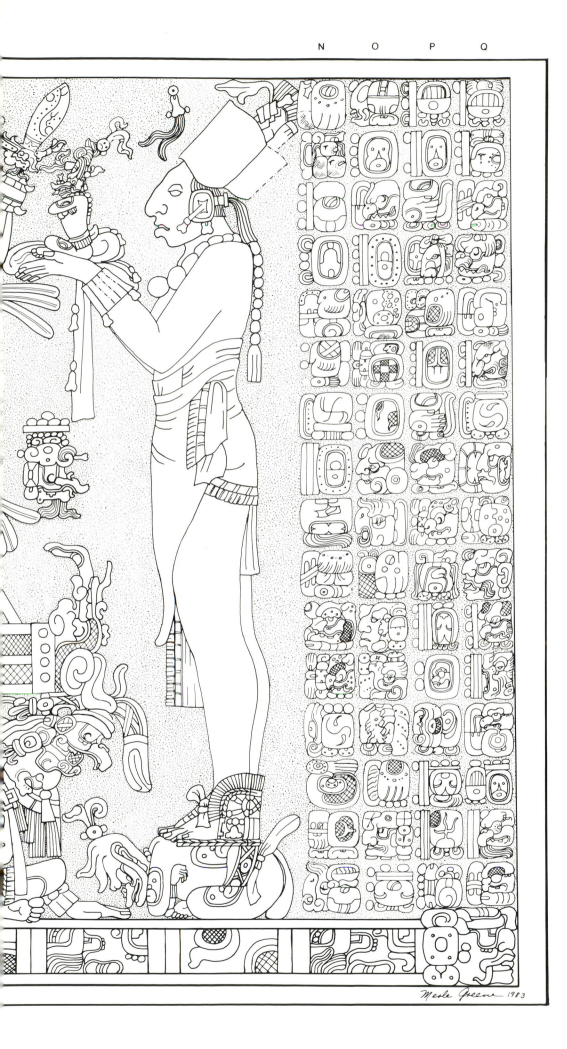

Merle Greene 1983

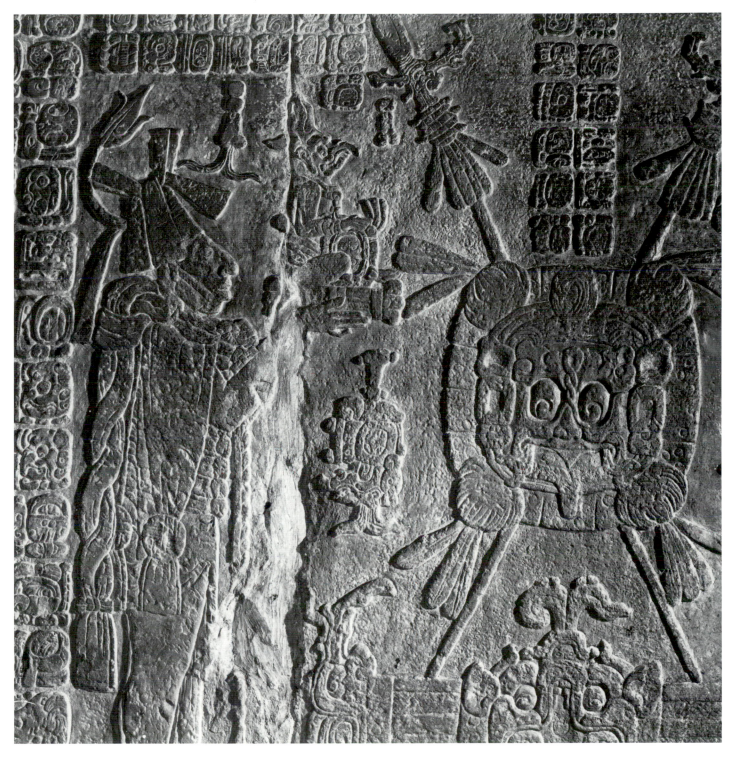

97. Temple of the Sun Tablet. The short figure.

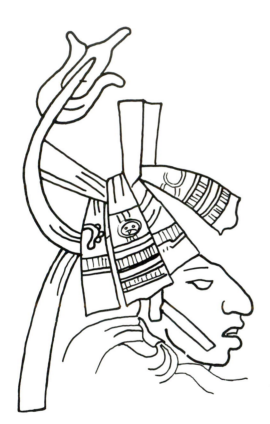

98. Temple of the Sun Tablet.
Head of the short figure.

99. Temple of the Sun Tablet. Embroidery on the short figure's hat.

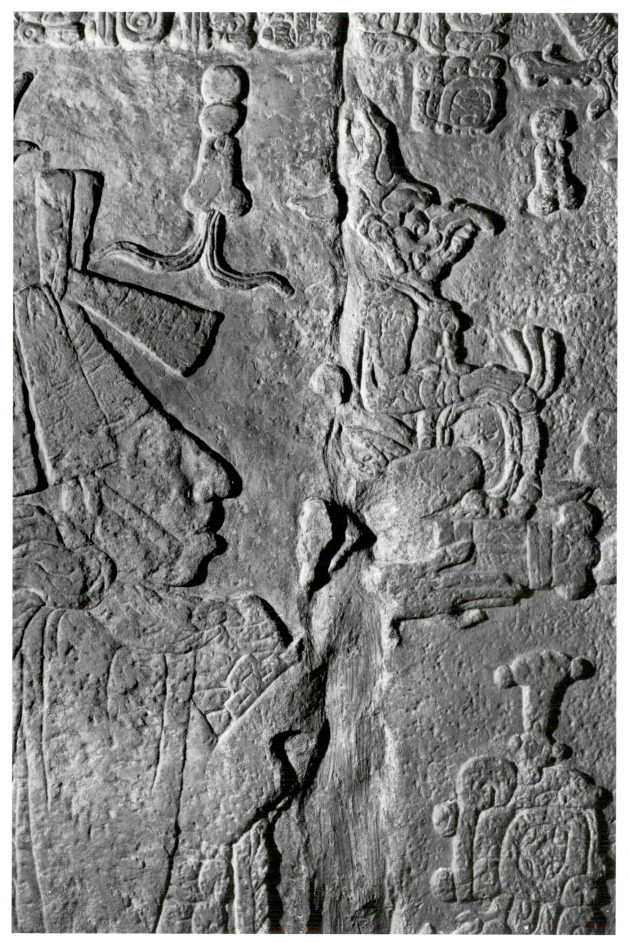

100. Temple of the Sun Tablet. Short figure holds the flint-shield god.

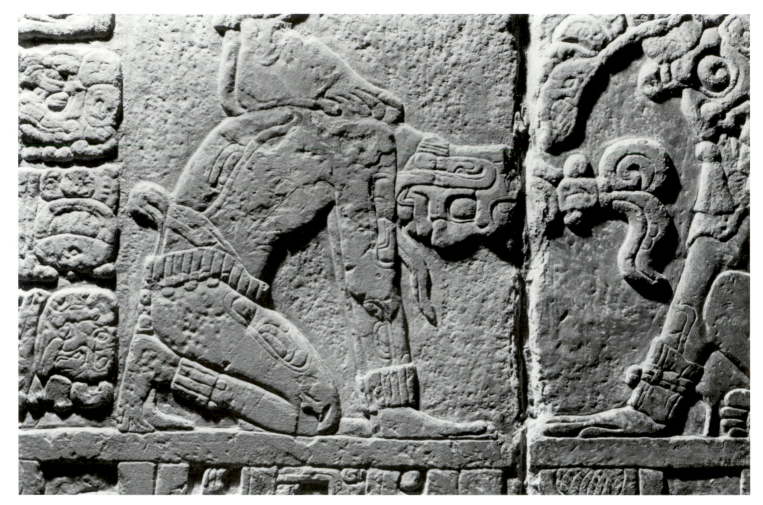

101. Temple of the Sun Tablet. The Roman-nose god crouches under the short figure.

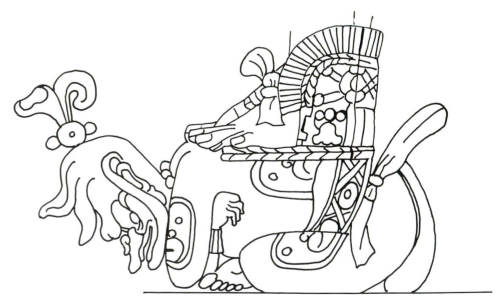

102. Temple of the Sun Tablet.
The god of merchants under the
tall figure.

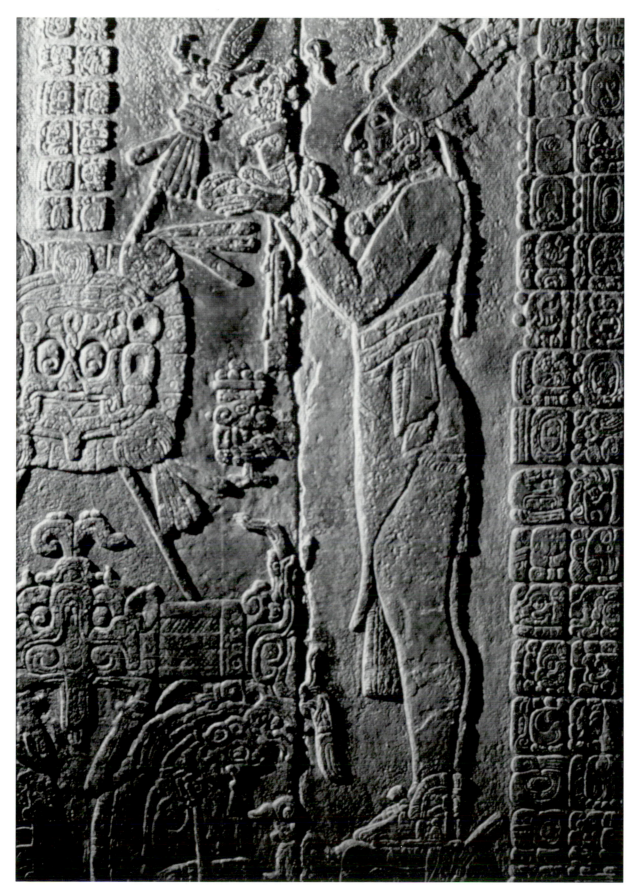

103. Temple of the Sun Tablet. Chan-Bahlum, the tall figure.

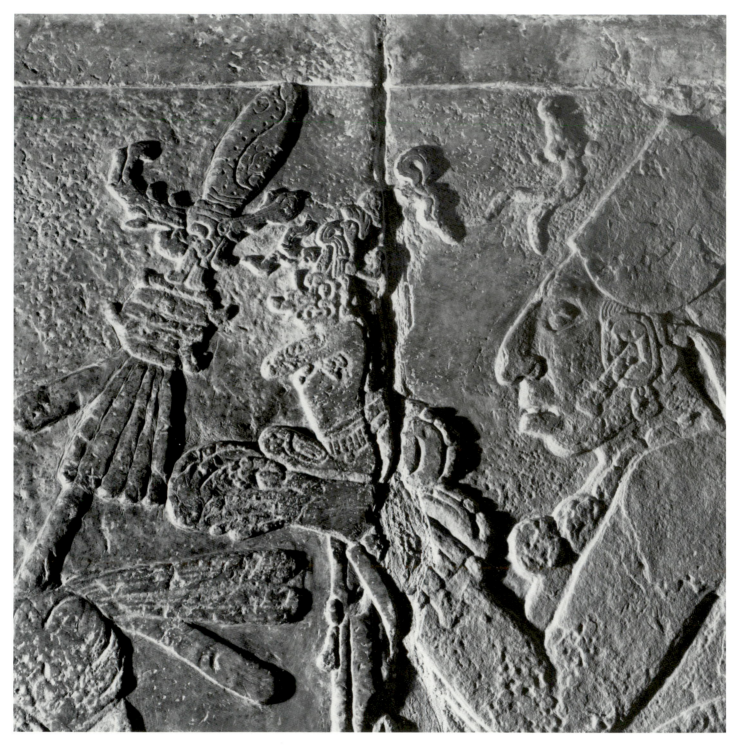

104. Temple of the Sun Tablet. Chan-Bahlum holds God K.

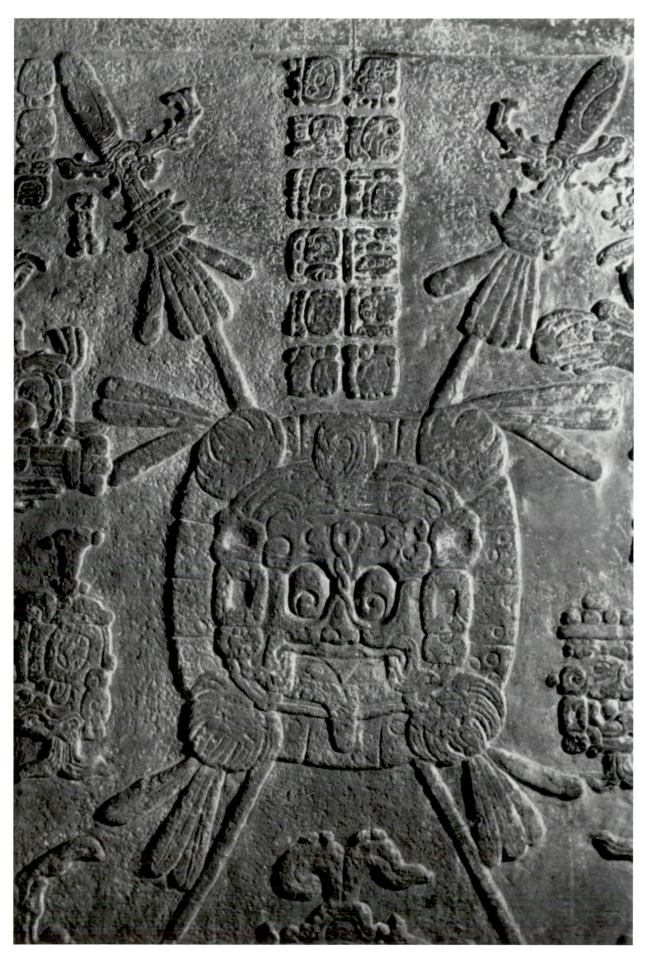

105. Temple of the Sun Tablet. The shield icon.

106. Temple of the Sun Tablet. The "smoking jaguar" bar.

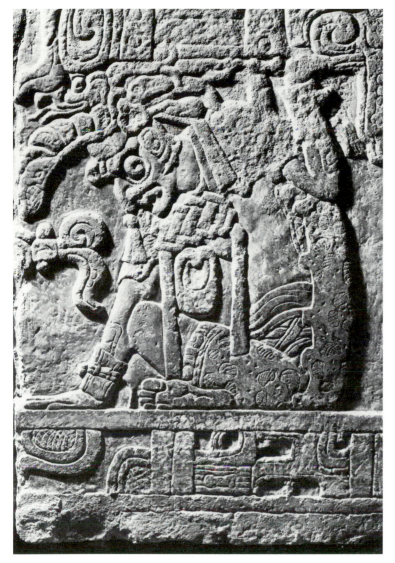

107. Temple of the Sun Tablet. God L holds up the "smoking jaguar" bar.

108. Temple of the Sun Tablet. God M holds up the "smoking jaguar" bar.

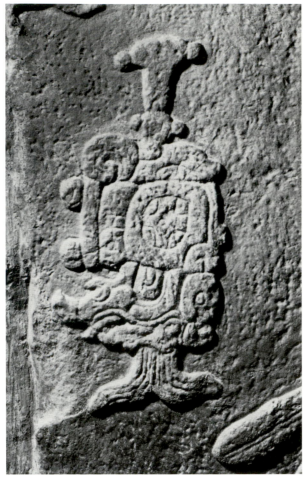

109

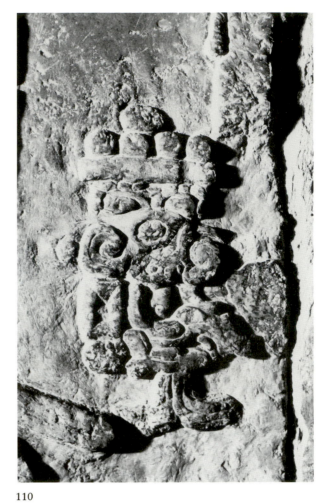

110

109. Temple of the Sun Tablet. The God of Number 7.

110. Temple of the Sun Tablet. The God of Number 9.

111. Temple of the Sun Tablet. Text over the shield.

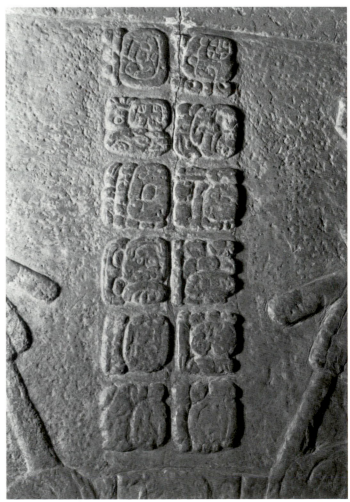

111

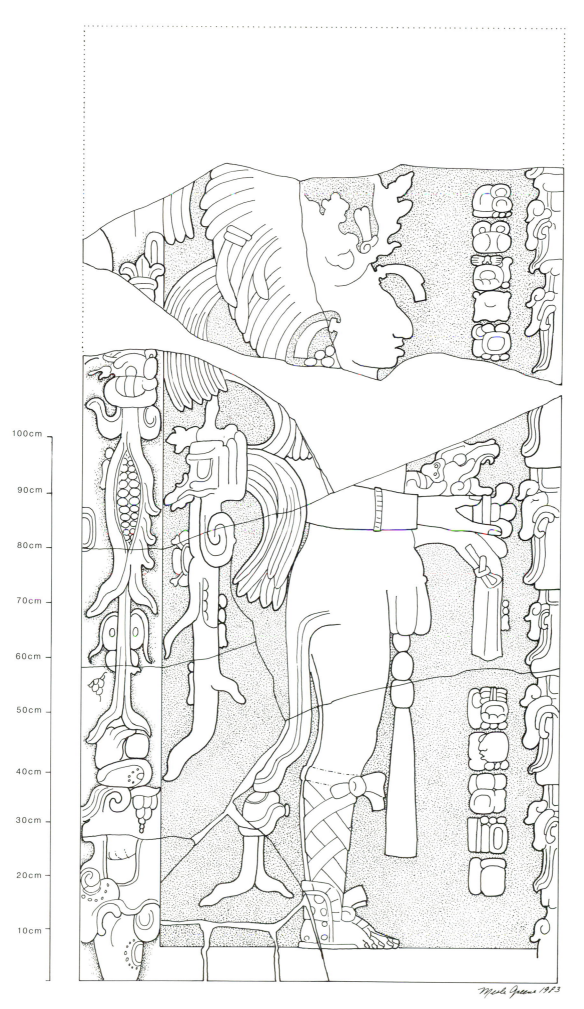

100cm
90cm
80cm
70cm
60cm
50cm
40cm
30cm
20cm
10cm

Merle Greene 1983

112. Temple of the Sun, South Jamb.

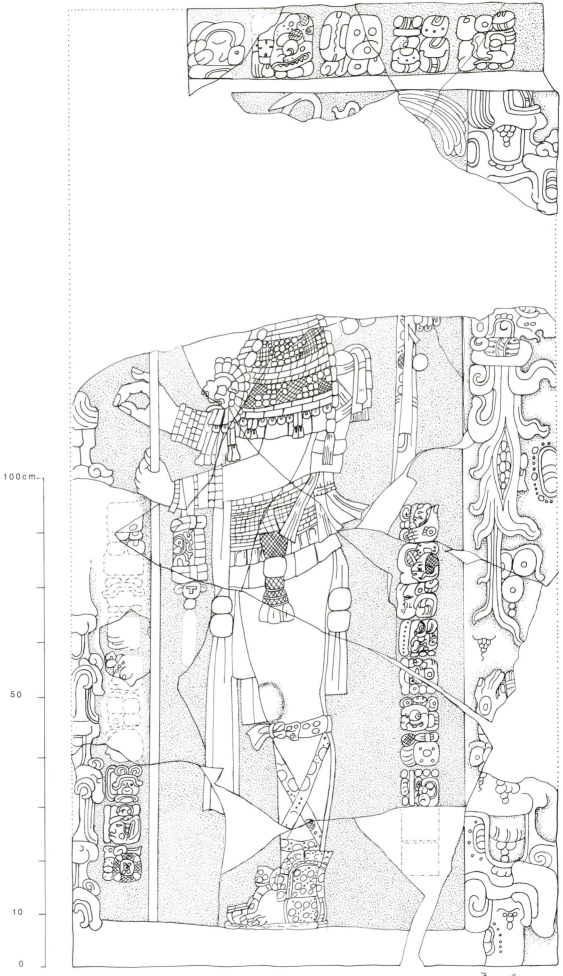

100 cm

50

10

0

113. Temple of the Sun, North Jamb.

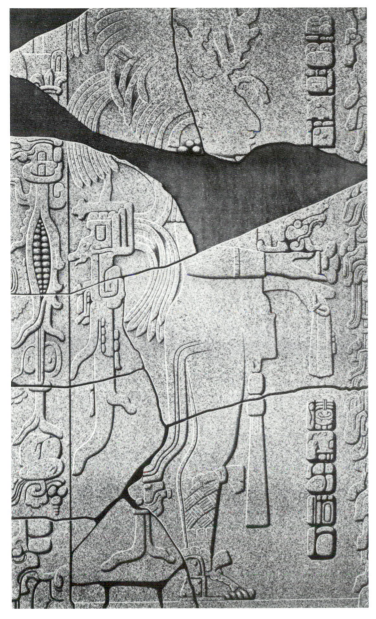

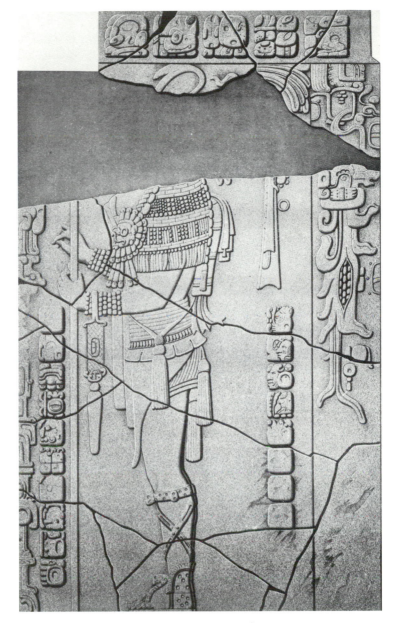

114. Temple of the Sun, South Jamb. By Jean Frédéric Waldeck, 1838.

115. Temple of the Sun, North Jamb. By Jean Frédéric Waldeck, 1838.

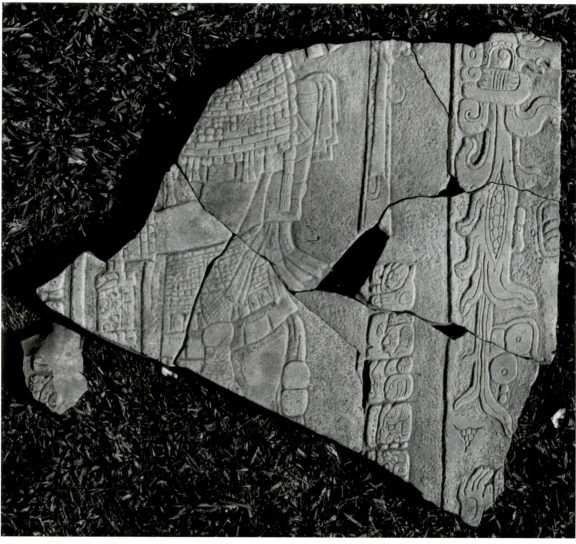

116

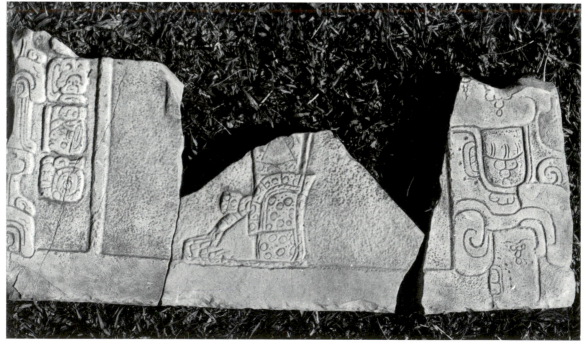

117

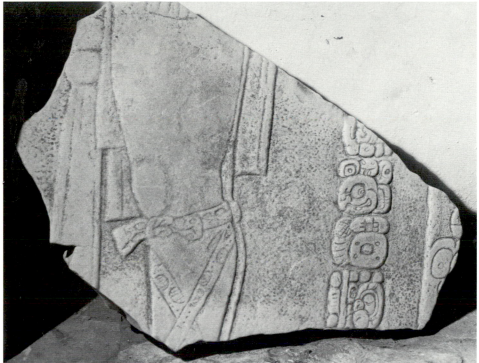

118

119

116. Temple of the Sun. Pieces of the North Jamb in the bodega at Palenque.

117. Temple of the Sun. Pieces of the North Jamb in the bodega at Palenque.

118. Temple of the Sun. Part of the North Jamb, discovered in 1981.

119. Temple of the Sun. Part of the North Jamb, discovered in 1981.

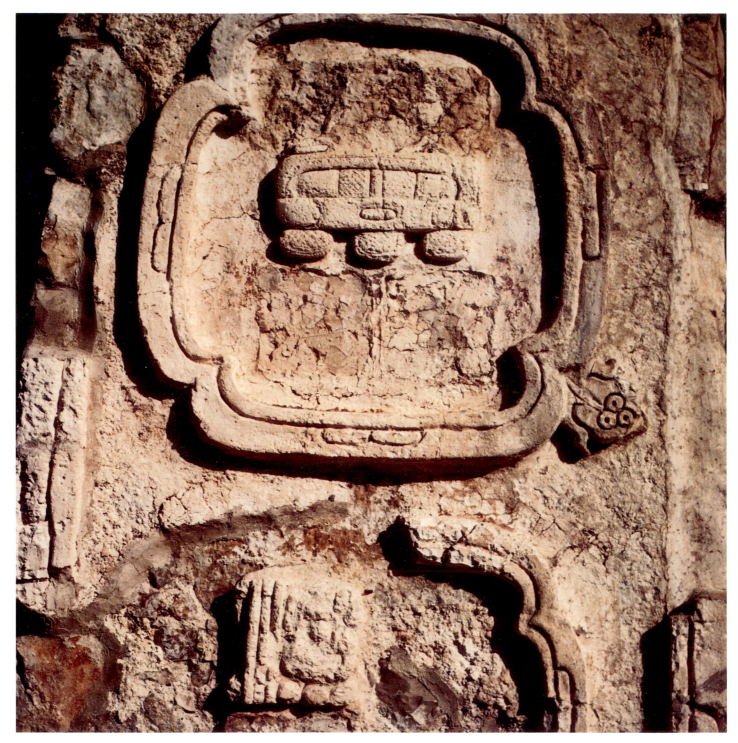

120. Temple of the Sun, Pier A cartouche.

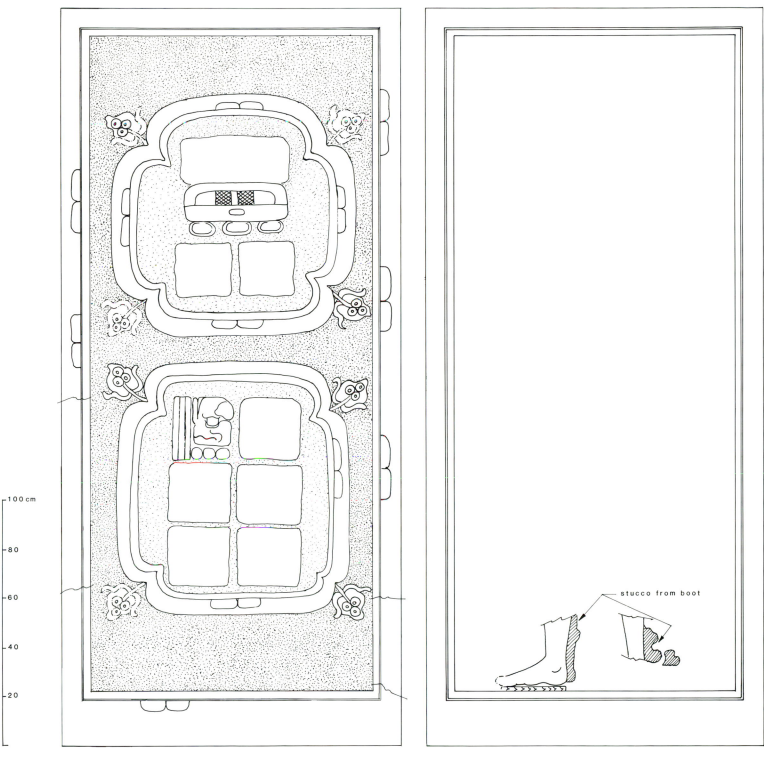

121. Temple of the Sun, Pier A.

122. Temple of the Sun, Pier B.

stucco from boot

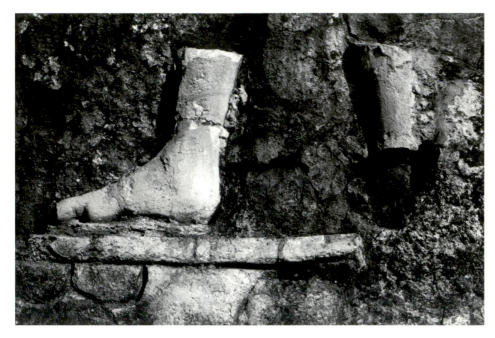

123. Temple of the Sun, Pier B. Leg and foot.

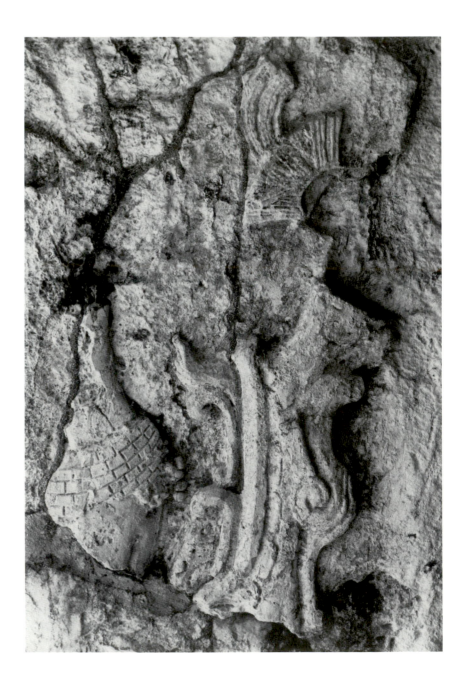

125. Temple of the Sun, Pier B. Figure sculptured
on the north side.

100cm
80cm
60cm
40cm
20cm

124. Temple of the Sun, Pier B, north side.

127. Temple of the Sun, Pier C.

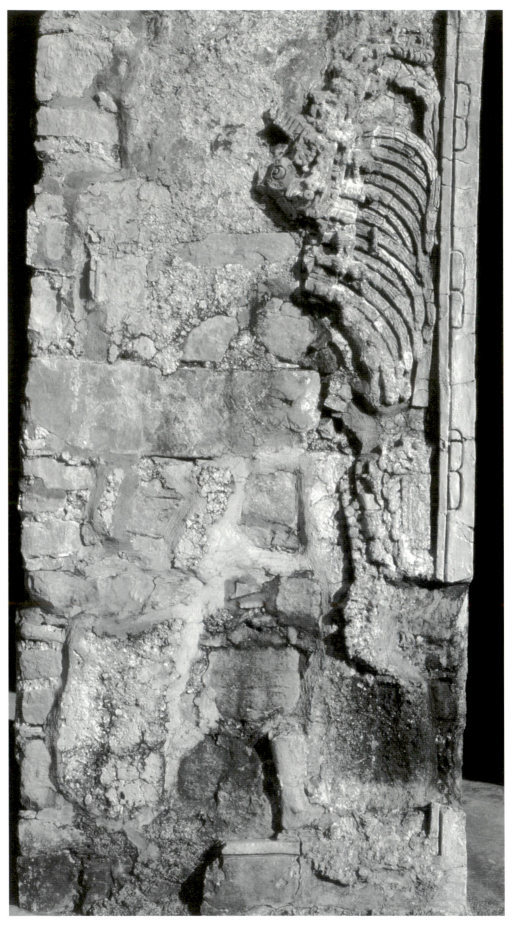

126. Temple of the Sun, Pier C.

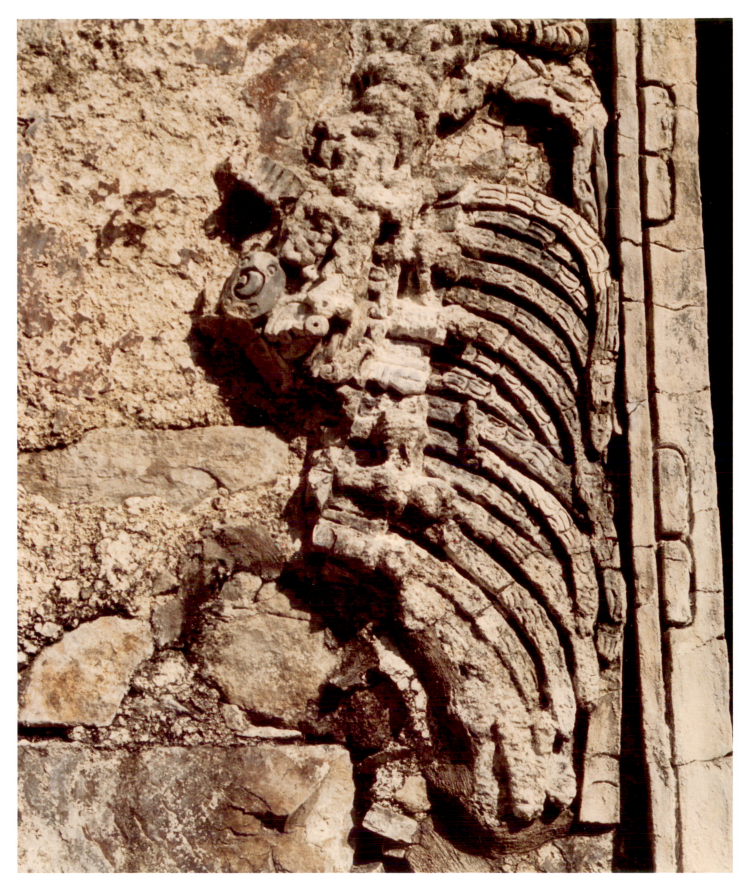

128. Temple of the Sun, Pier C. Feathers on the headdress.

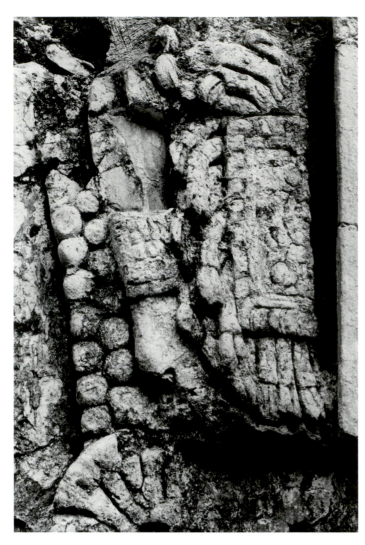

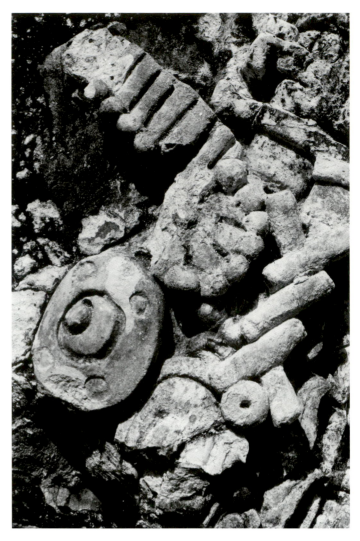

129. Temple of the Sun, Pier C. Wrist shield.

130. Temple of the Sun, Pier C. Headdress element.

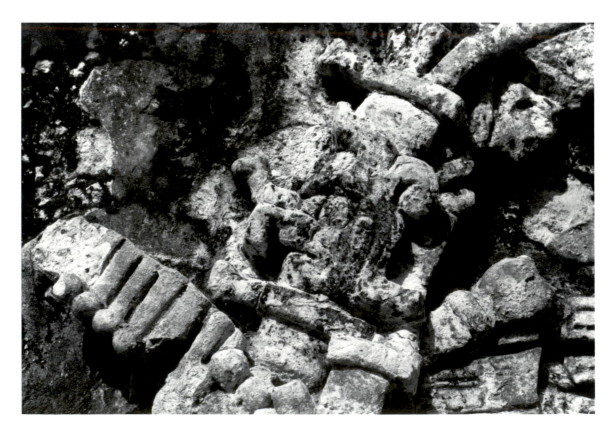

131. Temple of the Sun, Pier C. Jester god in headdress.

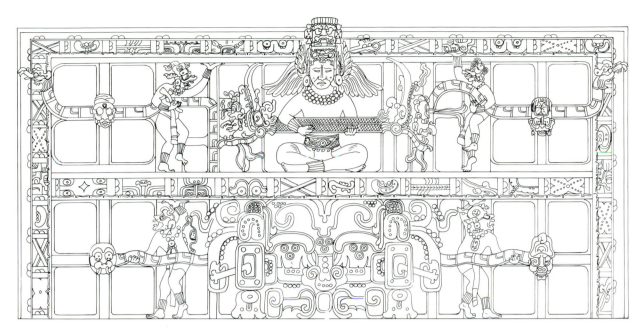

134. Temple of the Sun, Roofcomb.

132. Temple of the Sun, Pier C.
Foot of the figure.

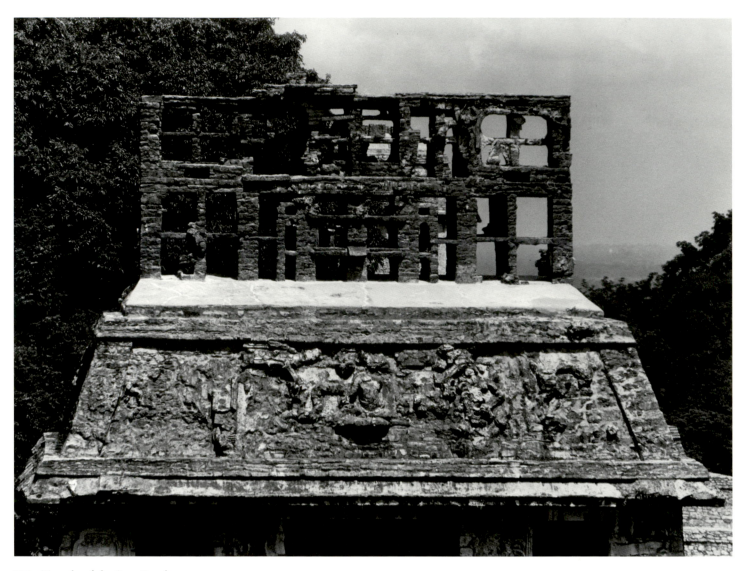

133. Temple of the Sun, Roof
and Roofcomb.

137. Temple of the Sun, Roof.
The 7 God through a telescope.

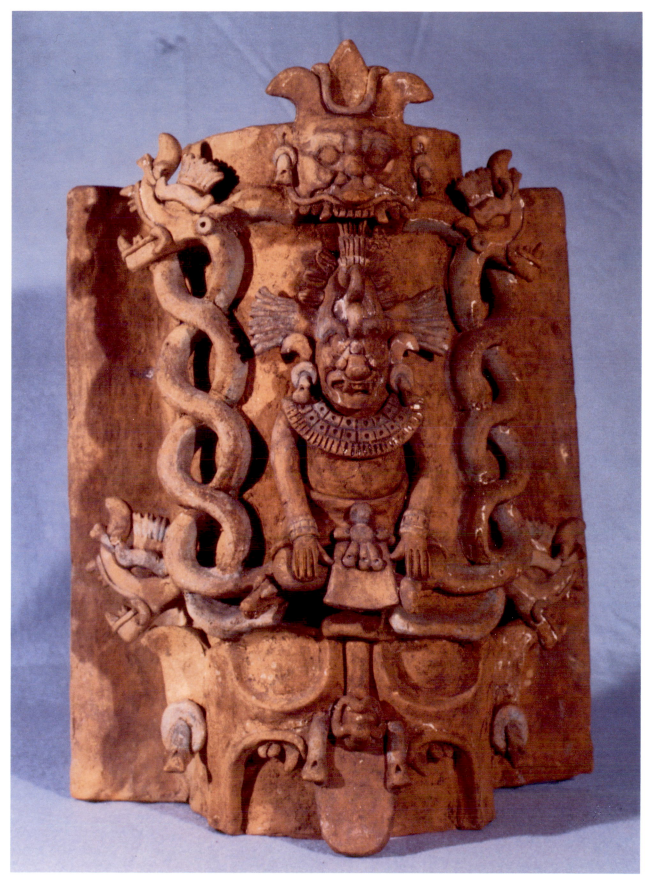

135. A God K incense burner.

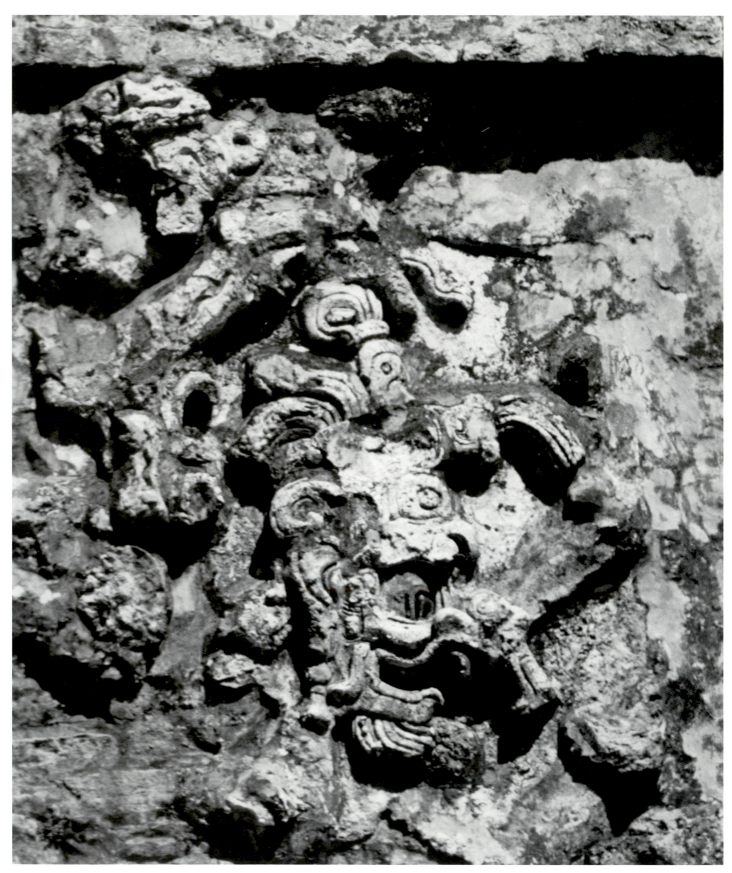

136. Temple of the Sun, Roof. The 7 God.

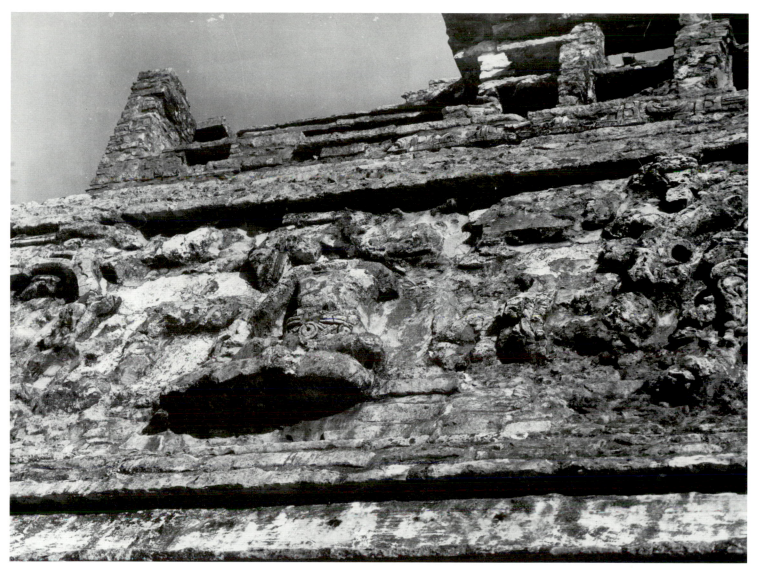

139. Temple of the Sun, Roof. Throne upon which the Sun King sits.

138. Temple of the Sun, Roof. Snaggletooth dragon overlaps the serpent body.

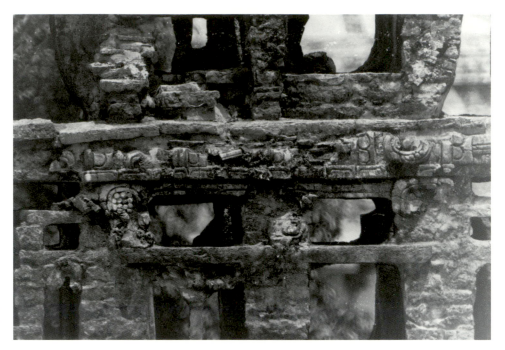

141. Temple of the Sun, Roofcomb.
Skyband elements.

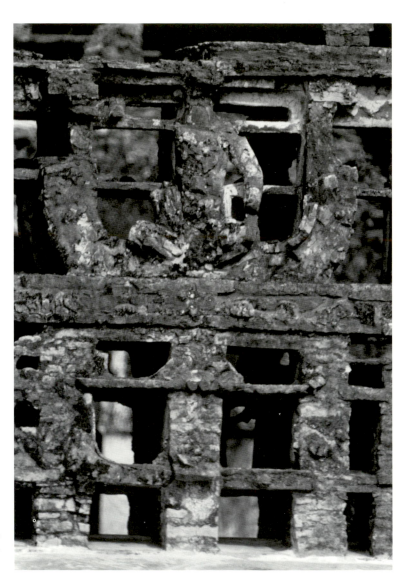

142. Temple of the Sun, Roofcomb.
Figure on the west side.

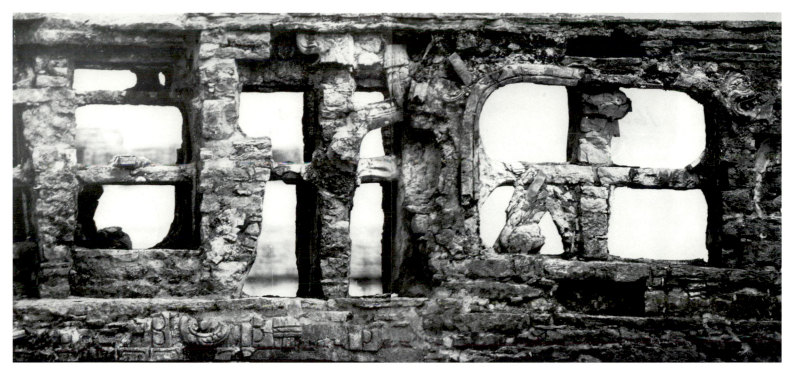

140. Temple of the Sun, Roofcomb. *Bacab*'s arms can be seen holding up the skyband.

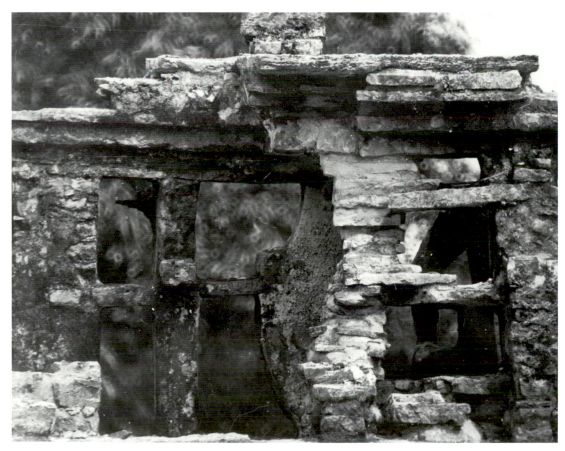

143. Temple of the Sun, Roofcomb. Workmanship of reconstruction is sloppy compared with that of the ancient Maya.

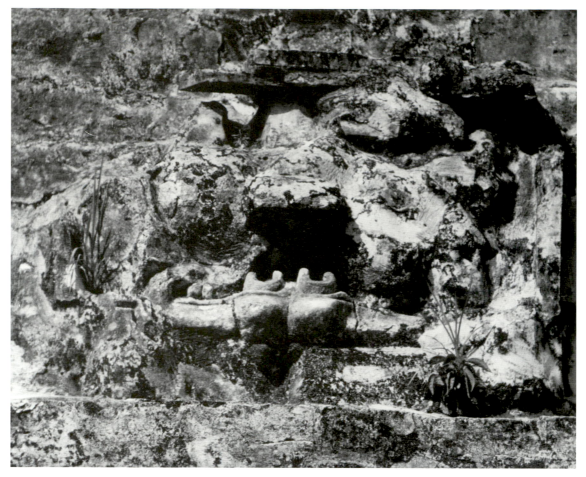

144. Temple of the Sun, North Roof. Mask.

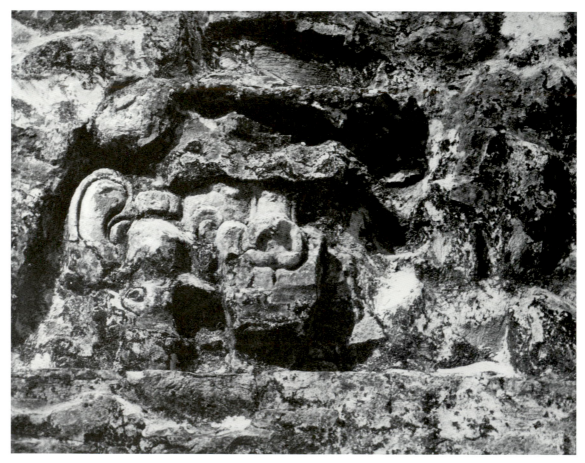

145. Temple of the Sun, North Roof. Another mask.

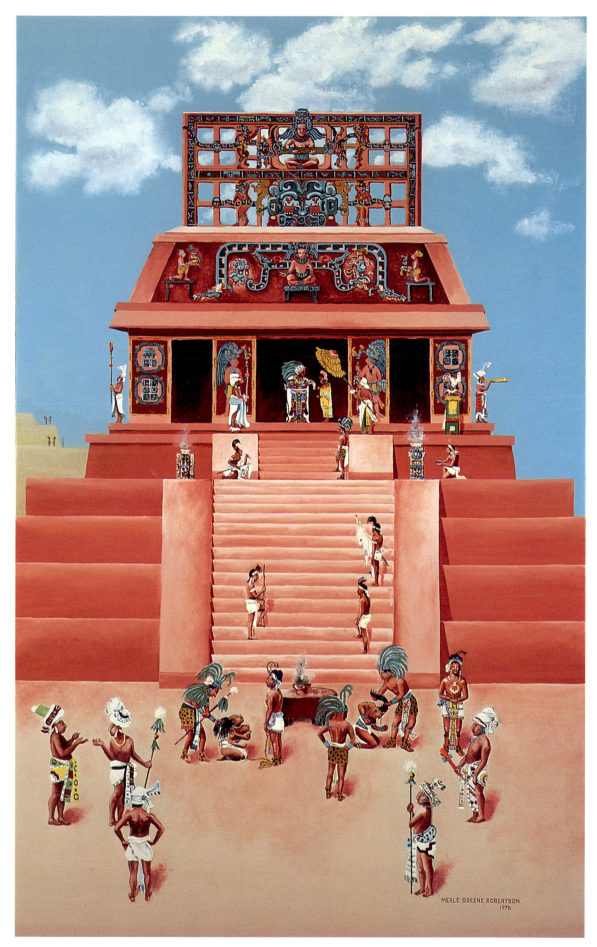

146. Temple of the Sun. Reconstruction painting by Merle Greene Robertson.

147. Temple of the Foliated Cross.

148. Temple of the Foliated Cross.

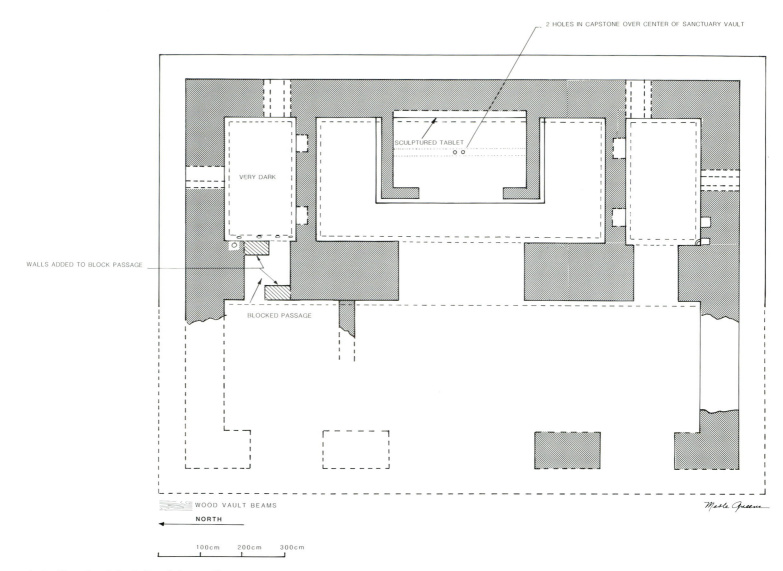

2 HOLES IN CAPSTONE OVER CENTER OF SANCTUARY VAULT

SCULPTURED TABLET

VERY DARK

WALLS ADDED TO BLOCK PASSAGE

BLOCKED PASSAGE

WOOD VAULT BEAMS

NORTH

100cm 200cm 300cm

Merle Greene

149. Temple of the Foliated Cross. Plan.

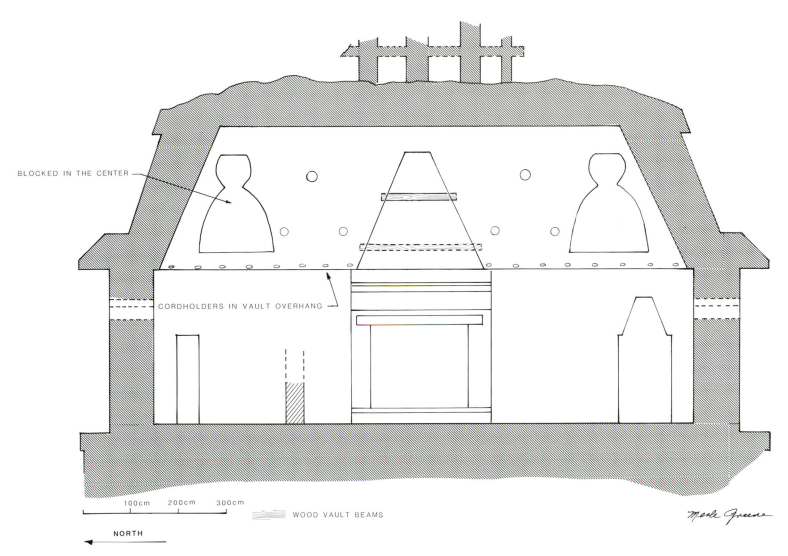

BLOCKED IN THE CENTER

CORDHOLDERS IN VAULT OVERHANG

100cm 200cm 300cm

WOOD VAULT BEAMS

NORTH

150. Temple of the Foliated Cross. Elevation.

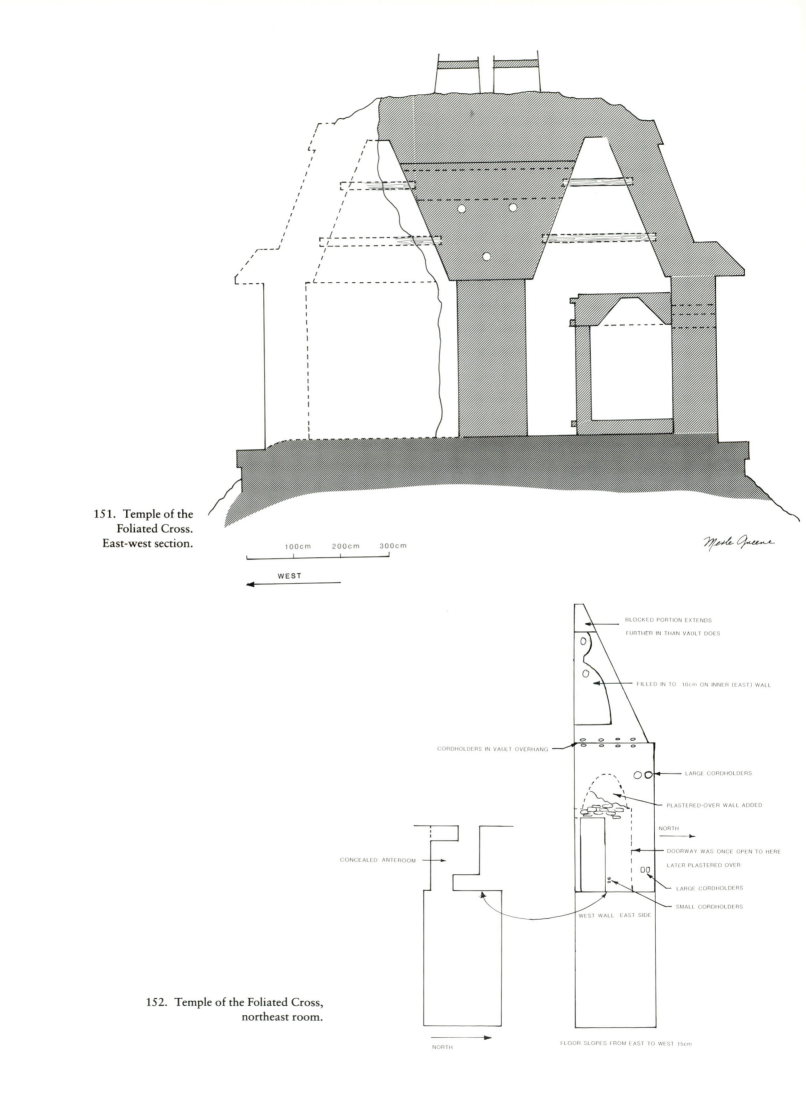

151. Temple of the
Foliated Cross.
East-west section.

Merle Greene

100cm 200cm 300cm

⟵ WEST

BLOCKED PORTION EXTENDS
FURTHER IN THAN VAULT DOES

FILLED IN TO 10cm ON INNER (EAST) WALL

CORDHOLDERS IN VAULT OVERHANG ⟶

LARGE CORDHOLDERS

PLASTERED-OVER WALL ADDED

NORTH ⟶

DOORWAY WAS ONCE OPEN TO HERE

LATER PLASTERED OVER

CONCEALED ANTEROOM ⟶

LARGE CORDHOLDERS

SMALL CORDHOLDERS

WEST WALL EAST SIDE

152. Temple of the Foliated Cross,
northeast room.

NORTH ⟶

FLOOR SLOPES FROM EAST TO WEST 15cm

153. Temple of the Foliated Cross Tablet.

auxiliary verb (he went)	the child of (father)	the 5 katun Ahau	Mah K'ina Pacal	Ahpo of Palenque
ta och te as "entered" of the succession.				
name or title Chan-Bahlum				
name or title.				
the noon of				
????				
GVI				
????				
he was displayed as God K				

(until) 2 Cib	14 Mol (9.12.18.5.16)	9 tuns	2 katuns (2.9.6.4) ago
he took part in an event	the ???? of	since he was born	until he took the bundle
Triad I.G.	????	of the succession	Bac Balam Ahau
GIII	GII	Mah K'ina Chan-Bahlum	Ahpo of Palenque
on the day	3 Caban	[on] 8 Oo	3 Kayab (9.12.11.12.10)
15 Mol (9.12.18.5.17)	part of verbal phrase he dedicated	(it was) 6 days, 11 uinals	6 tuns (6.11.6)
Mah K'ina as "west"	Mah K'ina K'uk house	since he was seated	as ahpo of the succession
ta otot in the house	title	until they took part in an event	the ???? of
Mah K'ina Chan-Bahlum	Ahau of Palenque	Triad I.G.	GI
(on) the third day	he let blood	GII	GIII
qualifications	of the blood-letting event	GIV/GV	GVI
with an obsidian lancet	he took (or held) the bundle	GVII (Hun Ahau) father of the gods	he took part in an event
his blood	Mah K'ina Chan-Bahlum	Mah K'ina Chan-Bahlum	(it was) 4 days, 12 uinals
Ahpo of Palenque	count since te naab	1 tun (1.12.4)	a future event (in katun 10)
chaan	the inverted sky	8 Ahau 8 Uo (9.13.0.0.0)	the 13th katun
6 Sky	Ox-Bolon Chac-Xib-Chac (GB)	since 2 Cib (the 14 Mol event)	until they took part in the anniversary event
Blood-seat Ahau (the place of power)	(it was) 4 days, 6 uinals	the children of (mother)	K'ina Chan-Bahlum Ahau of Palenque

P.E. (Period Ending)

D.N. Distance Number

I.G. Introductory Glyph

P.E.G. Palenque Emblem Glyph

I.S.I.G. Initial Series Introductory Glyph

D.N.I.G. Distance Number Introductory Glyph

Merle Greene 1983

	A	B	C	D	E
1–2	INITIAL SERIES INTRODUCTORY GLYPH — THE PATRON IS MAC		name (reference to the Triad ??) / Rodent Bone	title / GII - God K	
3	9 BAKTUN	(it was) 1 katun	14 tuns		
4	18 KATUNS	14 uinals	0 days (1.14.14.0)		(on) 8 Oc / 3 Kayab (9.12.11.12.10)
5	5 TUNS	(since) he was born	Rodent Bone		he was made zac-uinic
6	4 UINALS	GII - God K	the 'divinity'		of the succession / Mah K'ina Chan-Bahlum
7	0 KINS (1.18.5.4.0)	until were completed	2 baktuns (2.0.0.0.0)		the mirror (or reflection) of the succession
8	1 AHAU	(on) 2 Ahau	3 Uayeb		the NOUN of
9	13 MAC	G 8 was in office	she let blood	part of verbal phrase	
10	(it was) 10 days since the birth of the moon	5 lunations had ended	title/ 'Lady ...'	'Beastie' Ancestral Goddess	Bahlum-K'uk'-? / the abpo of ????
11	Glyph X (the patron of the lunation)	Glyph B 'the rabbit' was in the house	title Blood Divinity	title Ahau	
12	for 30 days	(it was) 19 days	count since	'he was born'	
13	14 uinals	(since) 1 Cauac	part of metaphor for birth	????	
14	7 Yax	he took part in the 819-Day-Count event	GII	on 1 Ahau	
15	God K	east	13 Mac (1.18.5.4.0)	7 baktuns	
16	the third one	was born	7 katuns	7 tuns	
17	name or title	name or title	4 uinals	16 days	

F column:
- verb or relationship
- Special expression for P.E.s divisible by 5
- Nominal I.G.
- he of the maize title the balam-ahau
- Mah K'ina Chan-Bahlum
- Ahaual of Palenque

0 10 50 100 cm

154. Temple of the Foliated Cross Tablet text.

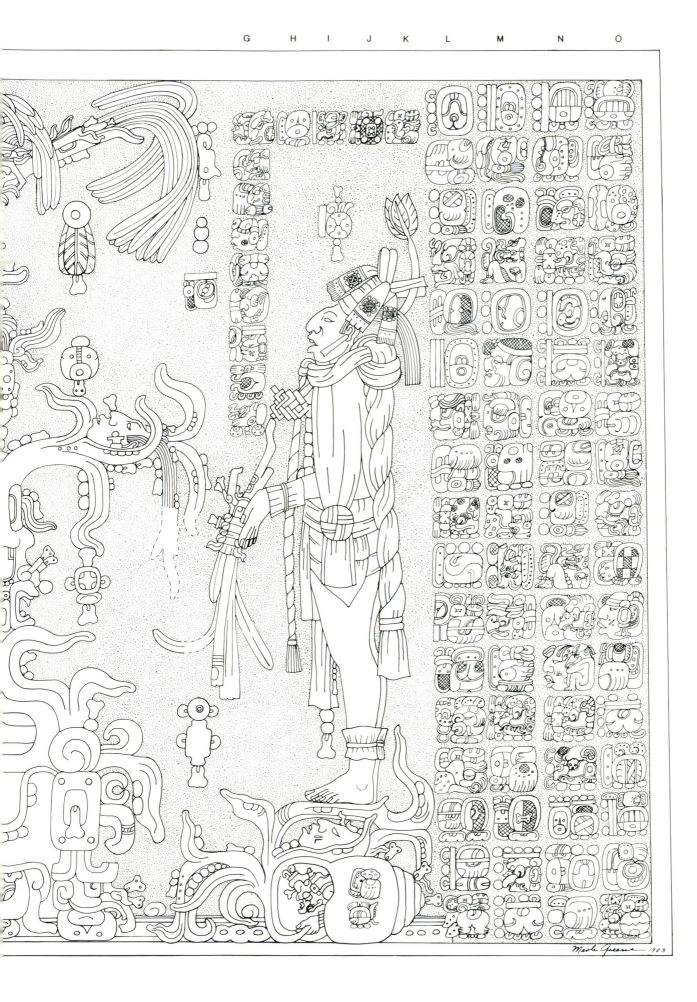

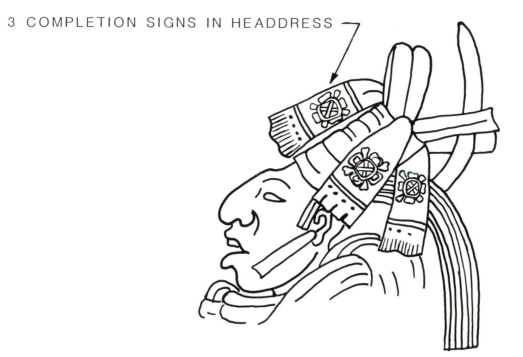

155. Temple of the Foliated Cross Tablet. Hat of the short figure with a *le* leaf at the top.

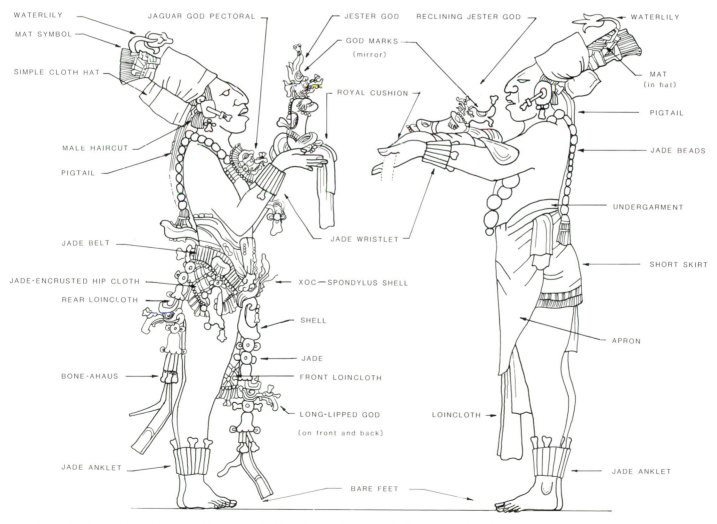

WATERLILY

MAT SYMBOL

SIMPLE CLOTH HAT

MALE HAIRCUT

PIGTAIL

JAGUAR GOD PECTORAL

JESTER GOD

RECLINING JESTER GOD

GOD MARKS (mirror)

ROYAL CUSHION

WATERLILY

MAT (in hat)

PIGTAIL

JADE BEADS

UNDERGARMENT

JADE BELT

JADE-ENCRUSTED HIP CLOTH

REAR LOINCLOTH

BONE-AHAUS

JADE ANKLET

JADE WRISTLET

XOC—SPONDYLUS SHELL

SHELL

JADE

FRONT LOINCLOTH

LONG-LIPPED GOD (on front and back)

LOINCLOTH

SHORT SKIRT

APRON

JADE ANKLET

BARE FEET

157. Temple of the Foliated Cross Tablet. Chan-Bahlum in royal costume (left) compared with his simple attire on the Cross Tablet.

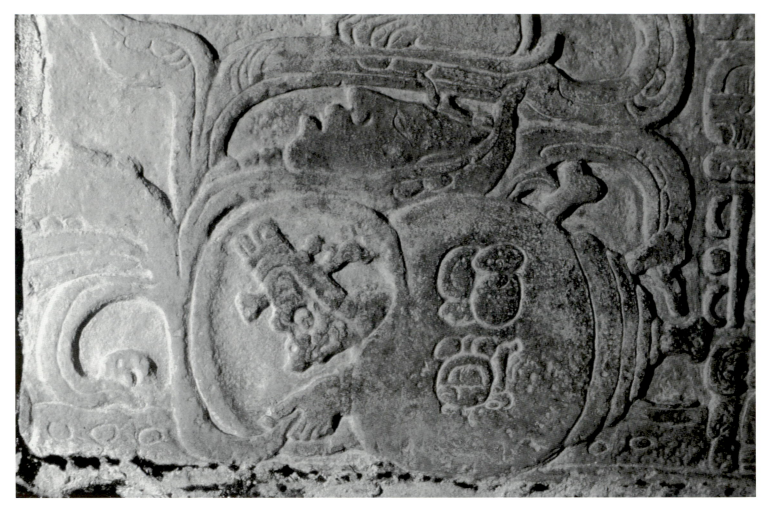

156. Temple of the Foliated Cross Tablet.
God K pulls the corn plant into the shell
of the Underworld.

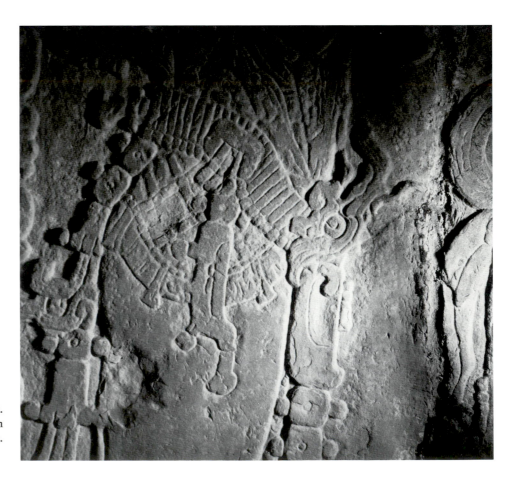

158. Temple of the Foliated Cross Tablet.
Chan-Bahlum wears a *xoc* emblem
on his belt.

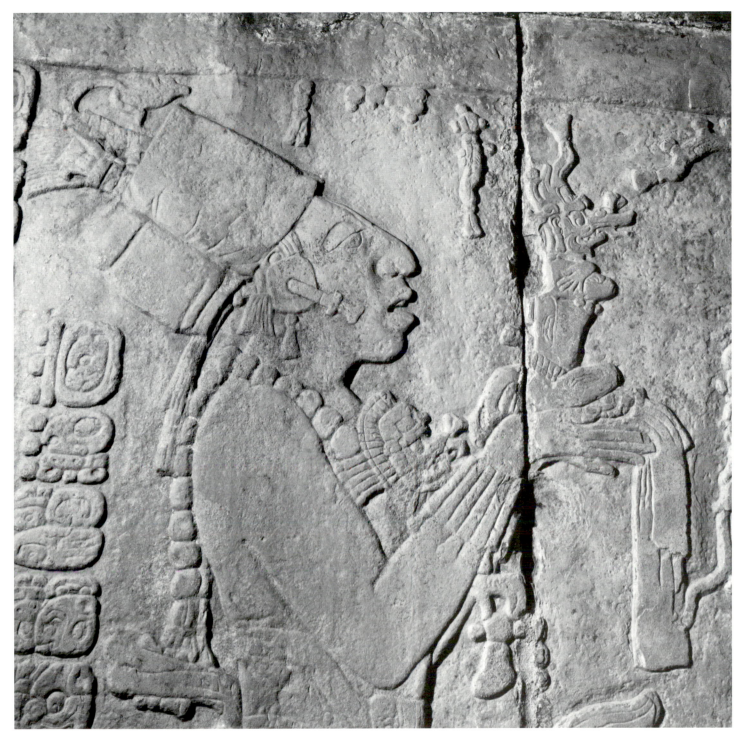

159. Temple of the Foliated Cross Tablet. Chan-Bahlum holds the jester god.

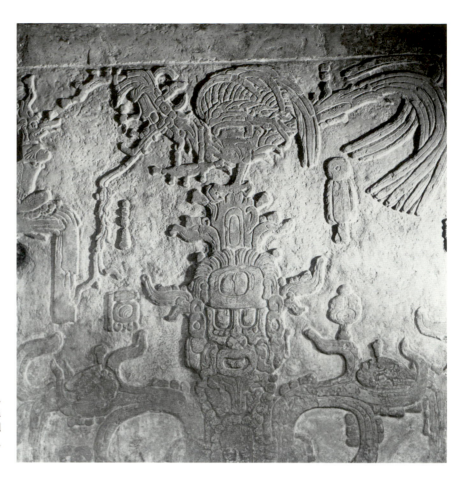

161. Temple of the Foliated Cross Tablet.
The top of the tree becomes a
three-dimensional Sun God with the bird
of the heavens above.

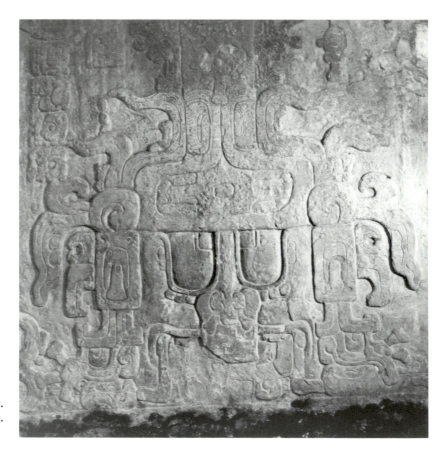

160. Temple of the Foliated Cross Tablet.
The Earth Monster at the base of the tree.

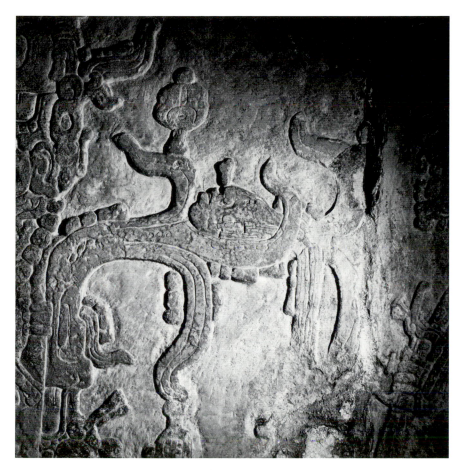

162. Temple of the Foliated Cross Tablet. Rebirth through
the corn plant.

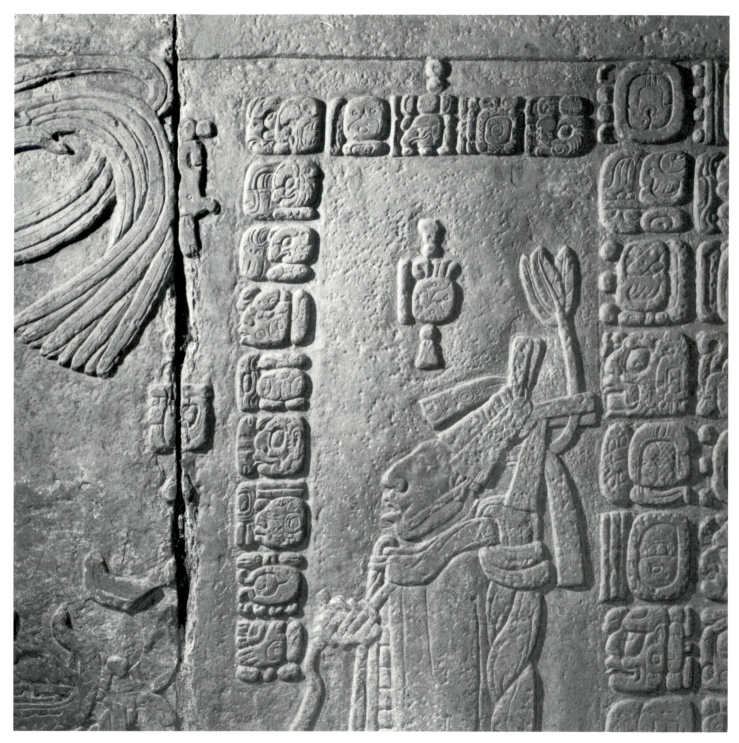

163. Temple of the Foliated Cross Tablet. The short figure is framed by glyphs saying that Chan-Bahlum was displayed as God K at an "heir-designation event."

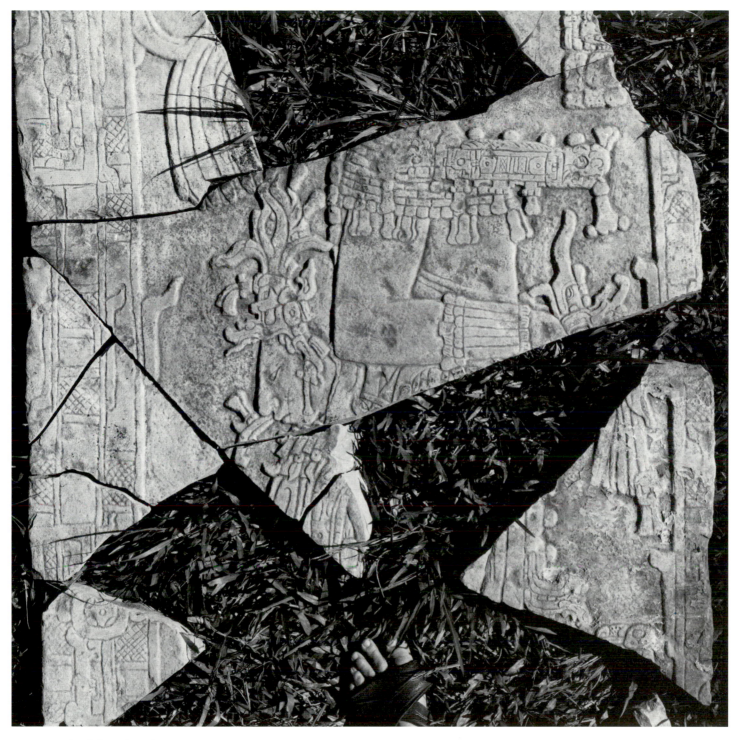

164. Temple of the Foliated Cross, North Jamb fragment.

165. Temple of the Foliated Cross, North Sanctuary Roof. Serpent fret with human busts.

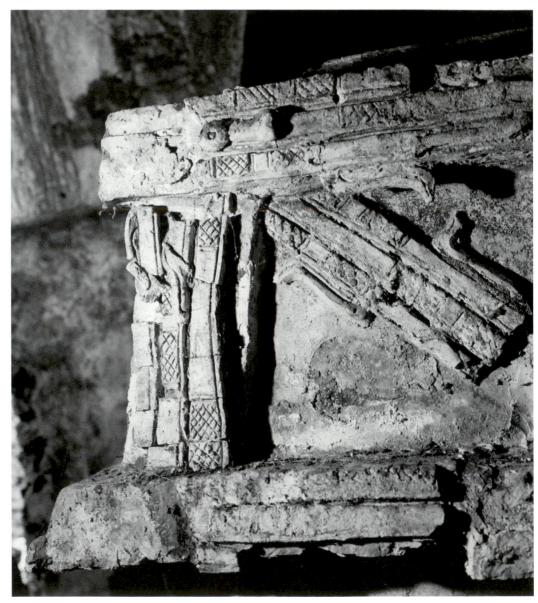

166. Temple of the Foliated Cross, South Sanctuary Roof. Serpents' bodies form the entire roof.

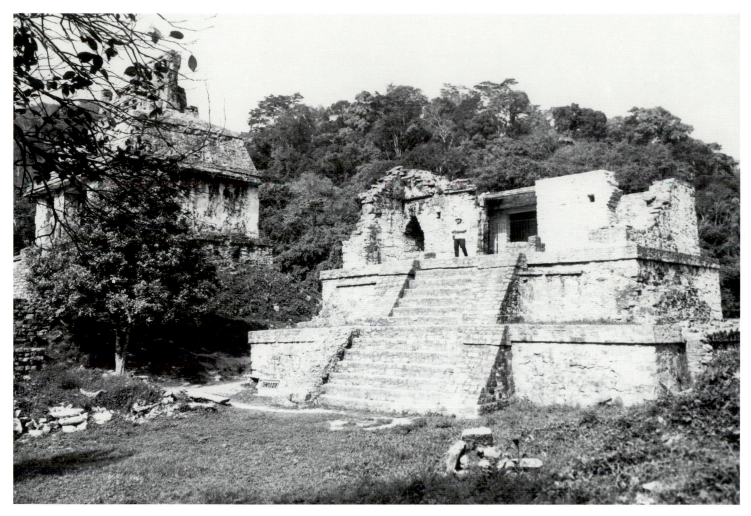

168. Temple XIV is built directly to the north of the Temple of the Sun.

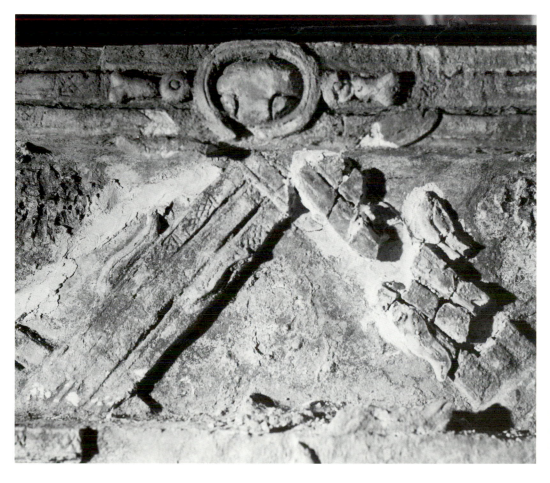

167. Temple of the Foliated Cross, South Sanctuary Roof. A *chuen* glyph on top border with bone-*ahaus* at sides.

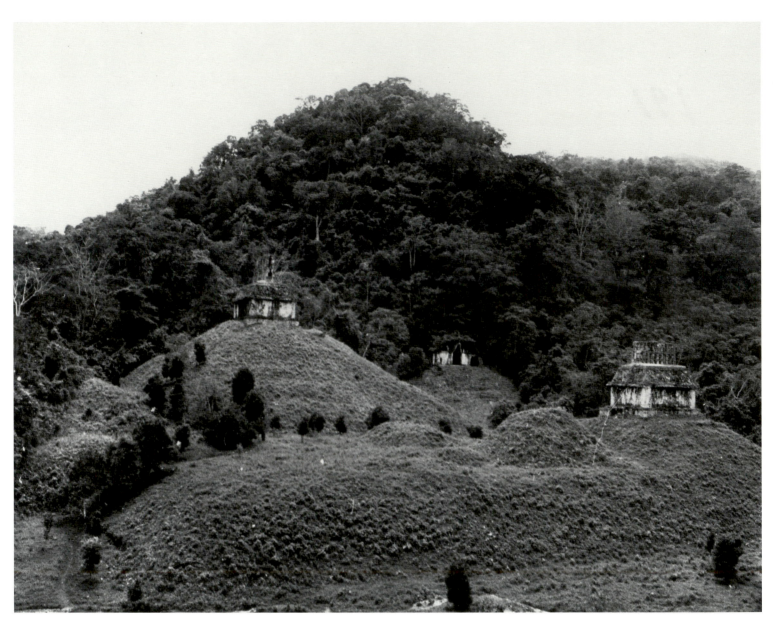

169. Temple XIV before it was uncovered in 1967 by Jorge Acosta. Photo 1963.

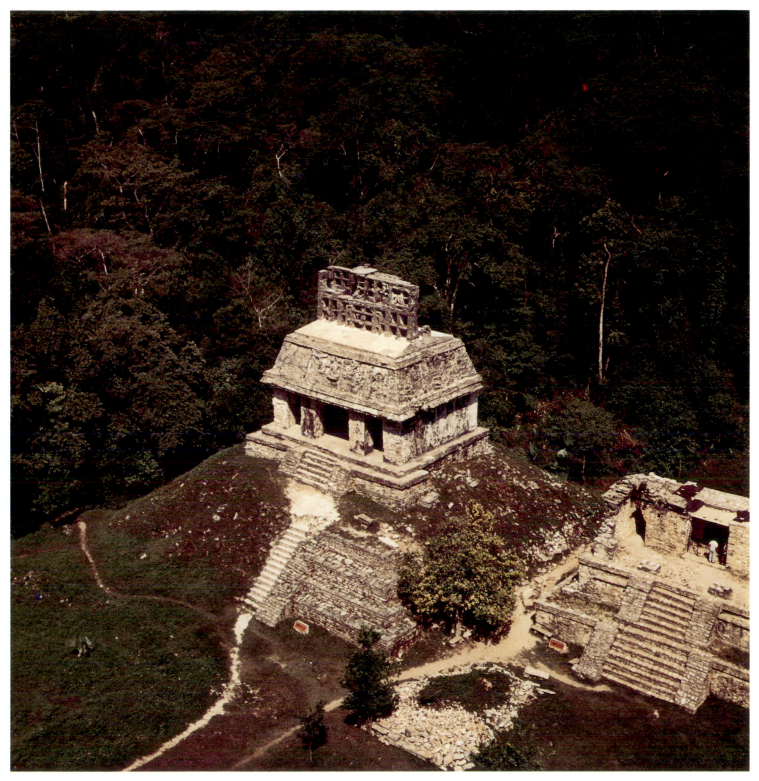

170. Temple of the Sun, with Temple XIV on the right.

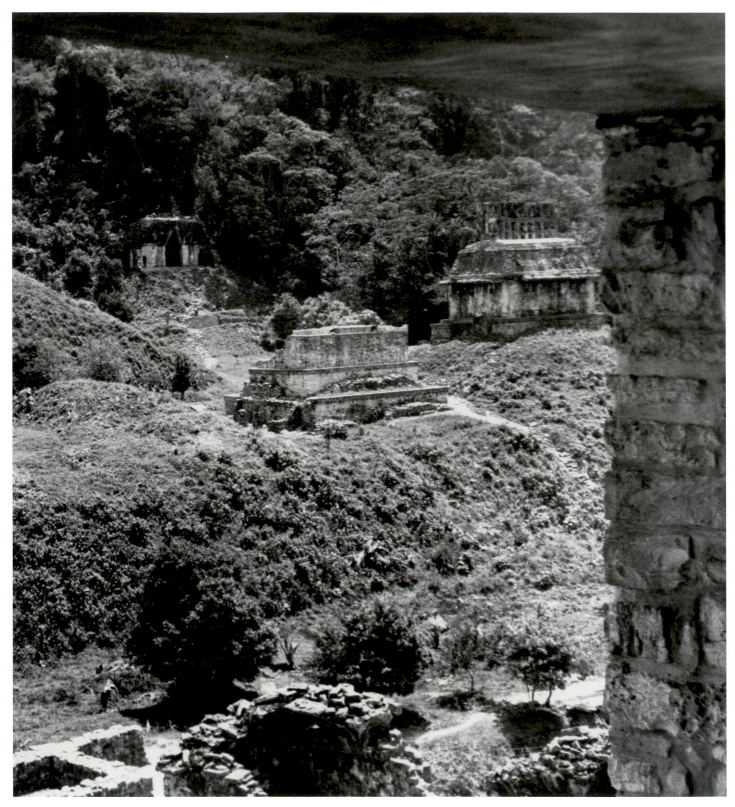

171. Temple XIV blocks the way to the Group of the Cross.

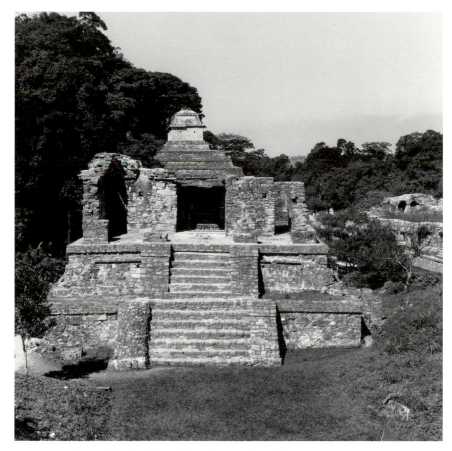

172. Temple XIV blocks the path to the Temple of the Inscriptions
(directly behind in photo).

173. Temple XIV has only two tiers instead of the
three of the Cross Group temples.

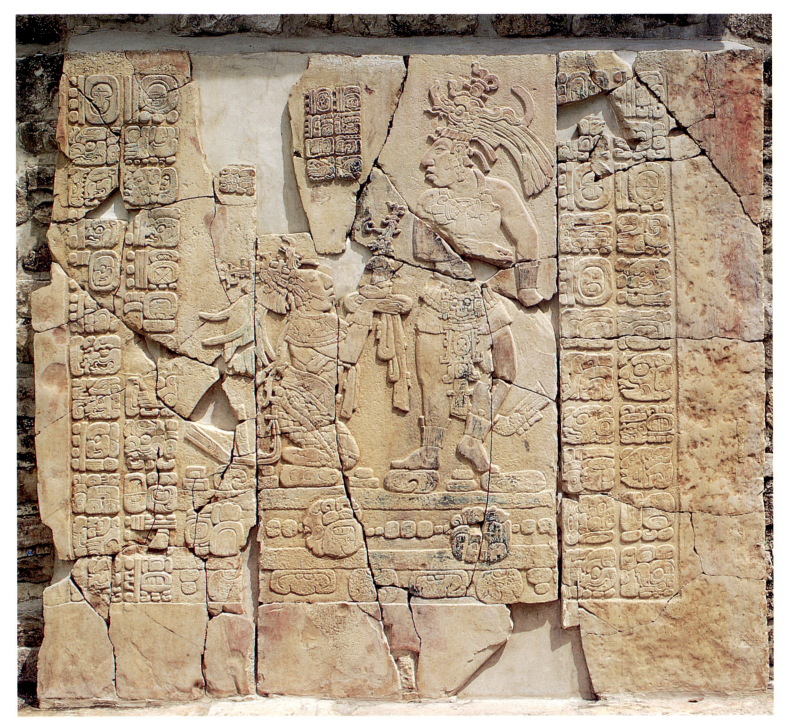

174. Temple XIV Tablet.

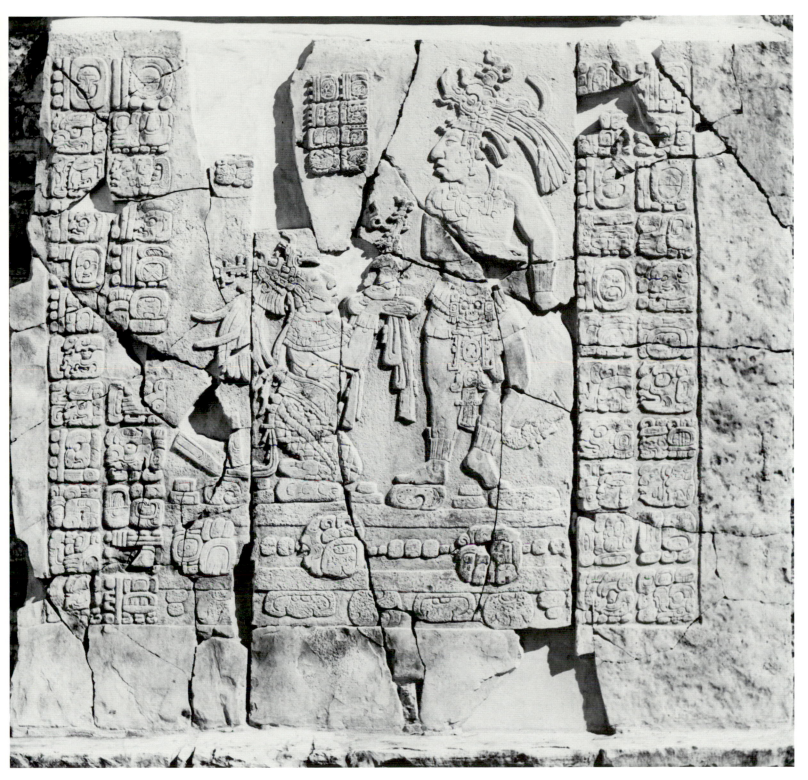

175. Temple XIV Tablet.

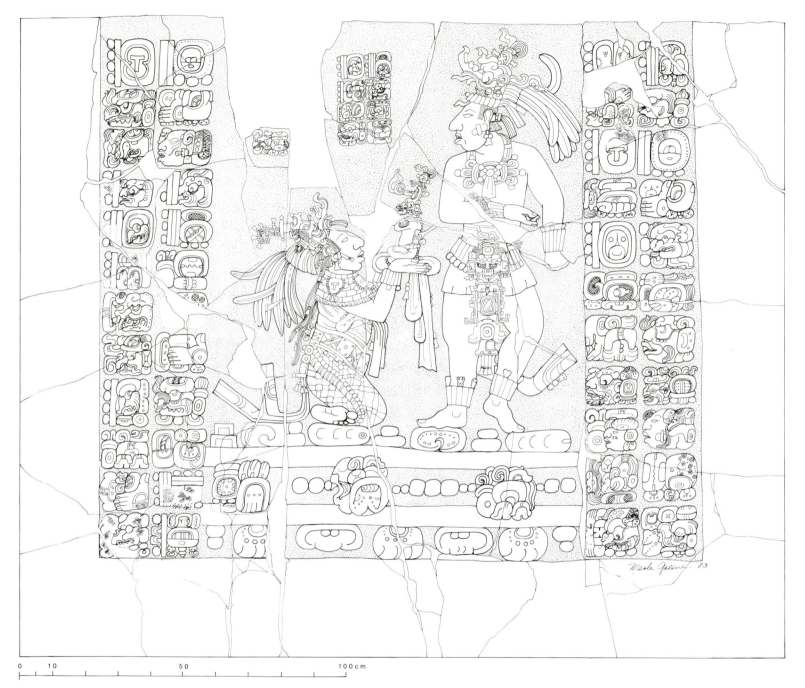

176. Temple XIV Tablet.

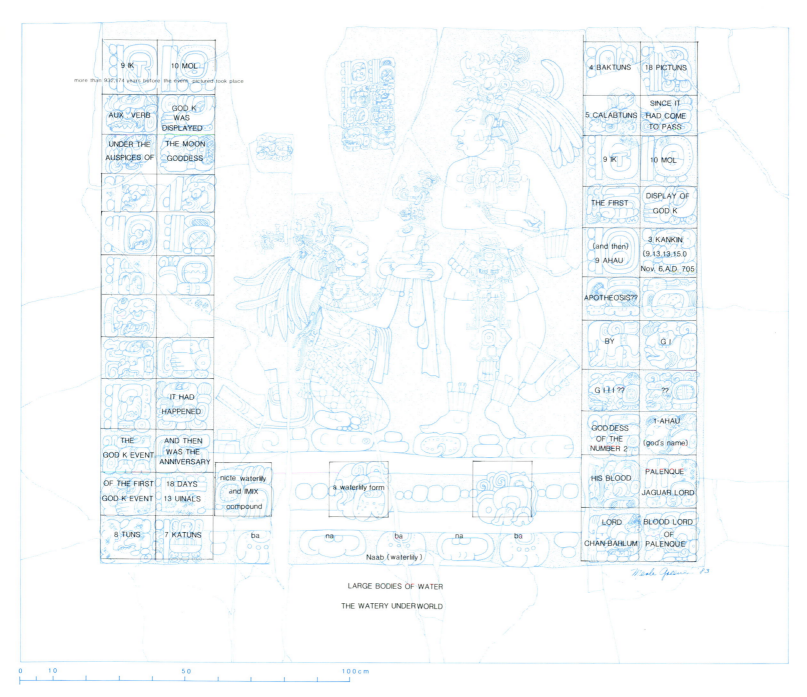

9 IK	10 MOL
more than 932,174 years before the event pictured took place	
AUX - VERB	GOD K WAS DISPLAYED
UNDER THE AUSPICES OF	THE MOON GODDESS
IT HAD HAPPENED	
THE GOD K EVENT	AND THEN WAS THE ANNIVERSARY
OF THE FIRST GOD K EVENT	18 DAYS 13 UINALS
8 TUNS	7 KATUNS

nicte waterlily and IMIX compound	ba

a waterlily form			
na	ba	na	ba

Naab (waterlily)

LARGE BODIES OF WATER

THE WATERY UNDERWORLD

4 BAKTUNS	18 PICTUNS
5 CALABTUNS	SINCE IT HAD COME TO PASS
9 IK	10 MOL
THE FIRST	DISPLAY OF GOD K
(and then) 9 AHAU	3 KANKIN (9.13.13.15.0 Nov. 6, A.D. 705
APOTHEOSIS??	
BY	G I
G I I I ??	??
GODDESS OF THE NUMBER 2	1-AHAU (god's name)
HIS BLOOD	PALENQUE JAGUAR LORD
LORD CHAN-BAHLUM	BLOOD LORD OF PALENQUE

Merle Greene '83

0 10 50 100cm

177. Temple XIV Tablet text.

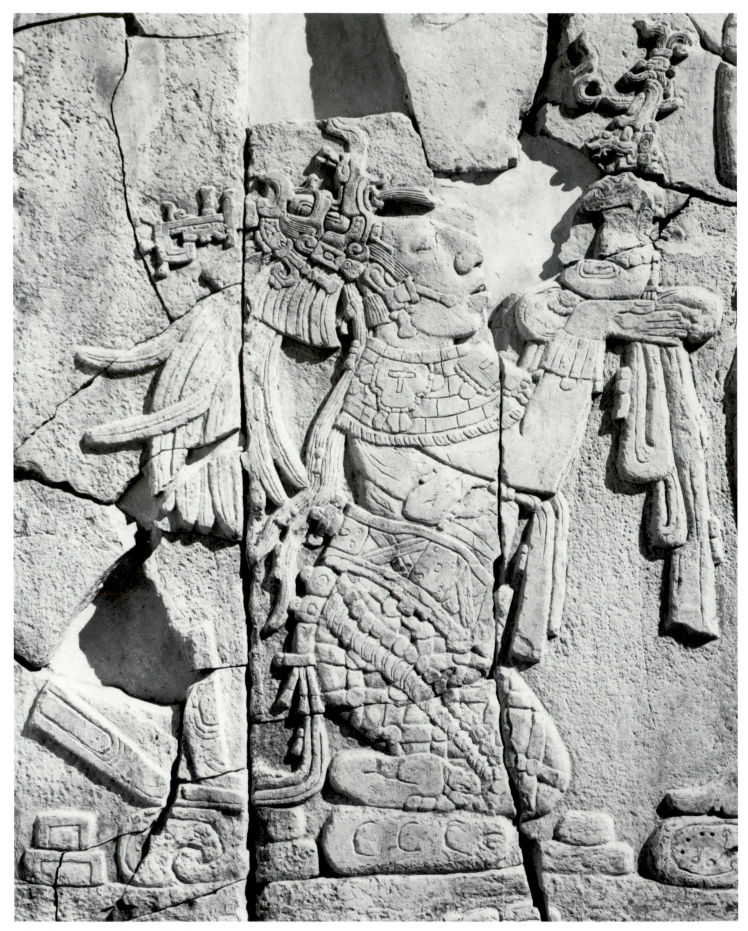

178. Temple XIV Tablet. Lady Ahpo-Hel presenting God K to Chan-Bahlum.

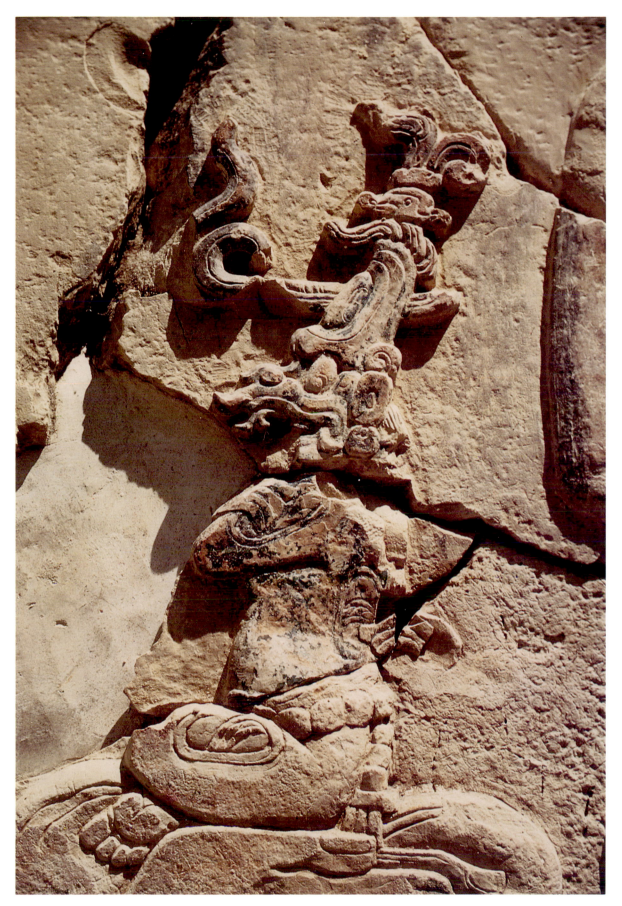

179. Temple XIV Tablet. God K.

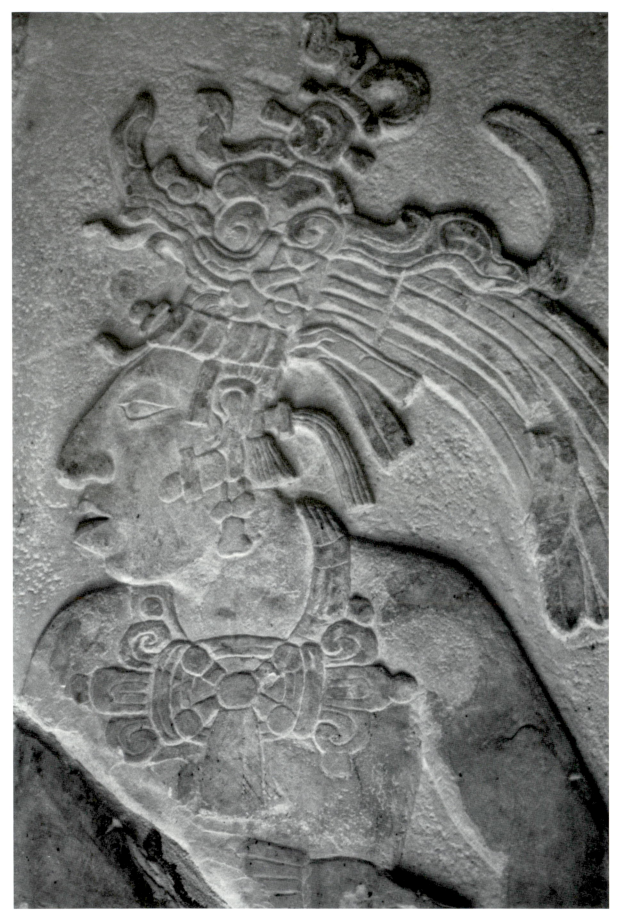

180. Temple XIV Tablet. Chan-Bahlum, showing his diagnostic protruding lower lip.

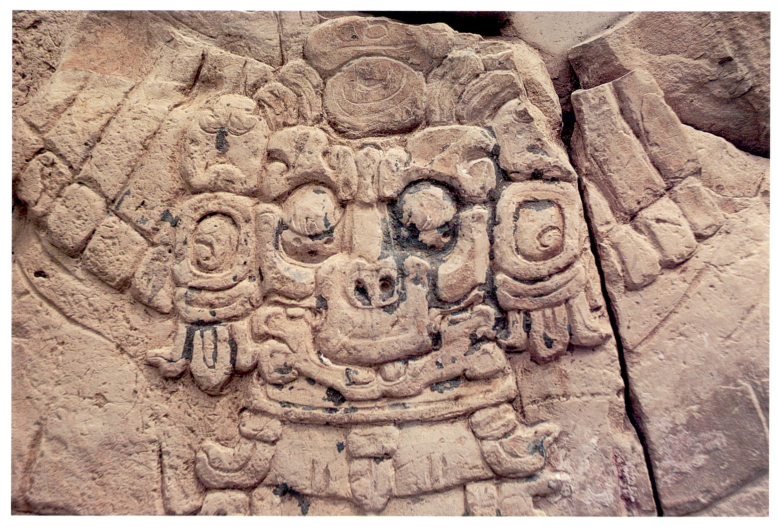

181. Temple XIV Tablet. The Jaguar God of the Underworld is Chan Bahlum's belt piece.

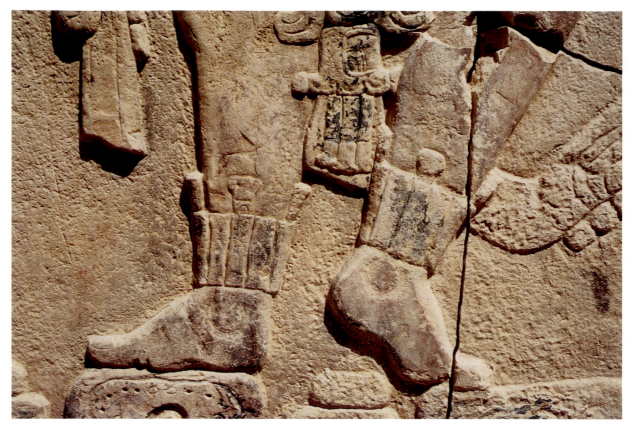

182. Temple XIV Tablet. Chan-Bahlum wears only bead anklets.

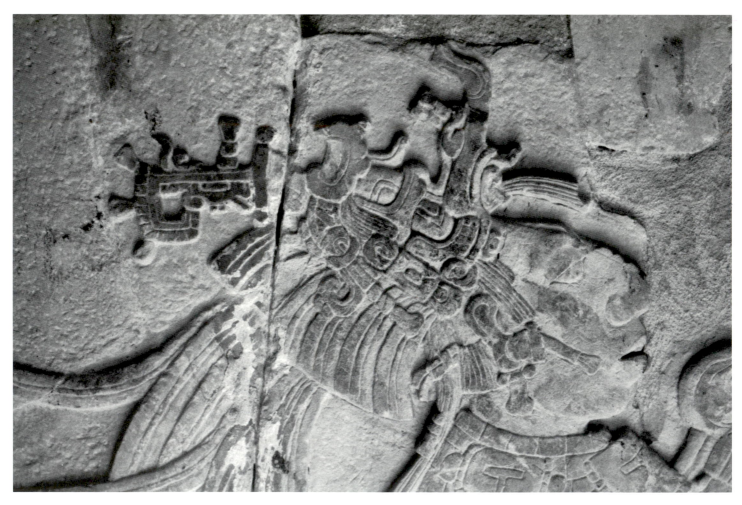

183. Temple XIV Tablet. Lady Ahpo-Hel.

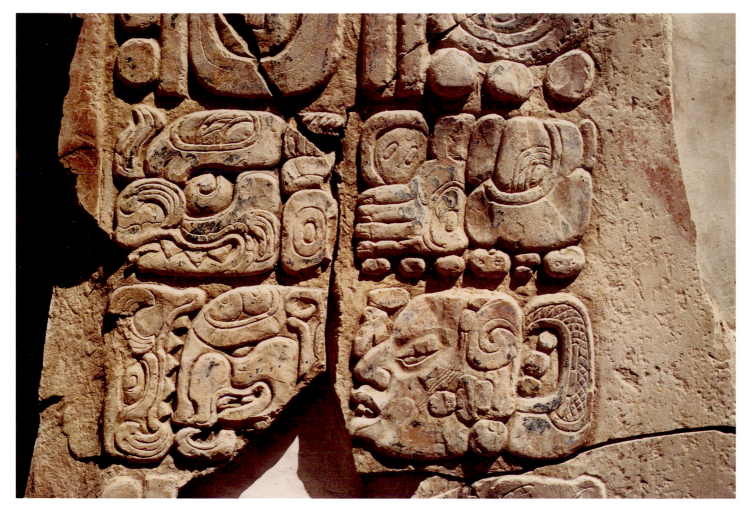

184. Temple XIV Tablet. These glyphs say that God K was first displayed by the Moon Goddess.

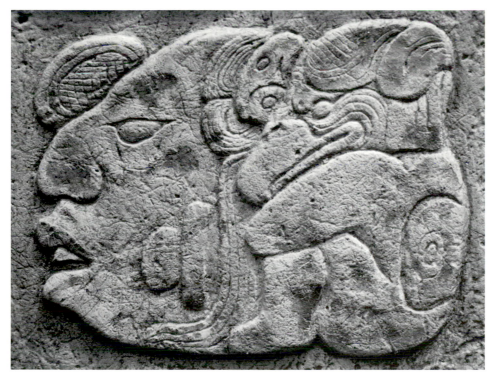

186. Temple XIV Tablet. The glyph for 1 *Ahau* (D9).

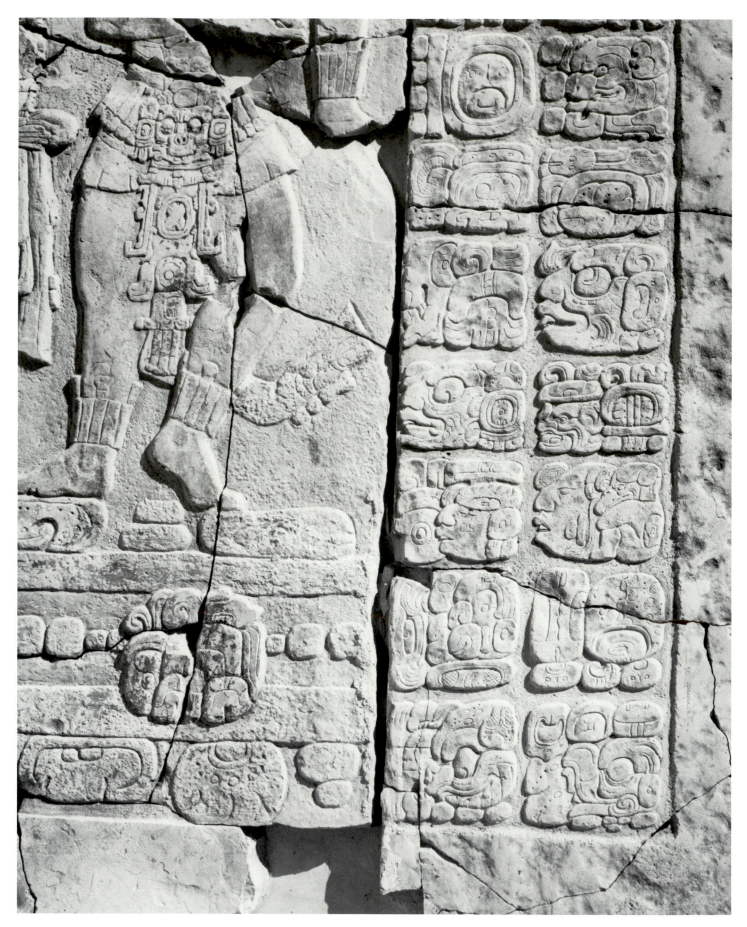

185. Temple XIV Tablet. Chan-Bahlum dances triumphant out of Xibalba on 9 *Ahau* 3 *Kankin* as Blood Lord of Palenque.

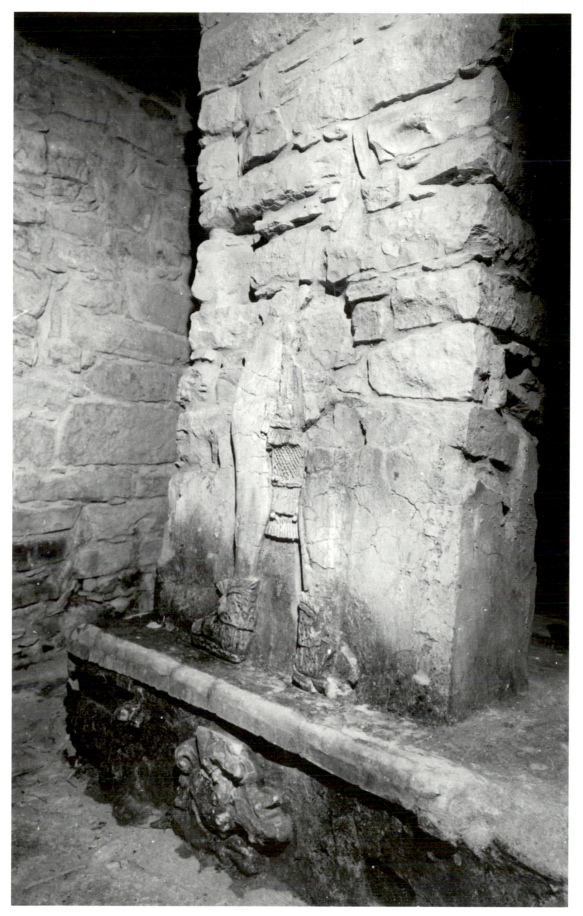

187. Temple XIV, South Jamb.

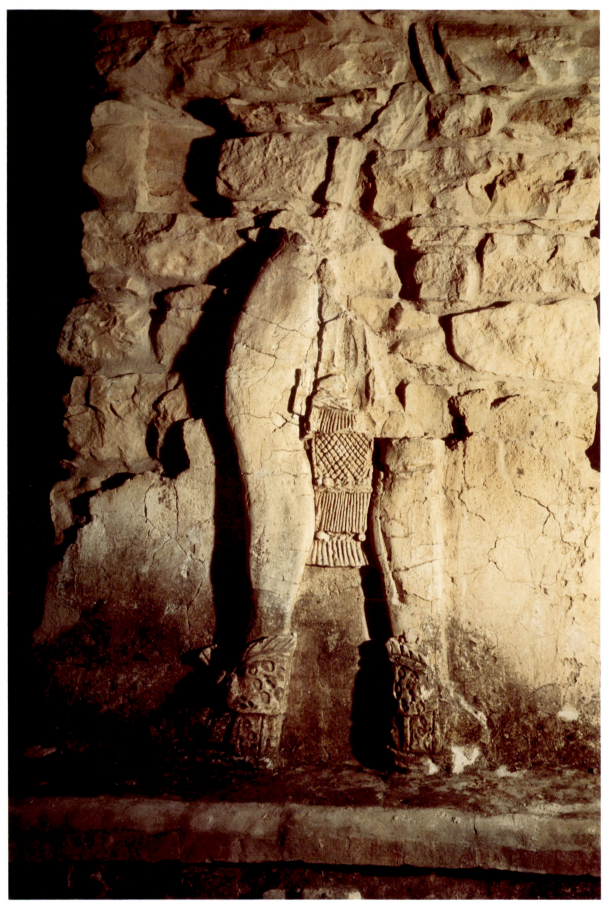

188. Temple XIV, South Jamb.

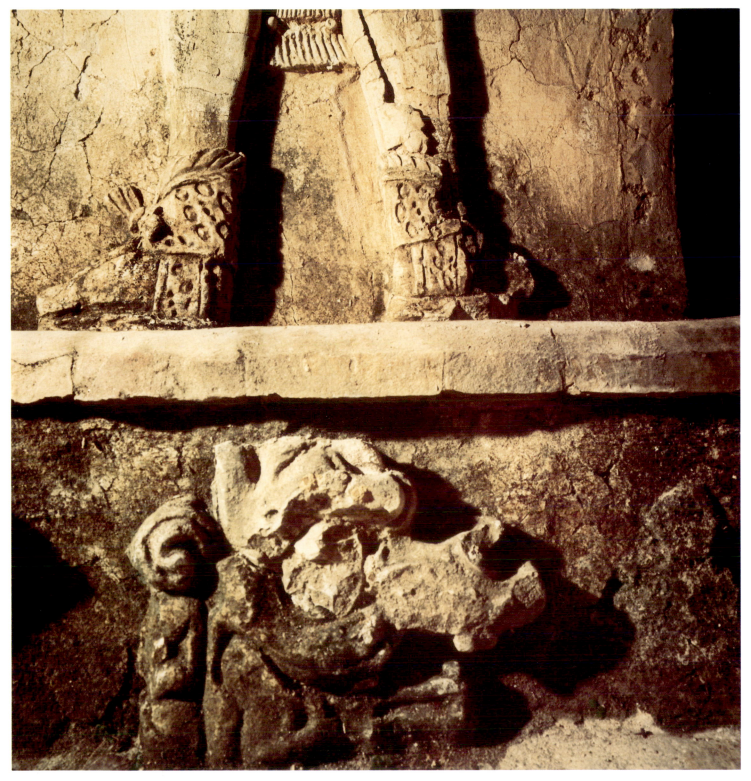

190. Temple XIV, South Jamb. The figure's boots.

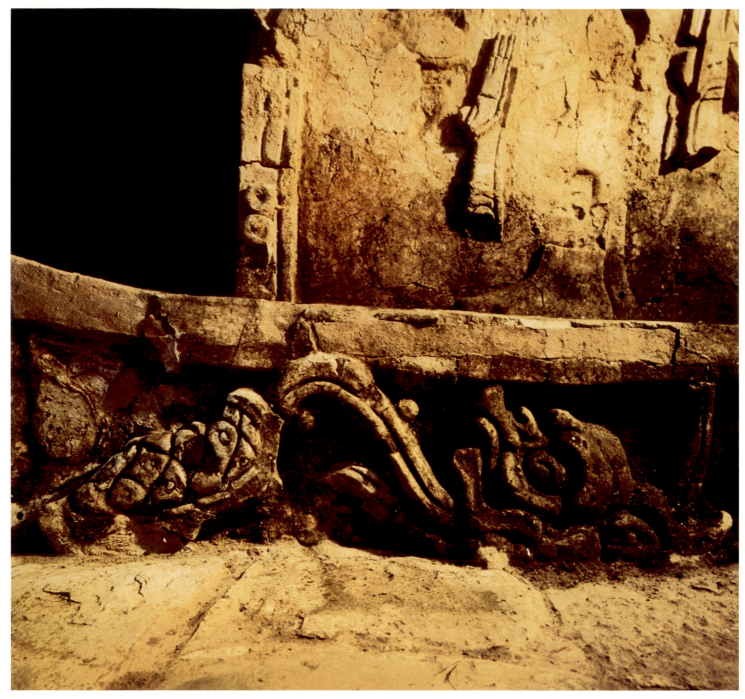

192. Temple XIV, North Jamb. Waterlily plant and Underworld god.

189. Temple XIV, South Jamb.

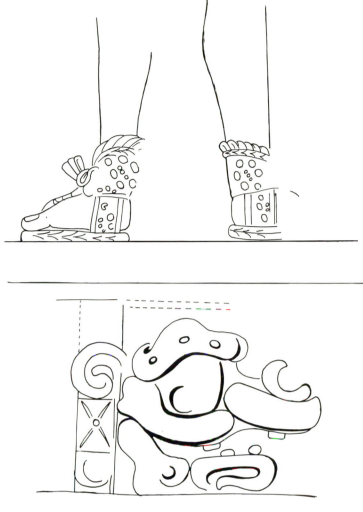

191. Temple XIV, North Jamb.

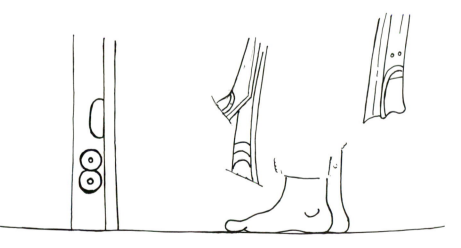

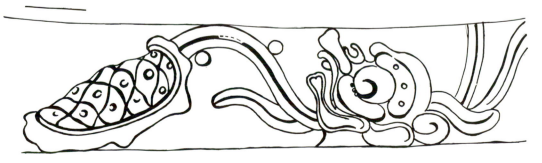

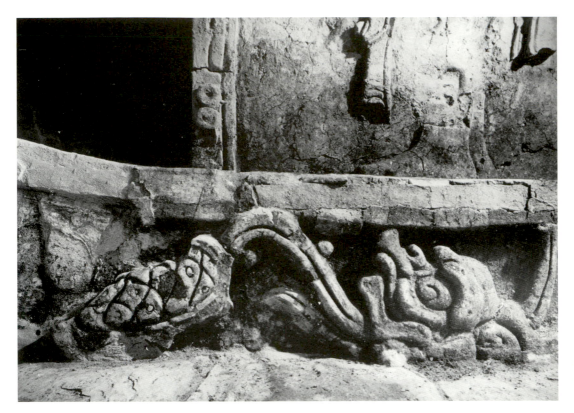

193. Temple XIV, North Jamb.
Waterlily god below the standing
figure.

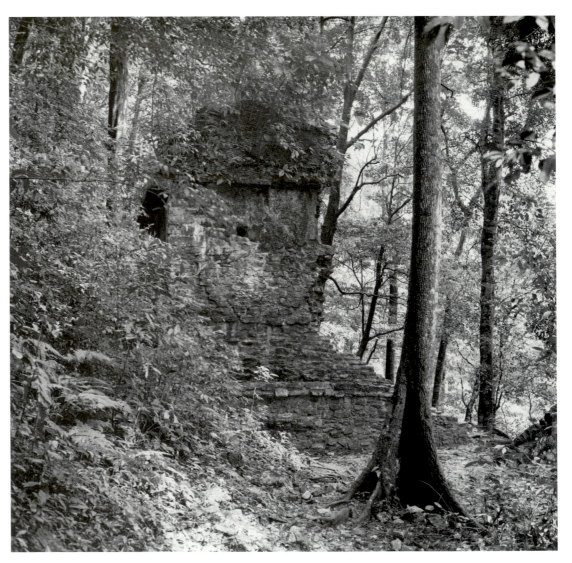

195. Temple of the Jaguar.
South facade.

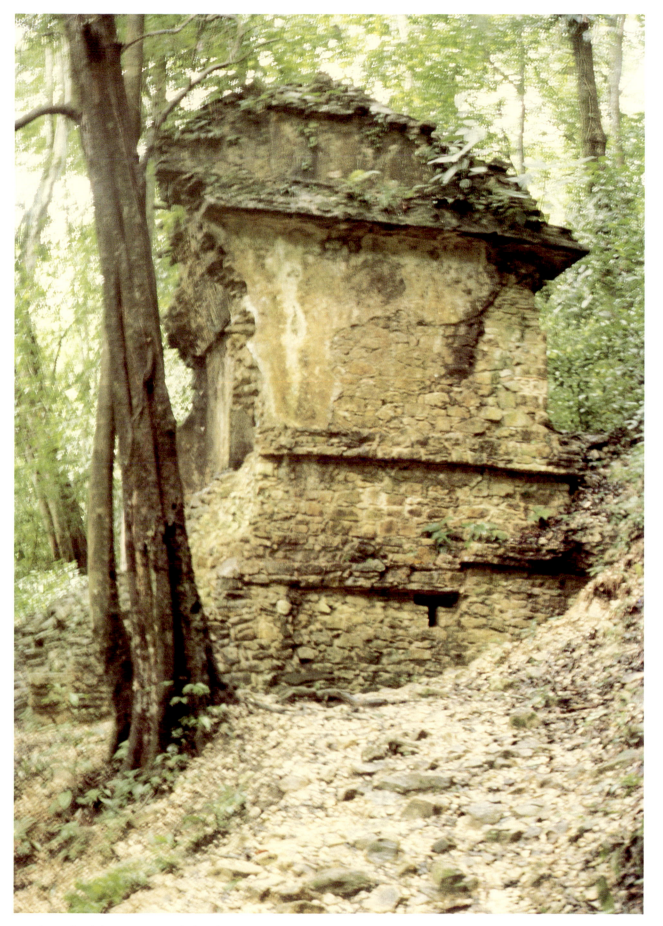

194. Temple of the Jaguar. North facade.

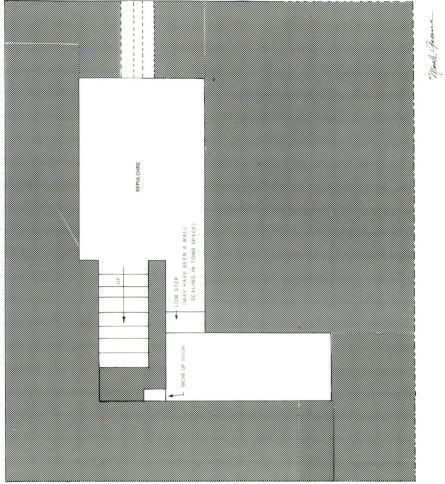

SEPULCHRE

UP

LOW STEP
(MAY HAVE BEEN A WALL
SEALING IN TOMB SPACE)

NICHE UP 101cm

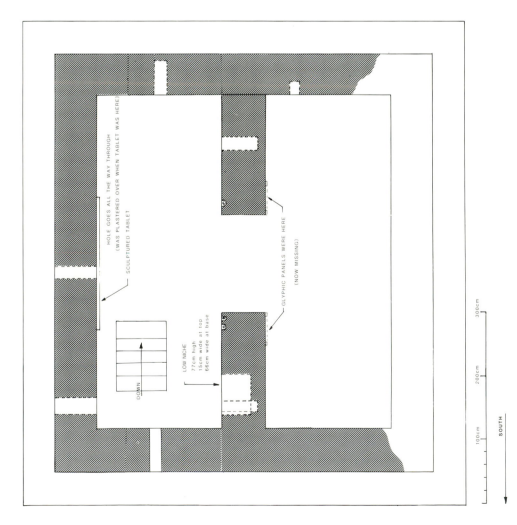

HOLE GOES ALL THE WAY THROUGH
(WAS PLASTERED OVER WHEN TABLET WAS HERE)

SCULPTURED TABLET

DOWN

LOW NICHE
77cm high
13cm wide at top
66cm wide at base

GLYPHIC PANELS WERE HERE
(NOW MISSING)

100cm 200cm 300cm

SOUTH

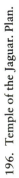

196. Temple of the Jaguar. Plan.

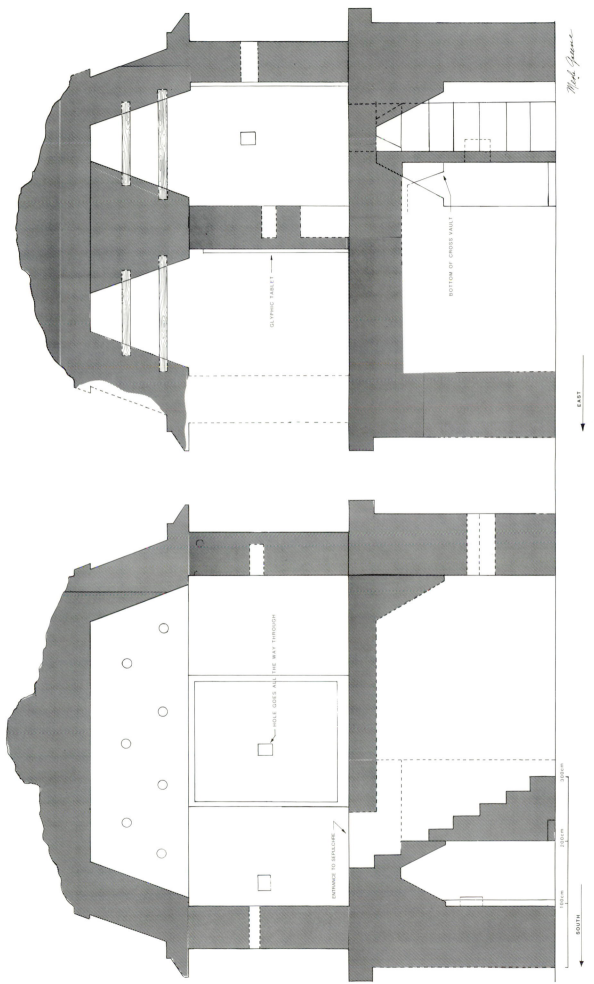

GLYPHIC TABLET

BOTTOM OF CROSS VAULT

HOLE GOES ALL THE WAY THROUGH

ENTRANCE TO SEPULCHRE

EAST

SOUTH

100cm 200cm 300cm

197. Temple of the Jaguar. Elevation.

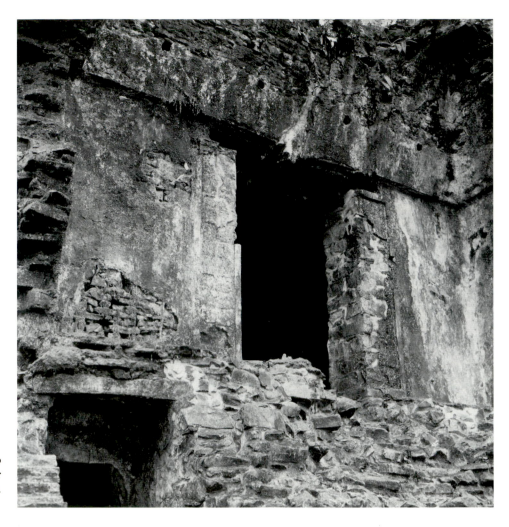

198. Temple of the Jaguar. Doorway to rear room is at right; exposed lower vault at lower left.

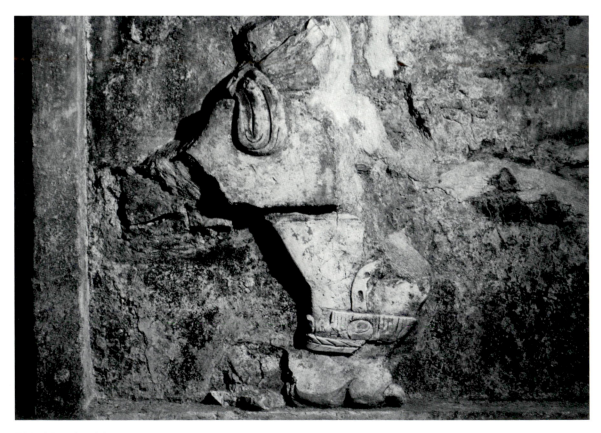

200. Temple of the Jaguar Tablet. Jaguar's front paw and bow tie.

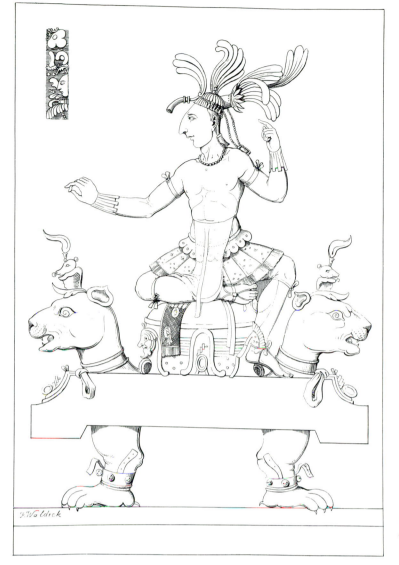

199. Temple of the Jaguar. Neoclassic interpretation of the Tablet by Jean Frédéric Waldeck, 1822.

201. Temple of the Jaguar Tablet.

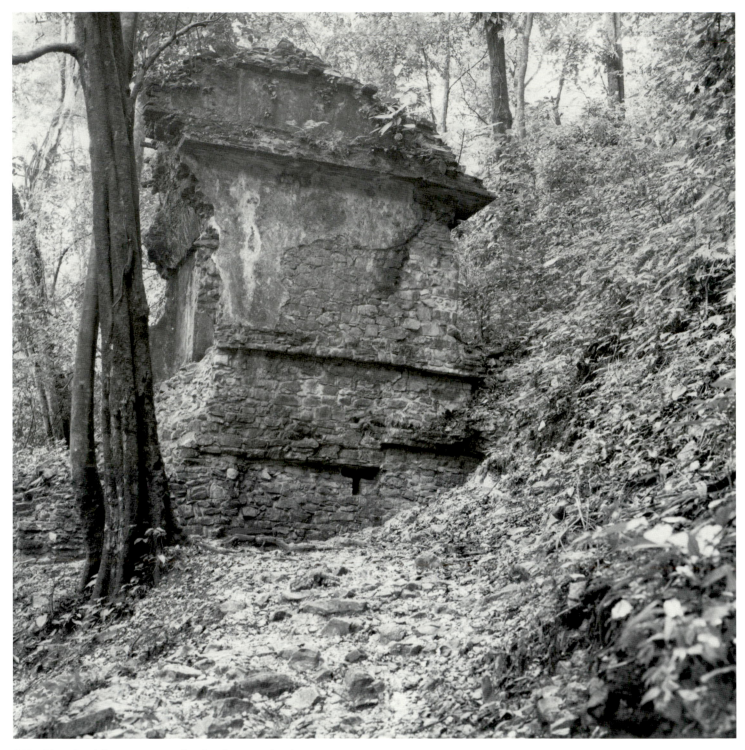

202. Temple of the Jaguar. North side, showing *Ik* in lower chamber.

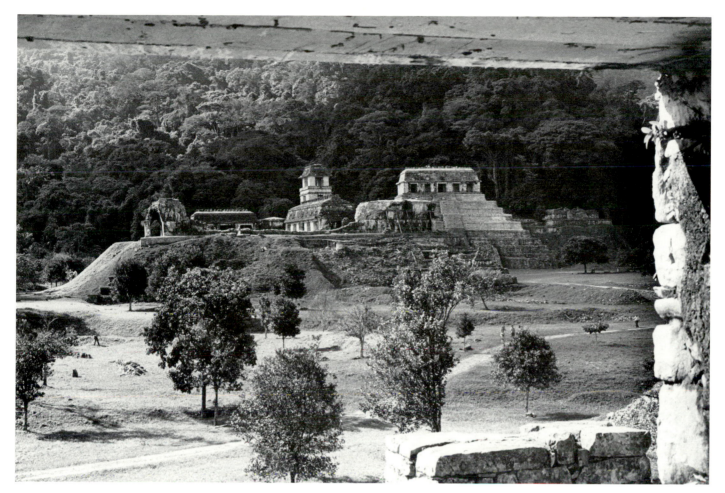

204. The Palace from the North Group.

205. The Ballcourt.

203. The North Group. From the right: Temples I-V, Temple of the Count, Temple X.

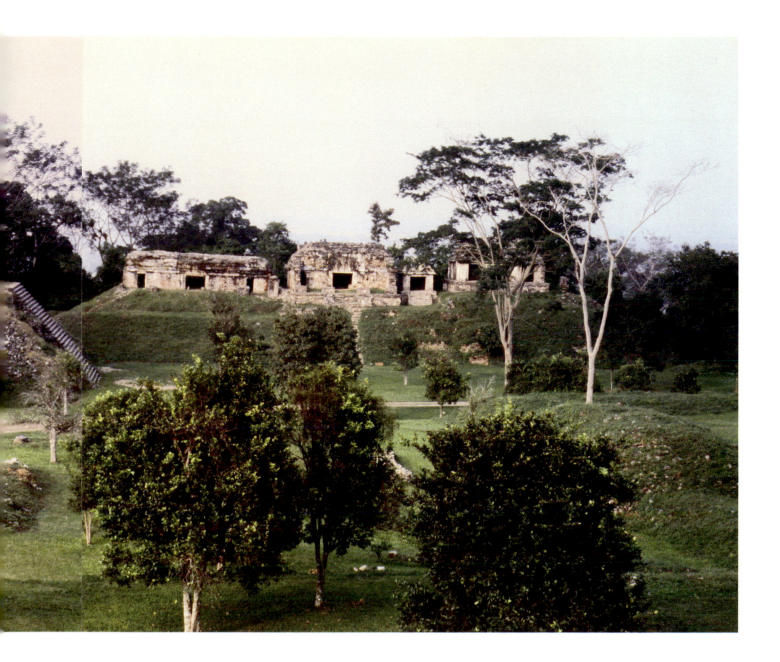

206. The northern plains and structures along the Michol River as seen from the North Group.

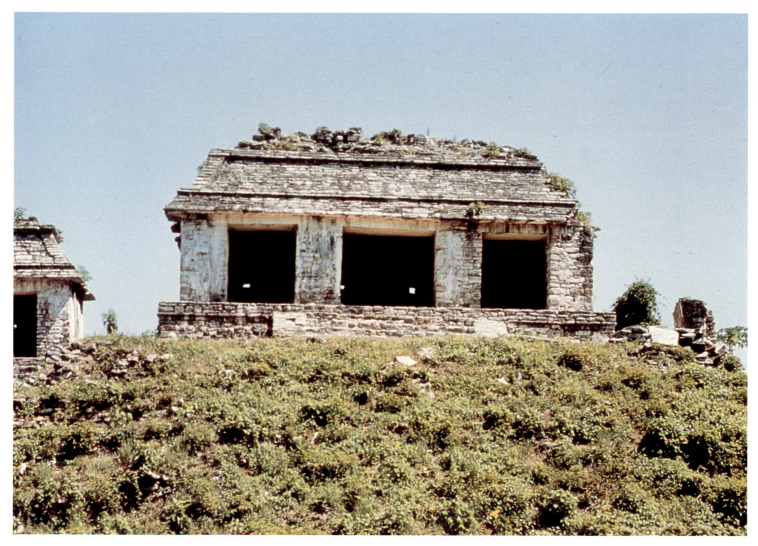

207. The North Group, Temple II.

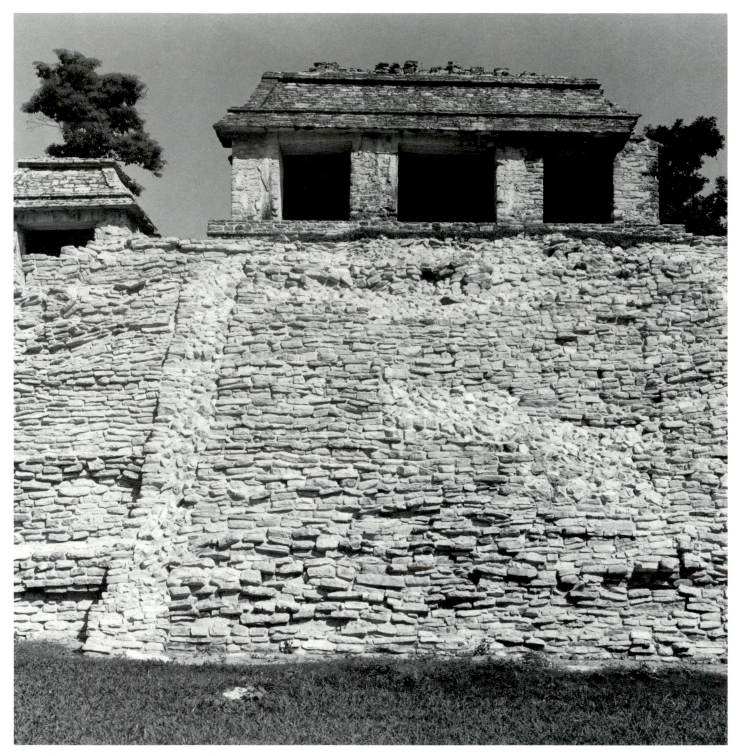

208. The North Group, Temple II with its wide stairway.

209. The North Group, Temple II, Pier A.

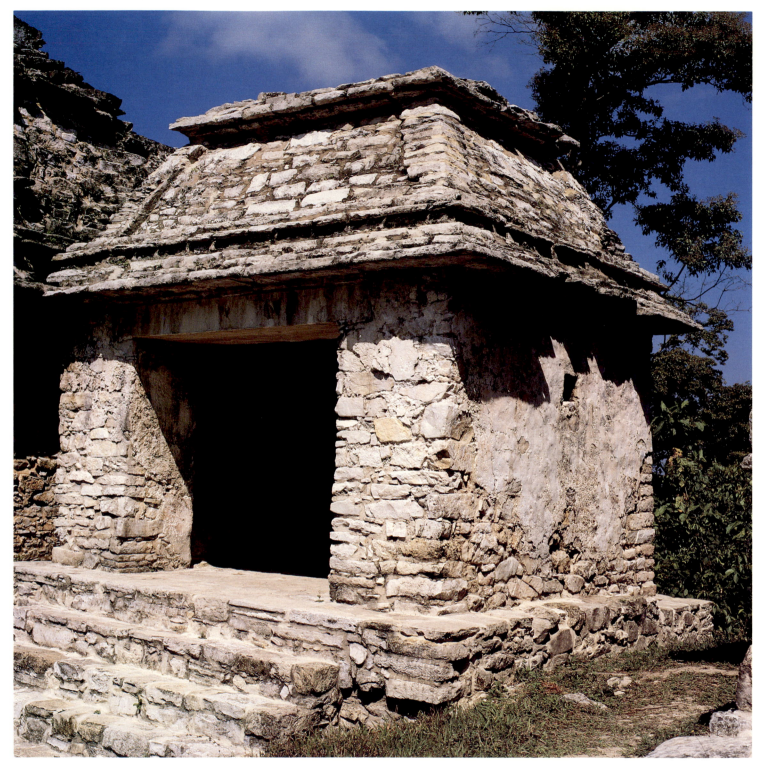

211. The North Group, Temple III.

212. The North Group, Temples IV, III, and II.

100cm
80cm
60cm
40cm
20cm

210. The North Group, Temple II, Pier A.

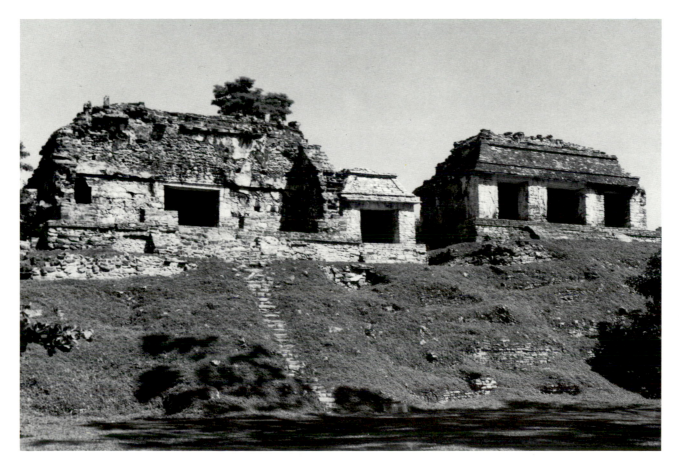

213. The North Group, Temple III. Photo by Teobert Maler, 1903.

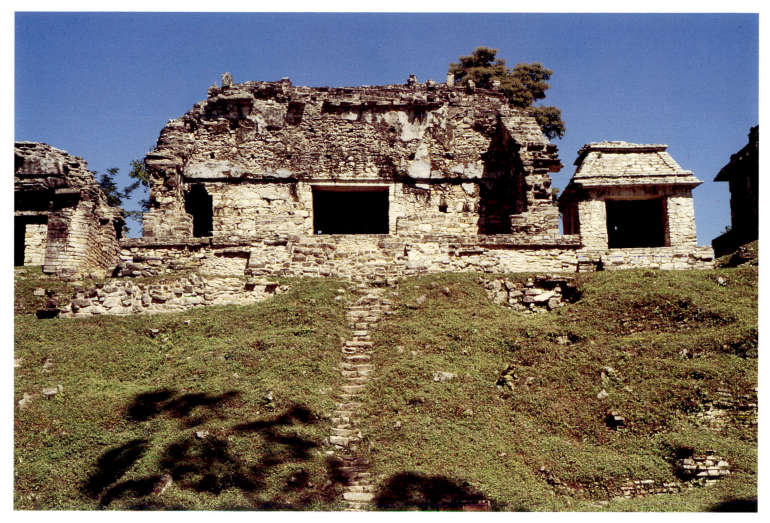

214. The North Group, Temple IV.

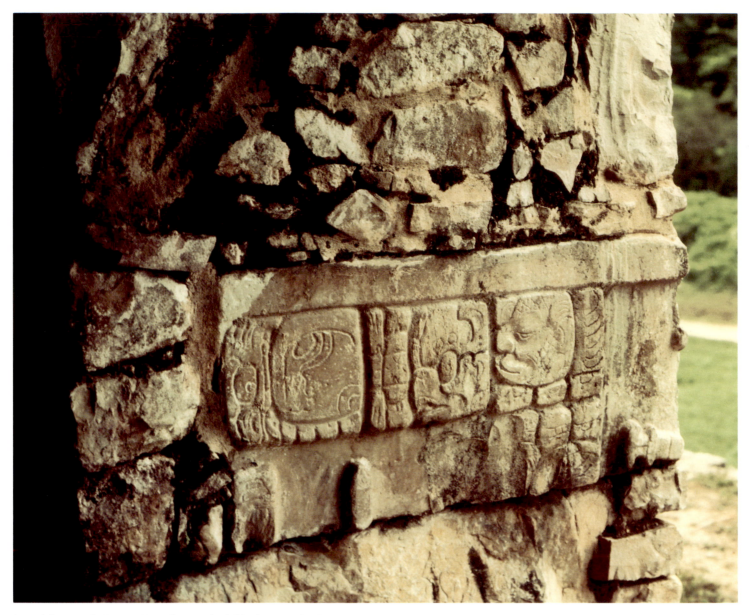

215. The North Group, Temple IV. Glyph block set in the doorway.

216. The North Group, Temple IV. Glyph block set upside down in wall.

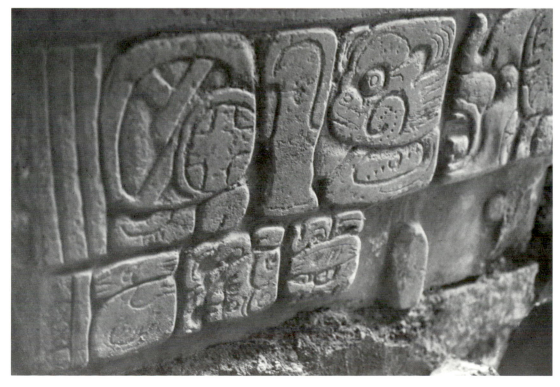

217. Glyph block of fig. 216 turned right side up.

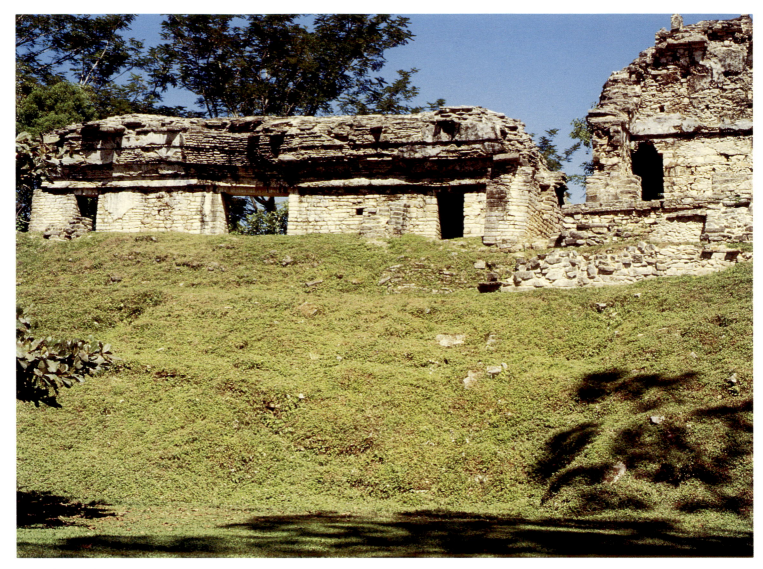

218. The North Group, Temple V.

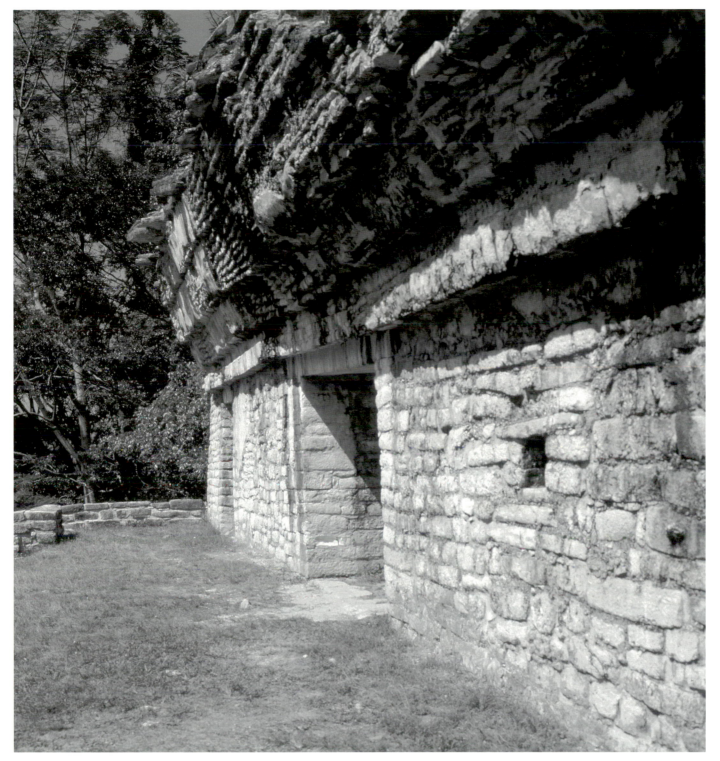

219. The North Group, Temple V. Center wall and vault overhang.

220. The North Group, Temple V. Stepped vault.

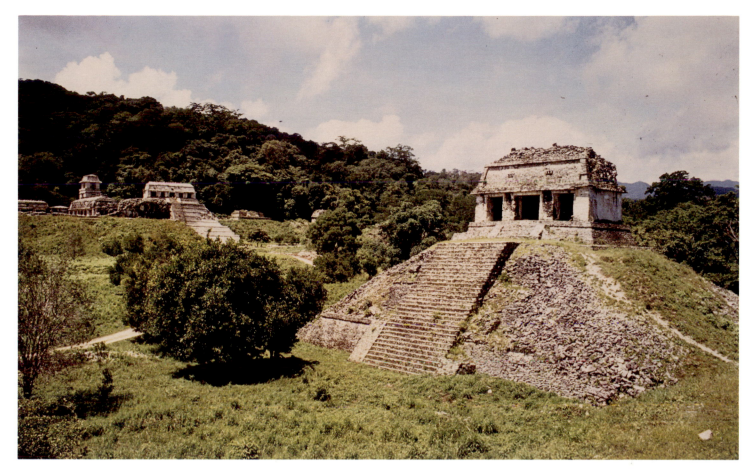

221. Temple of the Count.

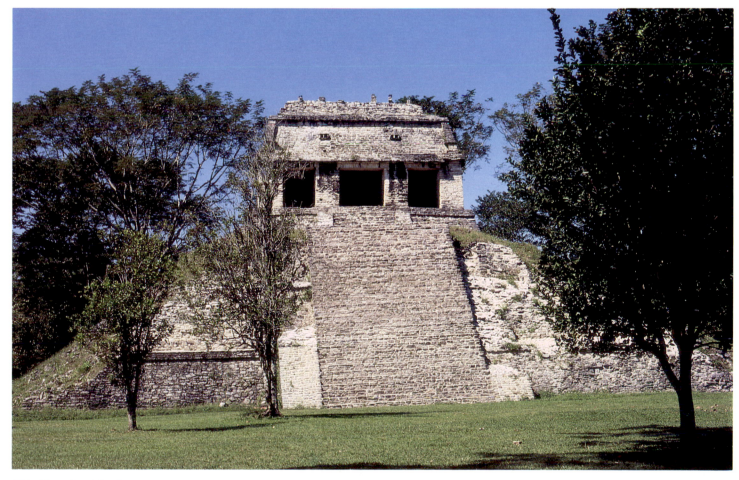

222. Temple of the Count.

223. Temple X.

225. Temple XII. North facade.

224. Temple XII (Temple of the Dying Moon).

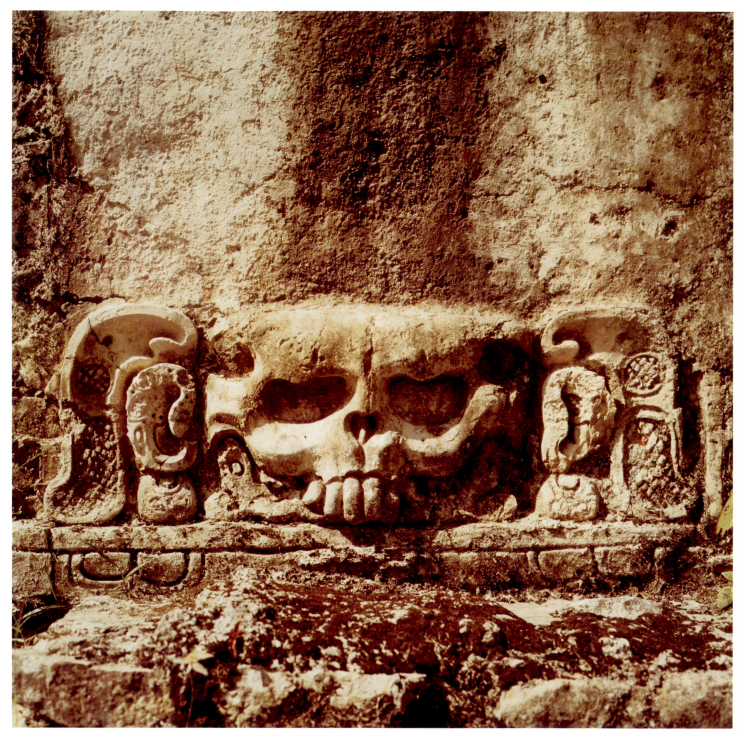

226. Temple XII. Skeletal rabbit mask at base of Pier B.

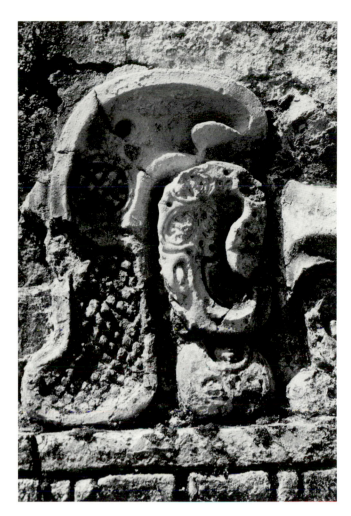

227. Temple XII. Ear of the skeletal rabbit mask.

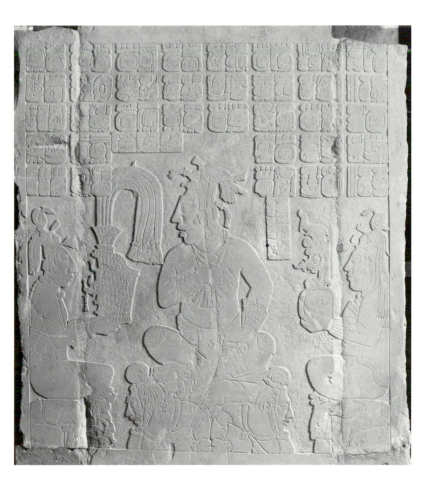

228. Group IV. Tablet of the Slaves.

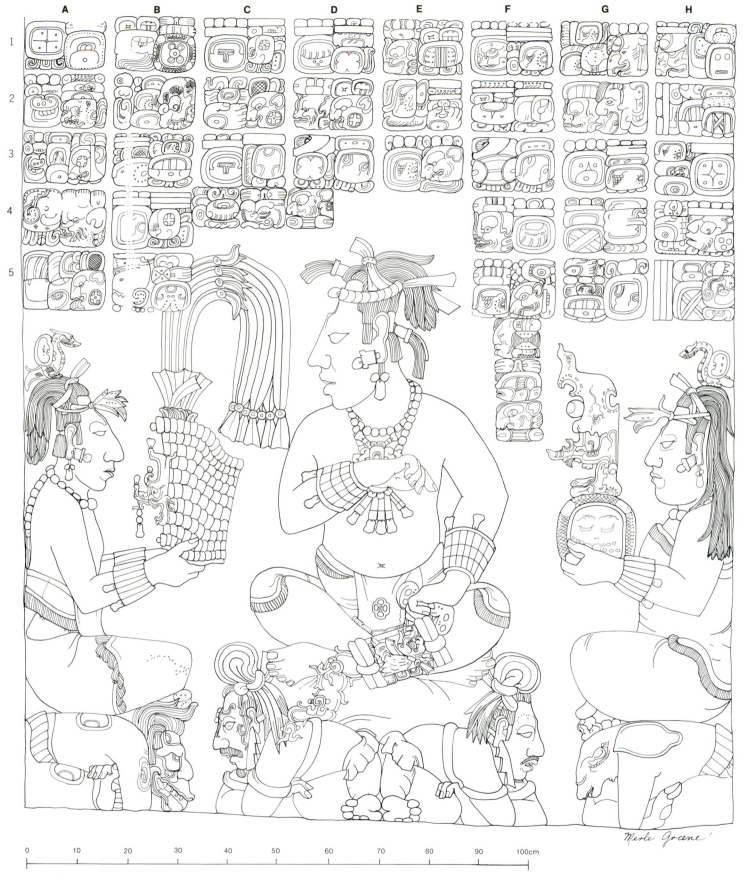

229. Group IV. Tablet of the Slaves.

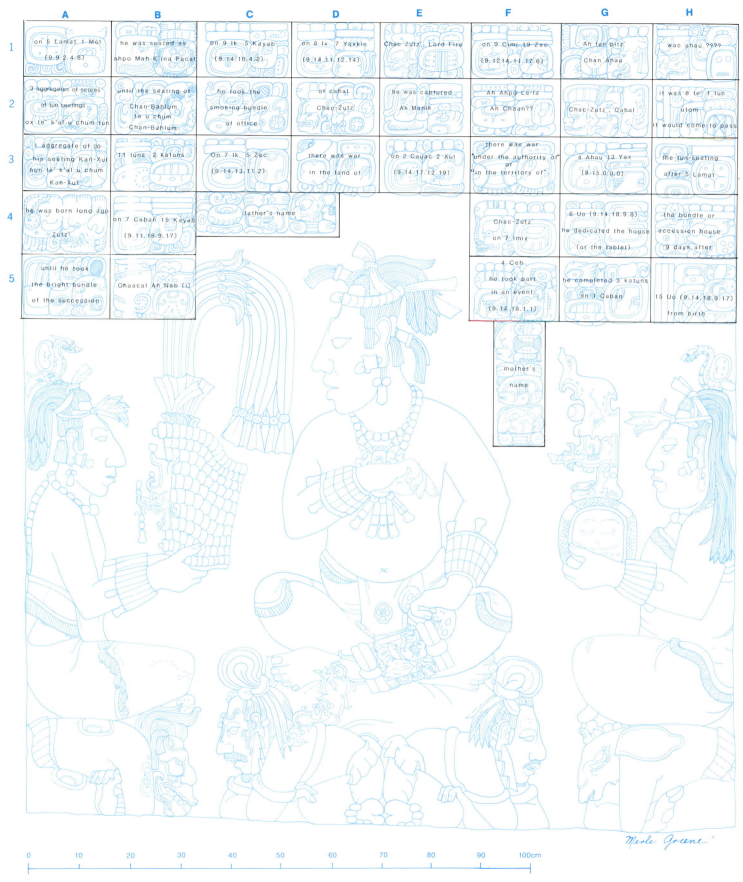

Columns: **A B C D E F G H**, Rows: **1–5**

A1: on 5 Lamat 1 Mol (9.9.2.4.8)
B1: he was seated as ahpo Mah K'ina Pacal
C1: on 9 Ik 5 Kayab (9.14.10.4.2)
D1: on 8 Ix 7 Yaxkin (9.14.11.12.14)
E1: Chac-Zutz', Lord Fire
F1: on 9 Cimi 19 Zac (9.12.14.11.17.6)
G1: Ah tun pitz' Chan Ahau
H1: wac ahau ????

A2: 3 aggregates of scores of tun seatings ox te' k'al u chum tun
B2: until the seating of Chan-Bahlum ta u chum Chan-Bahlum
C2: he took the smoking bundle of office
D2: of cahal Chac-Zutz'
E2: he was captured Ah Manik
F2: Ah Ahpo-La-ta Ah Chaan??
G2: Chac-Zutz', Cahal
H2: it was 8 te' 1 tun utom it would come to pass

A3: 1 aggregate of 20 his seating Kan-Xul hun te' k'al u chum Kan-Xul
B3: 11 tuns 2 katuns
C3: On 7 Ik 5 Zec (9.14.13.11.2)
D3: there was war in the land of
E3: on 2 Cauac 2 Xul (9.14.17.12.19)
F3: there was war "under the authority of" or "in the territory of"
G3: 4 Ahau 13 Yax (9.15.0.0.0)
H3: the tun-seating after 5 Lamat

A4: he was born long ago Zutz'
B4: on 7 Caban 15 Kayab (9.11.18.9.17)
C4/D4: father's name
F4: Chac-Zutz' on 7 Imix
G4: 6 Uo (9.14.18.9.8) he dedicated the house (or the tablet)
H4: the bundle or accession house 9 days after

A5: until he took the bright bundle of the succession
B5: Chaacal Ah Nab [i]
F5: 4 Ceh he took part in an event (9.14.18.1.1)
G5: he completed 3 katuns on 1 Caban
H5: 15 Uo (9.14.18.9.17) from birth

mother's name

230. Group IV. Text of Tablet of the Slaves.

0 10 20 30 40 50 60 70 80 90 100cm

Merle Greene

231. The Olvidado.

232. The Olvidado. Plans and elevations.

232a. North facade.

232b. Plan.

232c. Plan with stairs.

232d. North-south section.

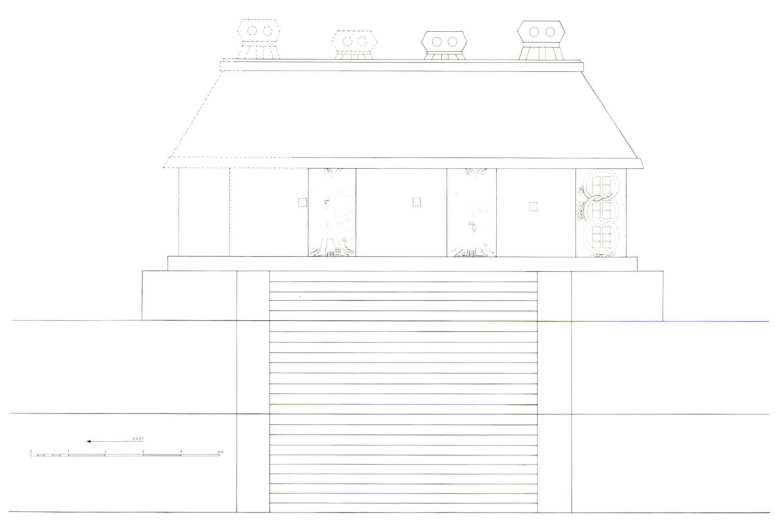

232a

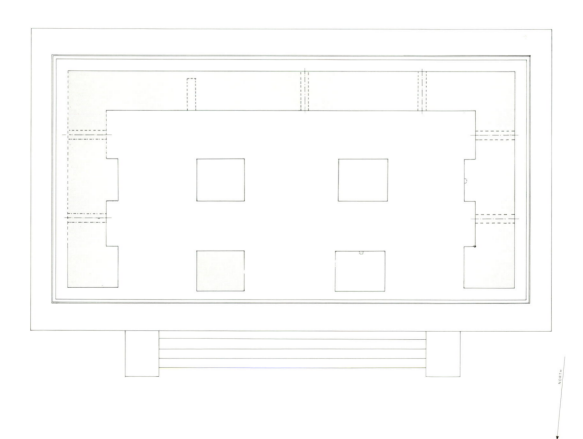

232b

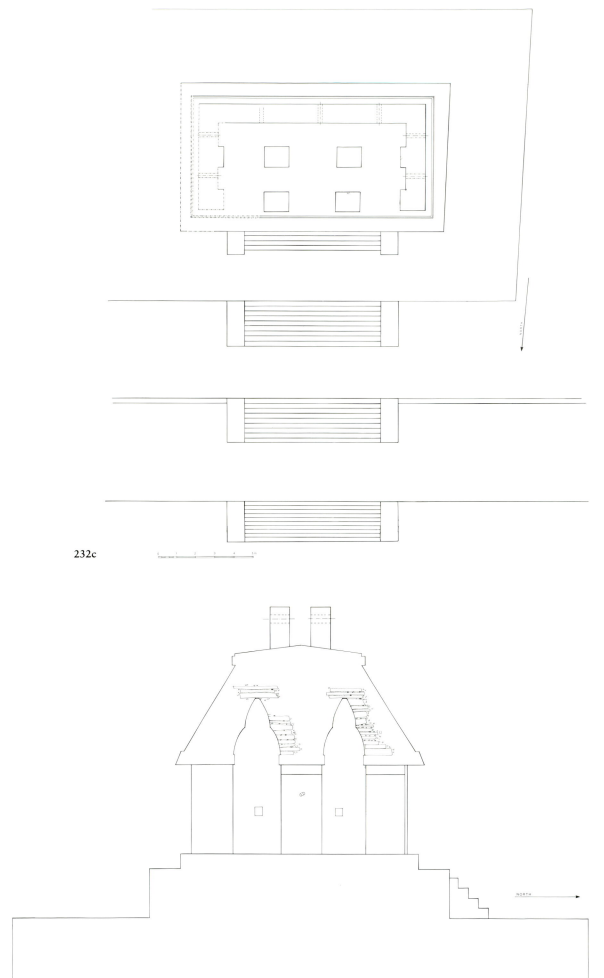

232c

232d

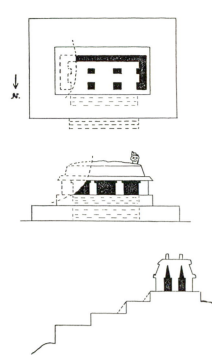

233. The Olvidado. Frans Blom's 1926 plan.

234. The Olvidado. Double curve of the vault.

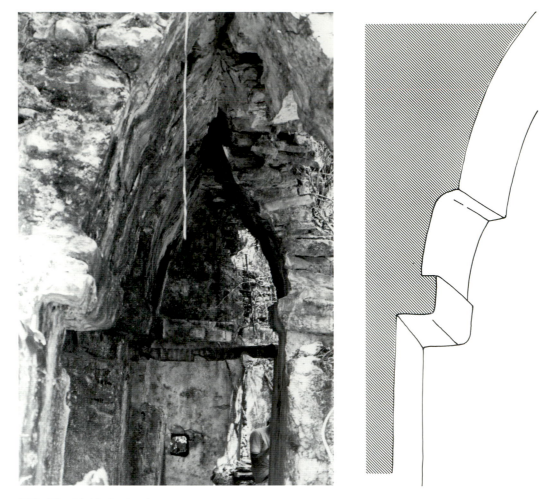

235. The Olvidado. Vault with double curve.

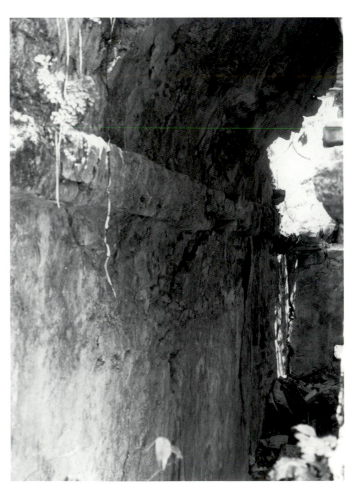

236. The Olvidado. Double vault spring.

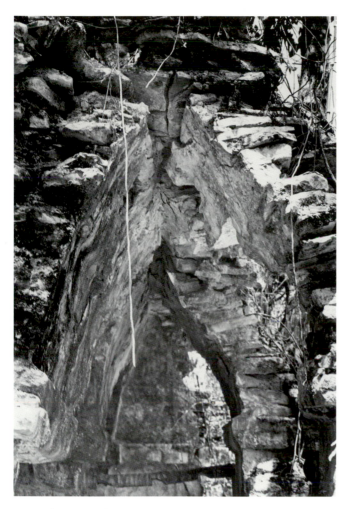

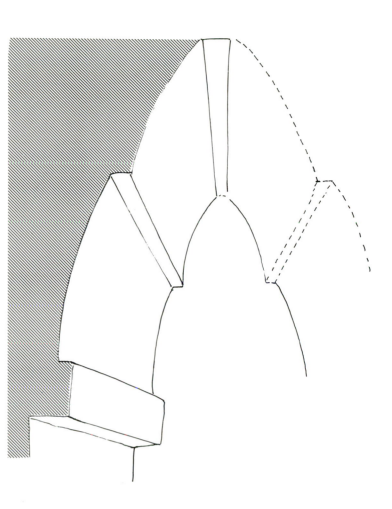

237. The Olvidado. Wide capstones close vault gap.

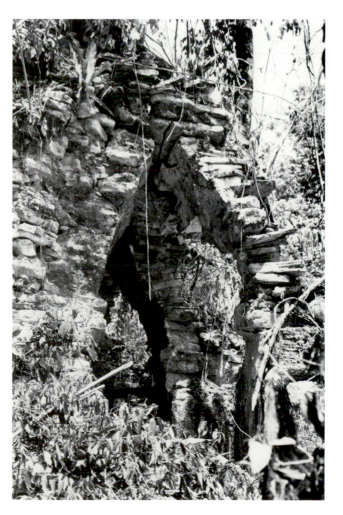

238. The Olvidado. Thick and thin vault stones are precariously placed.

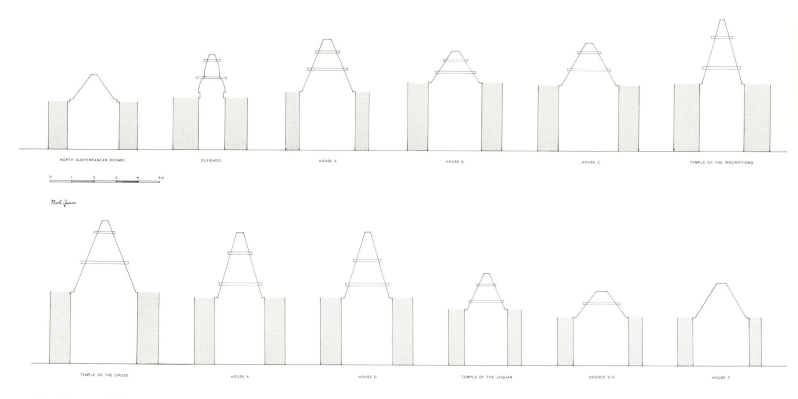

239. The Olvidado. Dimensions compared with other buildings at Palenque.

240. The Olvidado. Roof merlon.

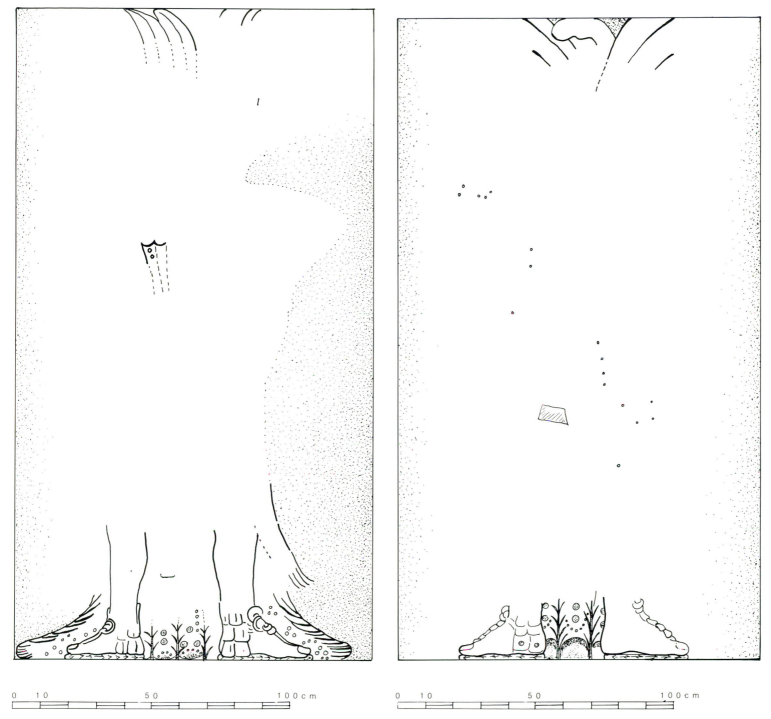

241. The Olvidado, Pier B.

244. The Olvidado, Pier C.

242. The Olvidado, Pier B. Jaguar-pelt cloak falls between legs and at side of figure.

243. The Olvidado, Pier B. Feet were first modeled and then boots put on.

245. The Olvidado, Pier C. Feet and cloak.

246. The Olvidado, Pier C. Foot is built up with thick stucco and armatures.

247. The Olvidado, Pier C. Foot is formed over armatures.

248. The Olvidado, Pier D.

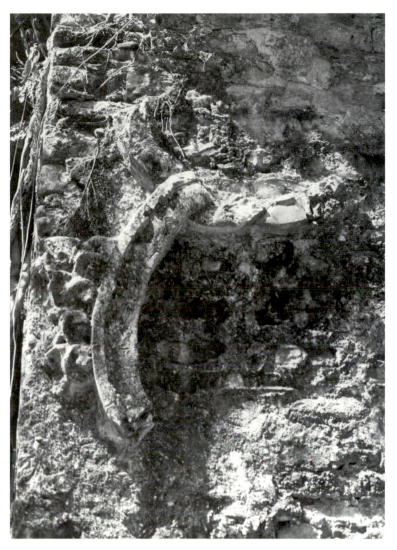

249. The Olvidado, Pier D. Double serpent cartouche.

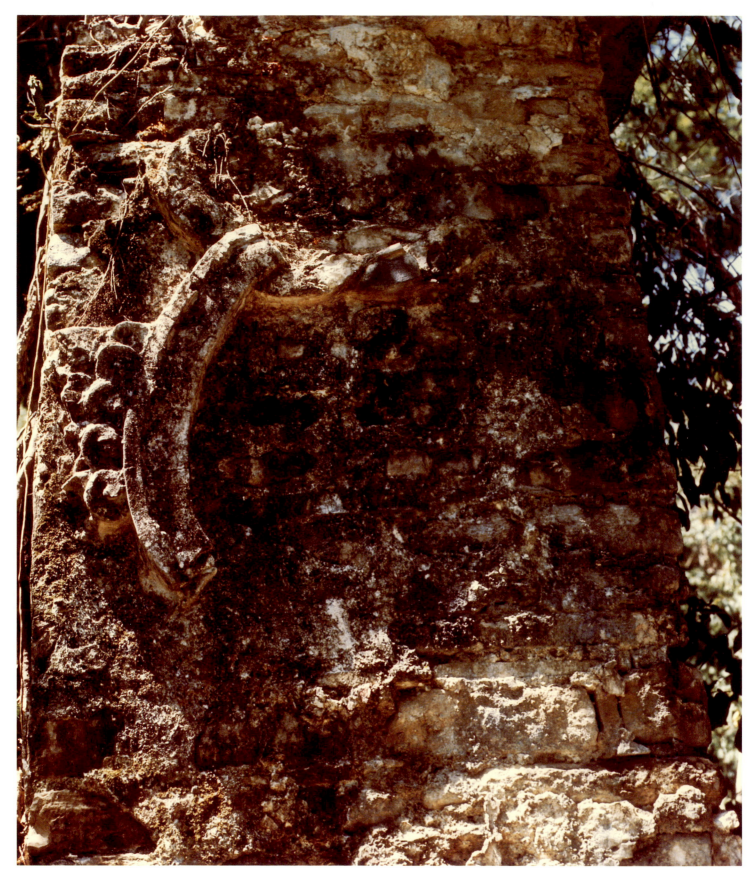

250. The Olvidado, Pier D. Entwined serpents form cartouches for glyph blocks.

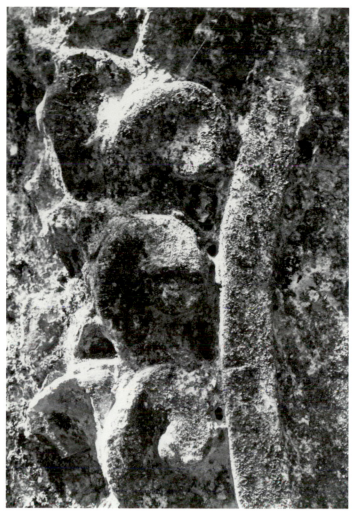

251. The Olvidado, Pier D. Serpent around cartouche.

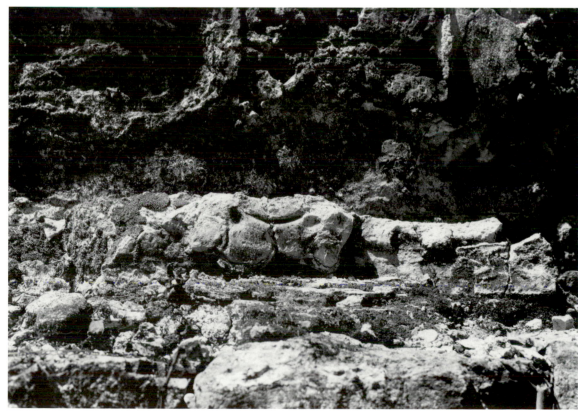

252. The Olvidado, Pier D. Stucco element at bottom of pier.

253. The Olvidado, Pier A.

254. The Olvidado, Pier D.

	A	B		C	D
1	I.S.I.G. the month Pop	9 Baktuns		?	?
2	10 Katuns	14 Tuns		?	possessed noun
3	5 Uinals	10 Kins		u-cab expression	?
4	3 Oc	Glyph G2 and F		?	Mah K'ina
5	Glyph D	Glyph 6C		ah-na-be Pacal's early name	Pacal
6	Glyph X	Glyph B		Palenque Emblem Glyph	child of the father
7	Glyph A	3 Pop		Kan-Bahlum-Mo'	E.G. or introduction to mother
8	?	?		child of the mother	Lady Zac-Kuk
9	?	?		female title	probably another title

255. The Olvidado. Text on Piers A and D.

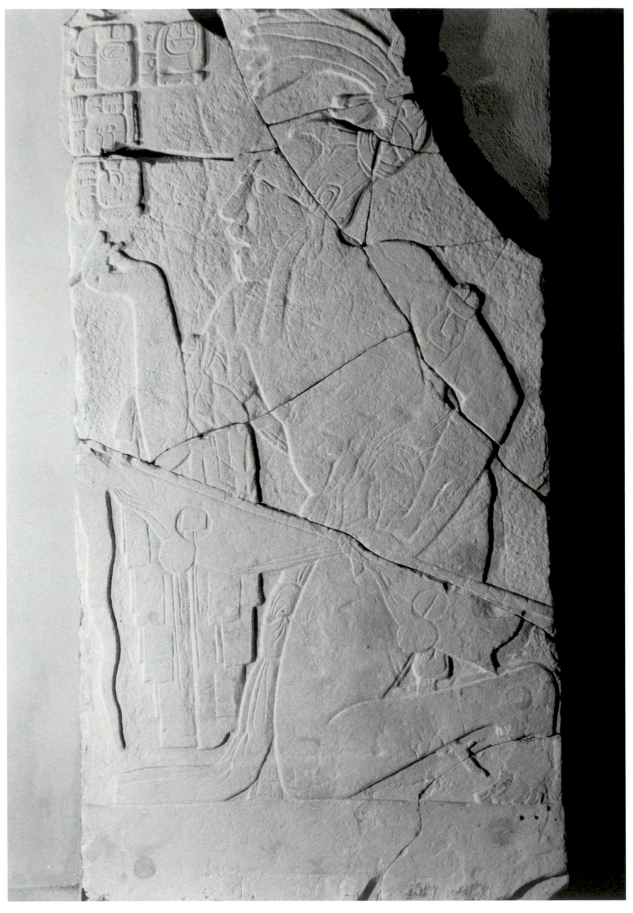

256. Tablet of the Scribe.

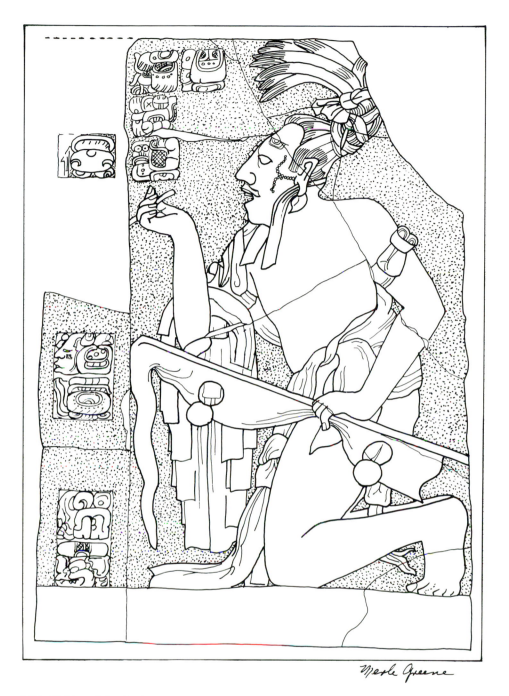

257. Tablet of the Scribe.

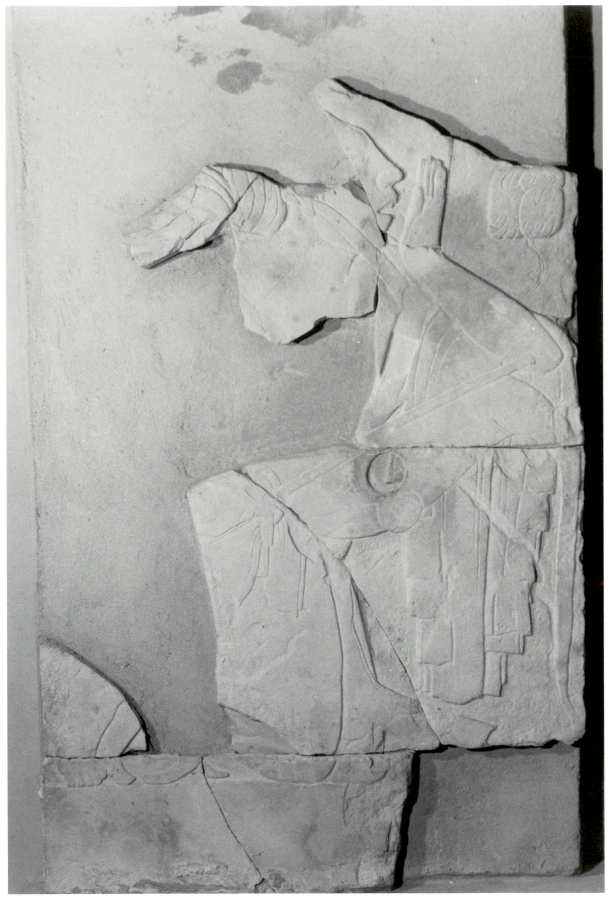

258. Tablet of the Orator.

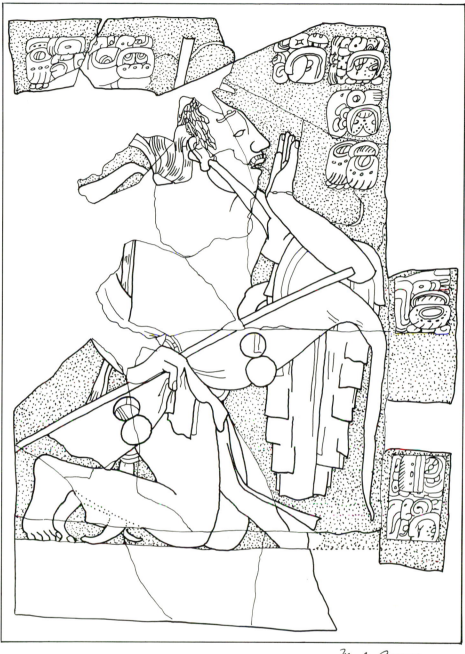

259. Tablet of the Orator.

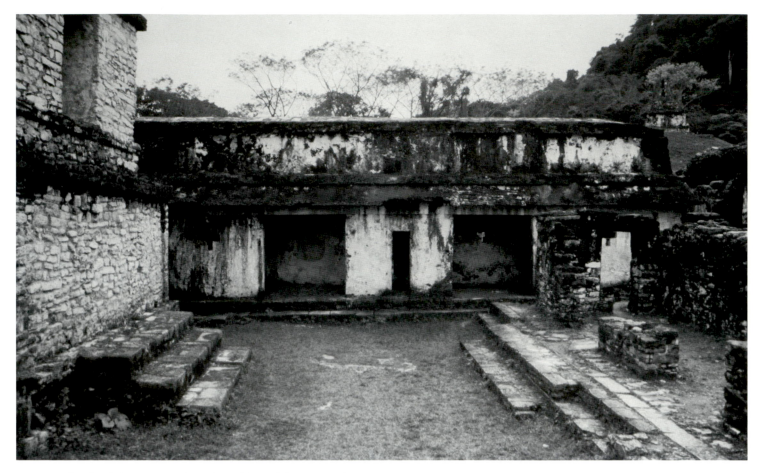

260. South side of the Tower, where the Tablets of the Scribe, the Orator, and 96 Hieroglyphs were found.

261. Tonina Monument 108.

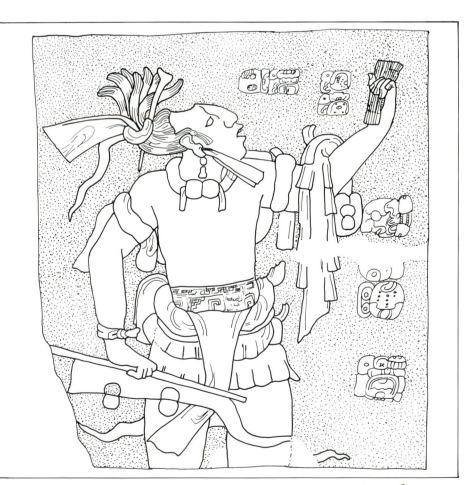

263. Tablet of Temple XXI.

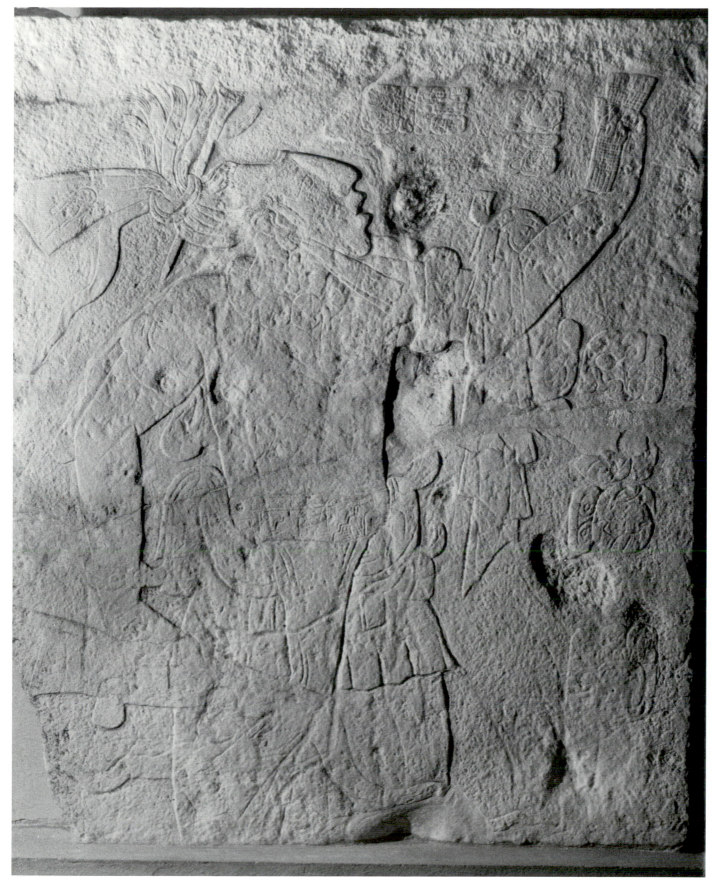

262. Tablet of Temple XXI.

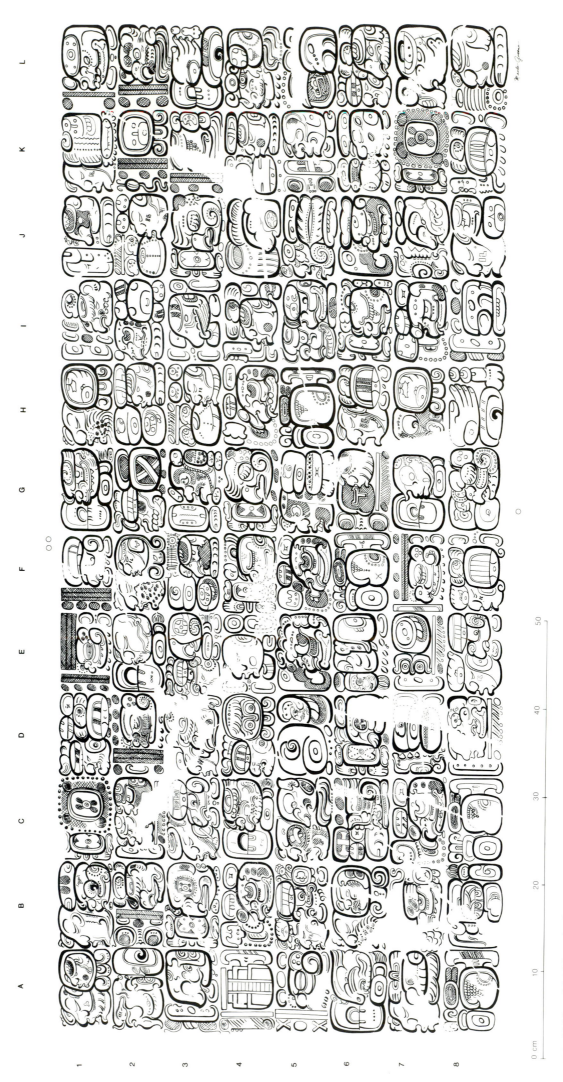

264. Tablet of 96 Hieroglyphs.

265. Text of Tablet of 96 Hieroglyphs.

266. Creation Stone.

on the TIKAL bone drawings

on the Metropolitan pot with ax in his hand

Traits common to both examples

1 HUMAN BODY

2 VEGETAL SCROLL DIADEM WITH SHELL

3 INFIXED CROSSED BANDS

4 LONG HAIR, GATHERED

269. Chac-Xib-Chac. 5 SHELL EARPLUG

6 WATER MARK

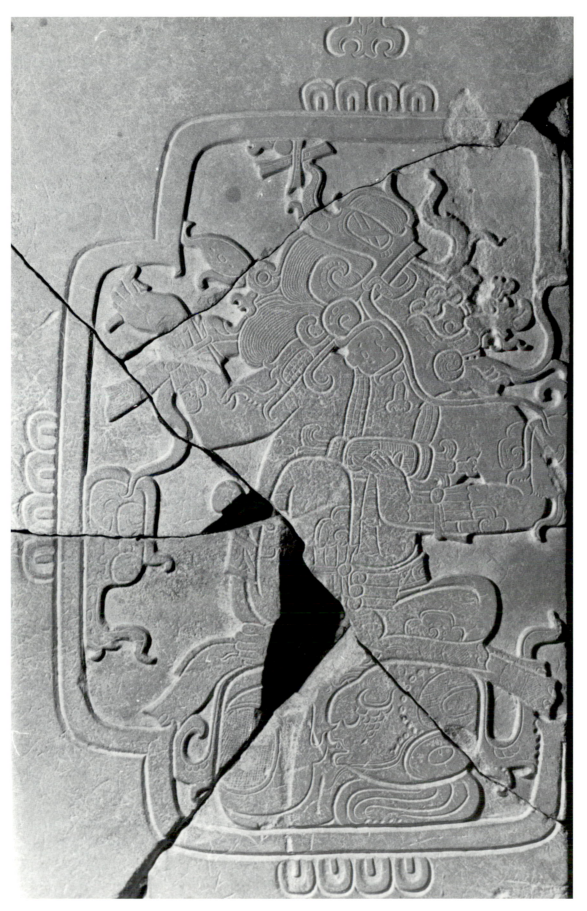

267. Creation Stone, right cartouche.

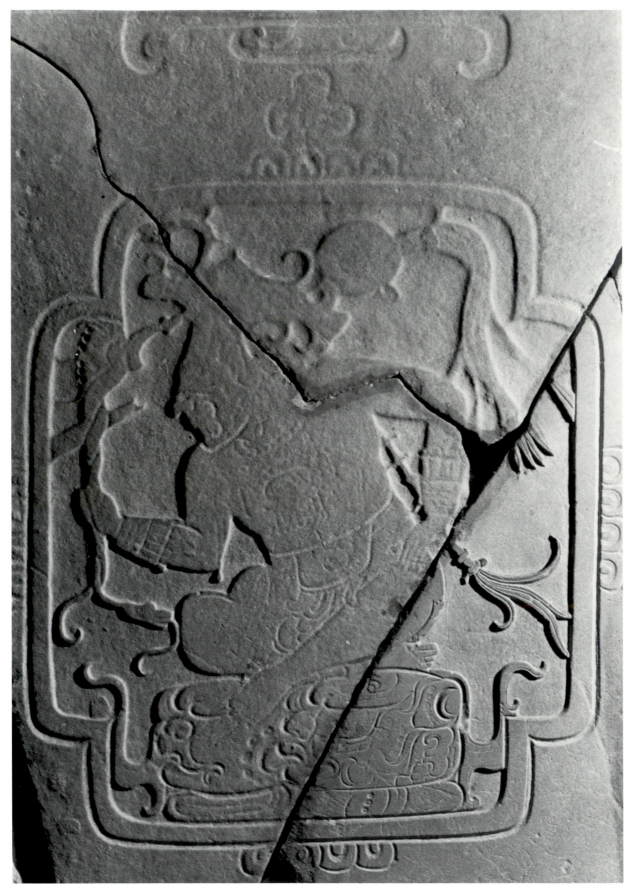

270. Creation Stone, left cartouche.

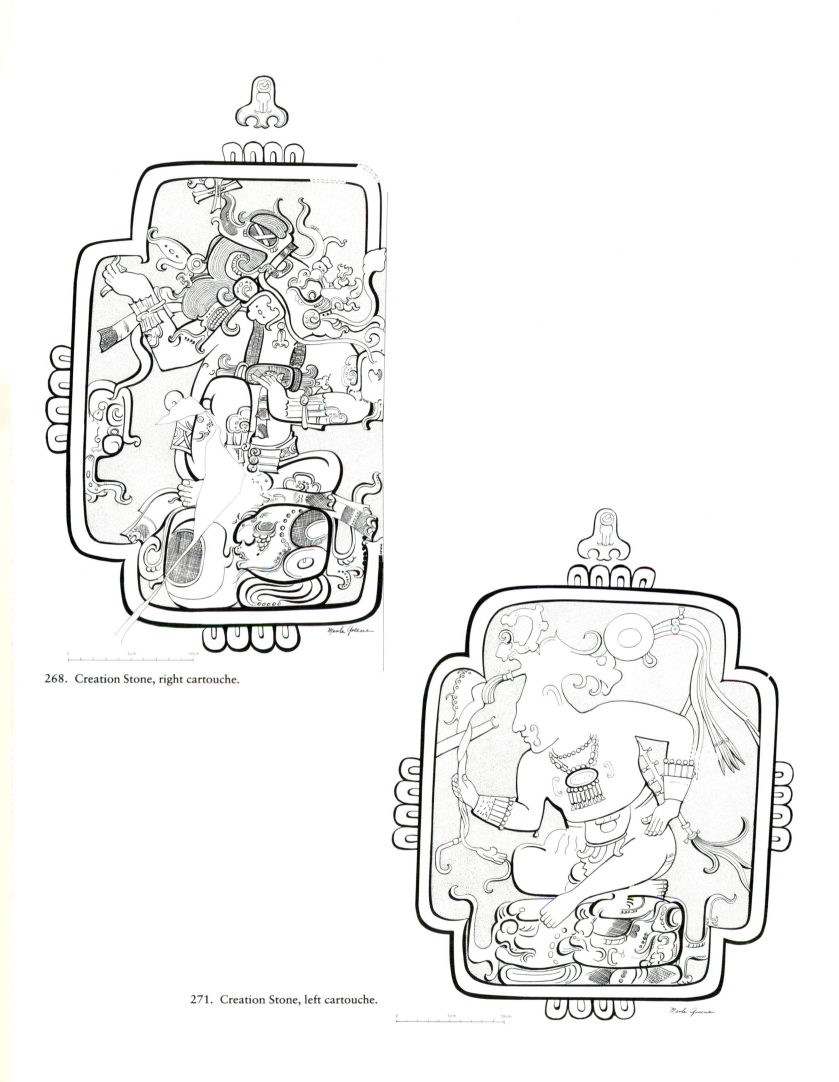

268. Creation Stone, right cartouche.

271. Creation Stone, left cartouche.

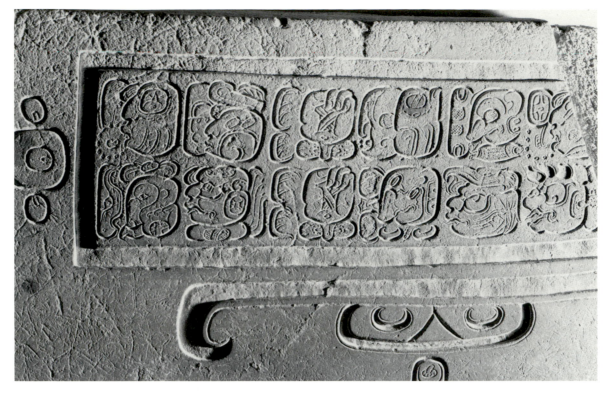

272. Creation Stone. Glyphs over right cartouche.

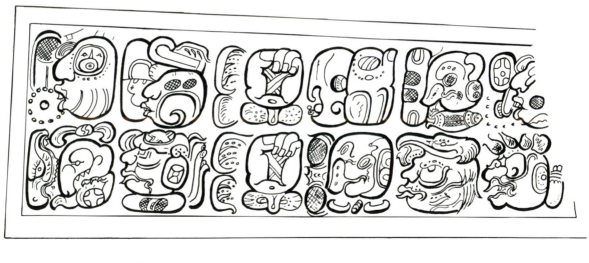

0 5cm 10cm 15cm 20cm 25cm

273. Creation Stone. Glyphs over right cartouche identify Chac-Xib-Chac.

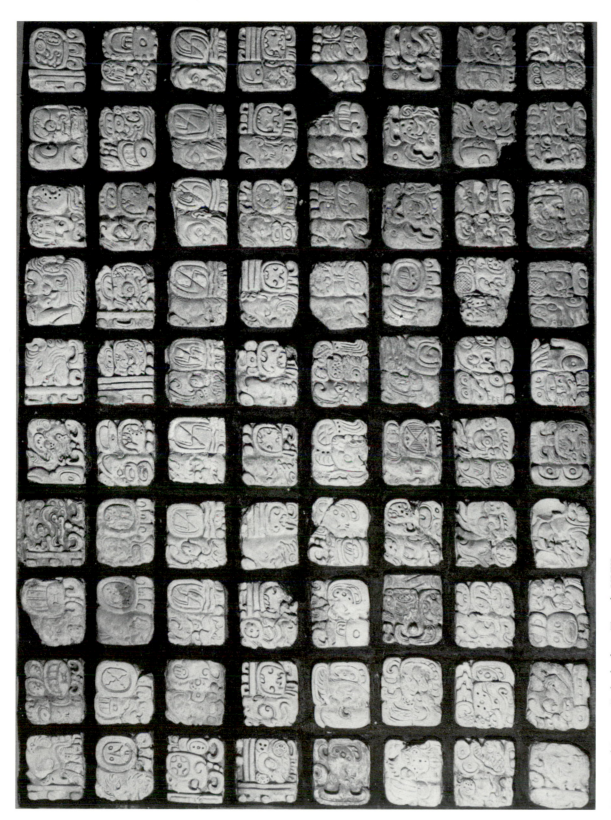

274. "Cookie cutter" glyphs from Temple XVIII.

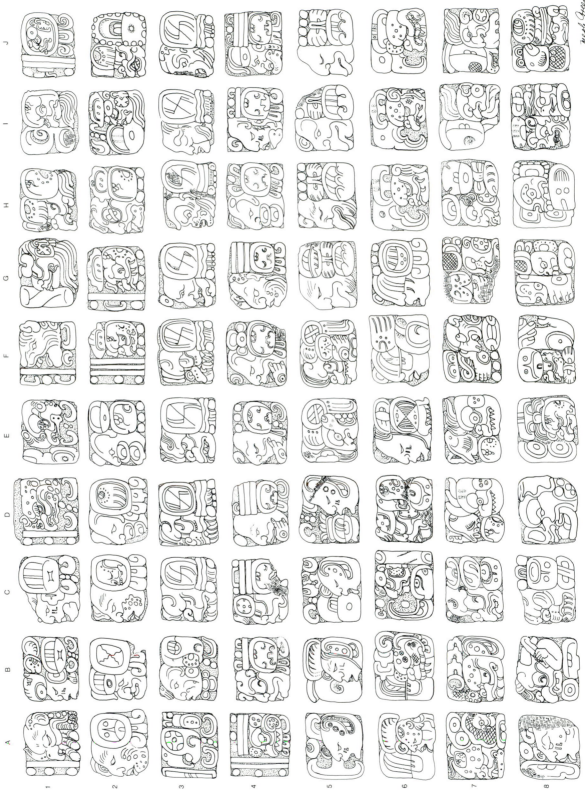

275. "Cookie cutter" glyphs from Temple XVIII.

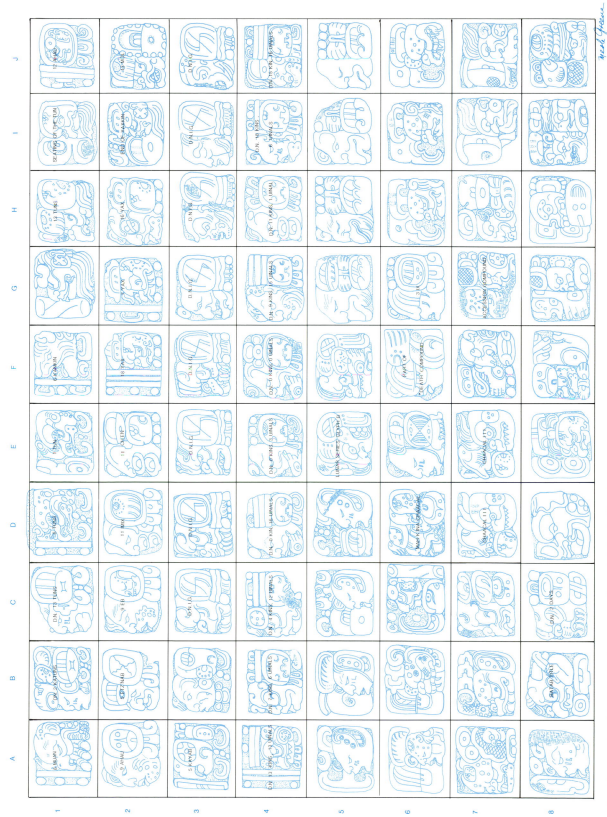

276. Text of "cookie cutter" glyphs from Temple XVIII. The glyphs are not placed in any meaningful order. This is the way they are displayed in the Palenque Museum.

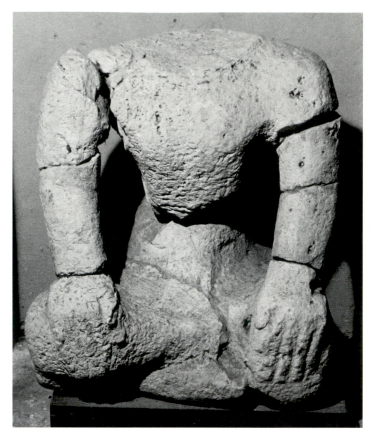

277. Limestone torso.

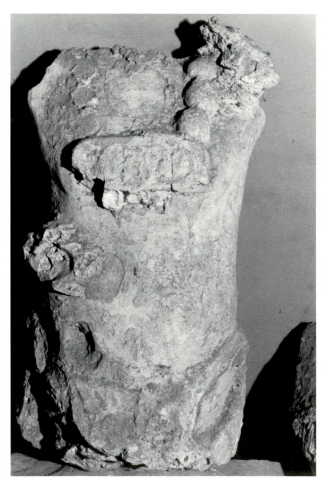

278. Torso with large pectoral.

D.N. 14 KINS 7 UINALS

9 EB

0 YAXKIN

DATE

9.13.0.4.12 9 Eb 0 Yaxkin

283. Text on flange of incense burner (fig. 279).

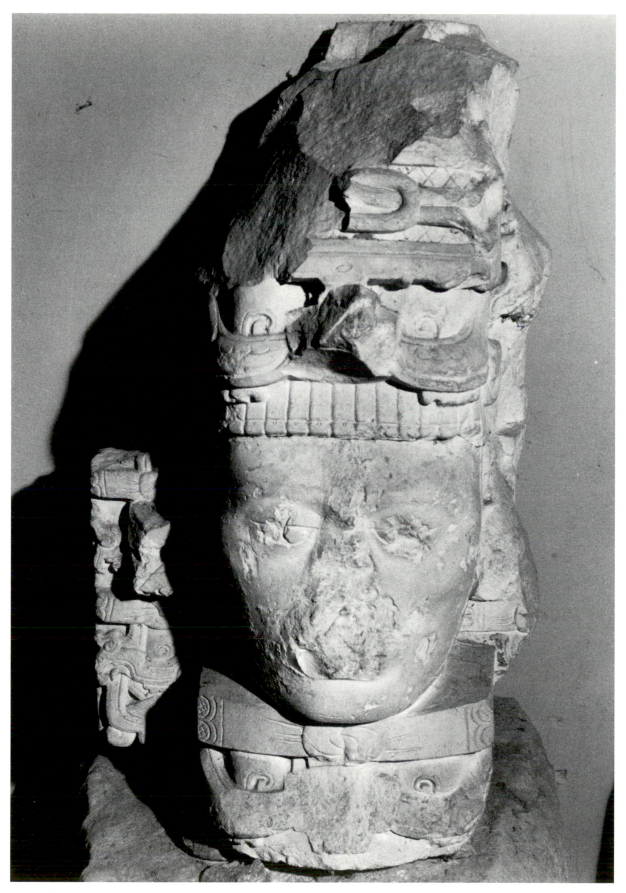

279. White limestone incense burner stand of a human head wearing a God K mask as headdress.

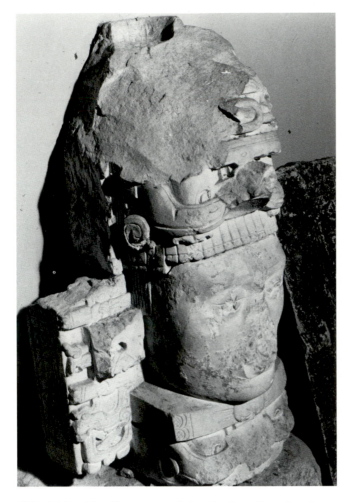

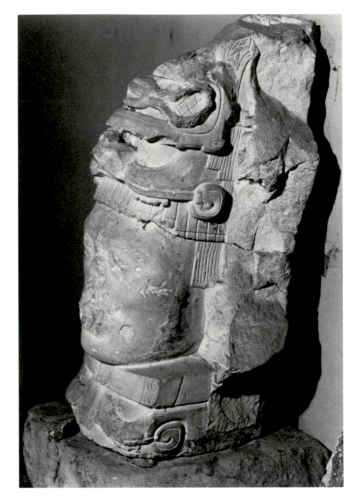

280. Right side of burner stand showing long-lipped-god earplugs with crossed bands below.

281. Left side of burner stand.

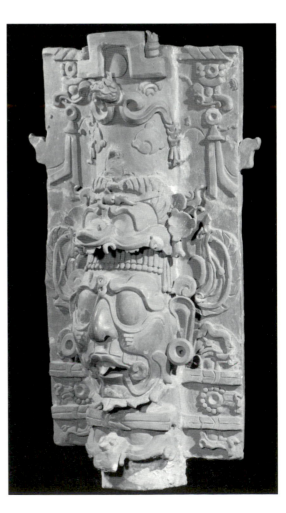

282. Palenque incensario with Sun God's head.

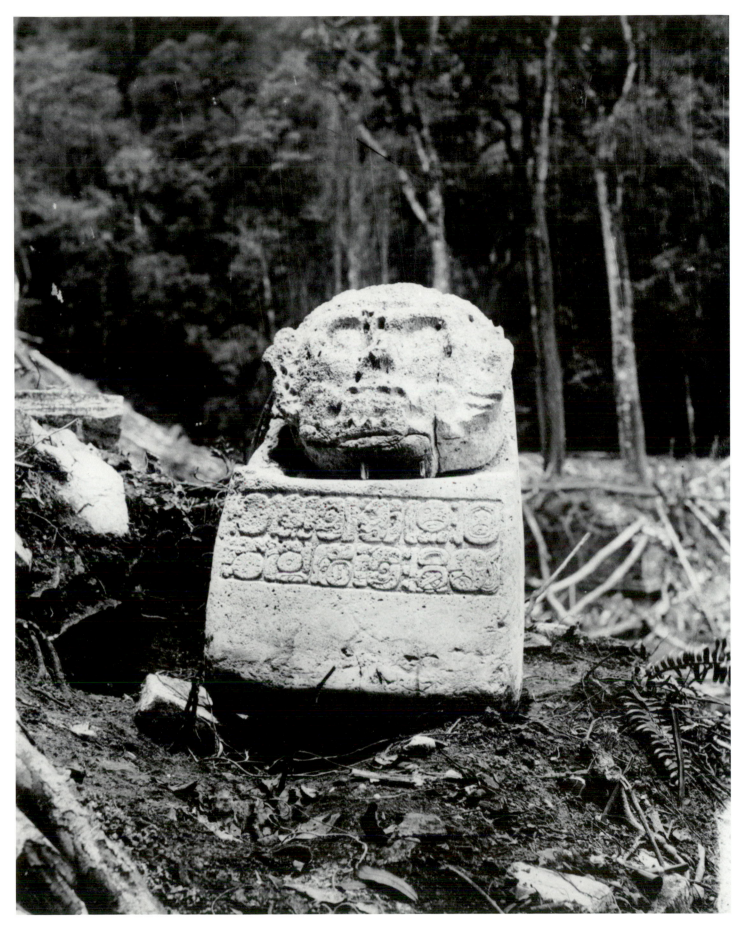

284. Death Head Monument. Photo by Alfred Maudslay, 1889.

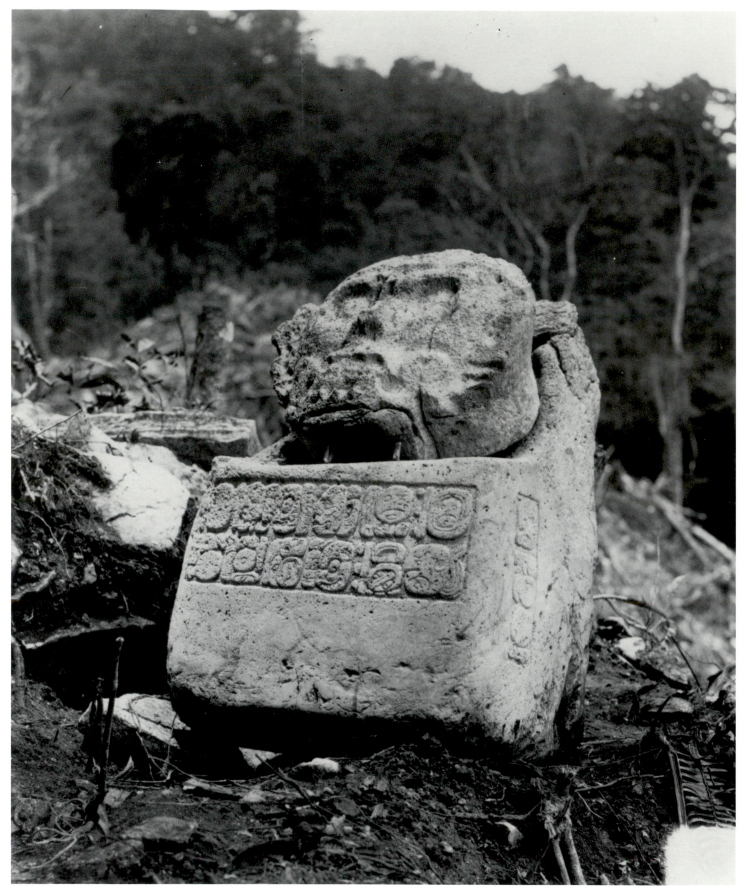

285. Death Head Monument. Photo by Alfred Maudslay, 1889.

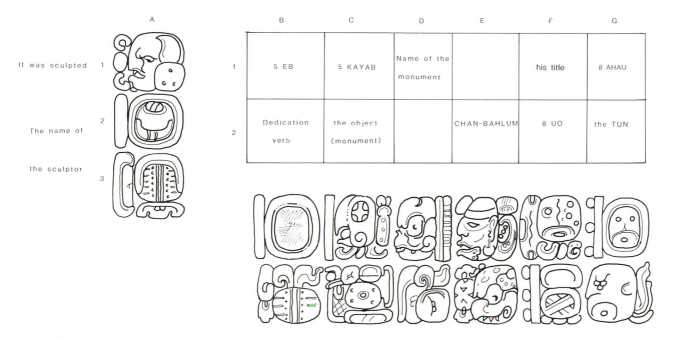

	A		B	C	D	E	F	G		H
It was sculpted		1	5 EB	5 KAYAB	Name of the monument		his title	8 AHAU		
The name of		2	Dedication verb	the object (monument)		CHAN-BAHLUM	8 UO	the TUN		The rest of the
the sculptor		3								sculptor's name

286. Glyphs on the Death Head Monument. On the eighth anniversary of Chan-Bahlum's accession on *5 Eb 5 Kayab* the sanctuaries inside the temples were dedicated (9.13.0.0.0 8 *Ahau* 8 *Uo*, A.D. 692).